# LIVING IN STYLE
# IBIZA

**Edited by Anke Rice and Clarisse Grumbach-Palme**
**Texts by Tiny von Wedel**

teNeues

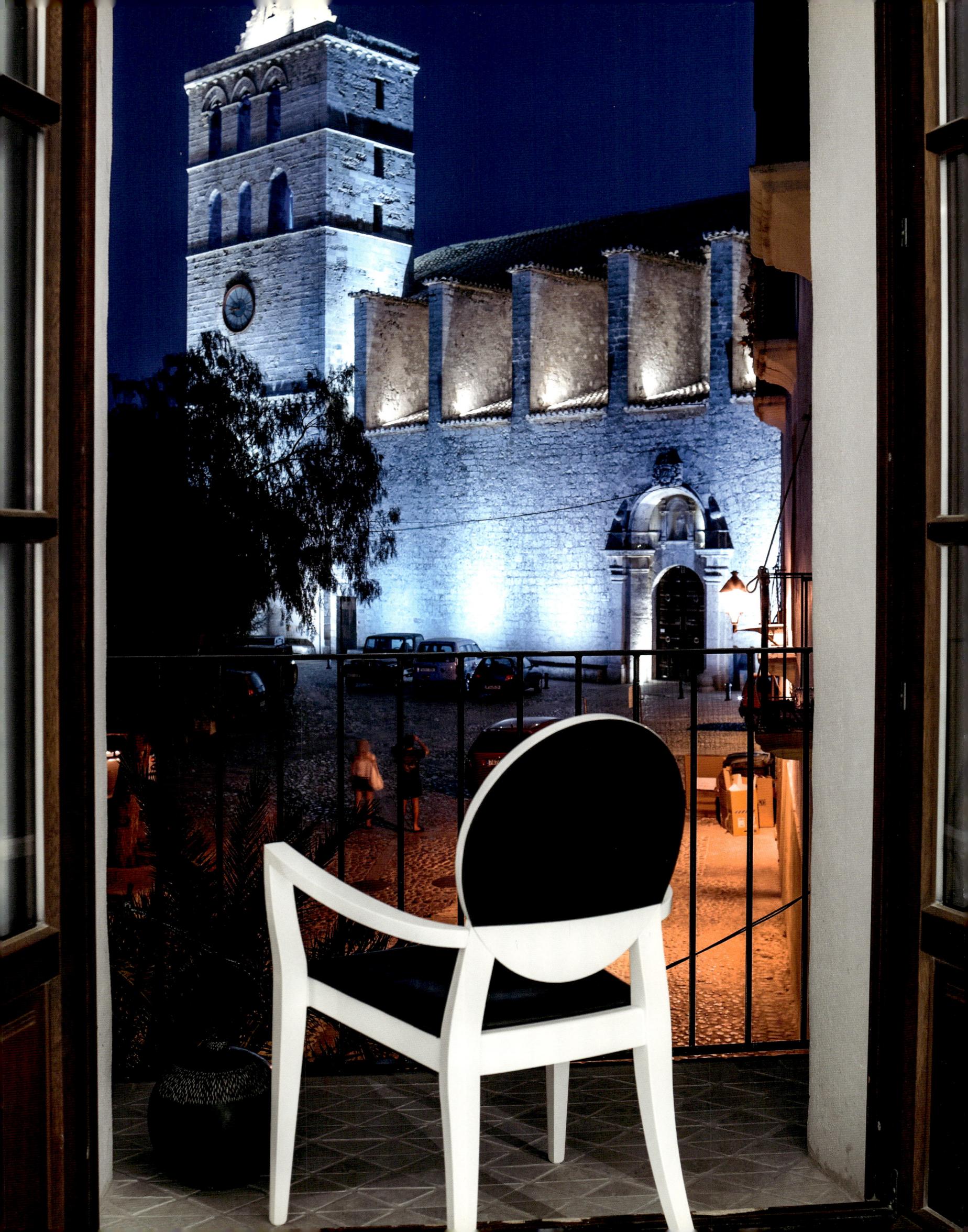

# Contents

# Introduction
## Tiny von Wedel

The third largest island in the Balearic archipelago, Ibiza has become a popular Mediterranean getaway for the international jet set. Ibiza Town's picturesque historic center is a UNESCO world cultural heritage site, and the island boasts a legendary night life. With its hilly landscape, endless beaches and one of the best club scenes in the world, Ibiza provides a perfect backdrop for many different styles of homes and refuges. The landscape in the south and southeast features vast plains, but the more mountainous sections in the north and west lend the island its unique charm. Evergreen forests that stretch as far as the eye can see constitute most of the vegetation. Combined with the landscape's warm, earth tones and the azure sea, the green canopy creates a bright palette of Mediterranean colors. Almond, carob and olive trees, thousands of years old, line the lanes that wind between hidden island houses, magnificent estates, and imposing city palaces. From the spectacular Ses Salinas Natural Park, with its hundreds of flamingos, to craggy coasts and the magical Mount Es Vedra—where Odysseus supposedly ran his ship aground, seduced by the sirens' song—Ibiza radiates a unique atmosphere. Celebrities from all over the world are drawn by the magical contrasts of island life. Many of them live here year round or have vacation homes on the island, where they've created unusual and unique residences with influences from around the globe. Ibiza offers a wide range of architectural styles and designs that blend with the Mediterranean landscape: futuristic architecture, casual ambience imbued with hippie-de-luxe style, Bohemian chic, and eclectic country homes. Depending on the location, terraces and gardens offer views of Ibiza Town's picturesque historic center, white beaches bordering turquoise water or the island's pristine landscape. On the horizon, rocky islands rise from the sea, while vineyards and orchards dot the landscape. Visitors can party with wild abandon in the island's capital or enjoy the quiet relaxation of its rural areas—the right mix and lifestyle can be found to suit every taste. The international demographics and the individual style of the island's homeowners are matched only by the variety of their residences. With our selection of the loveliest, most impressive and most inspirational homes, we take you on tour of the normally off-limits living spaces created by the island's celebrities and Ibiza aficionados.

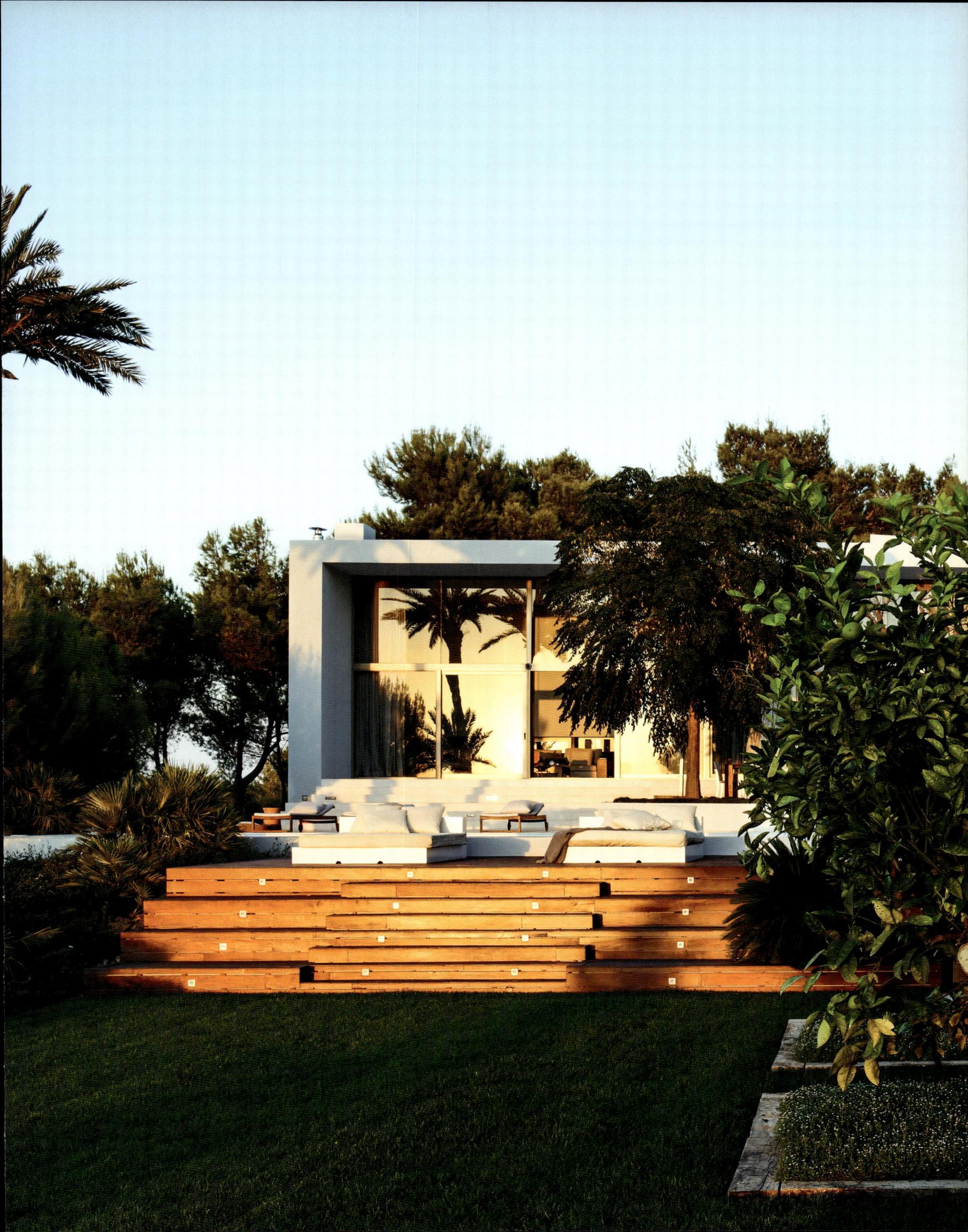

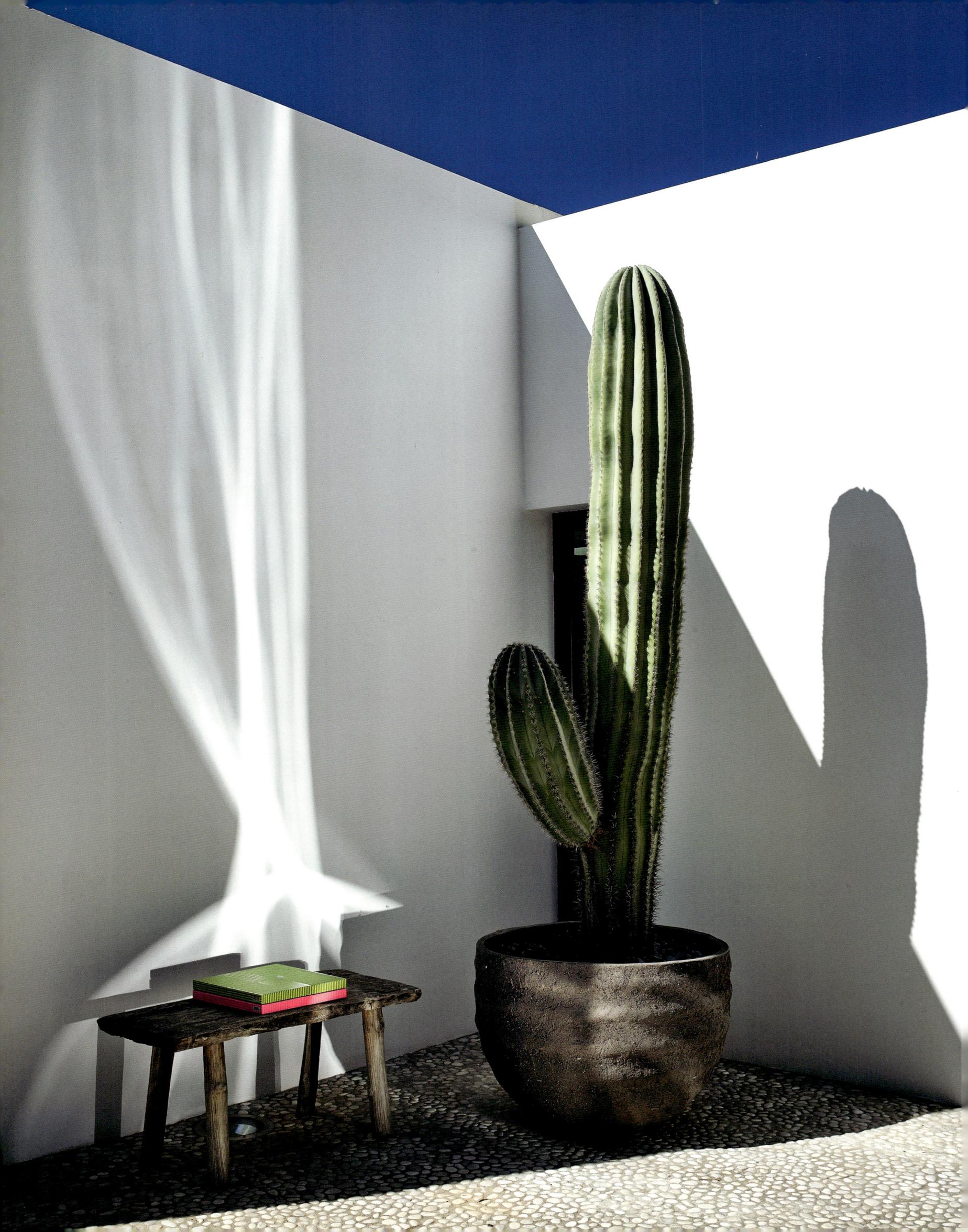

# Einleitung

## Tiny von Wedel

Als drittgrößte Insel der Balearen hat sich Ibiza zur internationalen Jet-Set-Insel des Mittelmeers entwickelt. Die malerische Altstadt von Ibiza gehört zum UNESCO-Weltkulturerbe und das Nachtleben der Insel ist legendär. Mit ihrer hügeligen Landschaft, den weitläufigen Stränden und einer der weltbesten Clubszenen bietet Ibiza den perfekten Standort für die unterschiedlichsten Häuser und Refugien. Während im Süden und Südosten die Landschaft durch weite Ebenen geprägt ist, geben im Norden und Westen bergigere Abschnitte die Kulisse für den ganz eigenen Charme der Insel. Ausgedehnte Pinien- und Kiefernwälder bilden die Hauptvegetation und ihr Grün erzeugt zusammen mit der warmen Erdfarbe der Landschaft und dem azurblauen Wasser ein mediterranes Farbenspiel. Mandel-, Johannisbrot- und tausendjährige Olivenbäume säumen die Wege zwischen den versteckten Insellandhäusern, beeindruckenden Anwesen und repräsentativen Stadtpalästen. Von dem spektakulären Salinennaturpark mit Hunderten von Flamingos, über schroffe Küstenabschnitte bis hin zum magischen Berg Es Vedra – an dem schon Odysseus Schiff zerschellt sein soll, verführt vom Gesang der Sirenen – verströmt Ibiza eine einzigartige Atmosphäre. Prominente aus aller Welt sind magisch angezogen von den Gegensätzen des Insellebens. Viele von ihnen haben die Insel zu ihrem Haupt- oder Ferienwohnsitz erklärt und mit den Einflüssen aus aller Welt sind so ungewöhnliche und einzigartige Wohnstrukturen entstanden. Im Zusammenspiel mit der mediterranen Landschaft findet man auf Ibiza die unterschiedlichsten Baustile und Stilrichtungen. Futuristische Architektur, entspanntes Hippie-de-Luxe-Ambiente, Bohemien Chic und eklektische Landhäuser. Von den Terrassen und Außenanlagen kann man je nach Insellage über die pittoreske Altstadt, die weißen Strände mit ihrem türkisfarbenen Wasser oder die unberührte ibizenkische Landschaft blicken. Am Horizont ragen Felseninseln aus dem Meer und die Natur ist mit Weingärten und Obstplantagen durchzogen. So wild und losgelassen die Partyszene in der Inselhauptstadt ist, so ruhig und abgelegen sind die ländlichen Gebiete. Für jeden die richtige Mischung und die passende Lebensart. Und so international und individuell die Inselhausbesitzer sind, so unterschiedlich sind auch ihre Domizile. Wir haben die schönsten, beeindruckendsten und inspirierendsten zusammengestellt und führen Sie hinter die Mauern der sonst unzugänglichen und abgeschiedenen Lebenswelten der Insel-Celebrities und Ibiza-Aficionados.

# Introducción
## Tiny von Wedel

Ibiza, la mayor de las Pitiusas, ha acabado convirtiéndose en punto de encuentro para los ricos y famosos en el Mediterráneo. El pintoresco casco antiguo de Ibiza forma parte del patrimonio cultural de la humanidad de la UNESCO, y la vida nocturna es legendaria. Con su paisaje montañoso, sus extensas playas y una de las mejores infraestructuras de ocio nocturno del mundo, Ibiza ofrece el emplazamiento perfecto para casas y refugios de todo tipo. Así como en el sur y el sudeste de la isla las amplias planicies determinan el paisaje, en el norte y el oeste se hallan zonas más escarpadas que establecen el marco del personalísimo encanto de la isla. El verde de los extensos bosques de pinos se combina con los cálidos tonos de la tierra local y el azul de las aguas para generar el inconfundible colorido mediterráneo. Almendros, algarrobos y milenarios olivos jalonan los caminos por los que se accede a las recónditas residencias rurales de la isla, sus asombrosas residencias y sus imponentes palacetes. Todo en Ibiza, desde el parque natural de Ses Salines con sus centenares de flamencos hasta los agrestes tramos costeros y la magia de Es Vedrà (donde supuestamente el mismísimo Ulises embarrancó, seducido por el canto de las sirenas) contribuye a crear una atmósfera inigualable. A la isla acuden famosos de todo el mundo, atraídos por los mágicos contrastes que esta ofrece. Muchos de ellos deciden establecer en ella su segunda residencia, cuando no la principal, y llevan consigo influencias de todo el mundo que han contribuido a crear inesperadas y e inimitables residencias. En el paisaje mediterráneo de la isla es posible encontrar los estilos arquitectónicos más variopintos: estructuras futuristas, lujosos ambientes de inspiración hippie, bohemian chic y eclécticas residencias rurales. Desde las terrazas y espacios exteriores de estas residencias es posible contemplar (según la ubicación de cada casa) el paisaje que ofrecen el casco antiguo de Ibiza, las blancas playas de aguas color turquesa o el prístino terreno interior de la isla. En el horizonte, pequeños islotes asoman sobre las olas, y sobre el terreno se suceden los viñedos y los huertos. La animación y el constante ambiente festivo de la capital contrasta con la serenidad y la calma que imperar en las zonas rurales. Todo el mundo puede encontrar aquí el entorno y la manera de vivir más acorde a sus inquietudes. Y la enorme internacionalidad e individualidad de los propietarios de estas casas se ven reflejadas en sus domicilios. Hemos querido asomarnos a algunas de las más hermosas, impresionantes e inspiradoras, y así podemos conducirle a usted, querido lector, al interior del mundo (habitualmente vedado a miradas ajenas) de las celebridades de la isla y los enamorados de Ibiza.

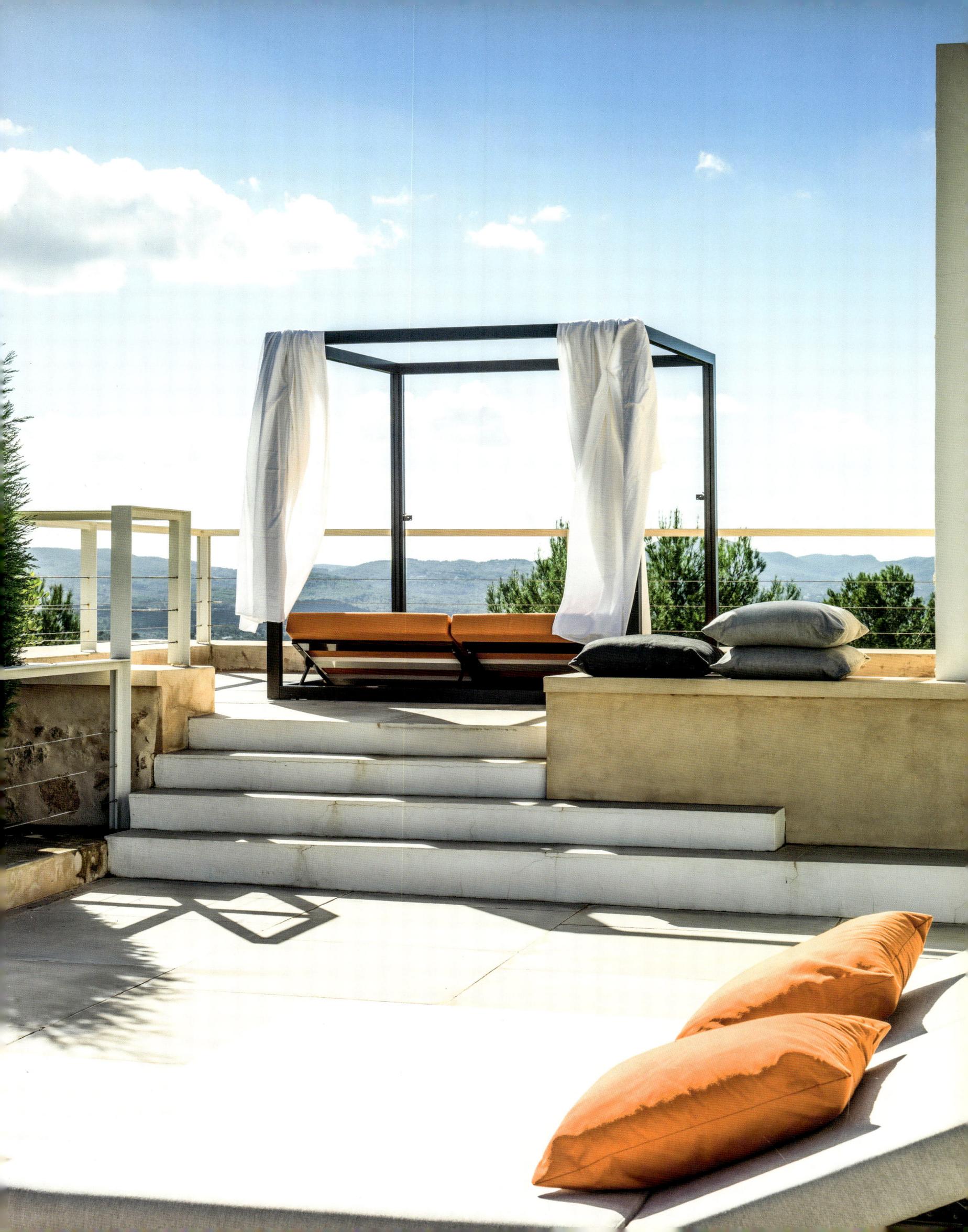

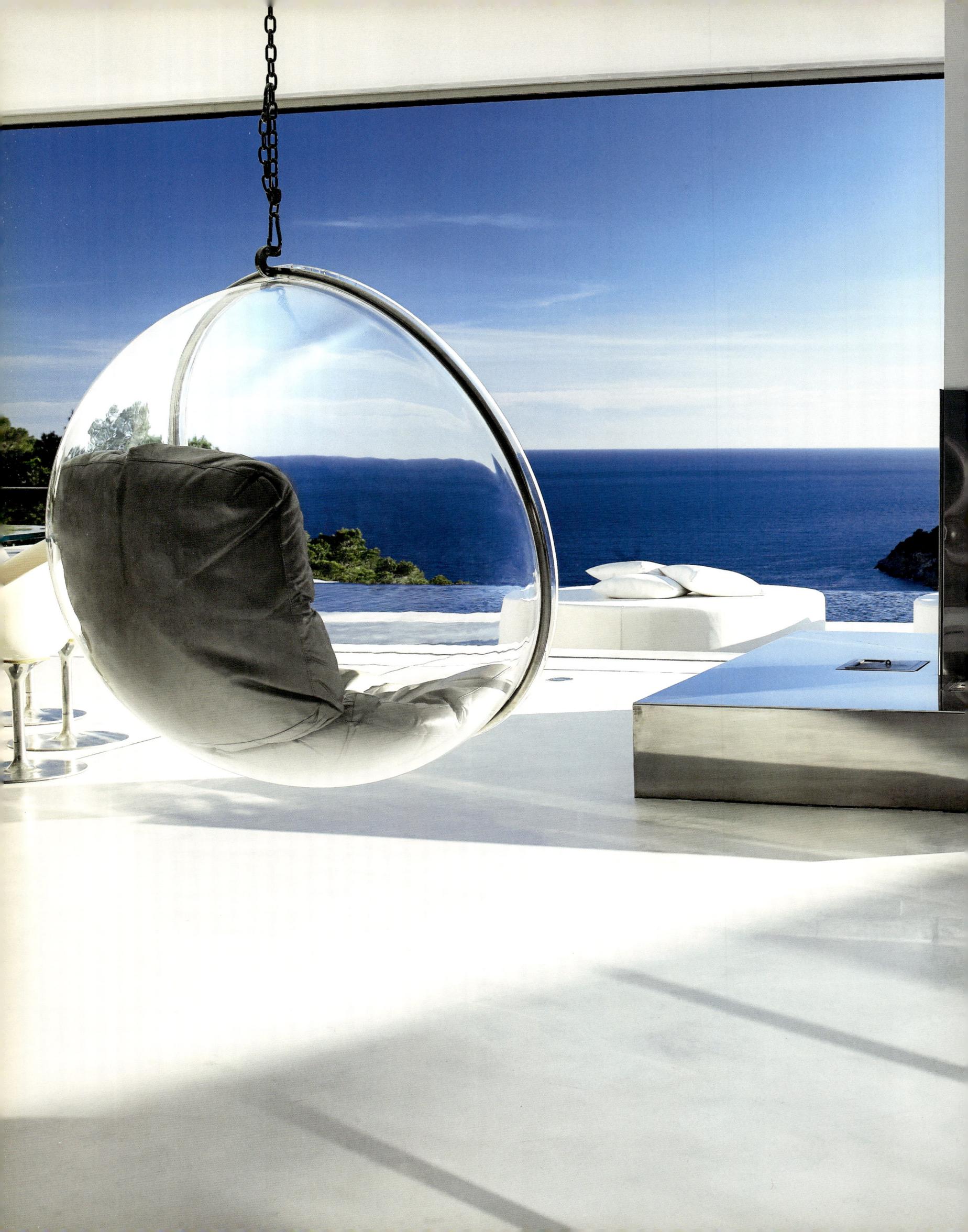

# Sa Caleta Hill

THE HOME OF German designer Anke Rice, which she designed and built together with architect Jaime Serra Verdaguer, provides the perfect setting for her custom-made furniture. Classic design elements from the 1970s combine with modern art photography to create a cool, 21st-century Barbarella atmosphere. The homeowner worked closely together with the French landscape designer, Stéphane Lahaye, to design the garden layout. Anke Rice fulfilled a life-long dream by building this Ibizan residence for herself and her two sons, Max and Christopher, in a location with a magnificent view of the sea. Anke Rice took her inspiration for the bed from the black and gold wrapper of a Ferrero Rocher chocolate.

DAS DOMIZIL DER deutschen Designerin Anke Rice, das sie gemeinsam mit dem Architekten Jaime Serra Verdaguer entworfen und realisiert hat, bietet den perfekten Rahmen für ihre maßgeschneiderten Möbel. In Verbindung mit Designklassikern aus den 1970er-Jahren und moderner Fotokunst entsteht so eine coole Barbarella-Welt des 21. Jahrhunderts. Für die Gartengestaltung wurde eng mit dem französischen Landschaftsarchitekten Stéphane Lahaye zusammengearbeitet. Die Designerin hat sich und ihren beiden Söhnen Max und Christopher mit diesem Zuhause auf Ibiza den Traum ihres Lebens erfüllt. Seine Lage eröffnet einen imposanten Blick aufs Meer. Für das Bett in den Farben Gold und Schwarz ließ sich Anke Rice von einer Ferrero-Rocher-Praline inspirieren.

EL DOMICILIO DE la diseñadora alemana Anke Rice, diseñado y construido en colaboración con el arquitecto Jaime Serra Verdaguer, ofrece el marco perfecto para sus muebles a medida. Apoyándose en clásicos del diseño de la década de 1970 y en imágenes fotográficas contemporáneas ha sabido crear un mundo afín al de Barbarella en pleno siglo XXI. El jardín es fruto de una estrecha colaboración con el diseñador de exteriores Stéphane Lahaye. La casa supone para la diseñadora y sus dos hijos Max y Christopher la materialización del sueño de toda una vida. Su situación le confiere asombrosas vistas al mar. La inspiración para el negro y los dorados de la cama le llegó a Anke rice a través de los colores de los bombones Ferrero Rocher.

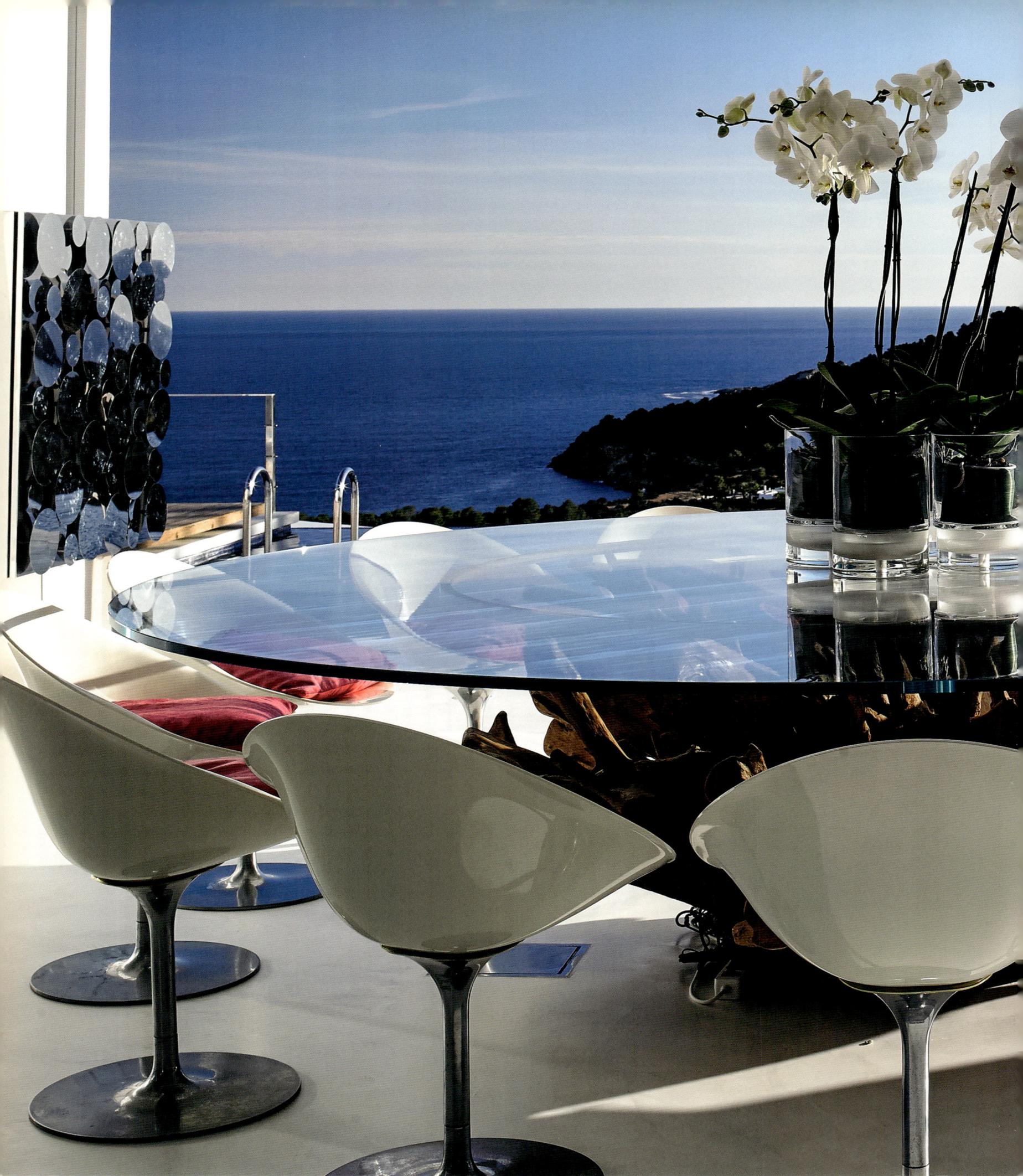

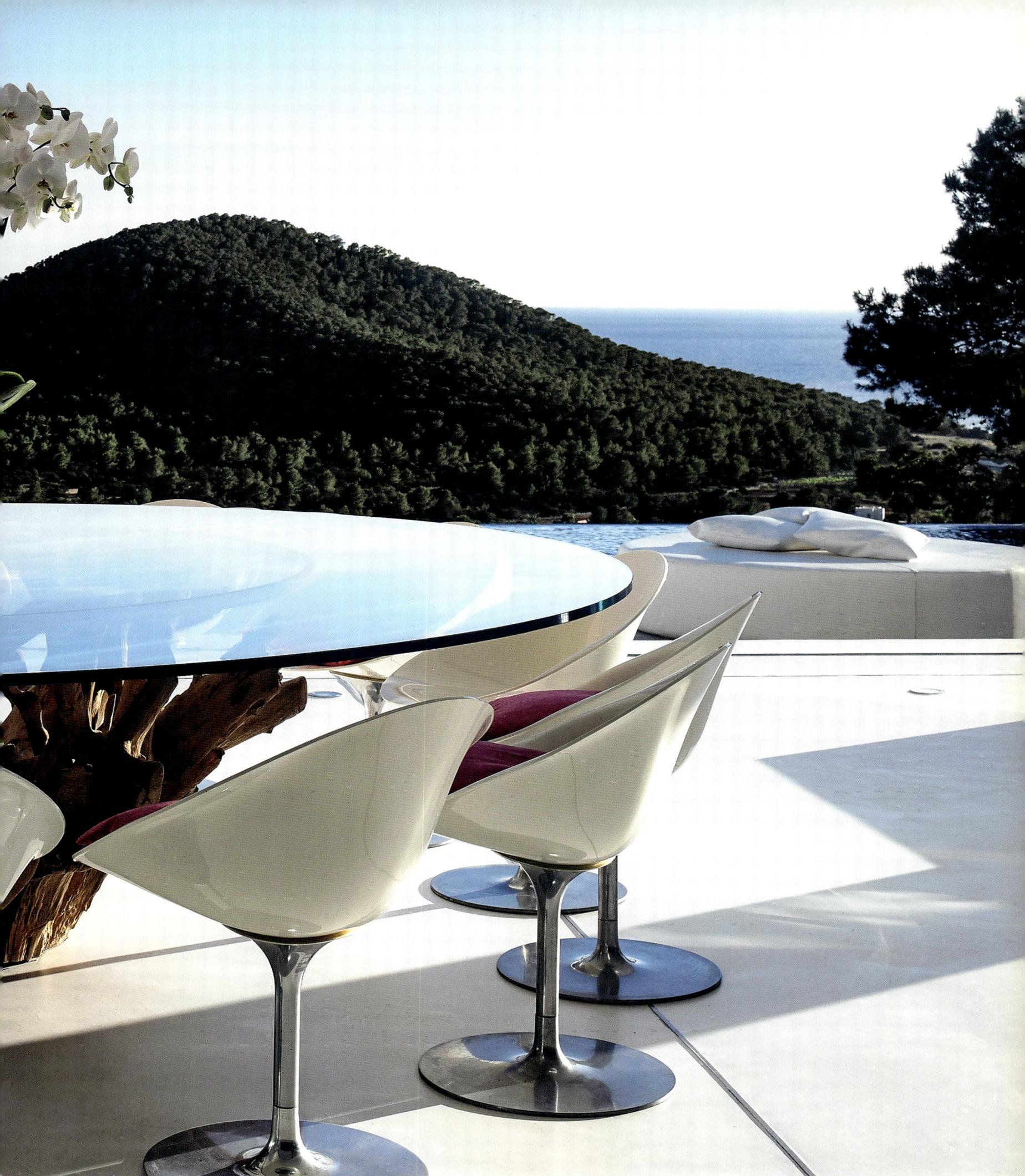

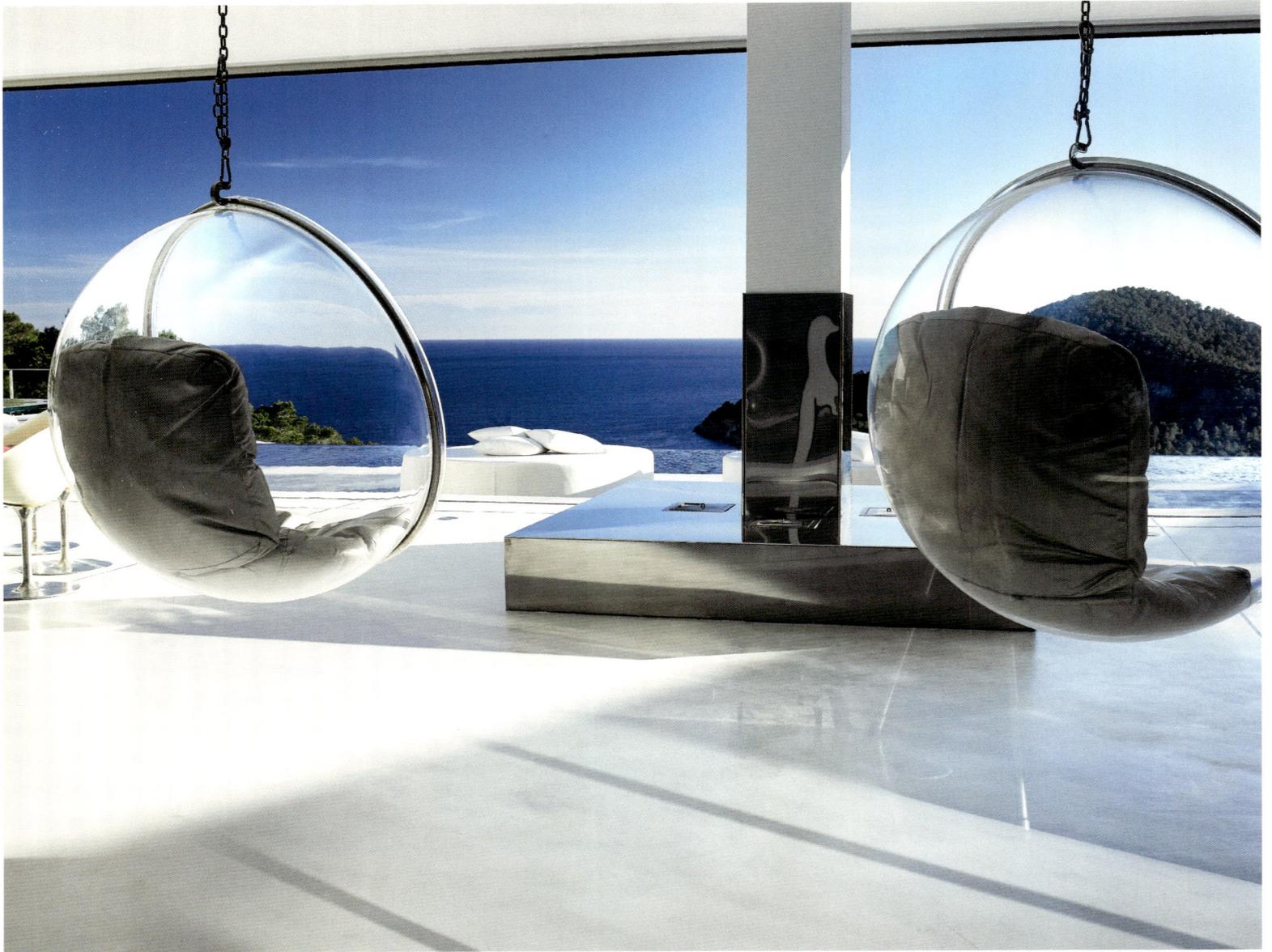

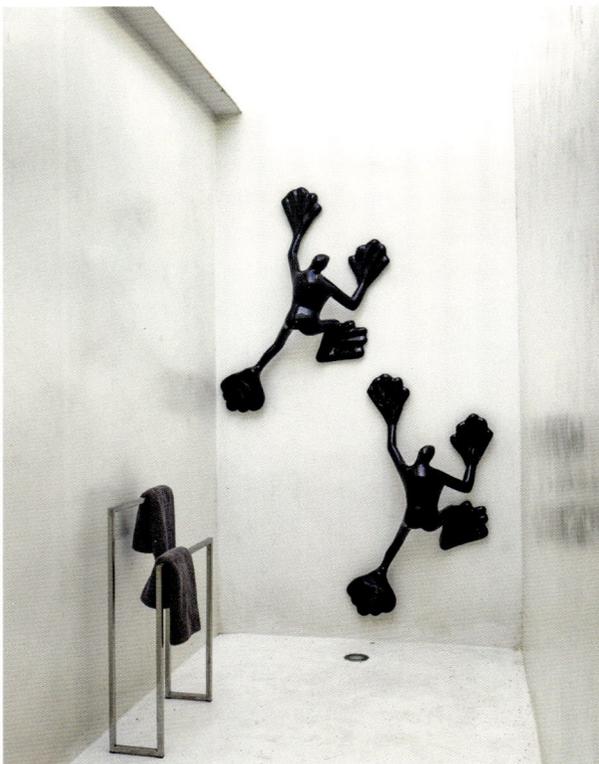

*Bubble chairs with a luxurious view of the sea. A photo of Naomi Campbell, which Nico Bustos took in Sa Caleta Hill, hangs in the hallway leading to a patio with the "Sperm" sculpture from Bali. "Flossi" wall sculptures by the German artist rosalie hang in the bathroom.*

*Bubble Chairs mit Meerblick de luxe. Der Durchgang führt auf einen Patio mit der Skulptur „Sperm" aus Bali vorbei an einem Foto von Naomi Campell, das Nico Bustos in Sa Caleta Hill aufgenommen hat. Im Bad finden sich „Flossi"-Wandskulpturen der deutschen Künstlerin rosalie.*

*Sillas burbuja con privilegiadas vistas al mar. El pasillo, adornado con una fotografía de Naomi Campbell tomada por Nico Bustos en Sa Caleta Hill, conduce a un patio en el que se expone la escultura balinesa "Sperm". En el baño, varias esculturas murales "Flossi" de la artista alemana rosalie.*

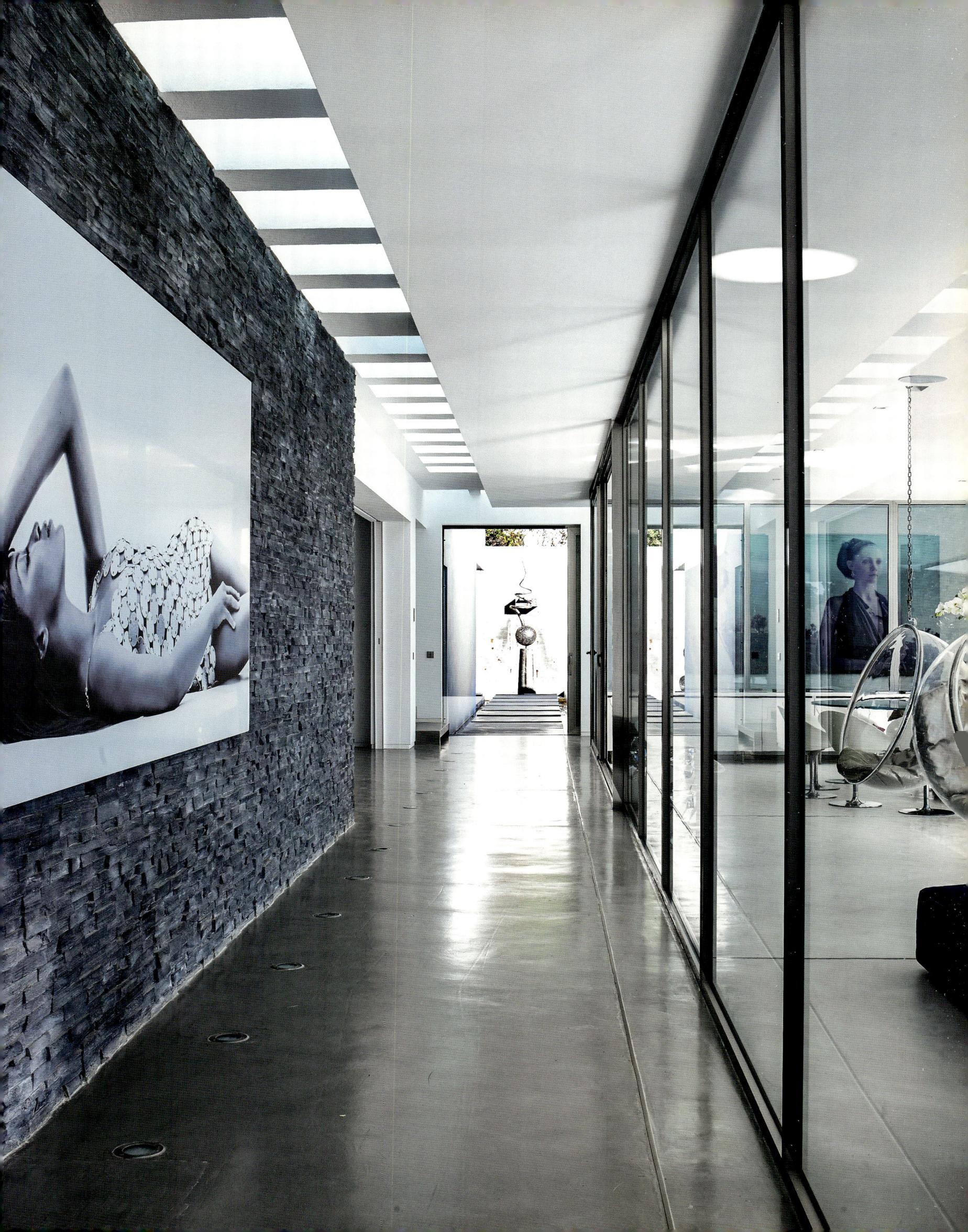

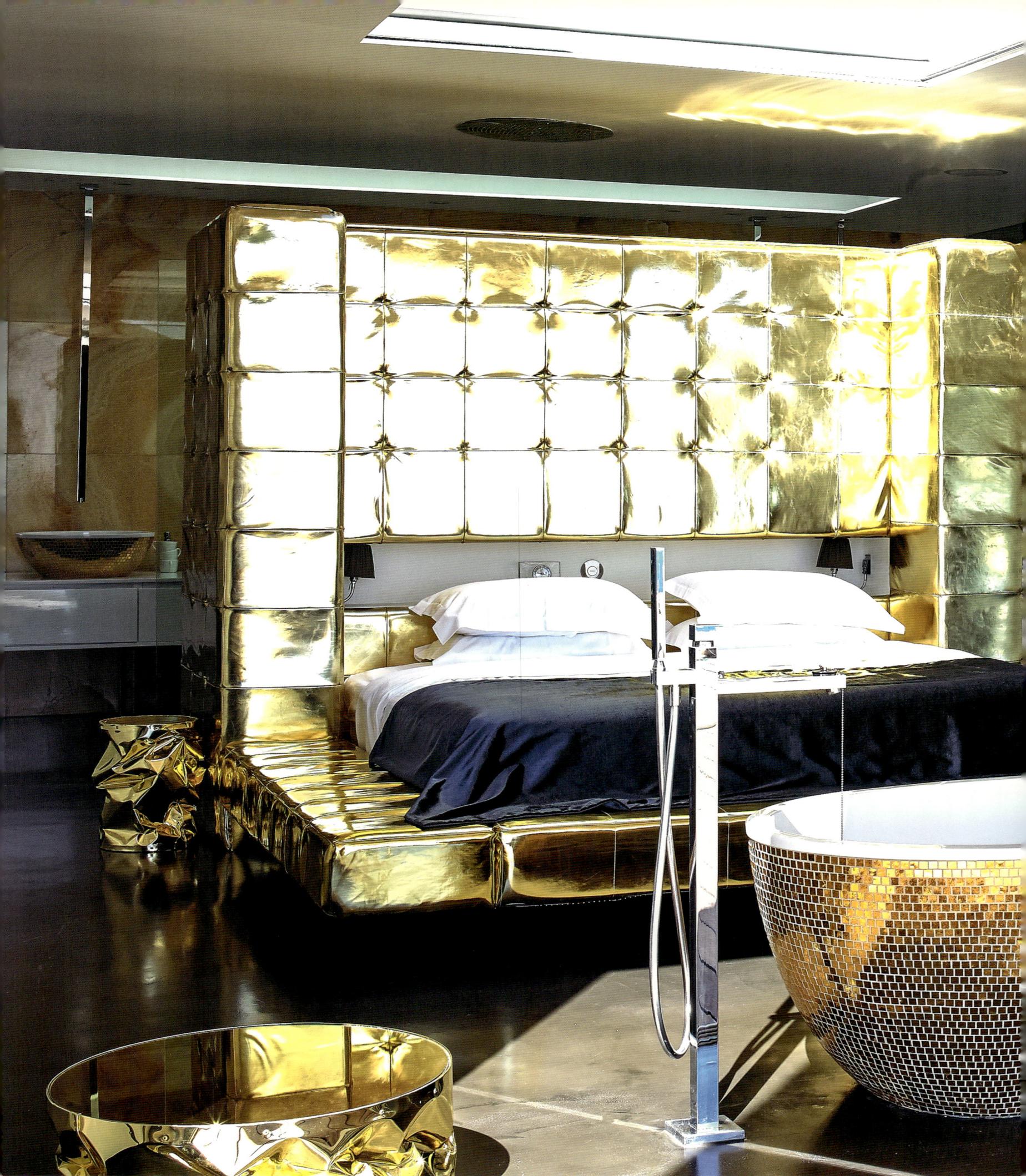

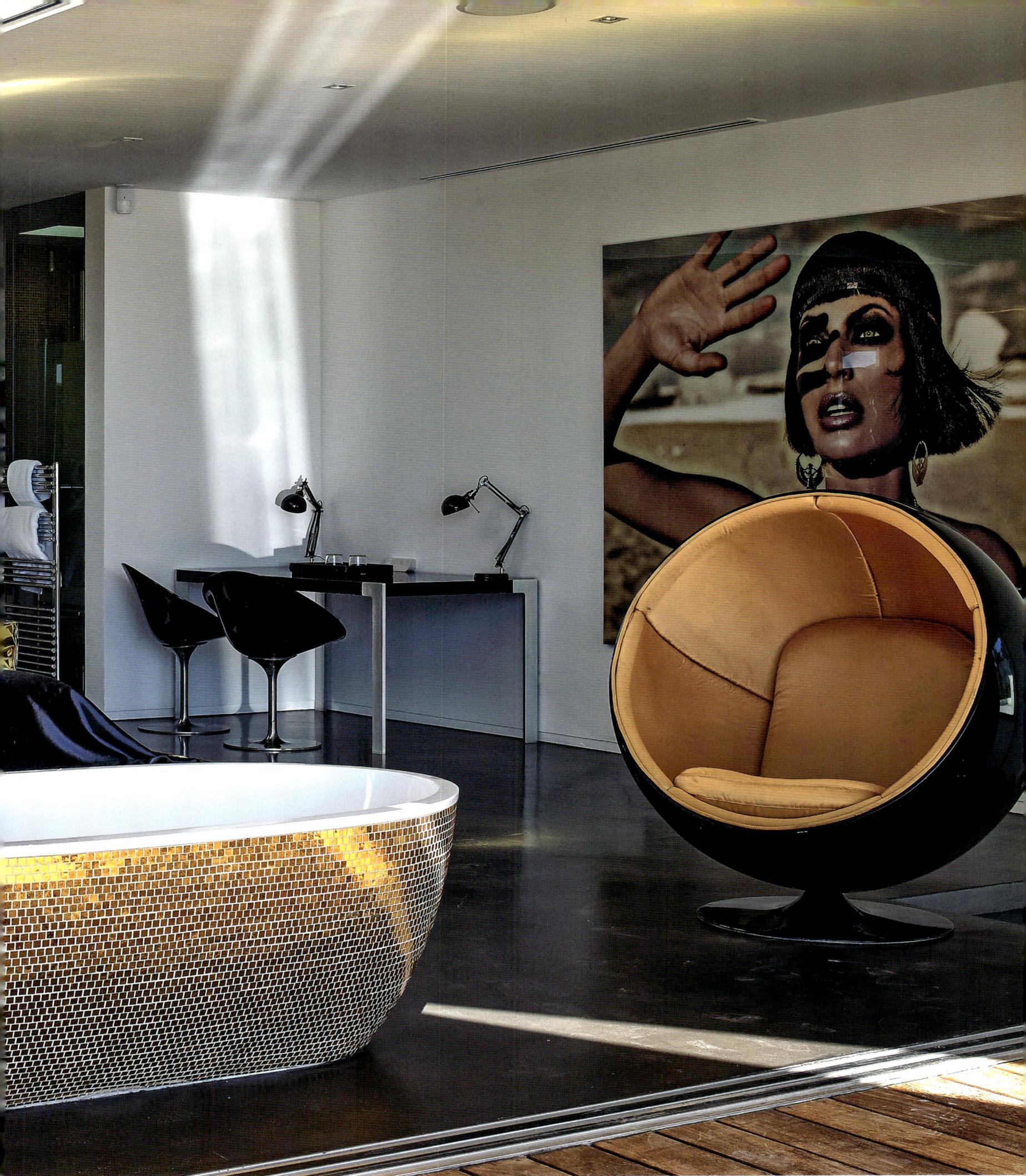

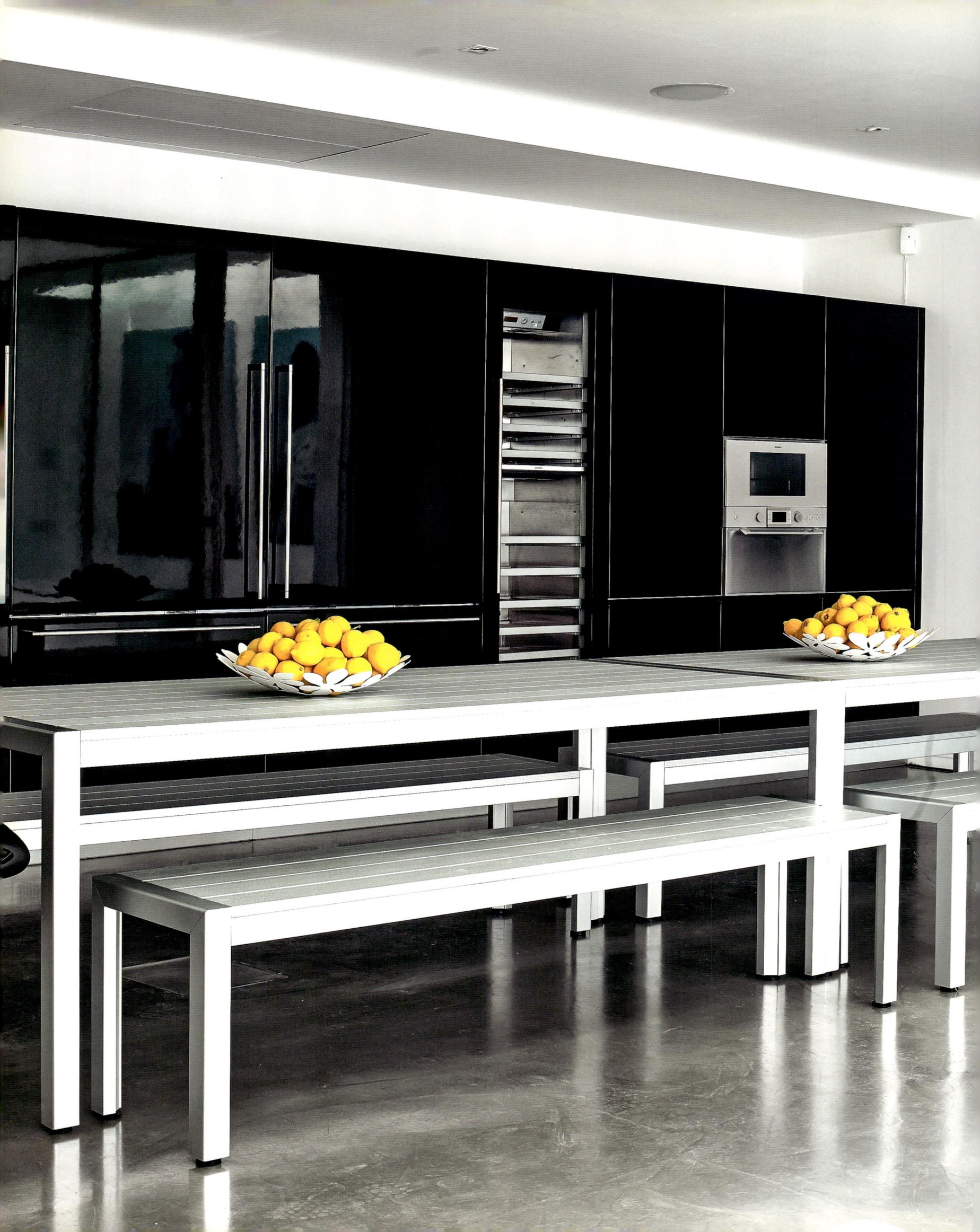

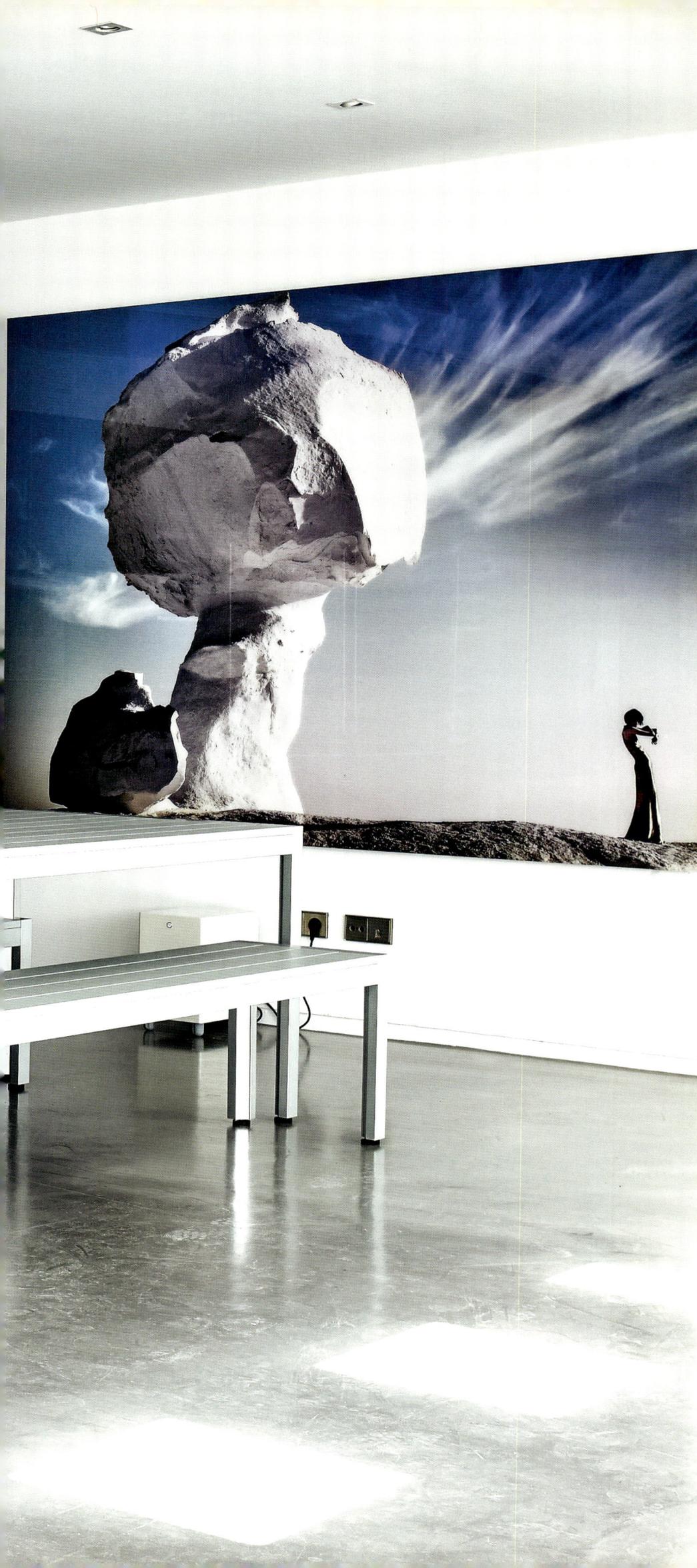

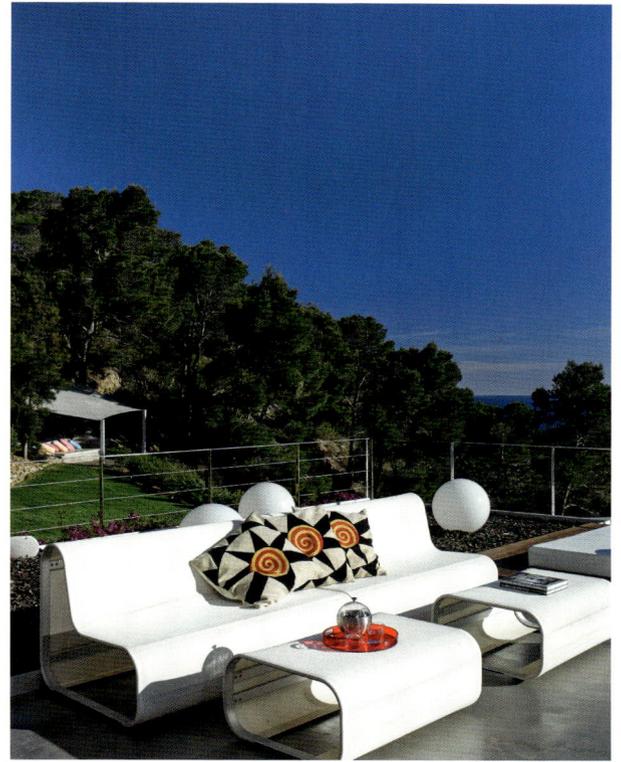

Ultra-sleek kitchen from Gunni with a photo of Egypt's White Desert by Eugenio Recuenco. Even the outdoor areas feature a minimalist interpretation of 1970s style.

*Ultra-sleeke Küche von Gunni mit einem Bild von Eugenio Recuenco aus der ägyptischen Weißen Wüste. Minimalistisch interpretierte 70er-Jahre-Ästhethik auch in den Außenanlagen.*

*Estilizadísima cocina de Gunni, con fotografía de Eugenio Recuenco del desierto egipcio. La minimalista interpretación de la estética de los años setenta continúa en las áreas exteriores.*

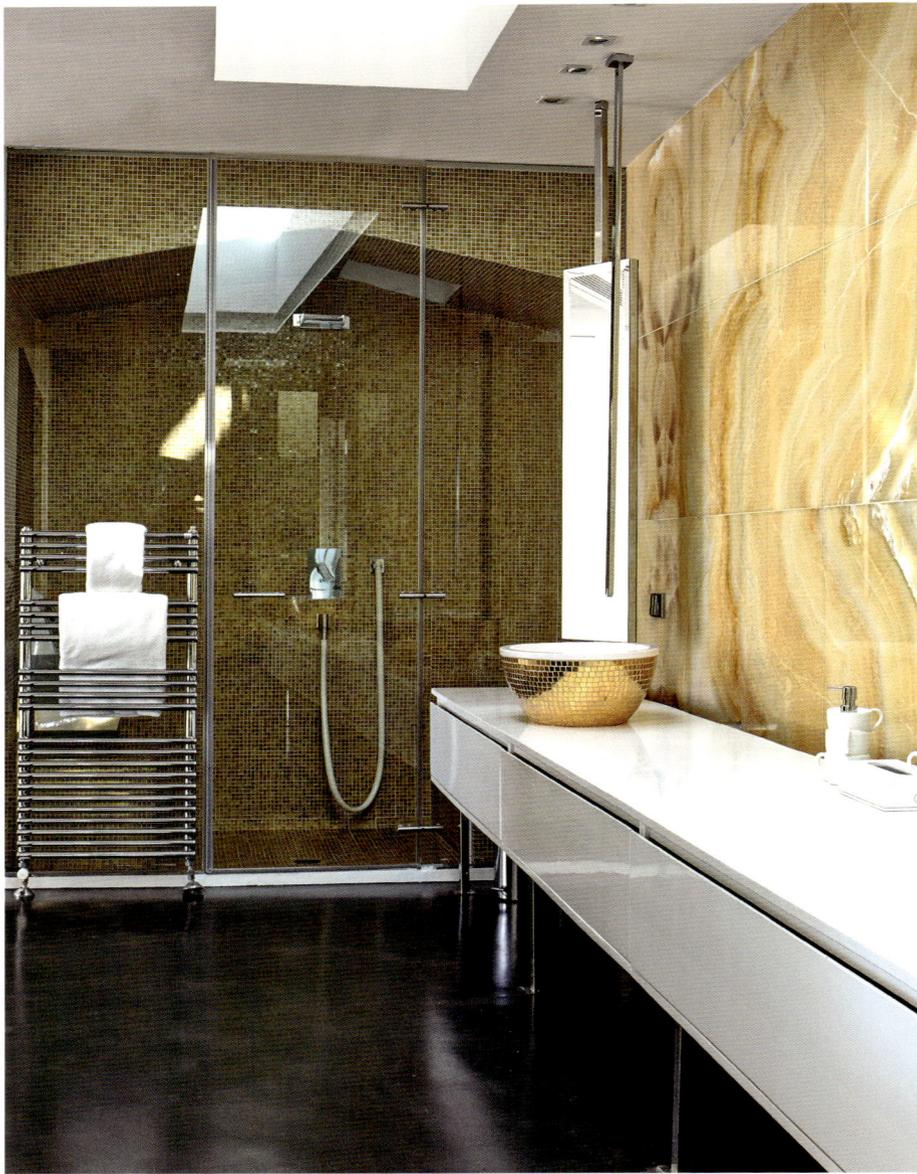

*Gold-colored Sicis mosaic tiles in the steam bath harmonize with the Onyx wall, while sculptures from the Sepik River in New Guinea provide a charming contrast with a wall-sized photo by Eugenio Recuenco.*

*Das Dampfbad mit goldenem Mosaik von Sicis harmoniert mit der Onyx-Wand, während im Schlafzimmer Skulpturen vom Sepik River in Neuguinea einen reizvollen Kontrast zu einem weiten großformatigen Bild von Eugenio Recuenco bilden.*

*El baño de vapor, adornado con mosaicos dorados de Sicis, hace juego con la bañera de ónice, mientras en el dormitorio las esculturas del río Sepik de Nueva Guinea ofrecen un agradable contraste con la fotografía de gran formato de Eugenio Recuenco.*

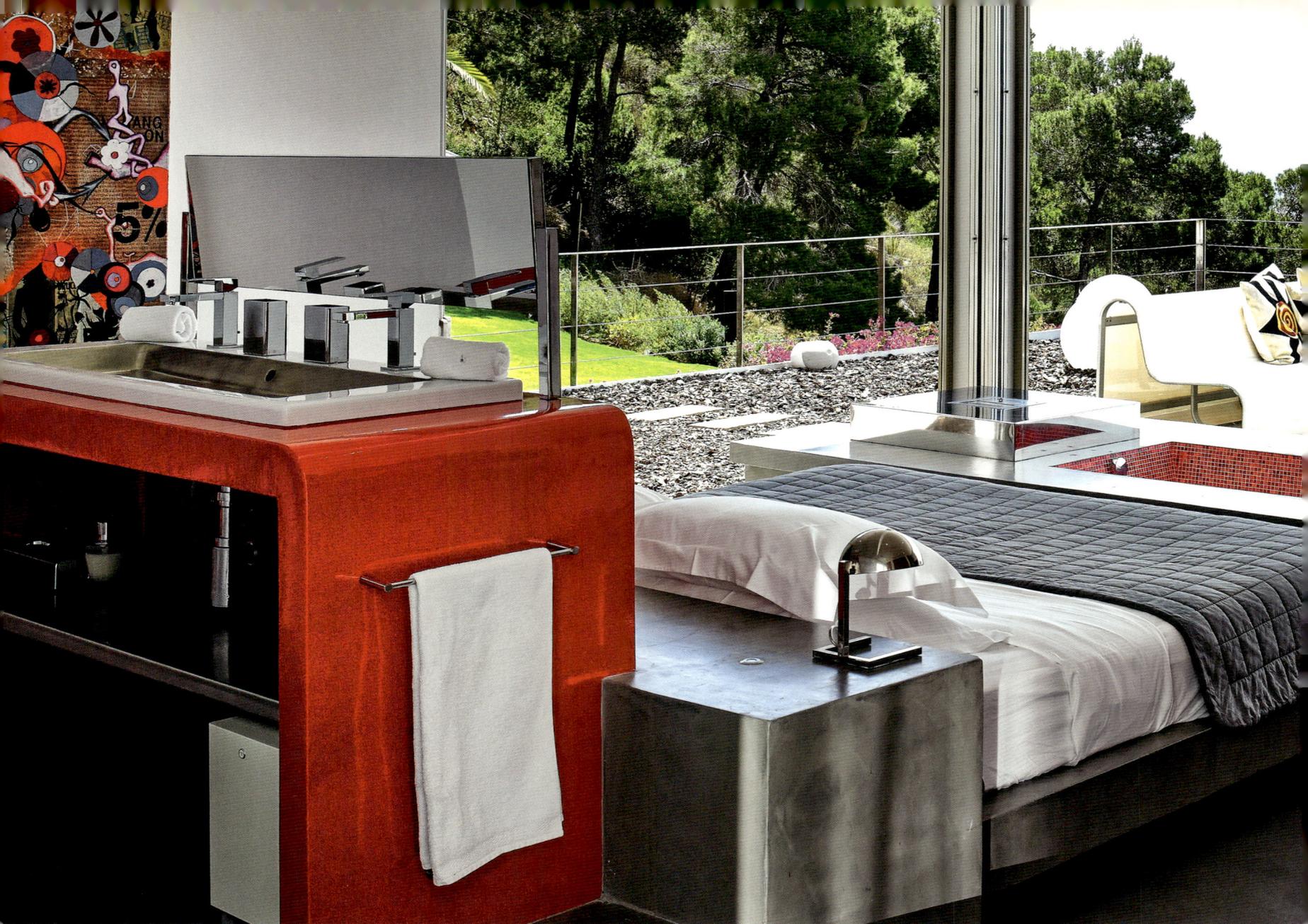

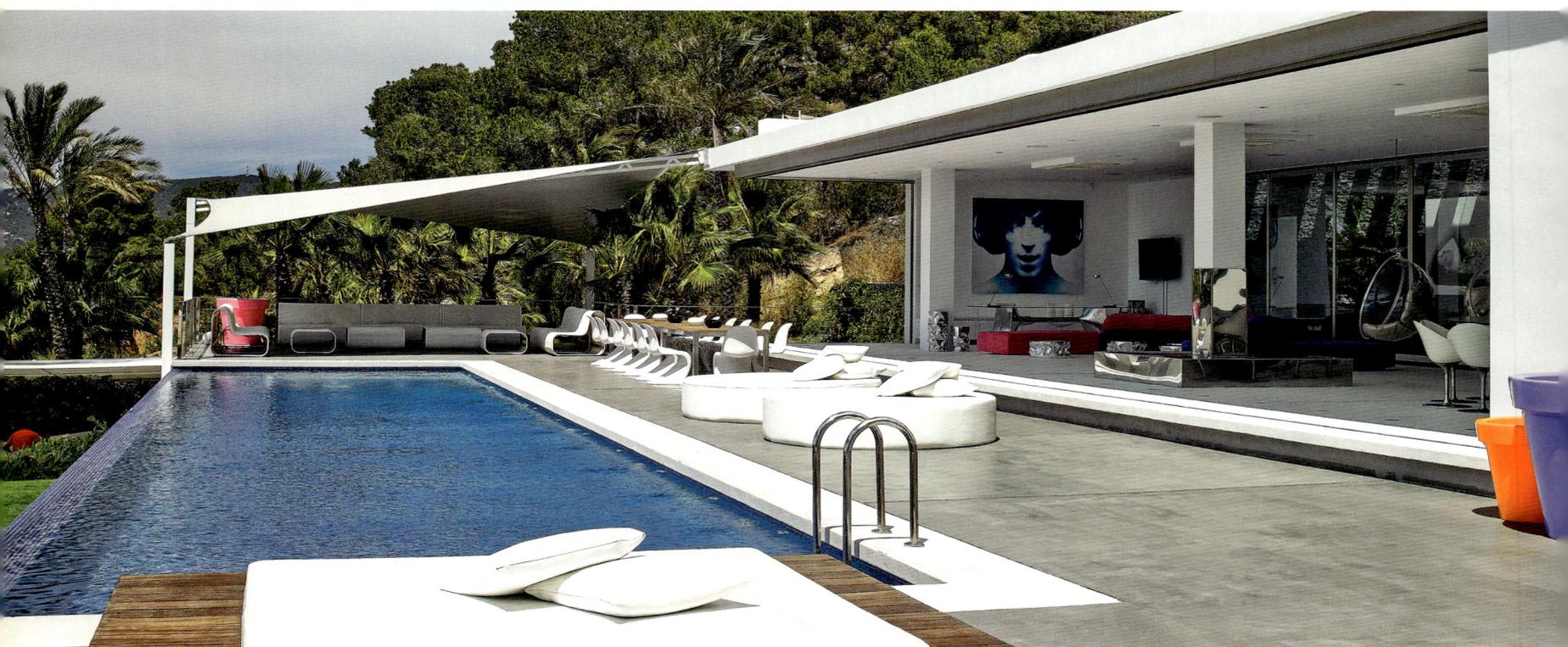

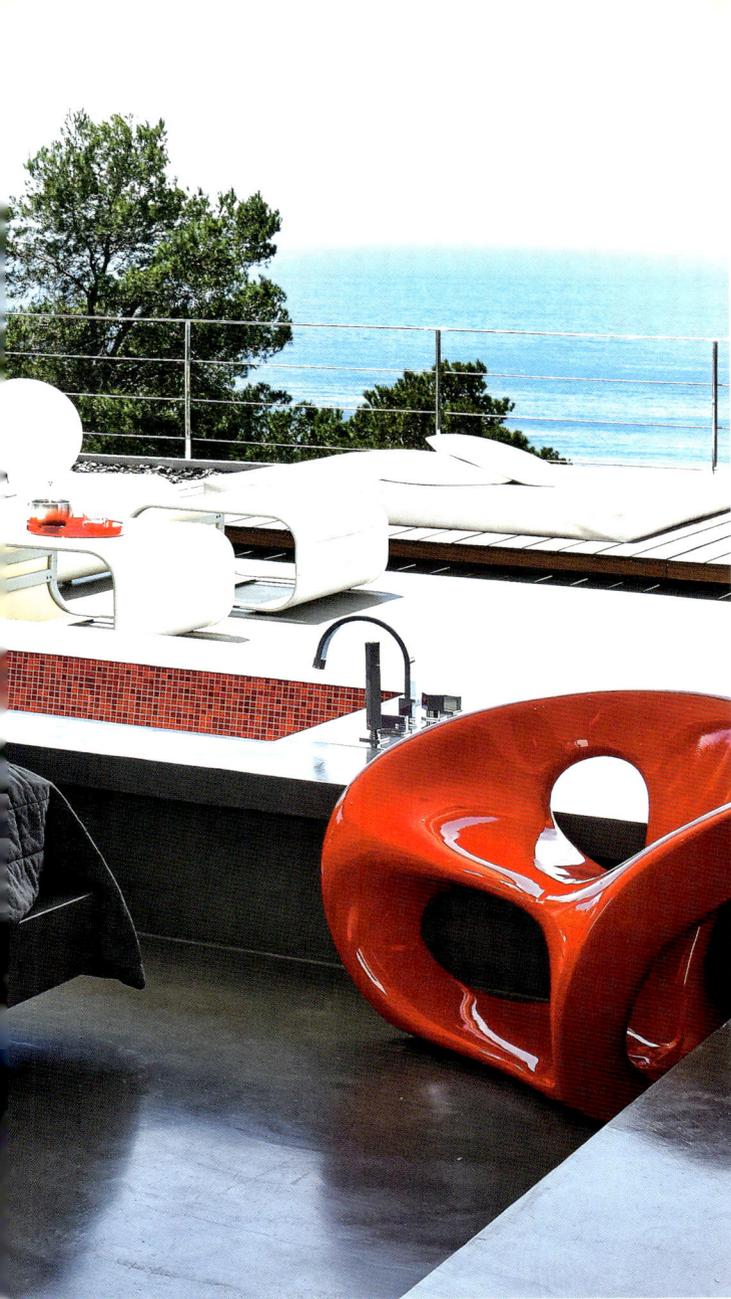

The bedroom, with its built-in, Ferrari red bath, offers a view across the terrace and ocean all the way to the horizon. Once a professional swimmer on the German national team, the homeowner now swims laps in her 82-foot pool.

*Das Schlafzimmer mit integrierter Badzeile in Ferrari-Rot bietet eine Aussicht über die Terrasse und das Meer bis zum Horizont. Im 25-Meter-Pool zieht die Hausherrin, die vormals als Profischwimmerin für die deutsche Nationalmannschaft antrat, ihre Bahnen.*

*El dormitorio, con baño integrado en vistoso rojo Ferrari, se abre a una terraza desde la que las vistas marinas se extienden hasta el horizonte. La propietaria, en otra época nadadora profesional e integrante de la selección alemana, se mantiene en forma en la piscina de 25 metros.*

# Can Francisco

FINCA CAN FRANCISCO nestles against a gently sloping hill, from where it looks out over the Morna Valley in northeastern Ibiza. Built over 200 years ago, the estate offers a breathtaking panoramic view of the sea and the wide, pristine landscape, dotted with the island's typical whitewashed farmhouses. Can Francisco underwent a complete renovation over a period of six years and now radiates a luxurious yet authentically Ibizan style. Wild rosemary, lavender, old olive trees and palms dominate the terraced property. An imposing foyer, a spacious living room with an open fireplace, a roomy kitchen, five bedrooms and numerous terraces occupy approximately 6,450 square feet of space. The salt water pool, which measures 49 feet long and 16 feet wide, is set slightly apart from the main house for ultimate privacy. It also provides a spectacular view of the valley and Mediterranean Sea, and on clear days you can see all the way to Ibiza's sister island of Majorca. Thick stone walls maintain a well balanced indoor temperature, eliminating the need for air conditioning during the summer months. A light, refreshing breeze wafts continuously through the rooms, thanks to the home's location high on the hill.

AN EINEN SANFTEN Hügel geschmiegt thront die über 200 Jahre alte Finca Can Francisco über dem Morna-Tal im Nordosten der Insel. Das an ein historisches Dörfchen erinnernde Anwesen bietet einen atemberaubenden Rundumblick auf das Meer und die weitläufige, unverdorbene Landschaft mit ihren für Ibiza typischen weißgekalkten Bauernhäusern. Can Francisco wurde in einem Zeitraum von sechs Jahren im authentisch ibizenkischen Stil von Grund auf luxuriös renoviert. Wilder Rosmarin, Lavendel, alte Olivenbäume und Palmen beherrschen das terrassierte Grundstück. Auf etwa 600 m² verteilen sich eine repräsentative Eingangshalle, ein weitläufiger Salon mit offenem Kamin, eine geräumige Küche, fünf Schlafzimmer und zahlreiche Terrassen. Der 15 mal 5 Meter große Salzwasserpool liegt etwas abseits vom Haupthaus, um die Privatsphäre zu wahren. Auch von hier genießt man die spektakuläre Aussicht über das Tal und Mittelmeer, an klaren Tagen kann man die Schwesterninsel Mallorca erblicken. Durch die dicken Steinmauern herrscht ein ausgewogenes Raumklima das auch in den heißen Sommermonaten keiner Klimaanlage bedarf, und aufgrund der erhöhten Lage weht immer eine leichte, erfrischende Brise durch die Räume.

ACODADA EN LA ladera de una loma, la Finca Can Francisco se alza desde hace 200 años sobre el valle de Morna, en el nordeste de la isla. La propiedad, cuya distribución recuerda la de una pequeña aldea, ofrece una asombrosa panorámica del mar y de un paisaje apenas afectado por el tiempo en el que destacan las casitas encaladas típicas de la isla. Can Francisco fue renovada en estilo auténticamente ibicenco a lo largo de seis años para conformar una residencia lujosa y de indudable buen gusto. En las terrazas de la propiedad predominan el romero silvestre, la lavanda, los olivos y las palmeras. Sus 600 m² de superficie acogen un gran vestíbulo, un salón extenso de chimenea abierta, una cocina espaciosa, cinco dormitorios y numerosas terrazas. La piscina de agua salada (15 x 5 m) está algo alejada de la casa principal para proteger aun más su intimidad. Desde ella se disfrutan también vistas espectaculares del valle y del Mediterráneo: en días despejados es posible incluso vislumbrar la isla de Mallorca. Los gruesos muros de la casa hacen innecesaria la instalación de aire acondicionado, incluso en los calurosos meses de verano, y gracias a su ubicación en el monte, una leve brisa recorre siempre las habitaciones.

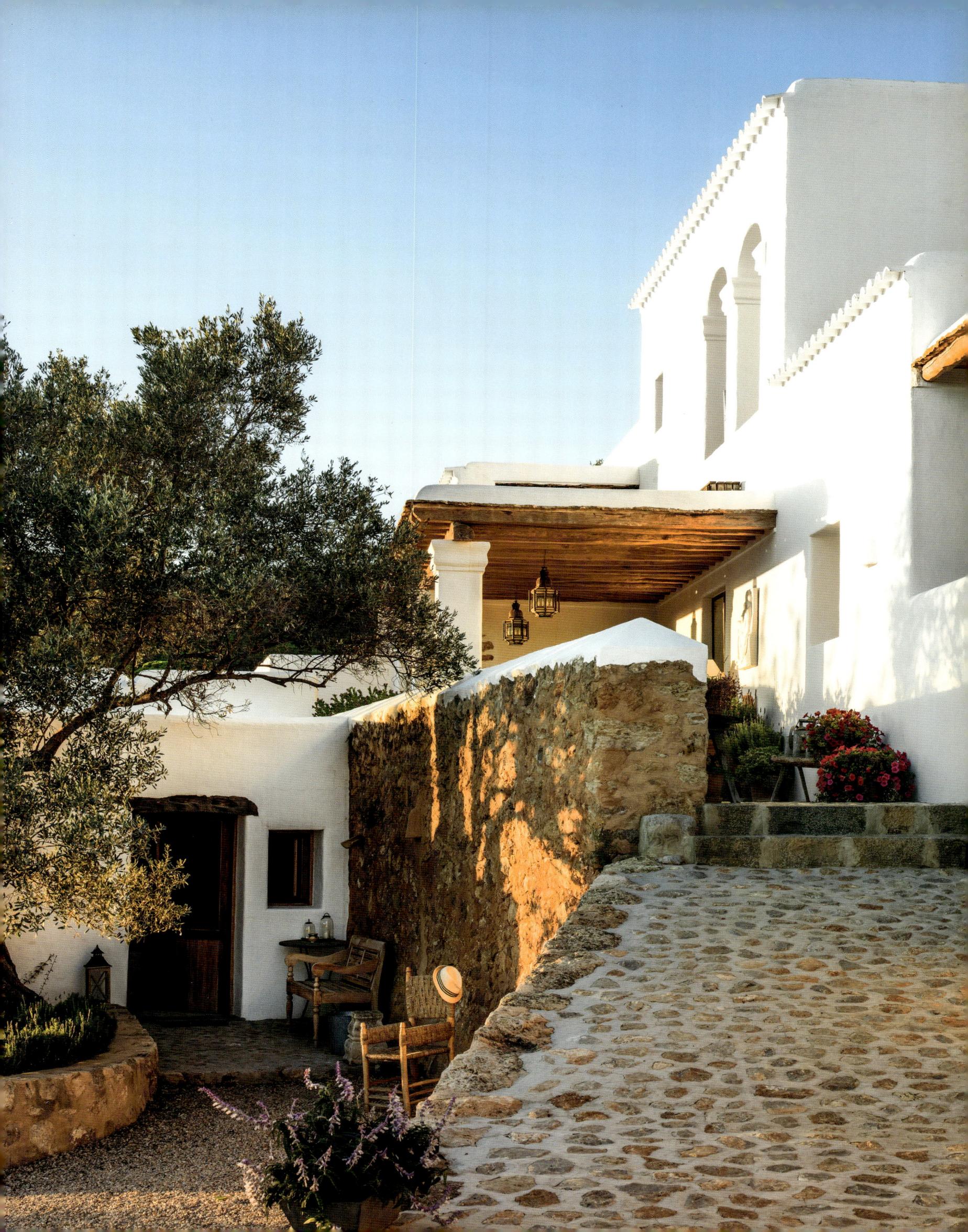

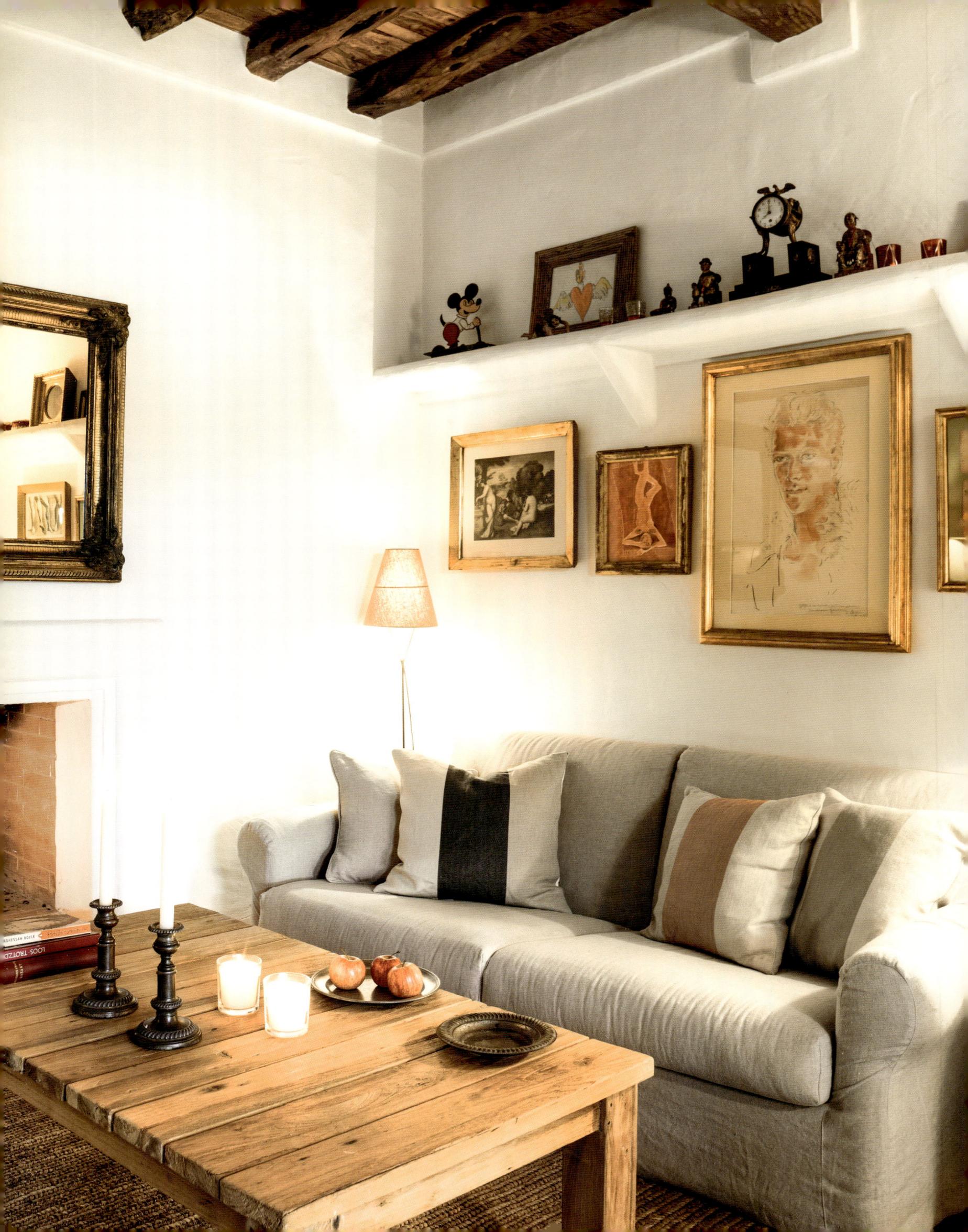

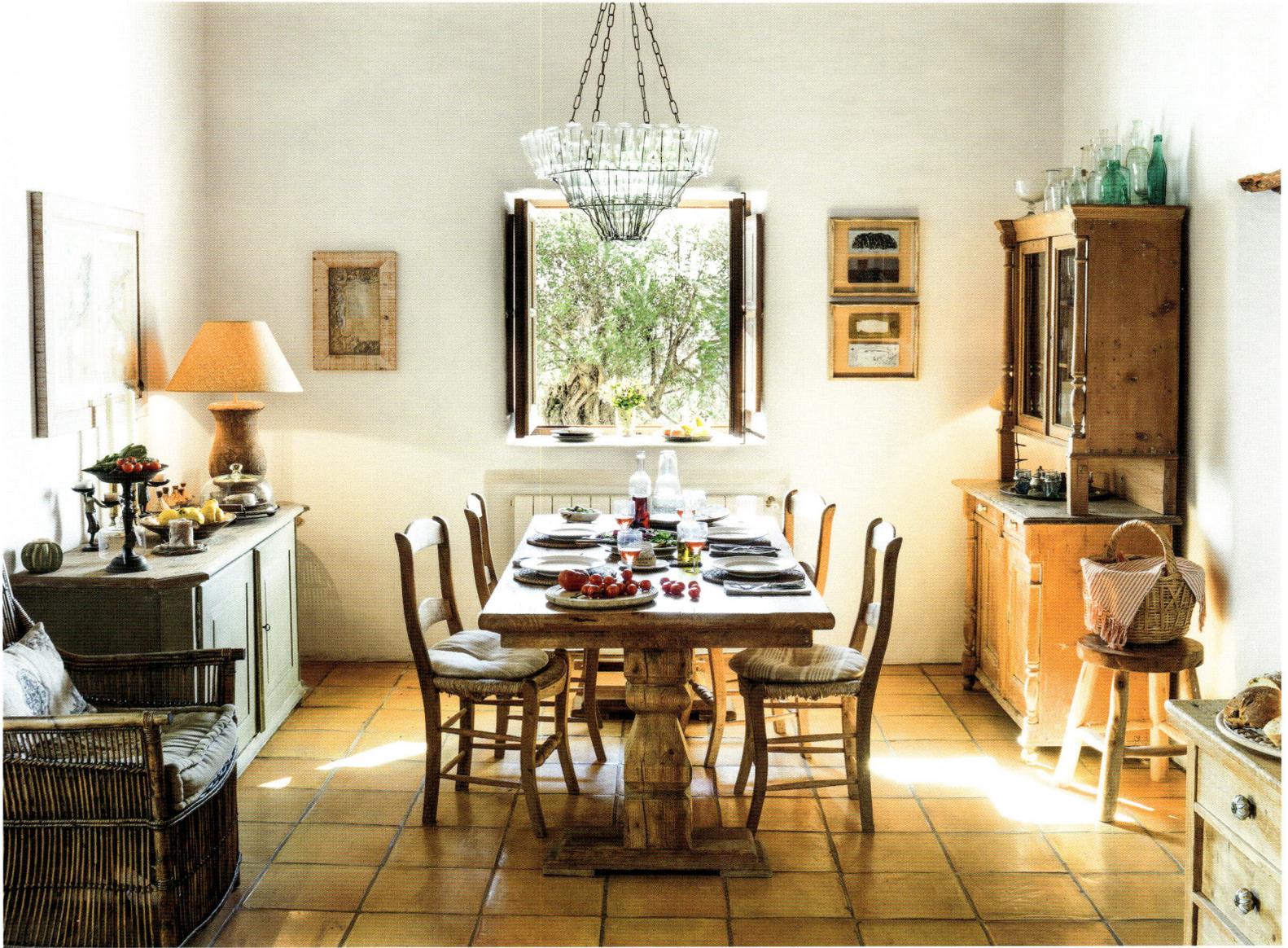

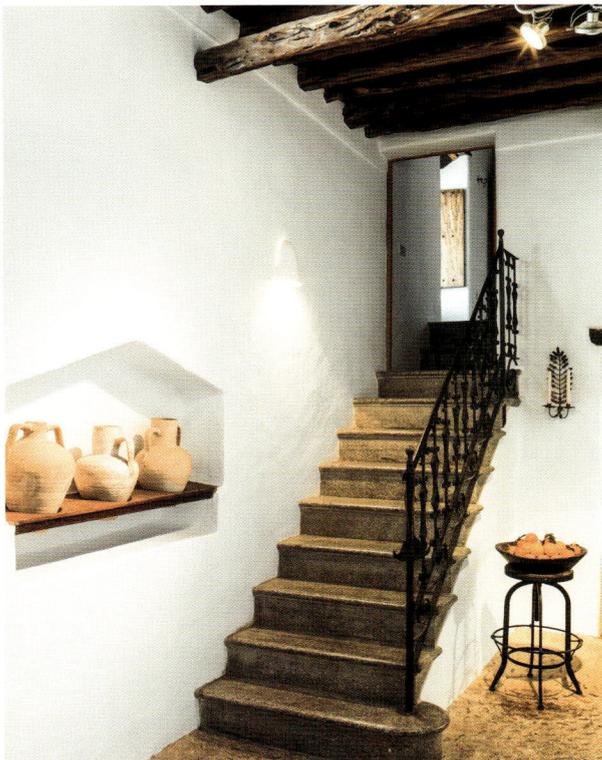

The kitchen has old-world décor with a Mediterranean flair. Warm hues and personal memorabilia give the living room an inviting atmosphere.

*Küche im traditionellen Stil und Mittelmeerflair. Im Salon schaffen warme Farbtöne und persönliche Memorabilien eine einladende Stimmung.*

*Cocina de estilo tradicional e inconfundiblemente mediterráneo. Los tonos cálidos del salón contribuyen a crear un ambiente acogedor, al igual que los recuerdos personales distribuidos por la habitación.*

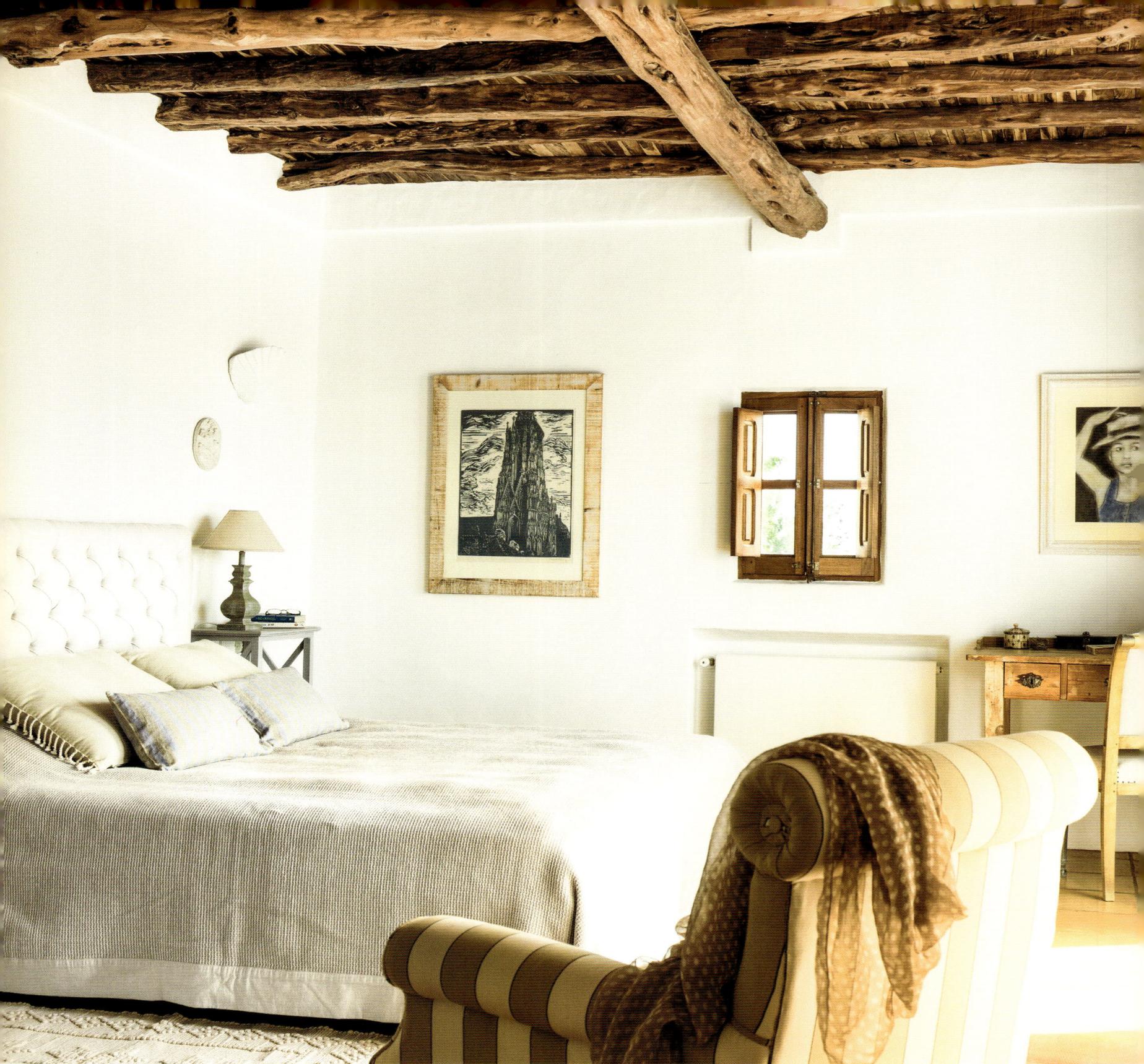

The bedroom features natural materials and colors that match the Mediterranean surroundings. The room also contains an antique desk and 200-year-old rafters overhead. The portrait hanging above the desk was painted by Renate Clary and depicts the owner as a young girl. The blue wood engraving is by Erwin Lang.

Im Schlafzimmer sind Naturmaterialien und eine Farbauswahl im mediterranen Stil ebenso zu finden wie ein antiker Schreibtisch und 200 Jahre alte Deckenbalken. Das Bild oberhalb des Schreibtischs, eine Arbeit der Malerin Renate Clary, zeigt ein Kinderporträt der Bewohnerin. Der blaue Holzstich stammt von Erwin Lang.

En el dormitorio pueden encontrarse tanto materiales naturales y colores mediterráneos como un escritorio antiguo y vigas de 200 años de antigüedad. El cuadro colgado sobre el escritorio, obra de Renate Clary, muestra un retrato de infancia de la inquilina. Grabado azul de Erwin Lang.

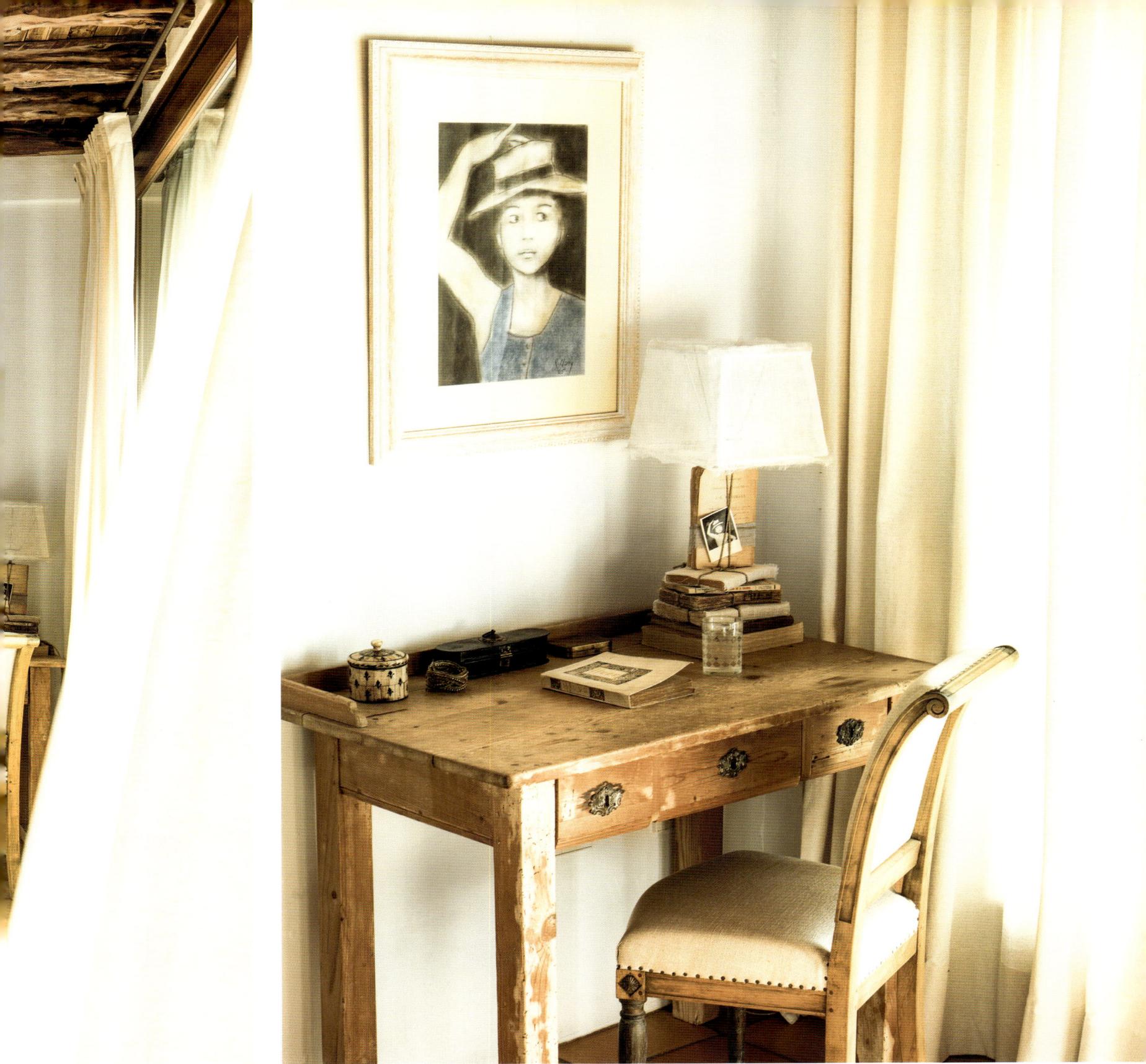

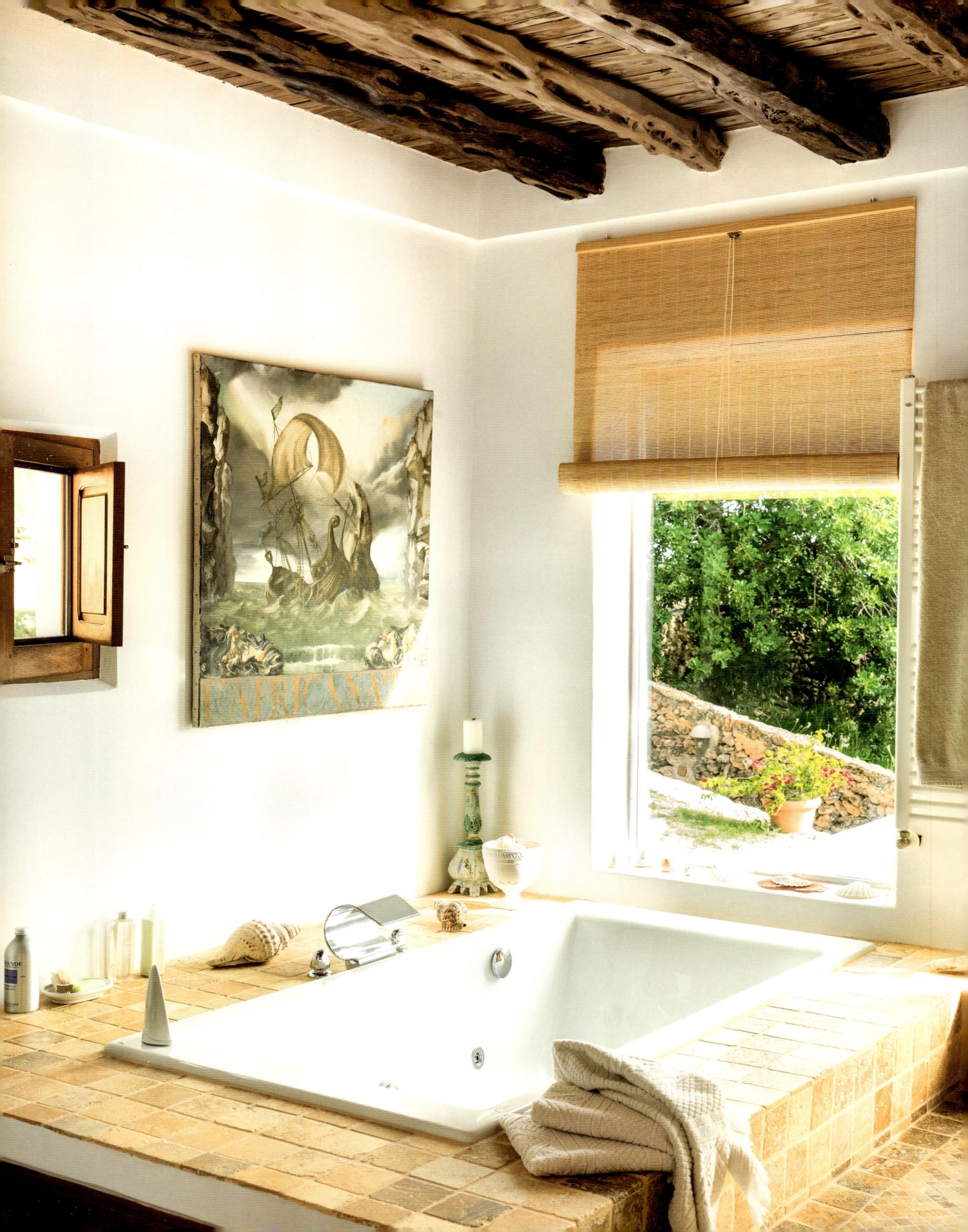

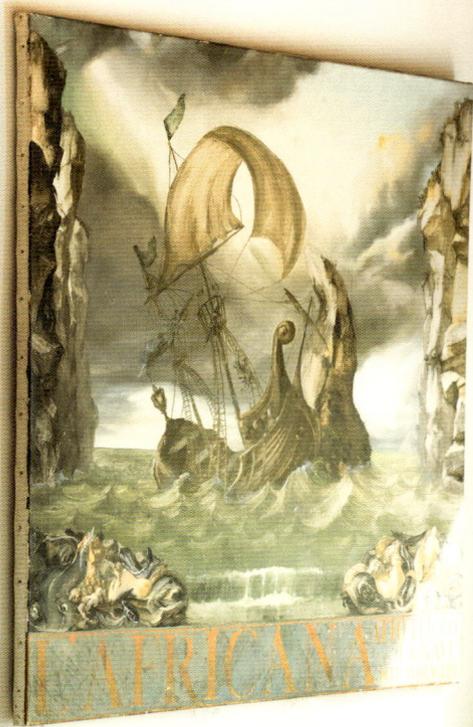

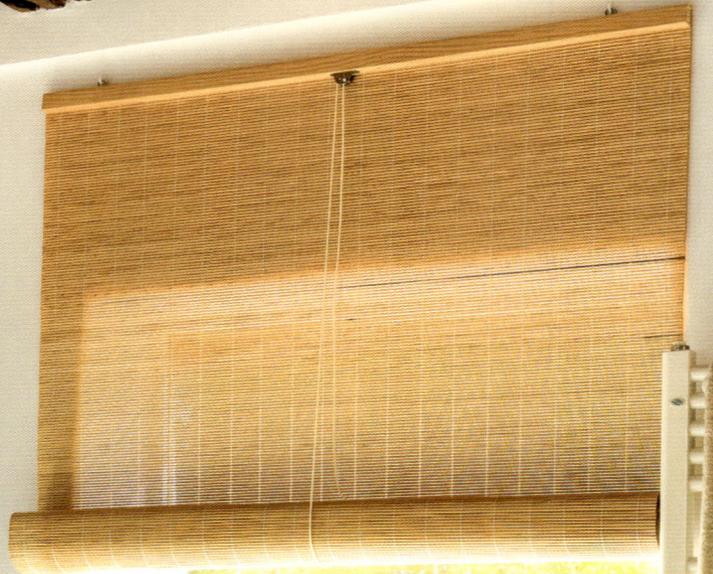

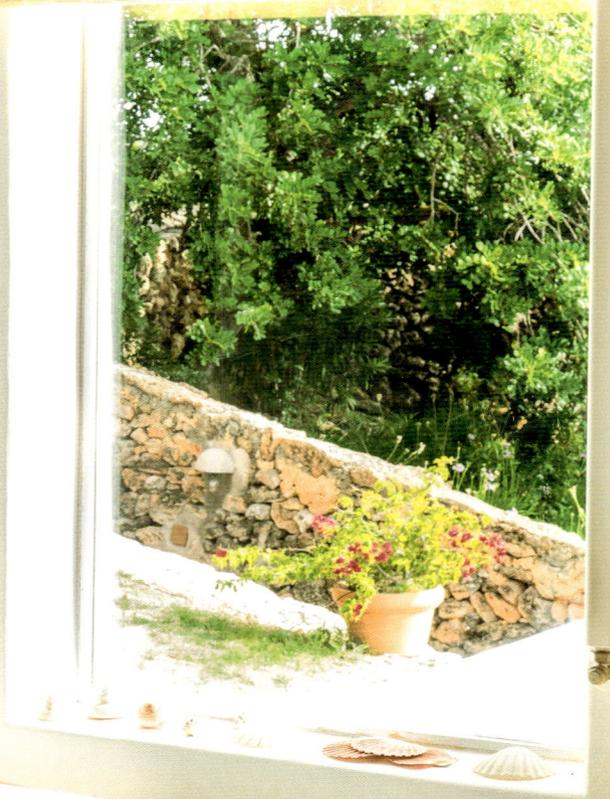

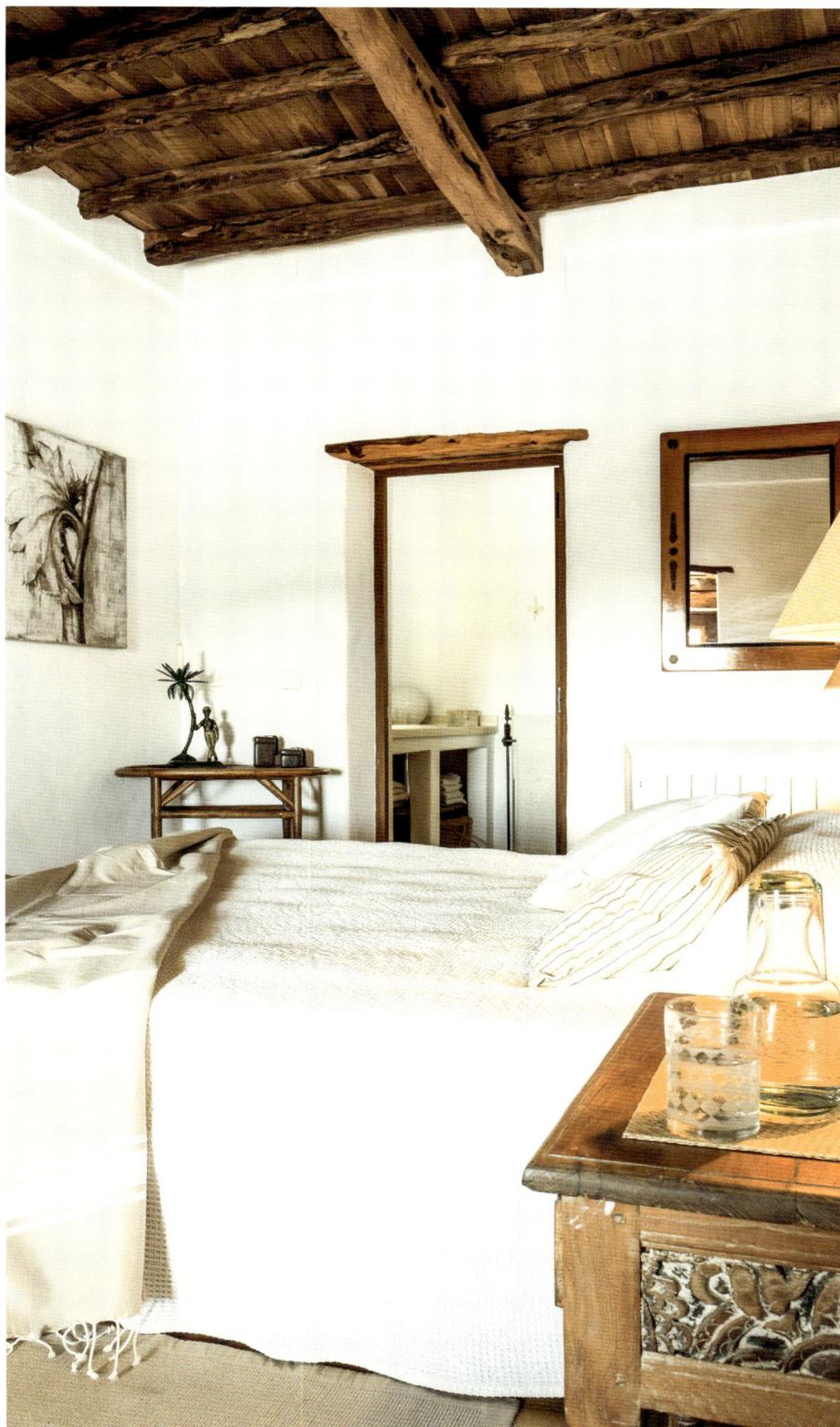

While relaxing in the bathroom Jacuzzi, you can enjoy the view through floor-to-ceiling windows, across the valley and all the way to the sea. Striking solid wooden ceilings lend the rooms a rustic charm. A painting by Stefan Riedl portrays a set from the "L'Africana" opera.

Aus dem Bad mit bodentiefem Fenster kann man über das Tal bis zum Meer sehen. Beeindruckende Massivholzdecken verleihen den Räumen ihren ruralen Charme. Das Trompe-l'œil-Bild von Stefan Riedl stellt ein Bühnenbild zur Oper „L'Africana" dar.

En el baño, un gran ventanal permite asomarse al valle y el mar desde el jacuzzi. Los techos de madera maciza confieren a las habitaciones un auténtico encanto rural. La imagen trompe l'oeil de Stefan Riedl reproduce la escenografía de la ópera "L'Africana".

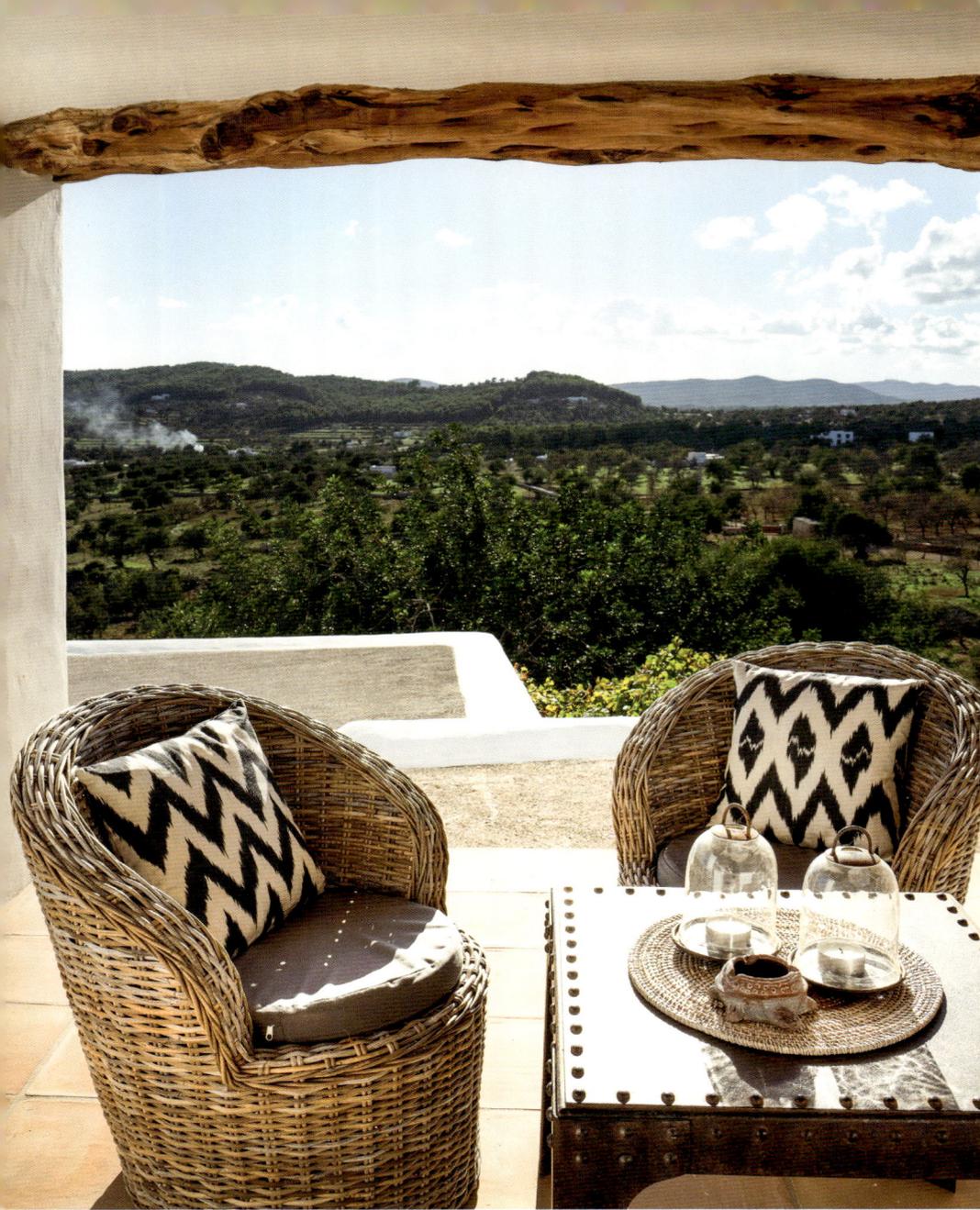

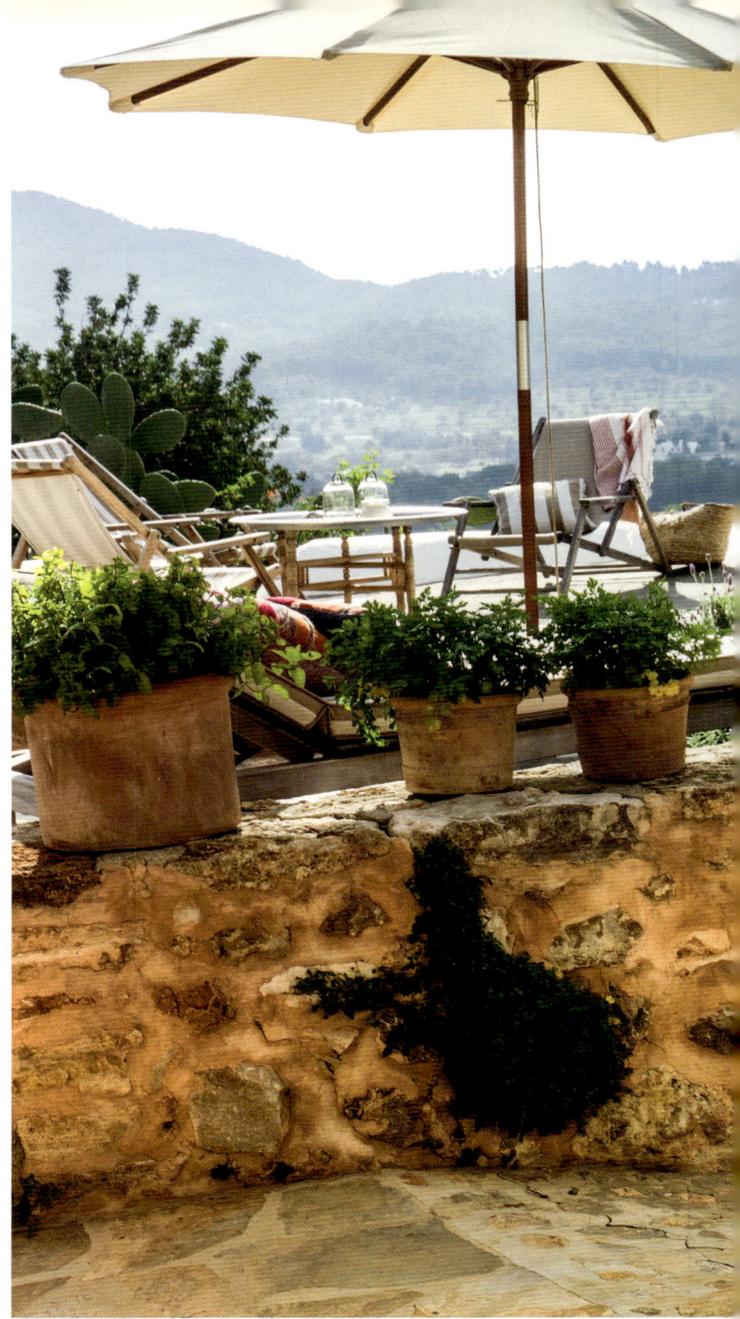

*Wood and rattan furniture on the terraces and around the pool blend harmoniously with the surrounding landscape. Ethnic décor elements set perfect accents.*

*Auf den Terrassen und am Poolbereich fügen sich die Möbel aus Holz und Rattan harmonisch in die umliegende Landschaft ein. Akzente werden durch Details im ethnischen Stil gesetzt.*

*En las terrazas y en torno a la piscina, los muebles de madera y ratán se integran armoniosamente en el entorno. Algunos detalles étnicos aportan un toque individual al conjunto.*

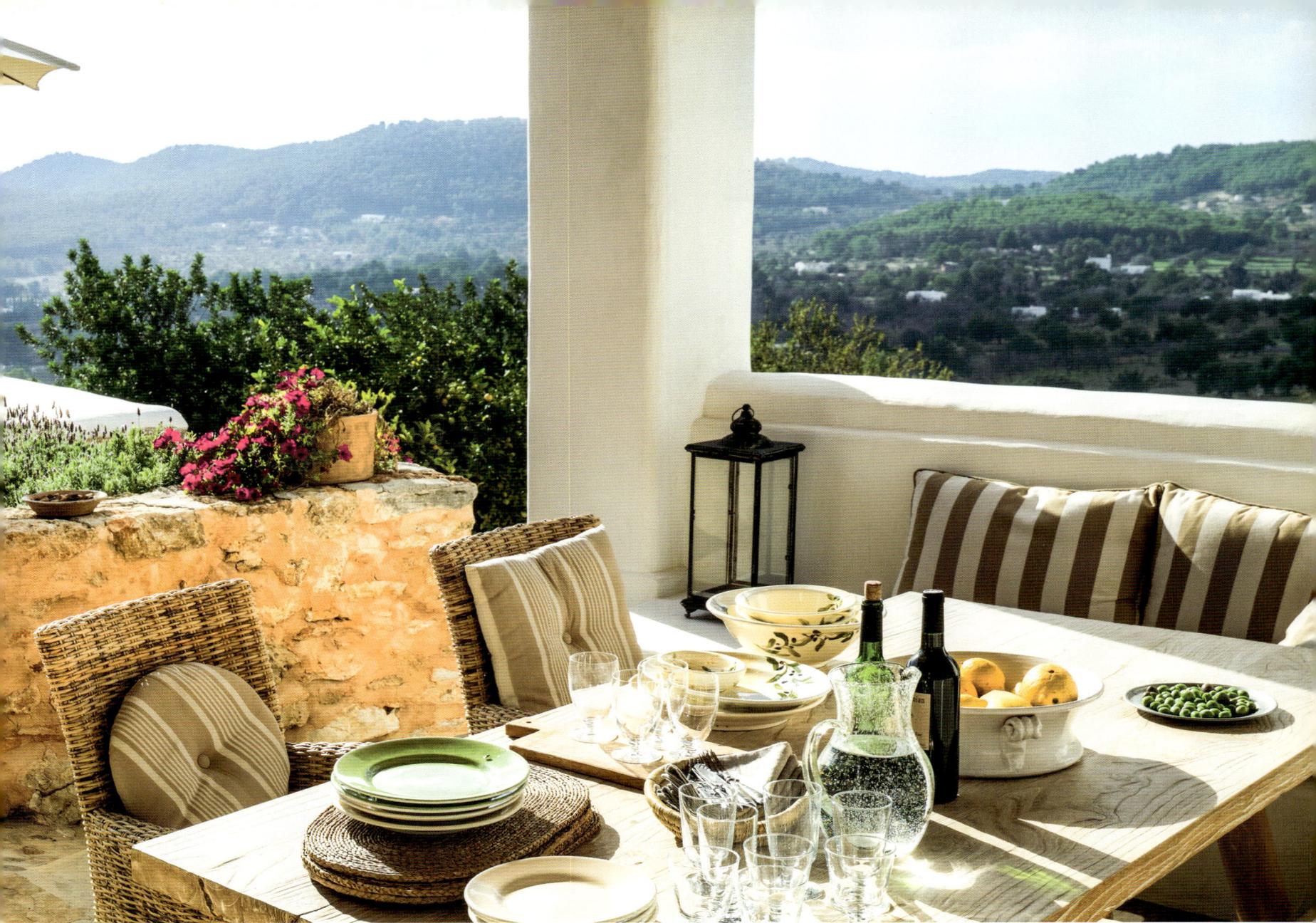

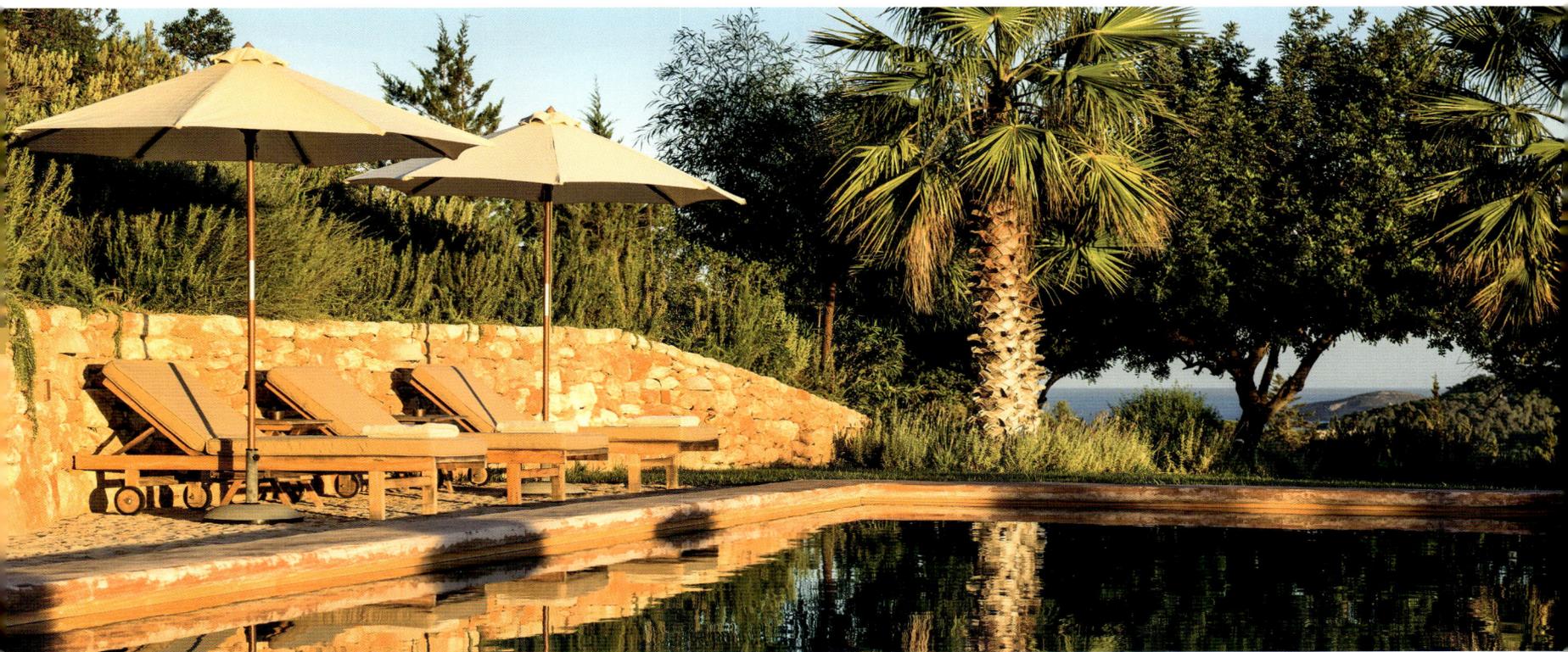

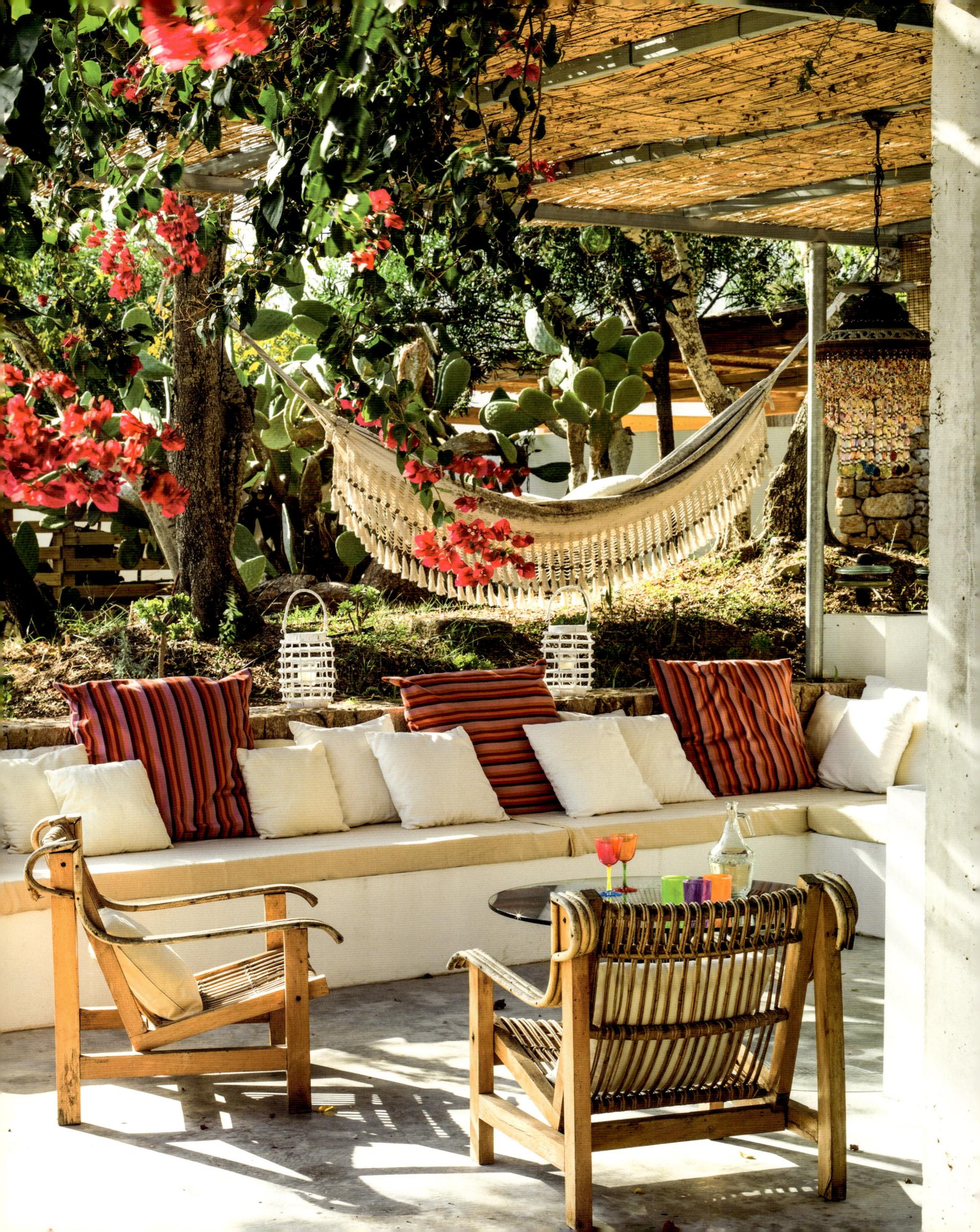

# Can Pep Bet

BOHEMIAN CHIC MEETS the seventies in this once dilapidated country house dating back to 1793. With its small windows and two hen houses, this hideaway is an oasis of tranquility. The new addition reinterprets the close-to-nature lifestyle of a traditional Ibizan finca for the modern age. In winter, the owners spend many enjoyable hours basking in the warmth of a hearth fire. In summer, they open the house up to the garden. The traditional dry stone walls and bougainvillea-draped patio, both of which are well preserved, will brighten the spirits of any Mediterranean aficionado. The eclectic décor combines classic design elements from the 1970s with ethnic art and natural materials to form a harmonious whole.

BOHEMIAN CHIC MEETS Seventies in dieser ehemaligen Ruine von 1793. Das abgelegene Landhaus mit seinen kleinen Fenstern und zwei Hühnerställen bildet eine Oase der Ruhe. Der angebaute Teil ist die neuzeitliche Reinterpretation einer ibizenkischen Finca mit ihrer naturverbundenen Lebensart. Im Winter findet das Leben hauptsächlich am Kaminfeuer statt, im Sommer öffnet sich das Haus zu den Gärten. Der Erhalt der traditionellen Trockenmauern und der Patio mit seinen Bougainvilleen lassen das Herz eines jeden Mittelmeer-Aficionados höher schlagen. Die eklektische Einrichtung verbindet Designklassiker aus den 1970er-Jahren mit ethnischen Elementen und Naturmaterialien zu einem harmonischen Ganzen.

EL ENCANTO BOHEMIO Y el estilo setentero se dan la mano en esta antigua ruina de 1793. La recóndita casa rural, con sus pequeños ventanucos y sus dos gallineros, es un auténtico remanso de paz. El ala adicional es una reinterpretación moderna de la clásica finca ibicenca, tan próxima siempre a la naturaleza. En invierno, la vida se desarrolla principalmente en torno al hogar, pero llegado el verano la casa se abre a los jardines. Se han conservado los muros de marger tradicionales, y las buganvillas del patio harán las delicias de las almas afines al Mediterráneo. Los interiores hacen gala de un eclecticismo que consigue combinar en un todo armonioso clásicos del diseño de la década de 1970 con elementos étnicos y materiales.

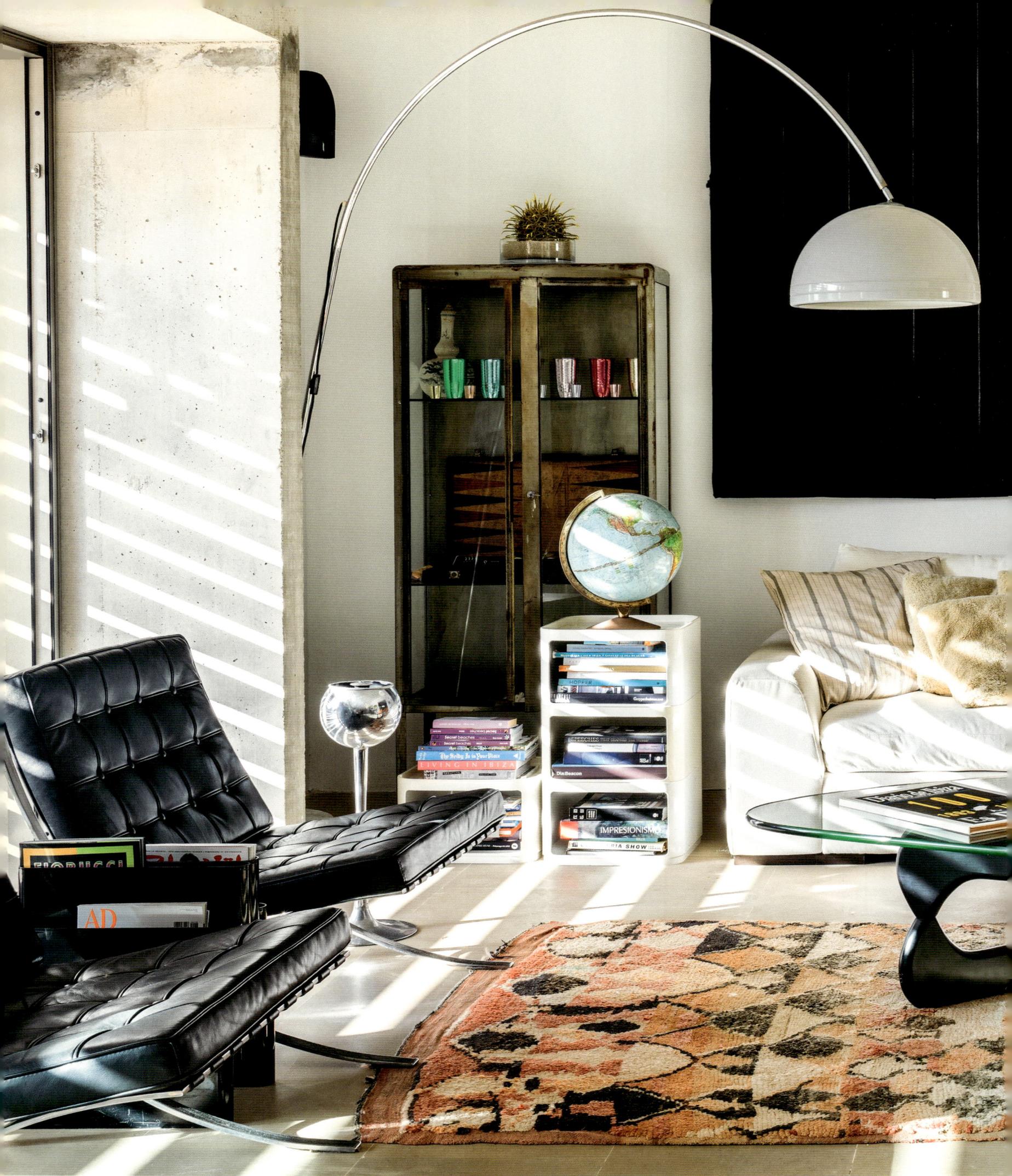

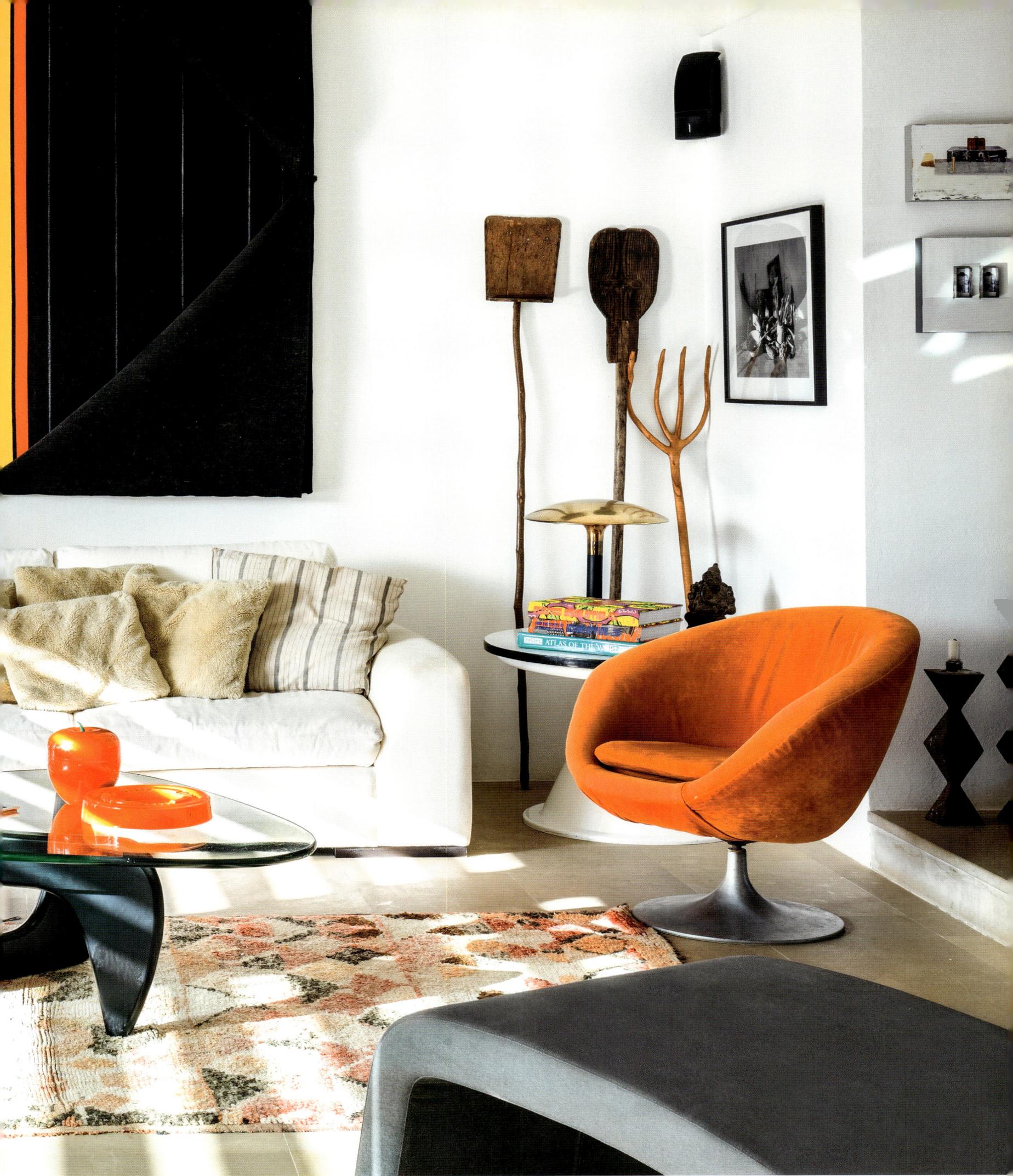

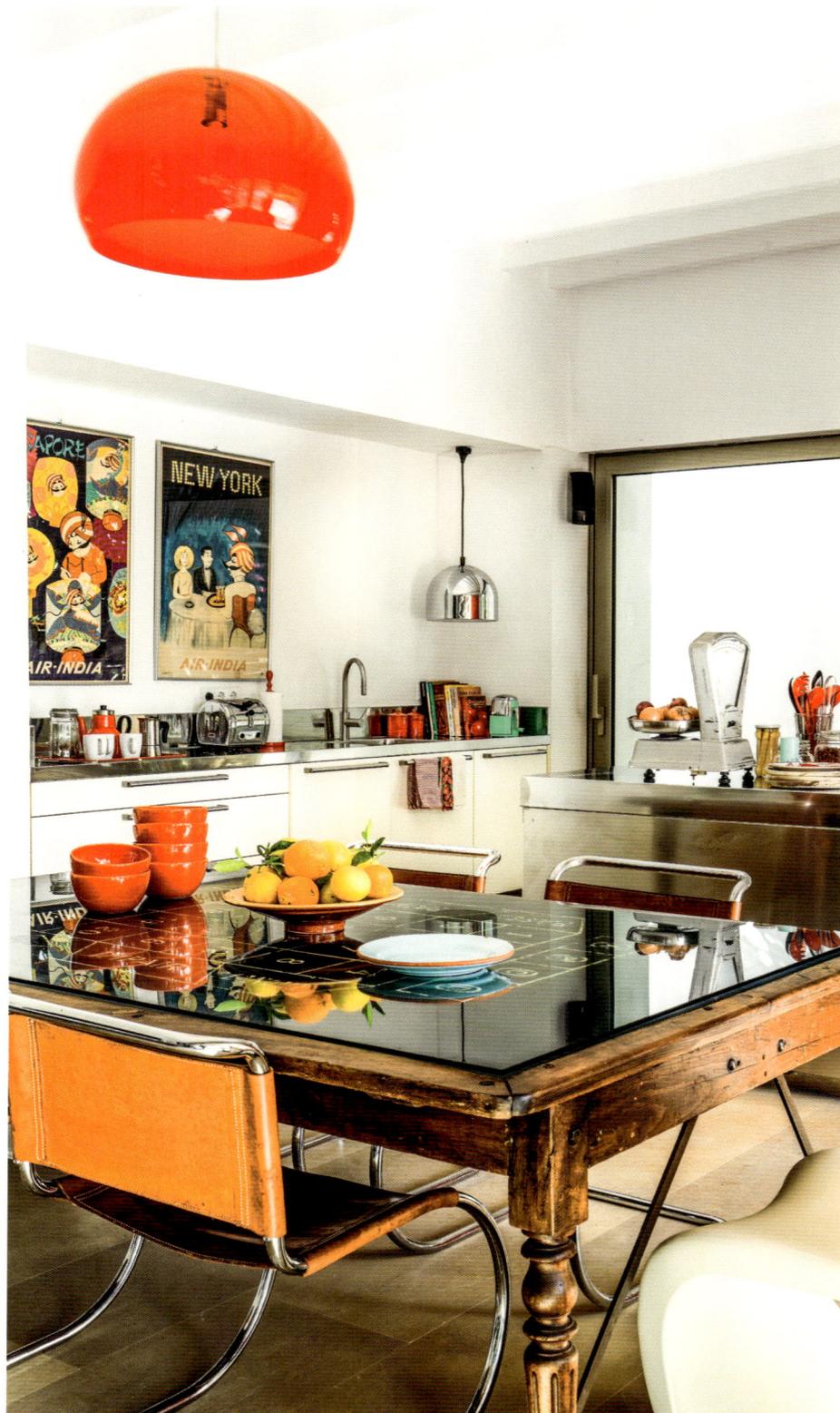

The antique kitchen table combines with vintage cantilever chairs and modern Inox furniture to form a perfect symbiosis.

Der antike Küchenesstisch bildet mit den Vintagefreischwingern und modernen Inoxmöbeln eine stimmige Symbiose.

La antiquísima mesa de la cocina establece una simbiosis armoniosa con los modernos muebles de acero inoxidable y las sillas tubulares vintage.

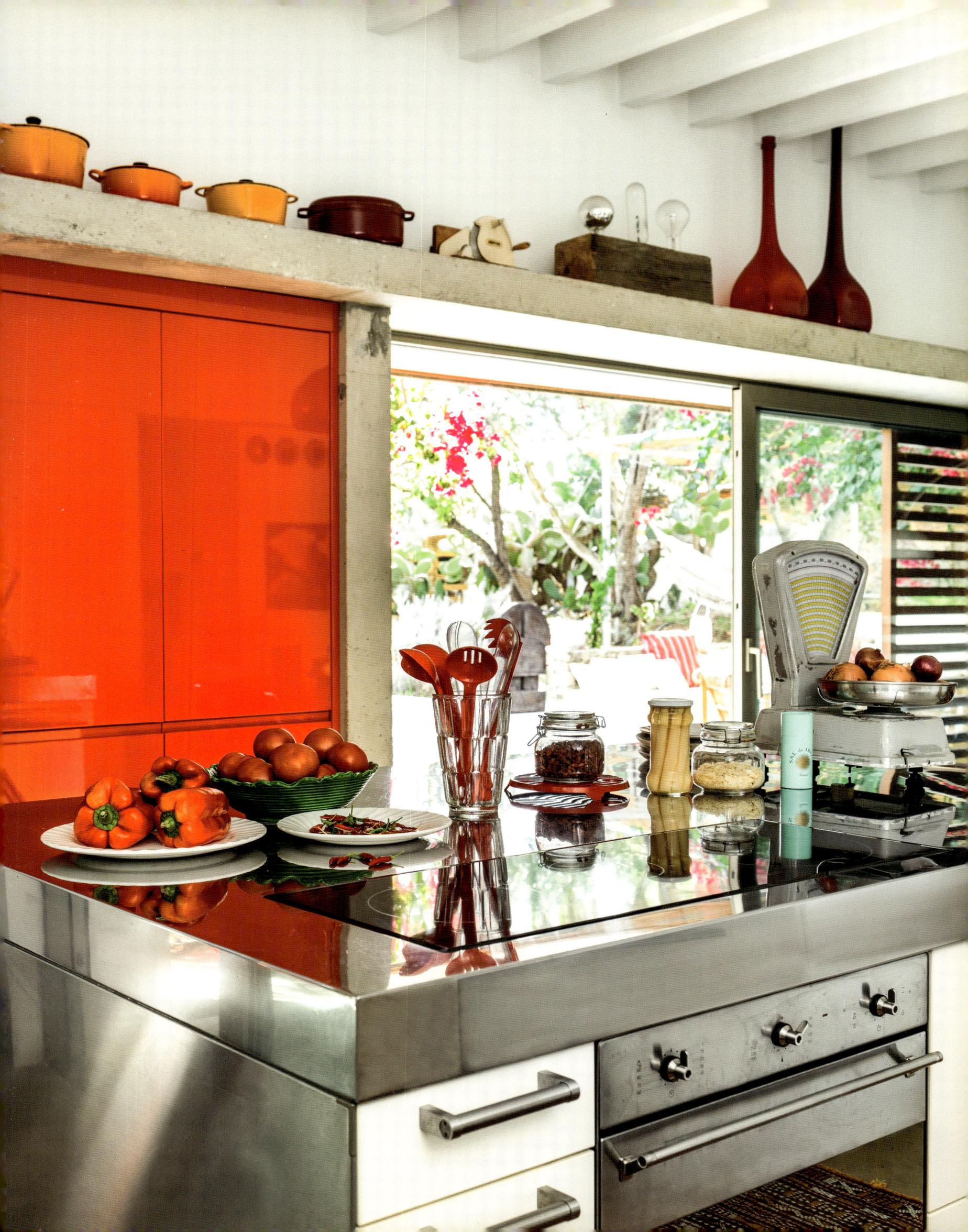

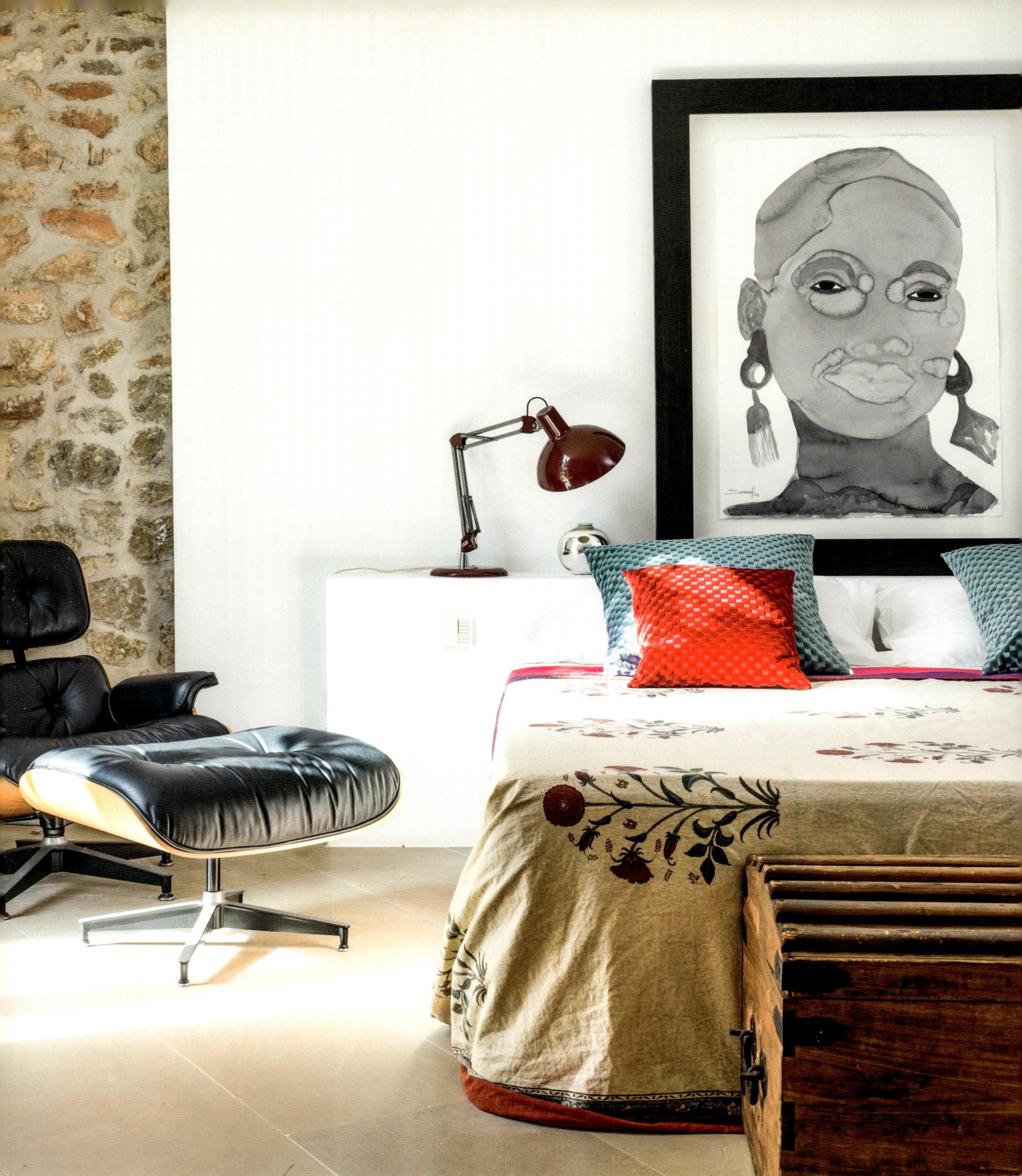

The master bedroom shares space with the bathroom. The mix of styles and patterns creates a comfortable Bohemian atmosphere.

*Das Hauptschlafzimmer geht direkt in das Bad über. Der Stil- und Mustermix schafft eine warme Bohemienatmosphäre.*

*El dormitorio principal se abre directamente al cuarto de baño. La mezcla de estilos y dibujos crea un ambiente acogedor y bohemio.*

# Can Frit

THIS UNUSUAL, FAN-SHAPED country home emerged from a much older structure. Featuring extremely high ceilings and unconventional proportions, the home centers on a large foyer, from where French doors open onto the south-facing terraces. The living room and master bedroom also lead off the foyer, and a helical staircase winds its way downstairs to a room with a fireplace at the very heart of the home. Dry stone walls contrast harmoniously with old wooden beams, creating a Mediterranean ambience. Color accents and natural materials lend the minimalist, modern décor a warm transparency.

AUS EINER ALTEN Bausubstanz ist dieses ungewöhnliche, fächerförmig angelegte Landhaus entstanden. Der Bau mit extremen Deckenhöhen und unkonventionellen Proportionen ist um eine große Empfangshalle herum angeordnet. Von hier gehen die französischen Fenster zu den Südterrassen ab sowie der Salon und das Hauptschlafzimmer. Eine schneckenförmige Treppe führt in die untere Etage. Mit seinem Kamin bildet der Raum gleichzeitig die Seele des Hauses. Die Trockenmauern und alten Holzbalken stehen in einem harmonischen Kontrast, der mediterranes Ambiente schafft. Die modern-minimalistische Einrichtung bekommt durch Farbakzente und Verwendung von Naturmaterialien eine warme Transparenz.

UNA RESIDENCIA RURAL de líneas desacostumbradas en abanico, construida a partir de los restos de una antigua casa. El edificio, de altísimos techos y proporciones desacostumbradas, se estructura en torno a un extenso vestíbulo. Desde aquí, las ventanas francesas se abren a la terraza sur, el salón y el dormitorio principal. Una escalera de caracol conduce a la planta inferior. La chimenea, además, hace de este espacio el centro neurálgico de la casa. Los muros sin mortero y las altas vigas de los techos ofrecen un armonioso contraste que exuda mediterraneidad. Diversas pinceladas de color aportan al conjunto una cálida transparencia, subrayada por el uso de materiales naturales.

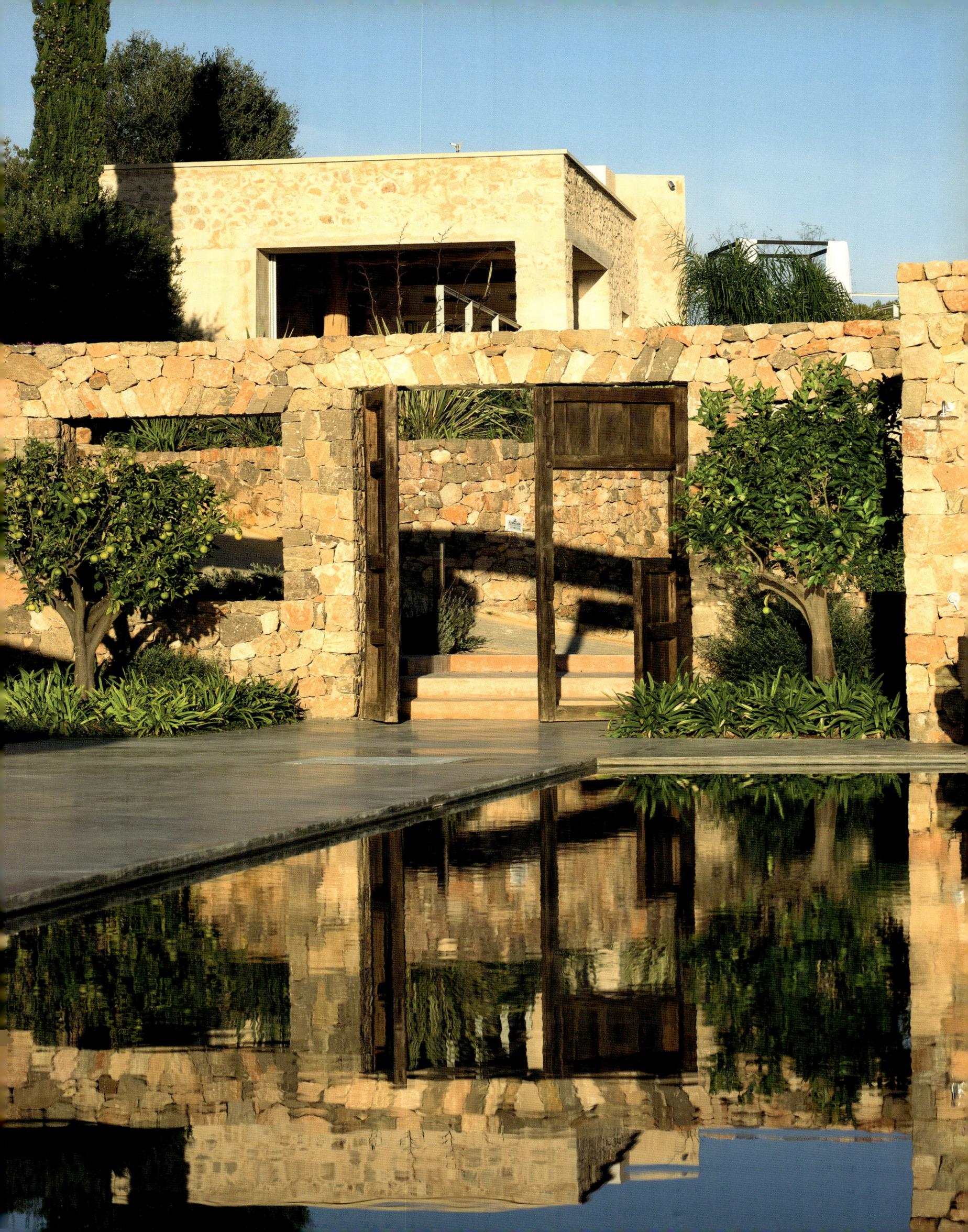

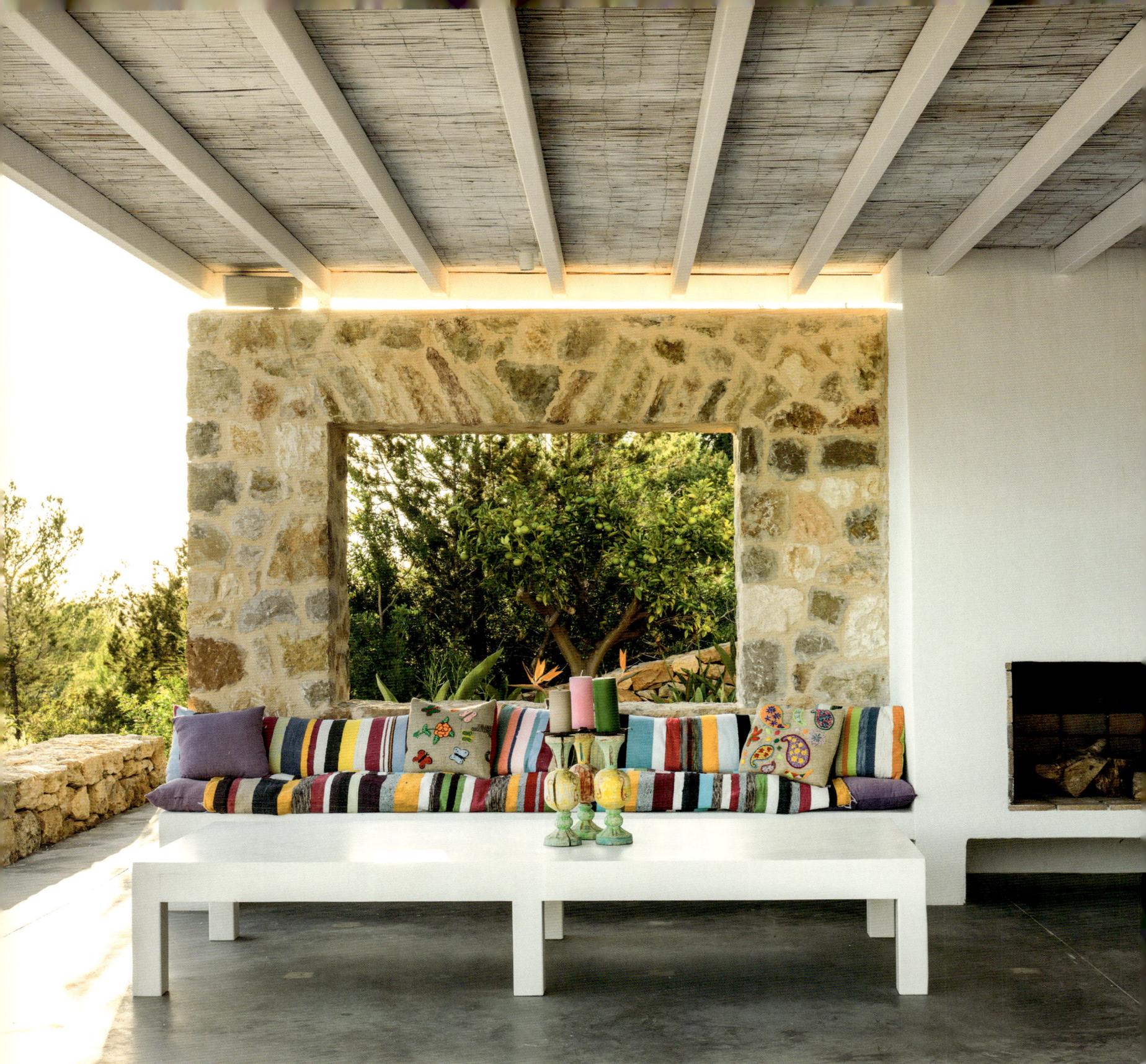

The fireplace terrace and surrounding sun porches offer endless vistas of the hills all around.

*Von der Kaminterrasse und den umliegenden Sonnenterrassen aus hat man einen endlosen Weitblick in die umliegende Hügellandschaft.*

*La chimenea exterior y las terrazas circundantes permiten disfrutar de una extensísima panorámica del paisaje montañoso de la zona.*

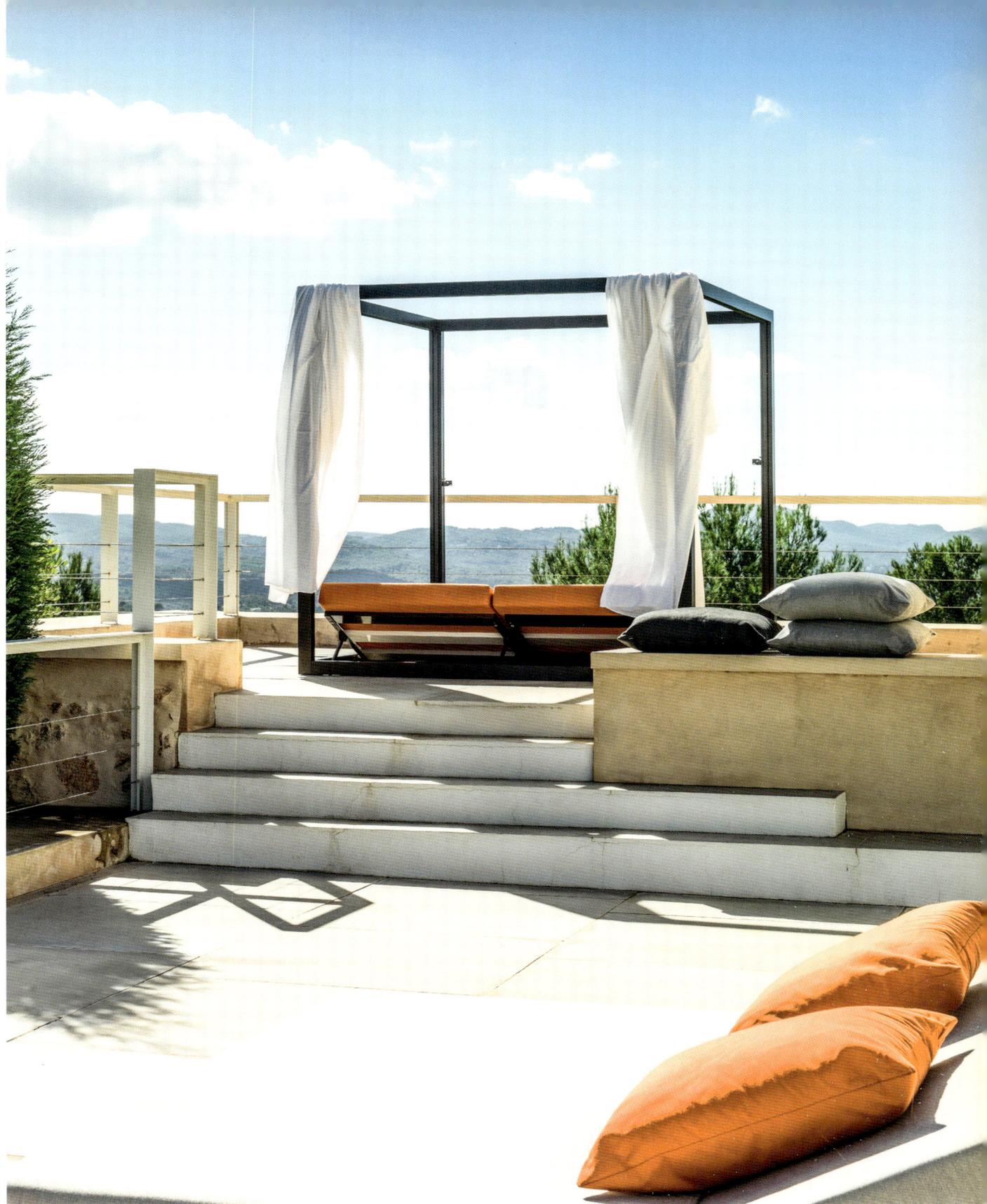

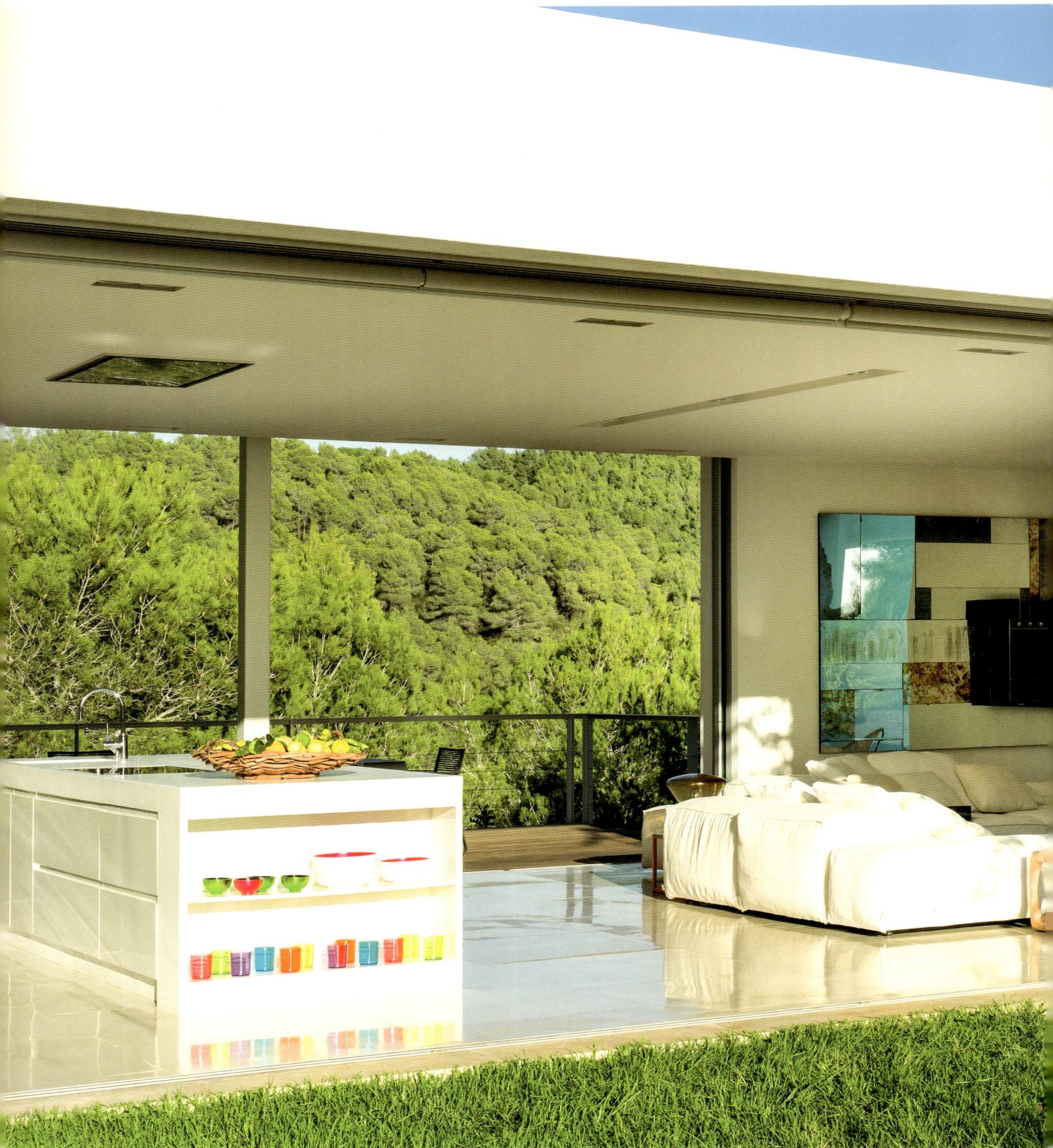

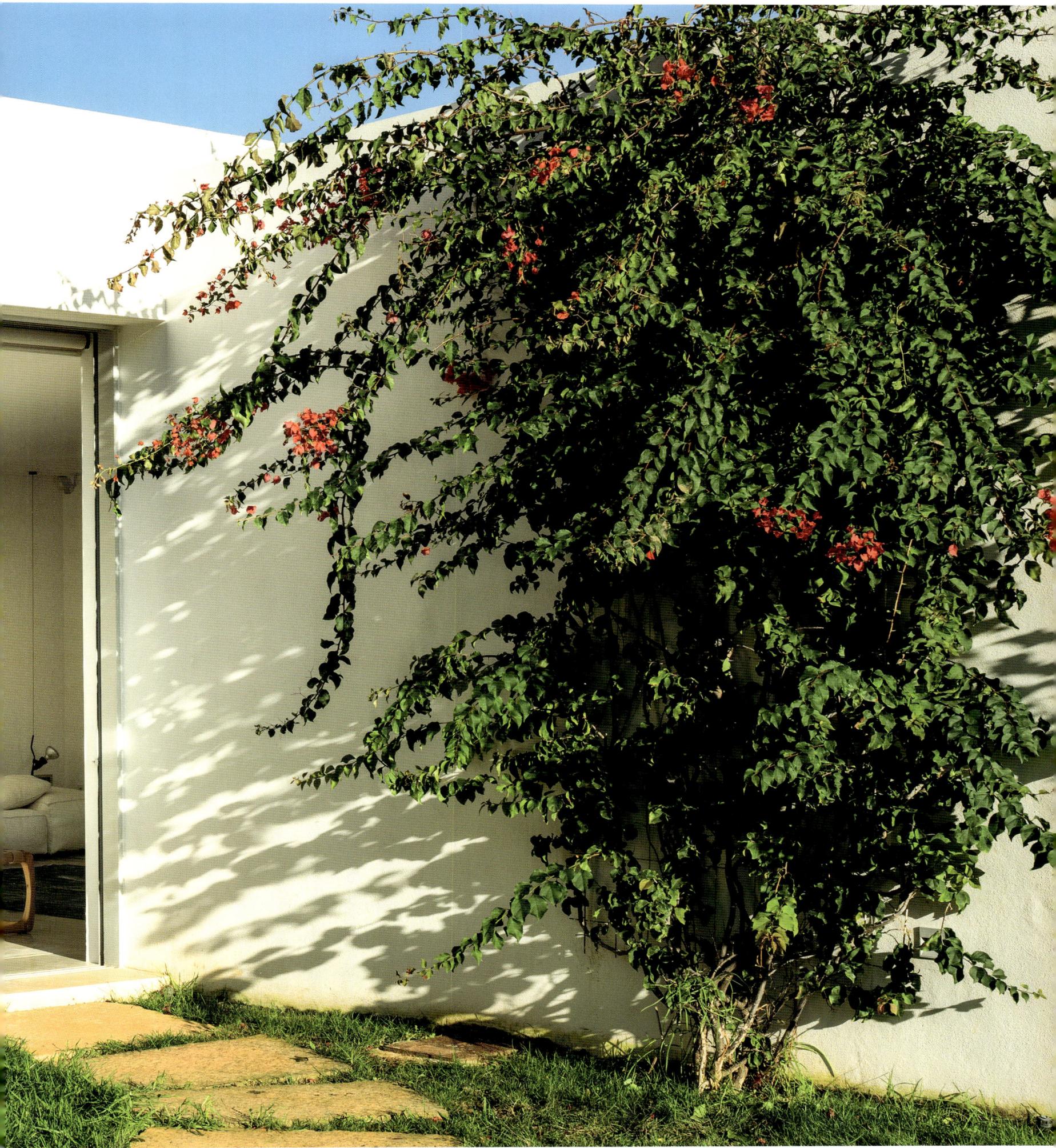

*The classic, suspended iron fireplace, and the helical staircase in the entrance area give the home a clean esthetic.*

*Der klassische, schwebende Eisenkamin und die Schneckentreppe im Empfangs-raum des Hauses schaffen eine klare Ästhetik.*

*La clásica chimenea flotante y la escalera de caracol en el vestíbulo de la casa definen una estética de líneas claras.*

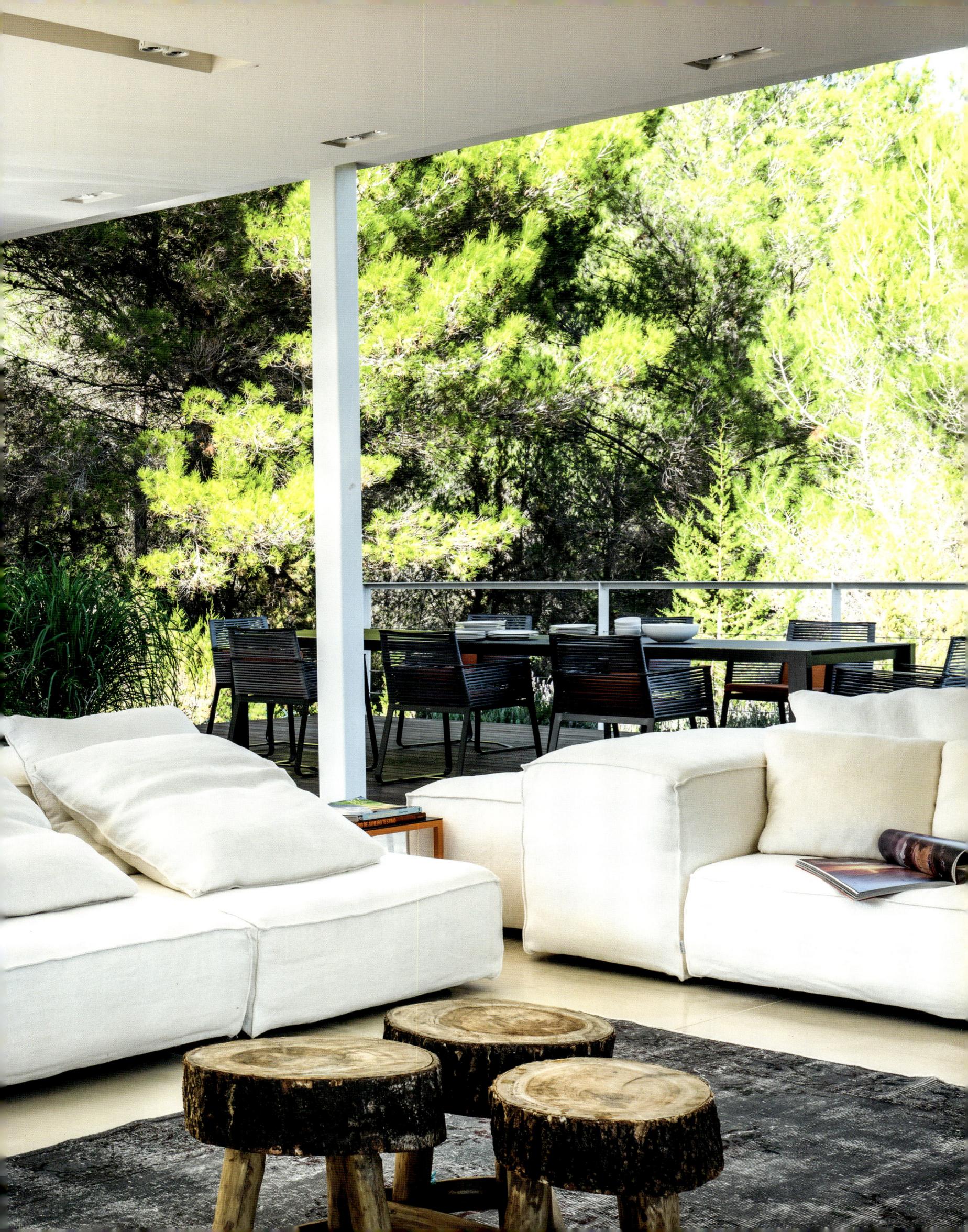

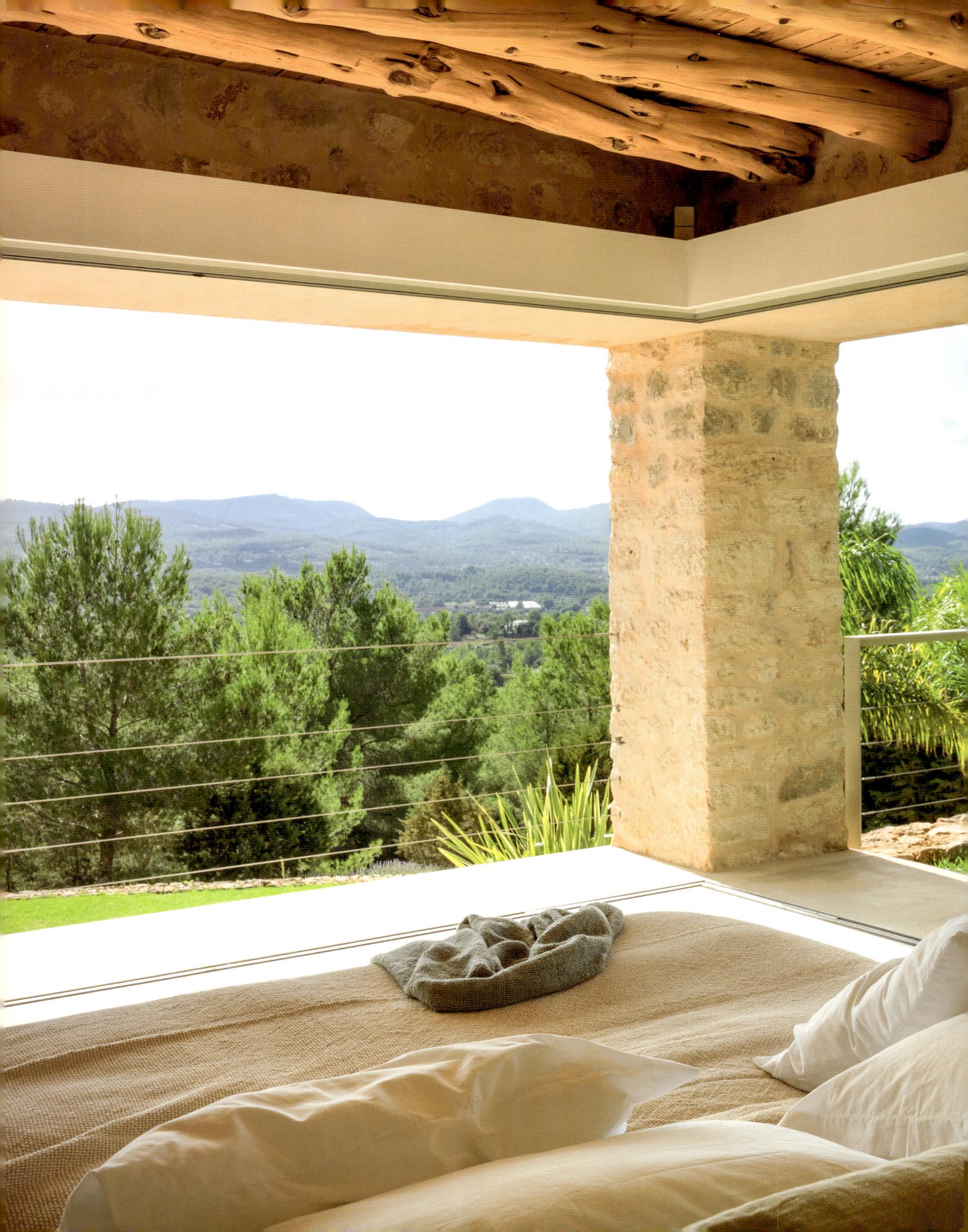

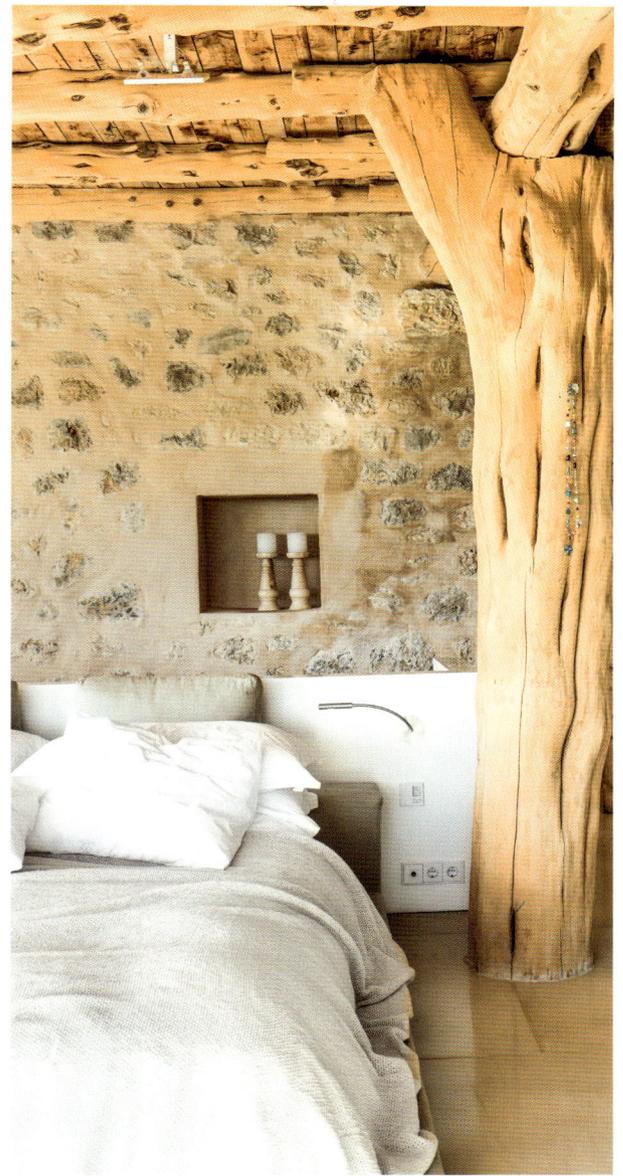

*View of the green Mediterranean landscape from the master bedroom. The 1950's-style mirrors in the minimalist bathroom provide an attractive counterpoint to the historic wooden beams and the home's otherwise Mediterranean design vocabulary.*

*Aussicht aus dem Hauptschlafzimmer auf die Mittelmeervegetation. Die 50er-Jahre-Spiegel im minimalistischen Bad bilden einen interessanten Bruch zu den historischen Holzbalken und der ansonsten mediterranen Formensprache.*

*Vista de la vegetación mediterránea desde el dormitorio principal. Los espejos años cincuenta del minimalista cuarto de baño suponen una interesante ruptura con las históricas vigas de madera y el lenguaje formal de la sala, claramente mediterráneo.*

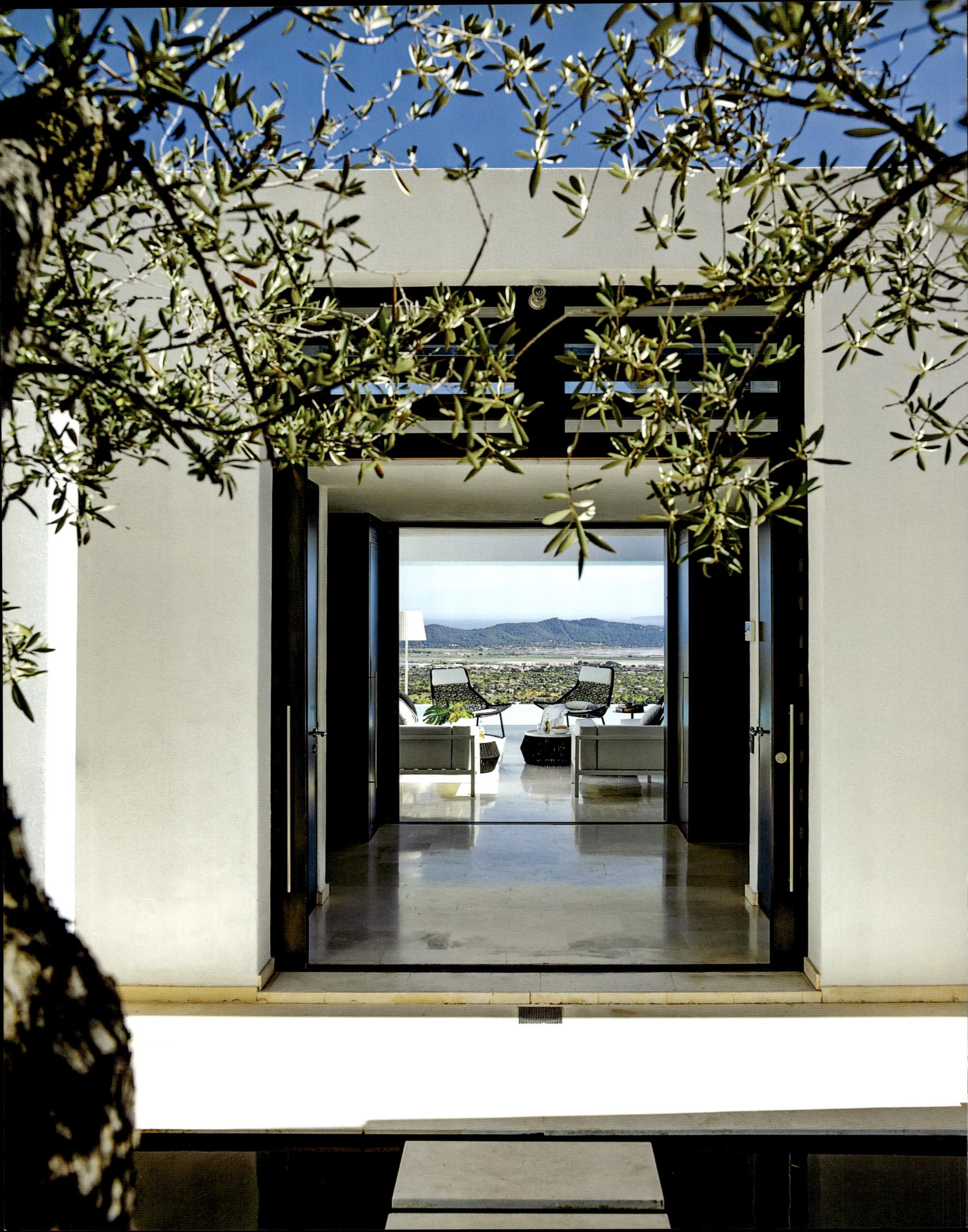

# Can Koi

A MINIMALIST DESIGN concept and spectacular vistas form the backdrop for striking contemporary art and modern design. Interior designer Anke Rice worked with classic design elements to create a David Hockney-style ambience on the Mediterranean Sea. Supersized photographs by Madrid-based Eugenio Recuenco—the Pablo Picasso of photography—dominate the mainly monochrome décor of the home's interior. Framed by an old-growth pine forest, the concrete architecture designed by the Belgian Bruno Erpicum architectural firm radiates a breezy, transparent elegance that makes the panoramic view of Formentera seem like an enormous movie screen.

EINE MINIMALISTISCHE FORMENSPRACHE und ein spektakulärer Weitblick bilden die Kulisse für beeindruckende zeitgenössische Kunst und modernes Design. Die Innenarchitektin Anke Rice hat mit Designklassikern eine David-Hockney-Aura im Mittelmeer gestaltet. Die großformatigen Bilder des Madrider Fotografen Eugenio Recuenco – der Pablo Picasso der Fotografie – bestimmen die ansonsten hauptsächlich in Schwarz-Weiß gehaltenen Räume. Umrahmt von einem alten Pinienwald strahlt die Zementarchitektur des belgischen Architektenteams von Bruno Erpicum eine kühle, transparente Eleganz aus, die den Panoramablick auf Formentera fast wie eine überdimensionale Leinwand wirken lässt.

MINIMALISMO FORMAL Y espectaculares vistas ofrecen el marco ideal para un diseño moderno complementado con notable arte contemporáneo. La interiorista Anke Rice ha recurrido a clásicos del diseño para crear un ambiente reminiscente de David Hockney en pleno Mediterráneo. Las imágenes a gran escala del fotógrafo madrileño Eugenio Recuenco, el Picasso de la fotografía, dan carácter a unas habitaciones que por lo demás se definen en blancos y negros. Integrada en un viejo pinar, la construcción de cemento del equipo belga de arquitectos comandado por Bruno Erpicum exuda una elegancia fría y transparente que confiere a la vista panorámica sobre Formentera la apariencia de un lienzo sobredimensionado.

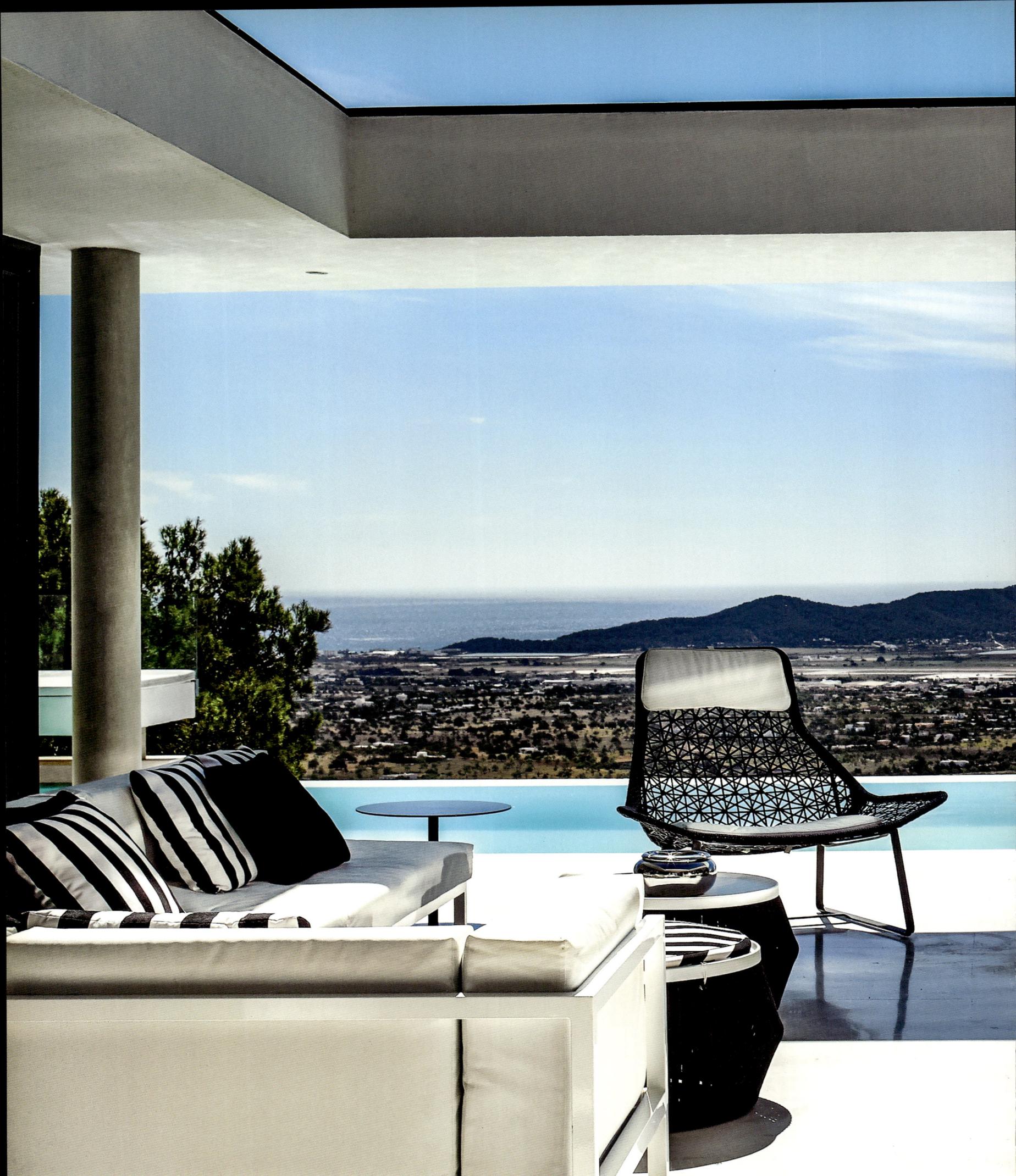

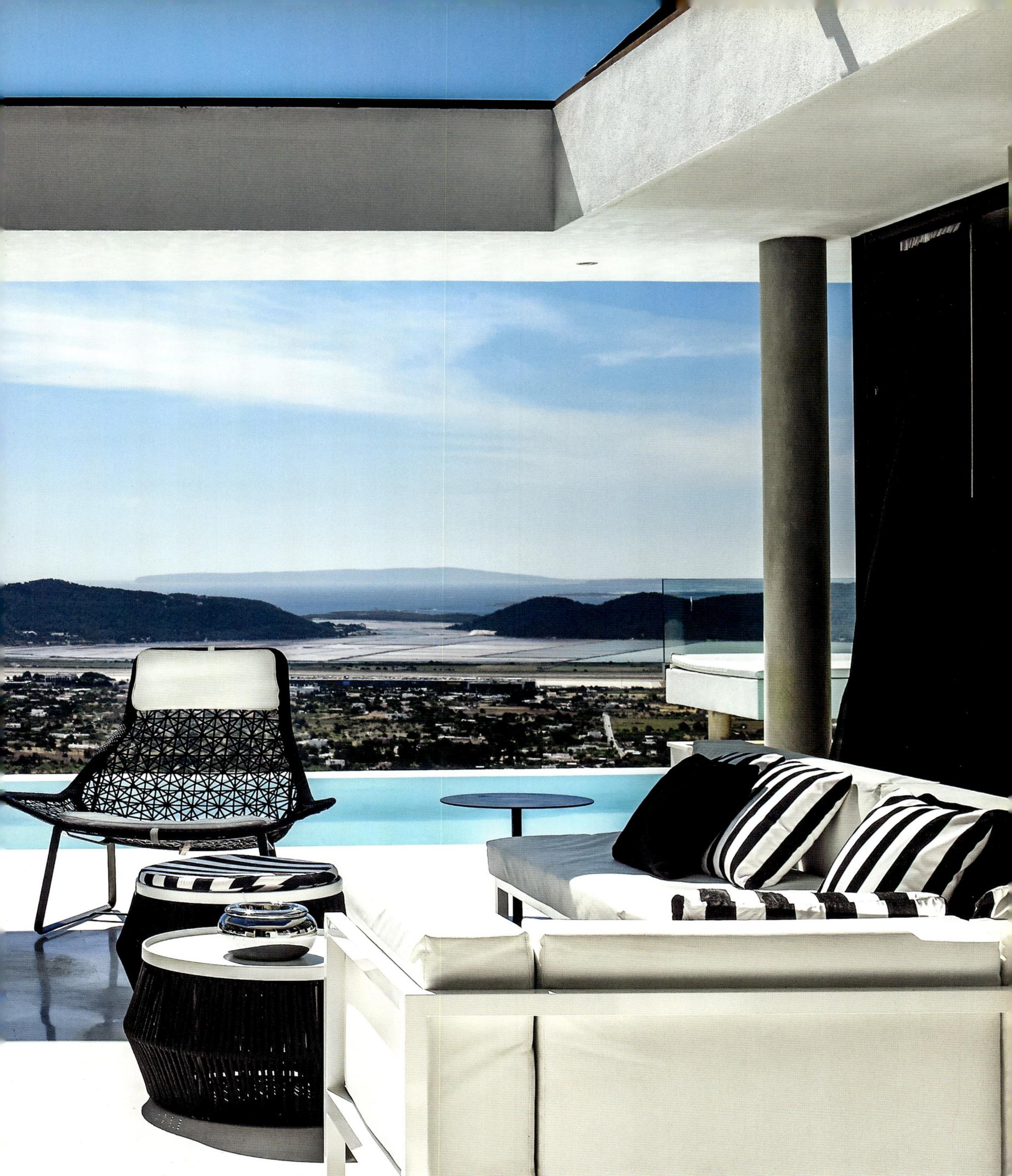

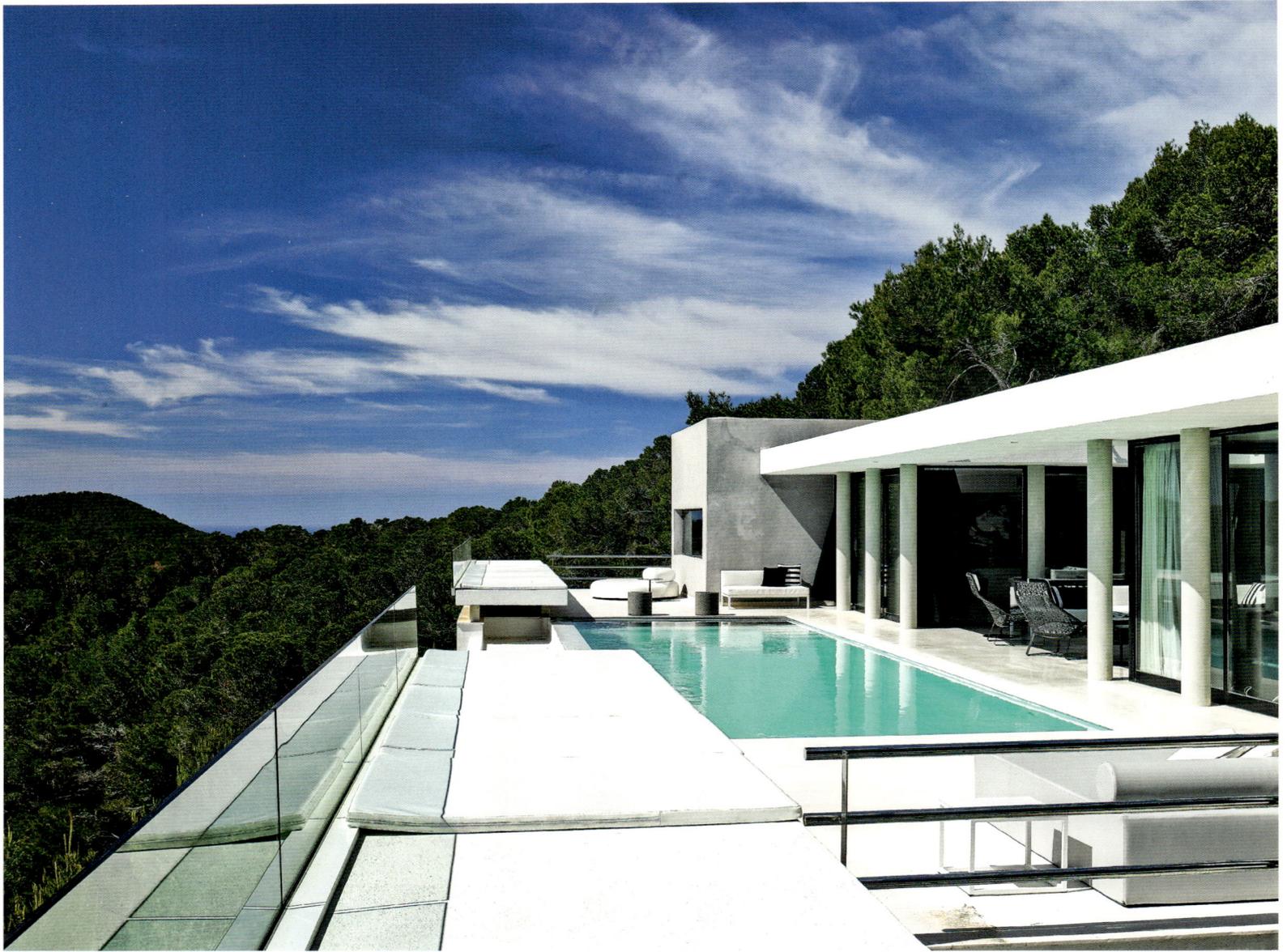

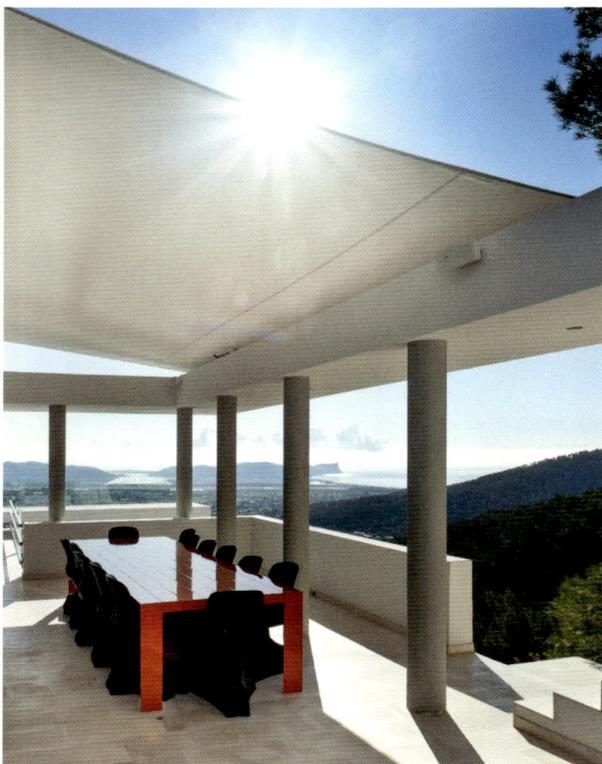

A white Bubble Rock sofa designed by Piero Lissoni for Living Divani and lounge chairs from Kettal invite guests to relax around the recessed pool. The ceiling above the patio opens and closes like a sunroof, depending on the position of the sun.

Am eingelassenen Pool laden ein weißer Bubble Rock von Piero Lissoni für Living Divani und Lounge-Chairs von Kettal zum Relaxen ein. Die Decke über der Außenterrasse lässt sich je nach Stand der Sonne wie ein Schiebedach öffnen und schließen.

Relax garantizado junto a la piscina gracias al sofá Bubble Rock blanco de Piero Lissoni para Living Divani y las tumbonas de Kettal. La cubierta sobre la terraza puede abrirse y cerrarse como un techo corredero en function de la posición del sol.

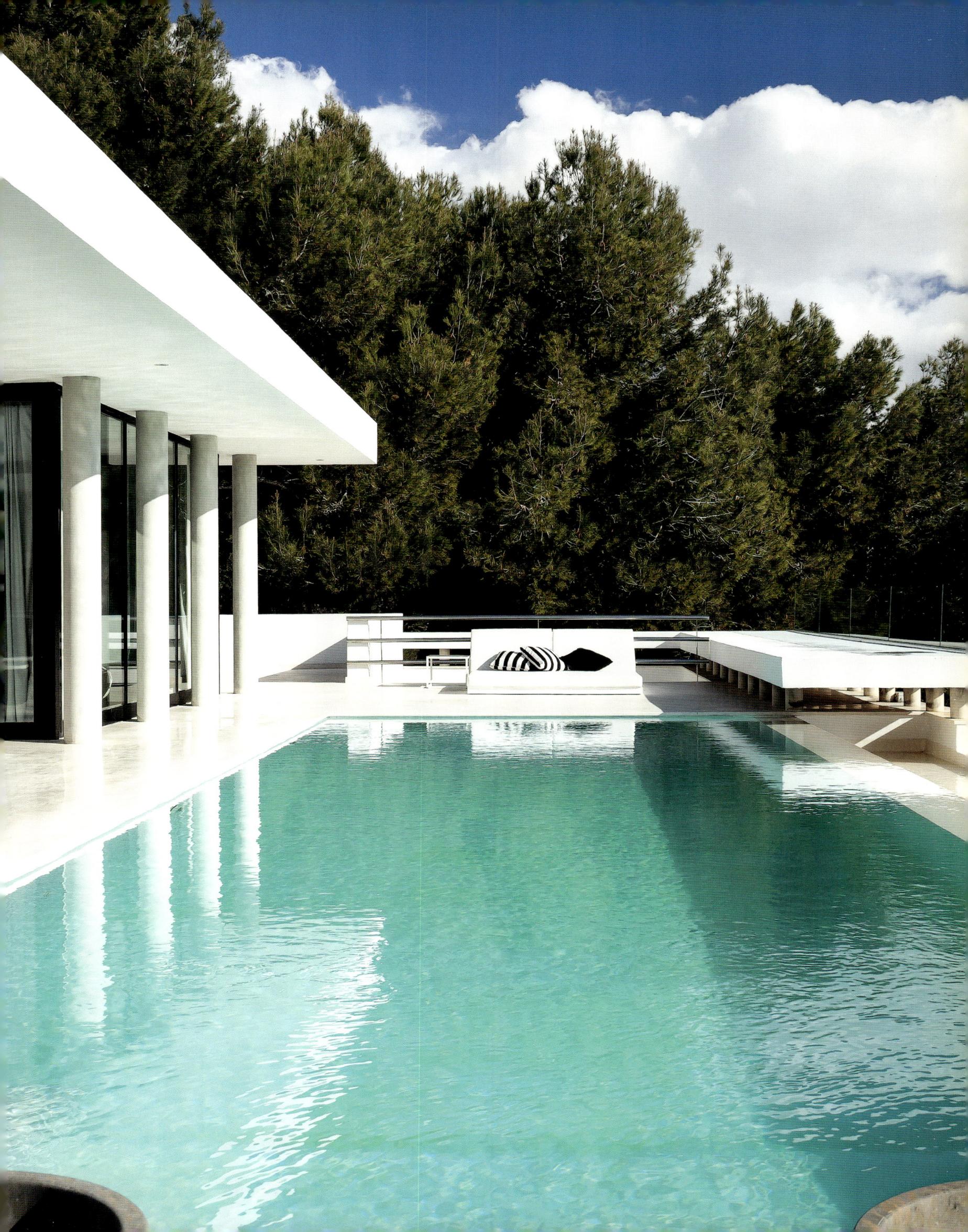

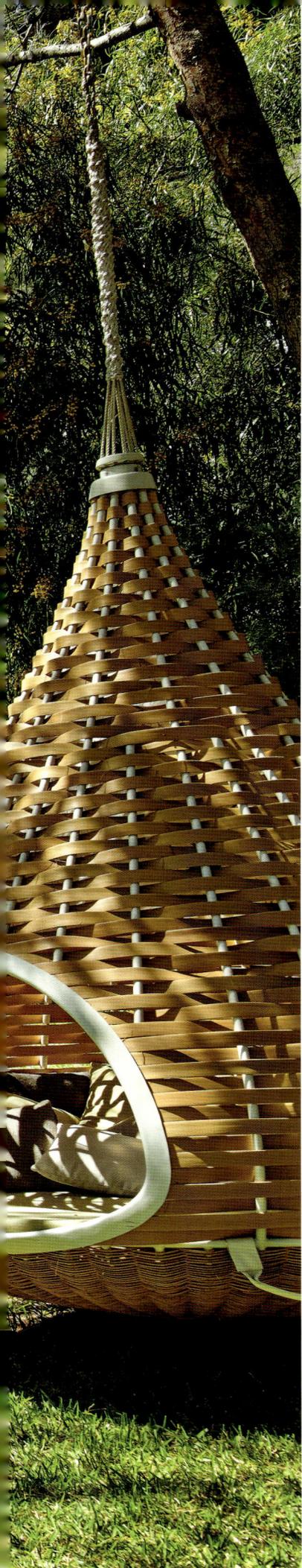

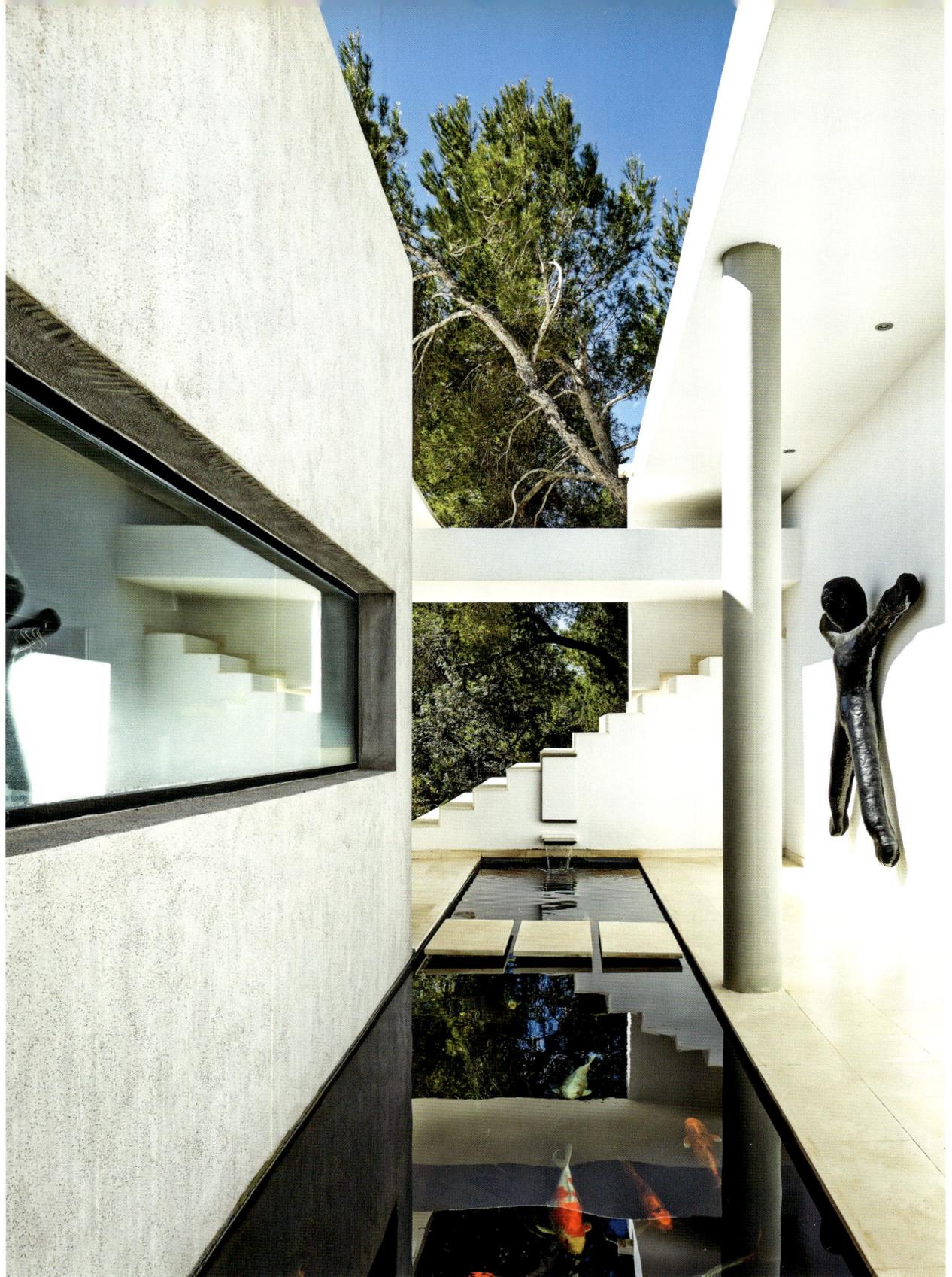

A Nestrest lounger from Dedon hangs from a tree in the adjacent pine grove, and a koi pond is built into the property, lending the house its name. A sculpture by Antonio Villaneuva clings to the wall.

*Im angrenzenden Pinienwald hängt eine Nestschaukel von Dedon. Der integrierte Koi-Karpfen-Teich gibt dem Haus seinen Namen. Die Wand ziert eine Skulptur von Antonio Villaneuva.*

*En el cercano pinar se ha instalado un nido-columpio obra de Dedon. La casa deriva su nombre del estanque donde nadan las carpas koi. Una escultura de Antonio Villanueva adorna el muro.*

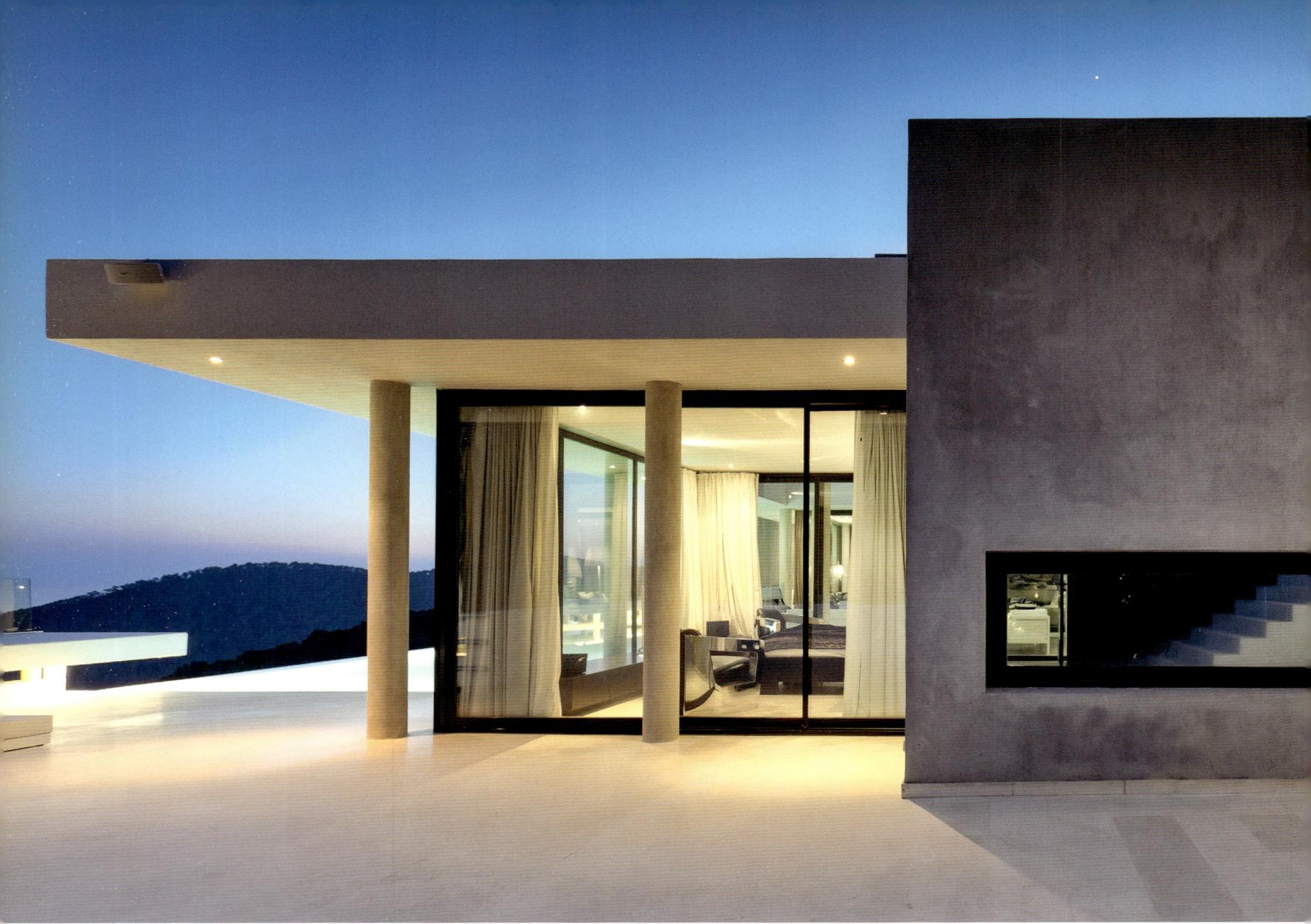

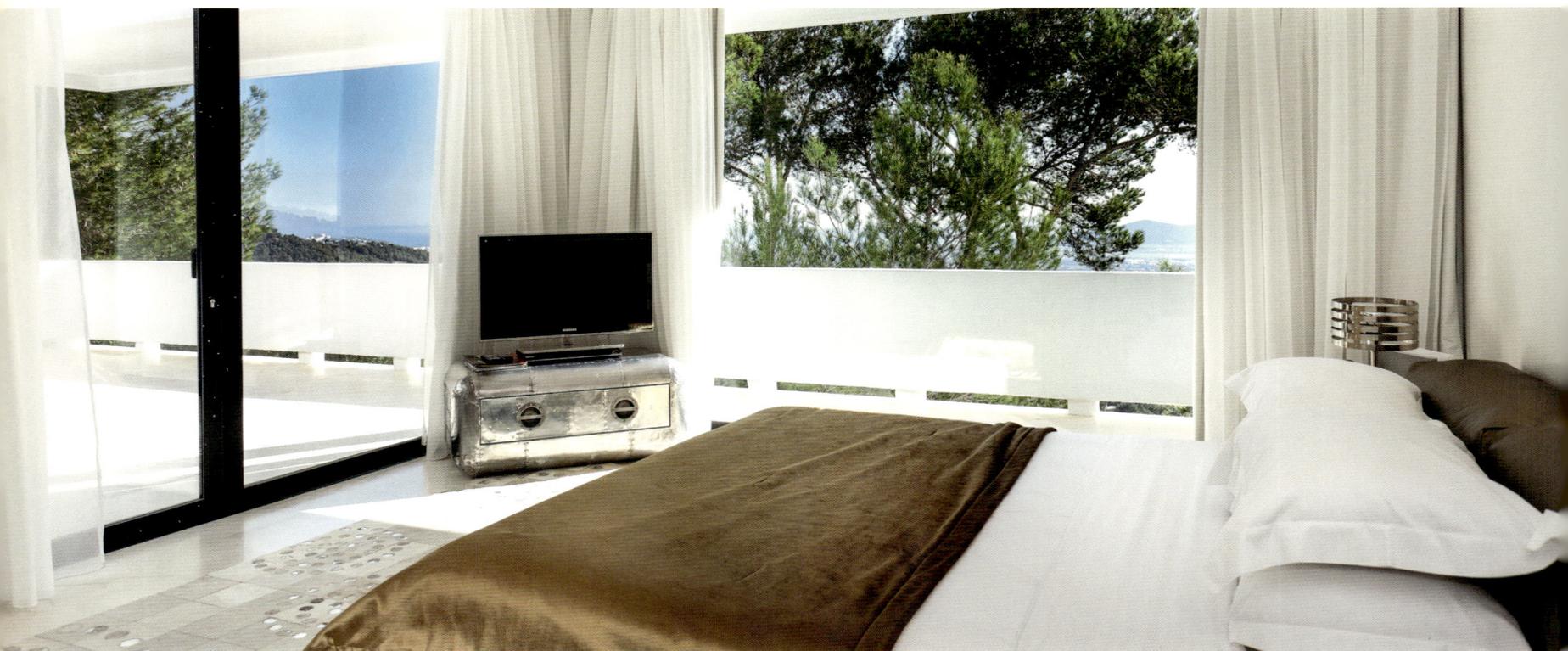

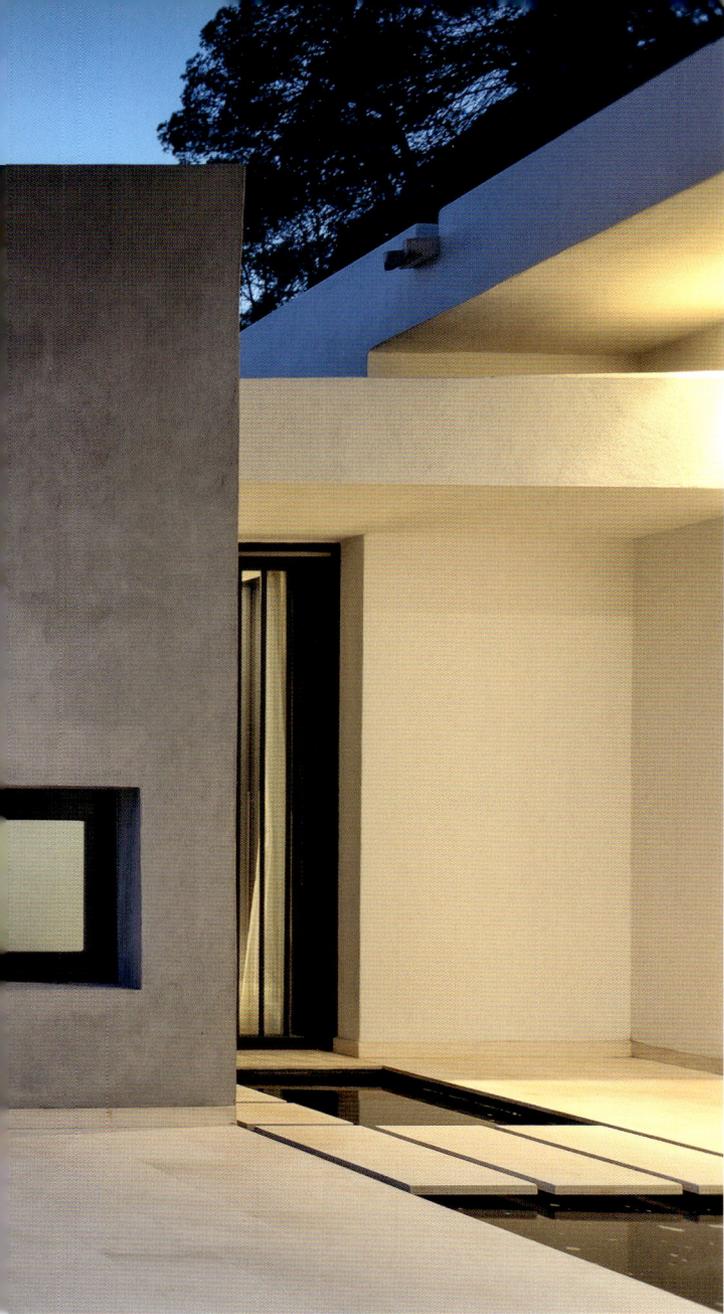

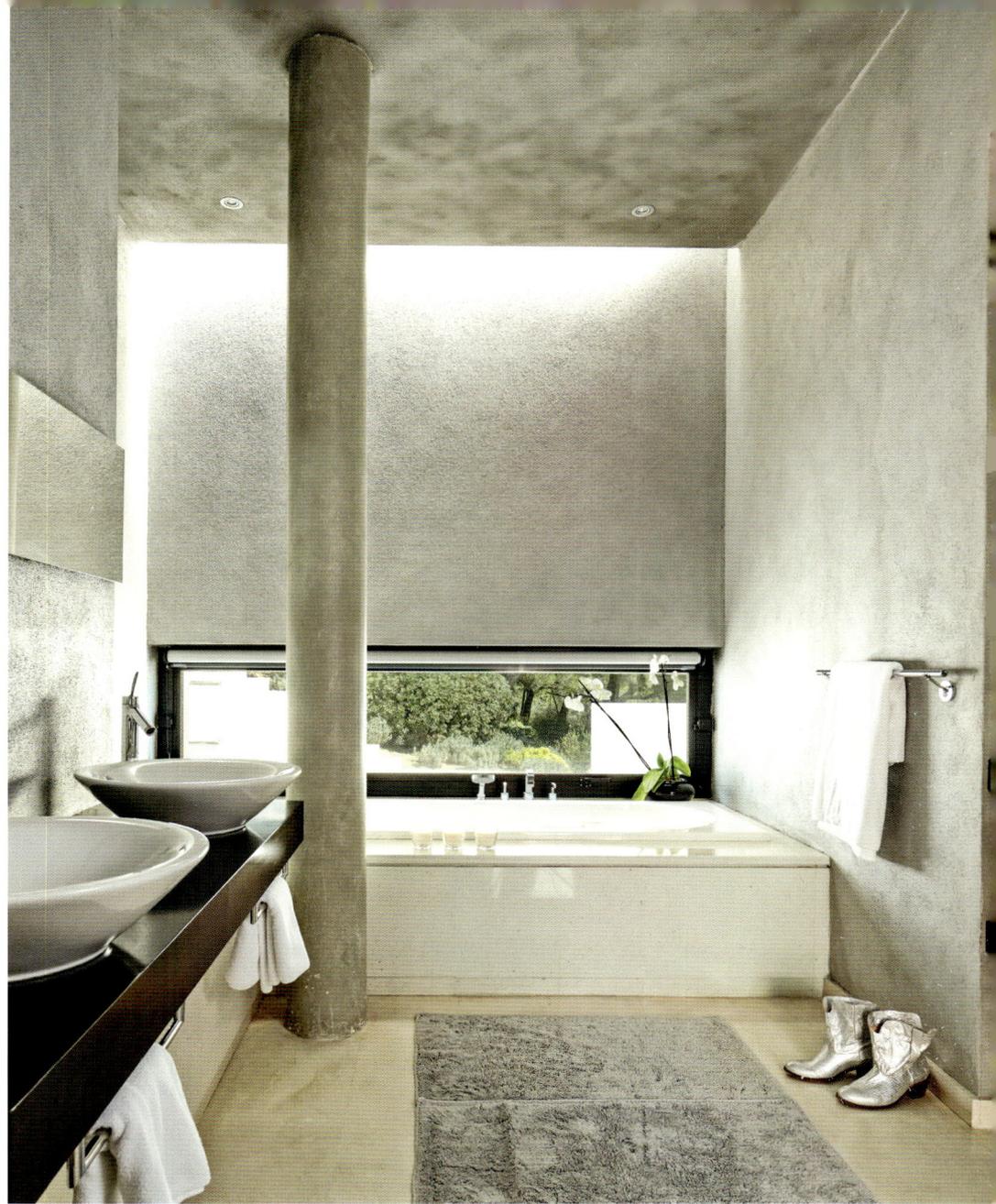

Rectangular windows and doors break up the lines of the house and combine with an understated color scheme to form a fascinating whole. Furniture from Living Divani dominates the living room.

Das gesamte Haus besticht durch eine zurückgenommene Farbgebung und rechteckige Maueröffnungen, die die Linienführung aufbrechen. Im Salon dominieren Möbel von Living Divani.

La casa entera se caracteriza por la moderación cromática y las aperturas rectangulares de las paredes con las que se interrumpen sus líneas generales. En el salón predominan los muebles de Living Divani.

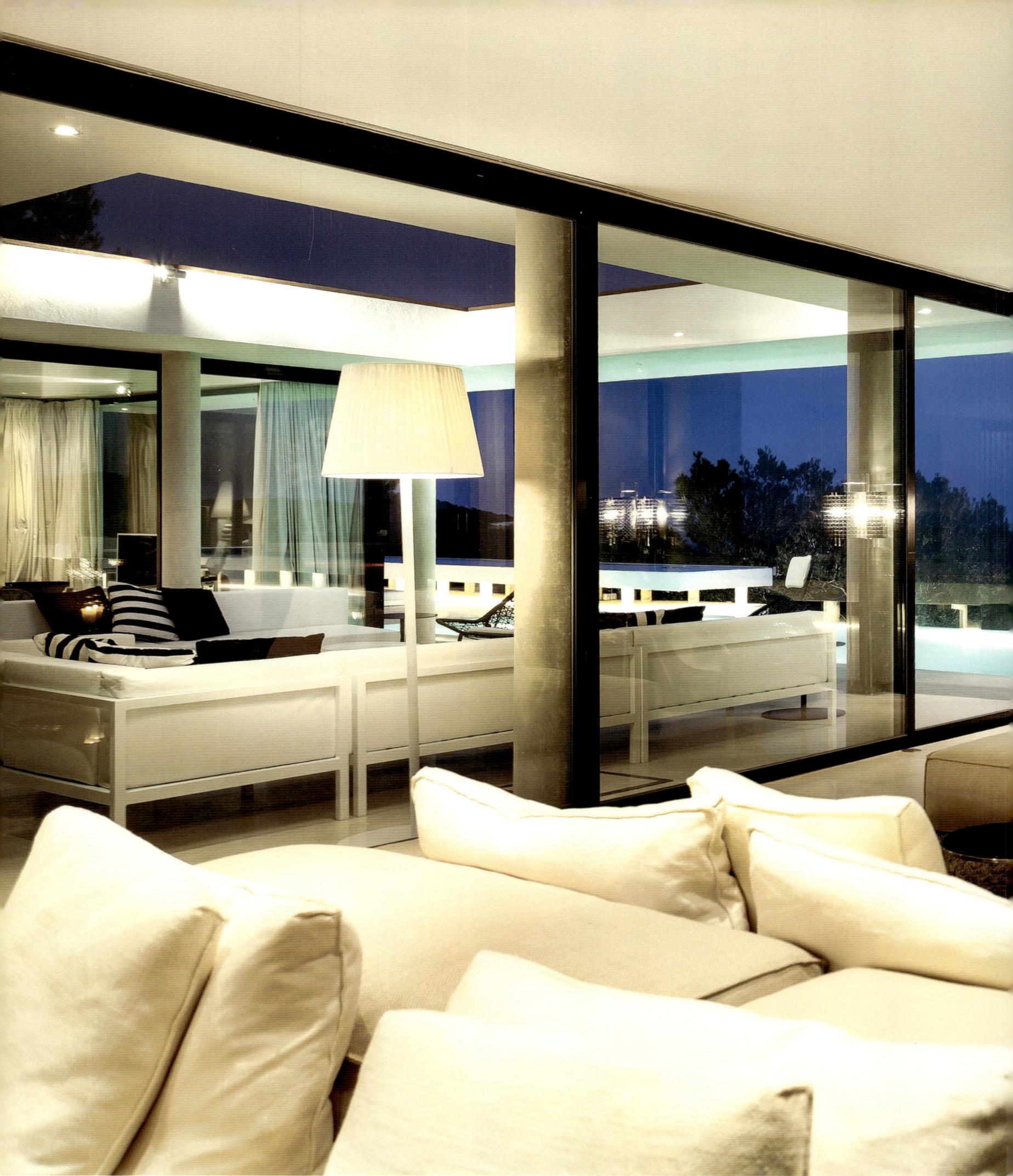

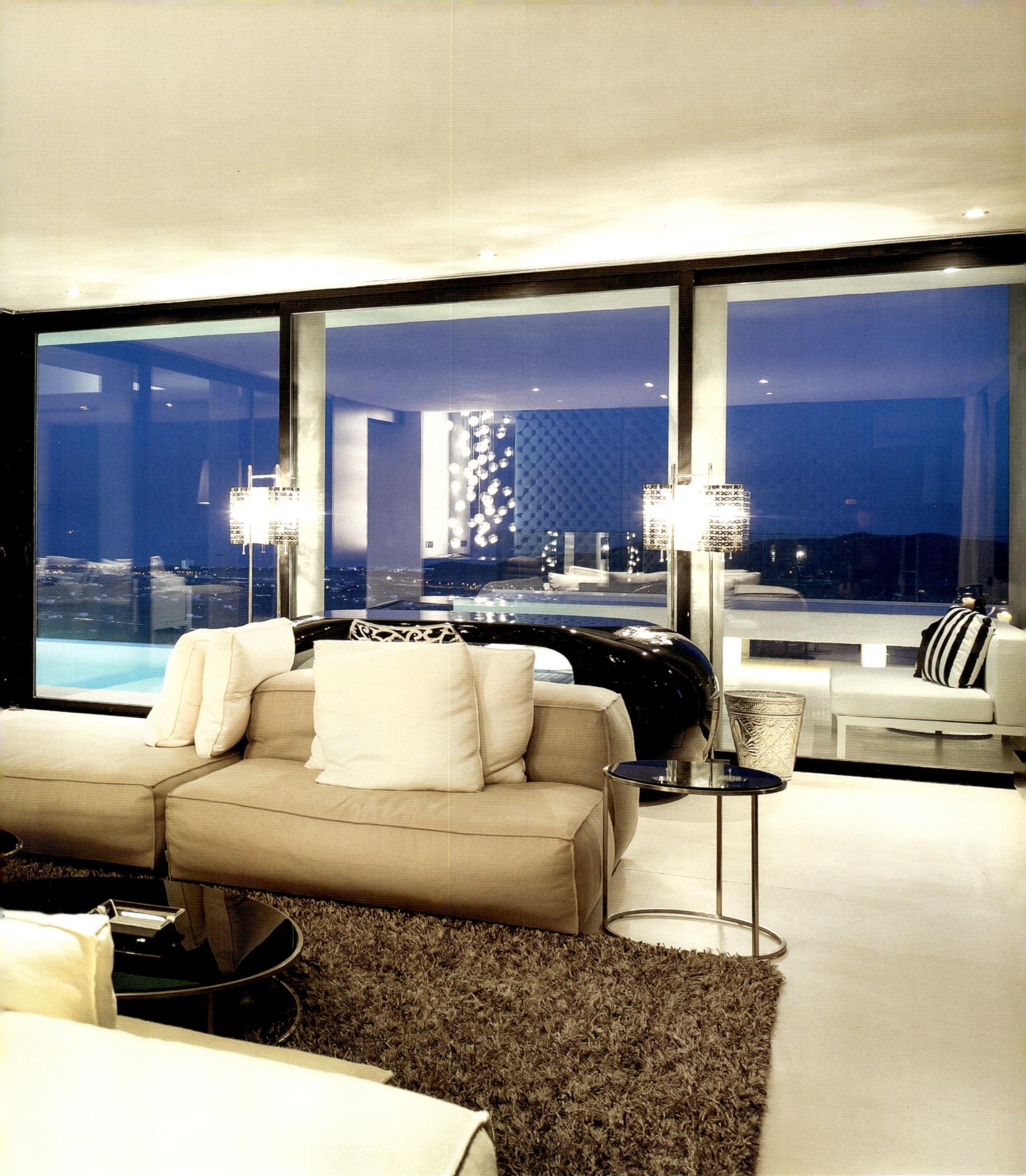

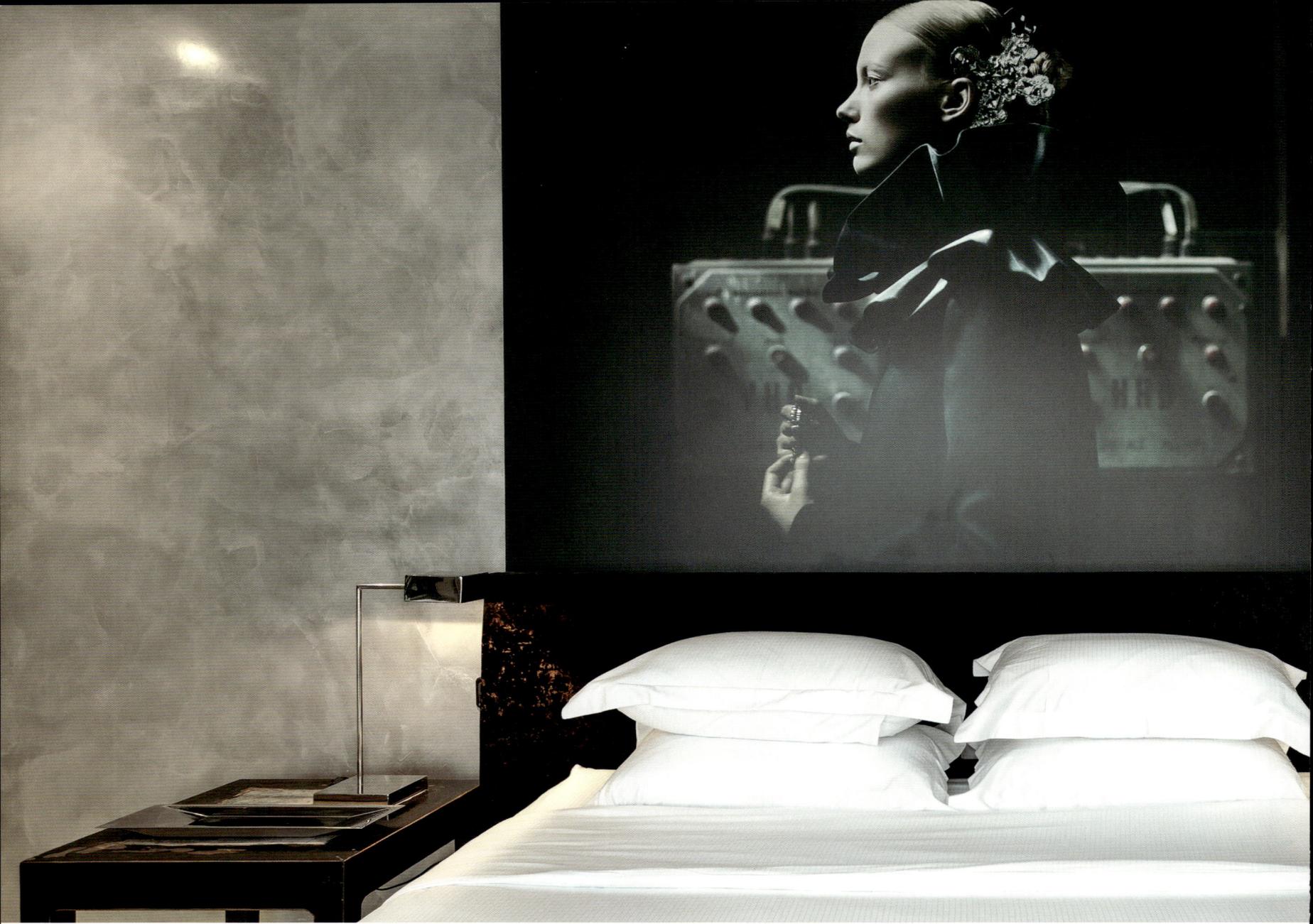

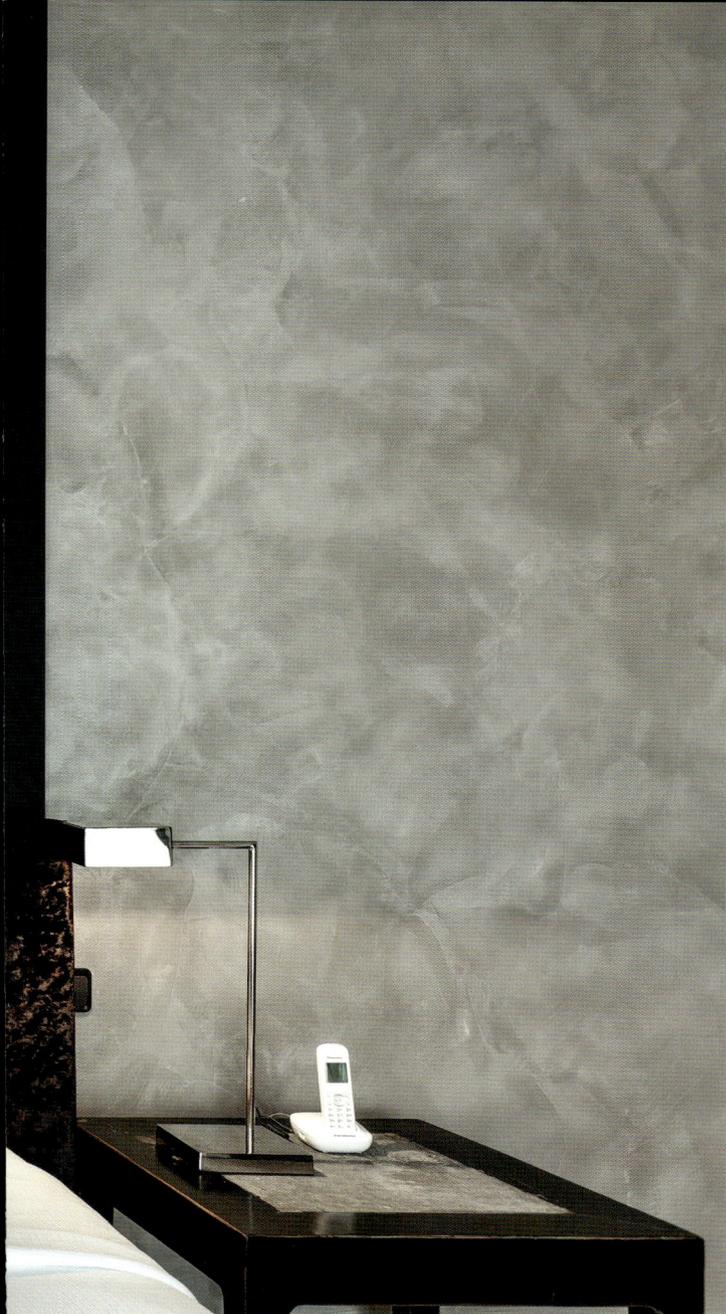

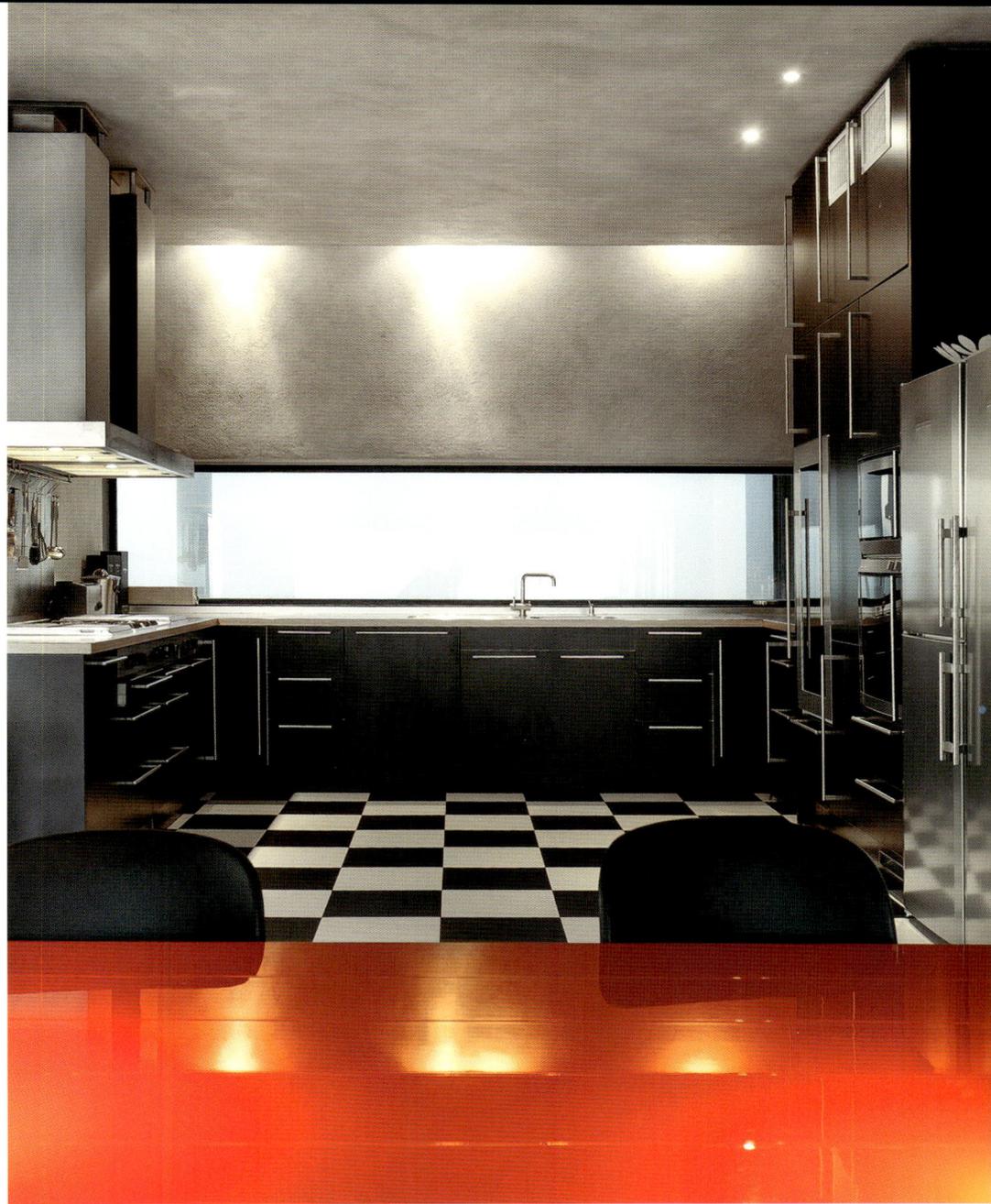

A dining table just outside the ultramodern Alpes Inox kitchen is painted the original Ferrari red, providing the only splash of bold color. Microcement lines the bathroom and bedroom walls.

Einziger kräftiger Farbakzent: der Esstisch vor der ultramodernen Alpes-Inox-Küche ist im original Ferrari-Rot lackiert. Mikrozement an den Wänden der Bäder und Schlafzimmer.

La mesa lacada en rojo Ferrari ante la ultra moderna cocina de acero inoxidable de Alpes aporta una pincelada de color. Microcemento en las paredes de baños y dormitorios.

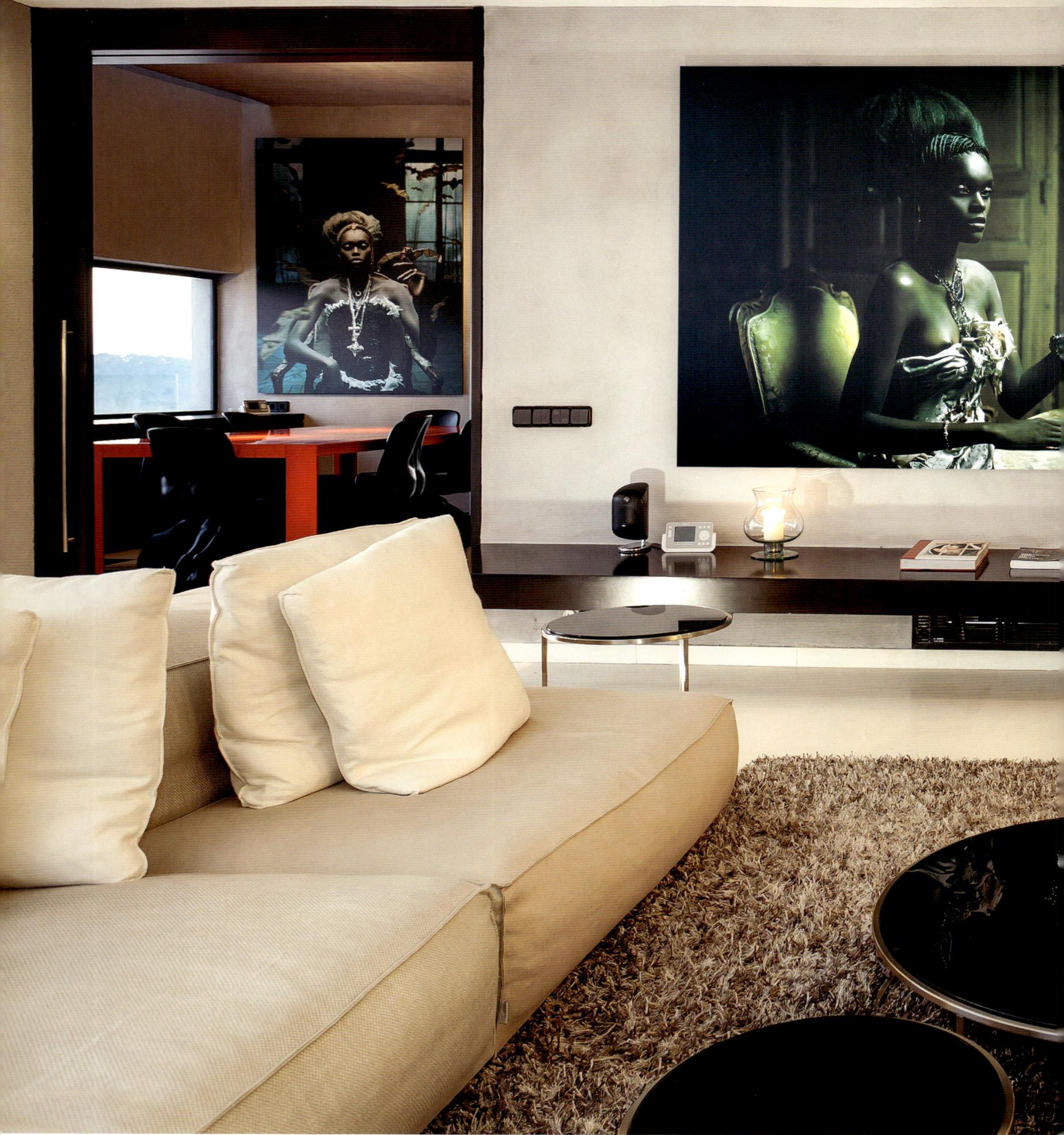

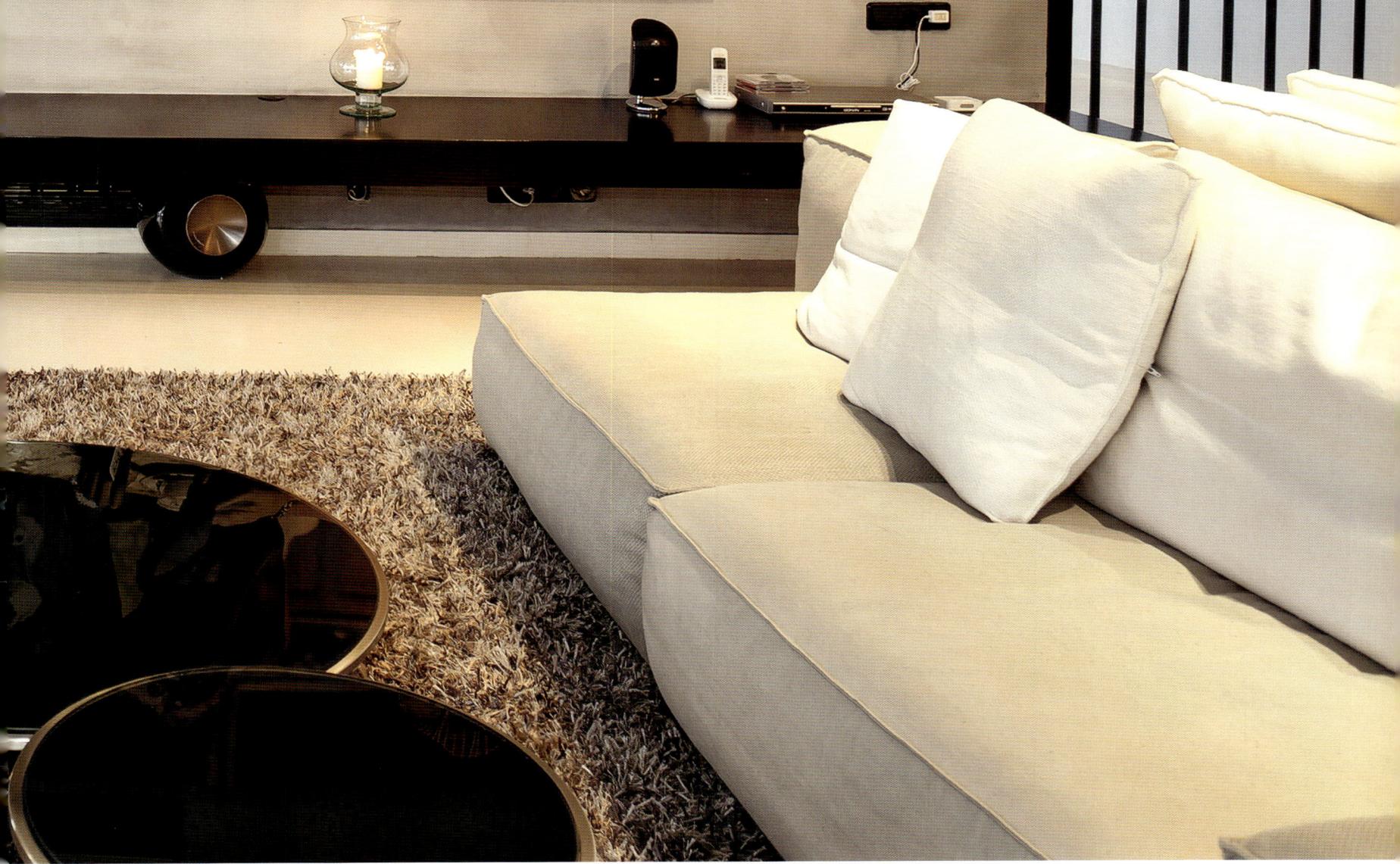

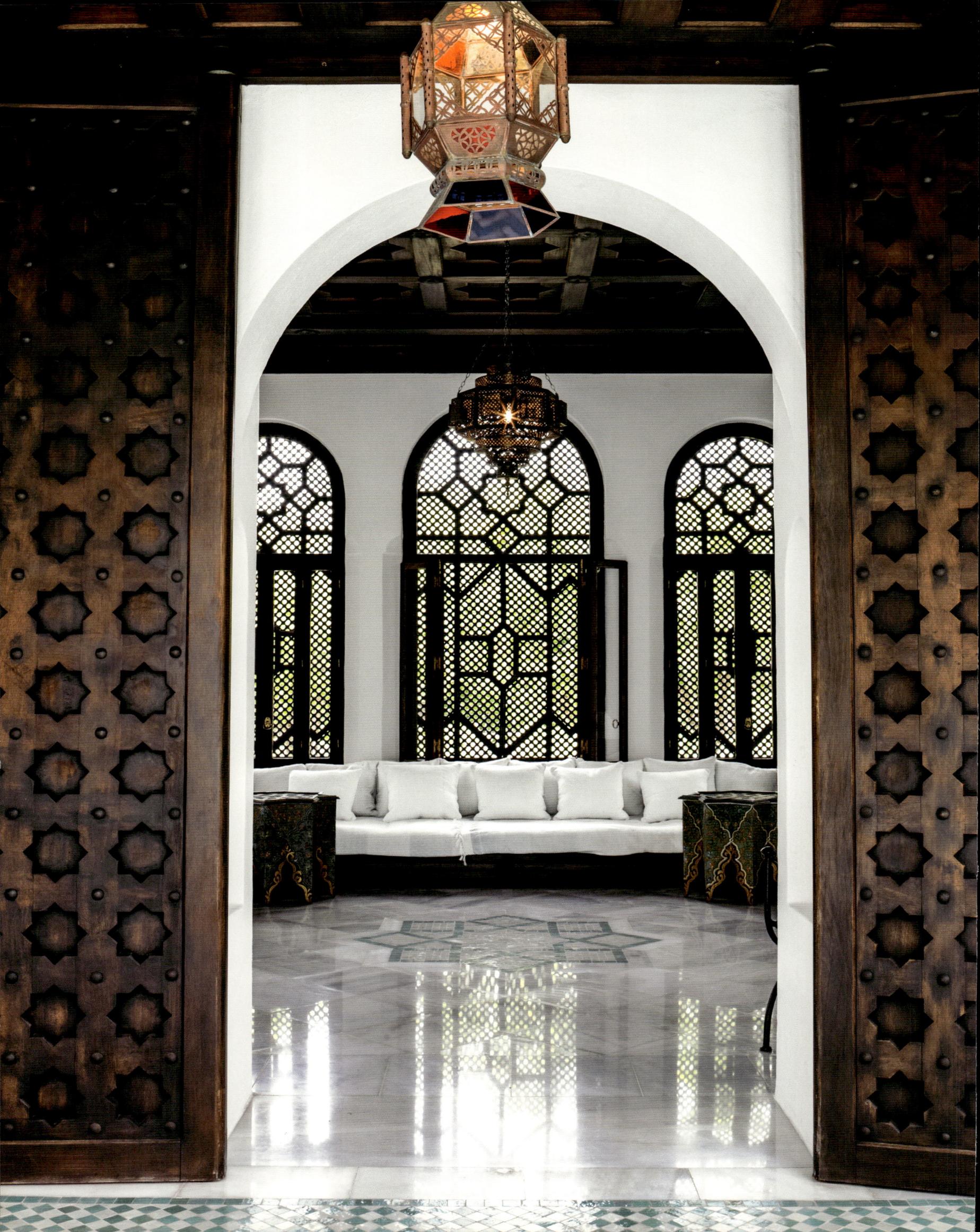

# Alhambra

BUILT IN THE style of a Moroccan palace, but modeled on a mosque in Zabid, Yemen, the house rises from the crest of Mount San Lorenzo in central Ibiza. The main villa is shaped like a cross and has a typical Moorish fountain bubbling at its center, symbolizing a home's abundance and prosperity. All rooms converge on the central courtyard and its 39-by-16-foot pool. A wooden bridge leads to a domed tea house in a small pond, which provides an especially romantic setting for the many weddings held here. Beyond the tea house lie the traditional Moorish gardens with their characteristic, rectangular hedges and orange trees in the shape of lollipops.

DAS HAUS IM marokkanischen Palaststil erhebt sich auf der Spitze des San-Lorenzo-Berges in der Mitte Ibizas. Als Kopie einer Moschee in Zabid in Jemen bildet der Hauptteil der Villa ein Kreuz, in dessen Mittelpunkt ein typisch maurischer Brunnen plätschert – das Symbol für Überfluss und Wohlstand eines Hauses. Der zentrale Innenhof mit einem Pool von 12 mal 5 Metern ist der Platz, der alle Räume des Hauses verbindet. Ein Teehaus, das man über eine hölzerne Brücke erreicht, liegt in einem kleinen Teich. Dieser besonders romantische Platz wird häufig für Hochzeiten genutzt. Von hier gelangt man auch zu den traditionellen maurischen Gärten mit ihren charakteristischen rechteckigen Hecken und Orangenbäumen in Lollipop-Form.

EN EL CENTRO DE Ibiza, sobre la cumbre del monte de San Lorenzo, se alza una casa con aire de palacete marroquí. Copia de una mezquita en Zabid (Yemén), la parte principal de la residencia forma una cruz, en cuyo centro murmulla plácidamente una fuente típicamente morisca, símbolo de la opulencia en una casa. El patio central está dotado de una piscina de 12 x 5 m, el punto en el que confluyen las habitaciones de la casa. En el centro de un pequeño estanque se alza una casita de té de techo picudo, a la que se accede a través de una pasarela. Se trata de un espacio especialmente romántico, en el que a menudo se celebran bodas. Desde aquí puede entrarse también en los jardines, típicamente magrebíes, de setos rectangulares y naranjos redondeados.

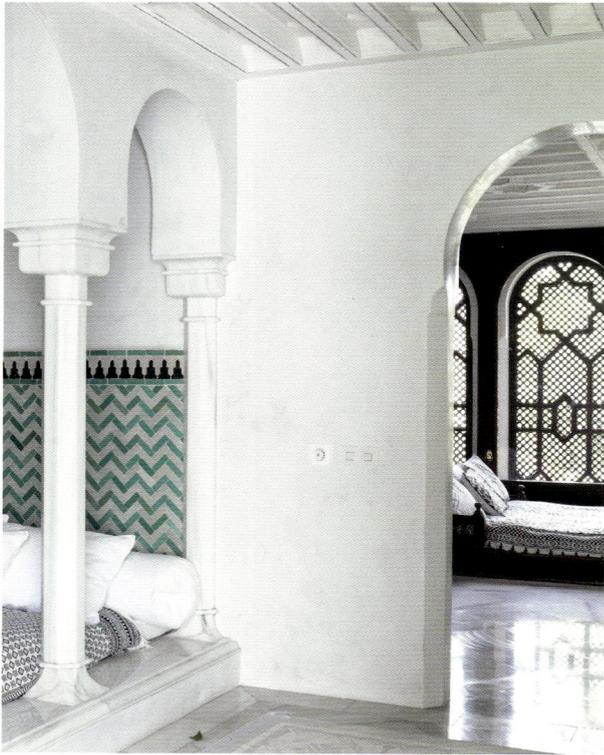

All the rooms in the home converge on the central courtyard, whose fountain is bathed in an ethereal light in the evening.

*Alle Wohnräume laufen auf den zentralen Innenplatz mit Brunnen zu, der abends in ein märchenhaftes Licht getaucht ist.*

*Todos los espacios habitables de la casa convergen en el patio interior de la fuente, bañado de noche por una iluminación que invita a soñar.*

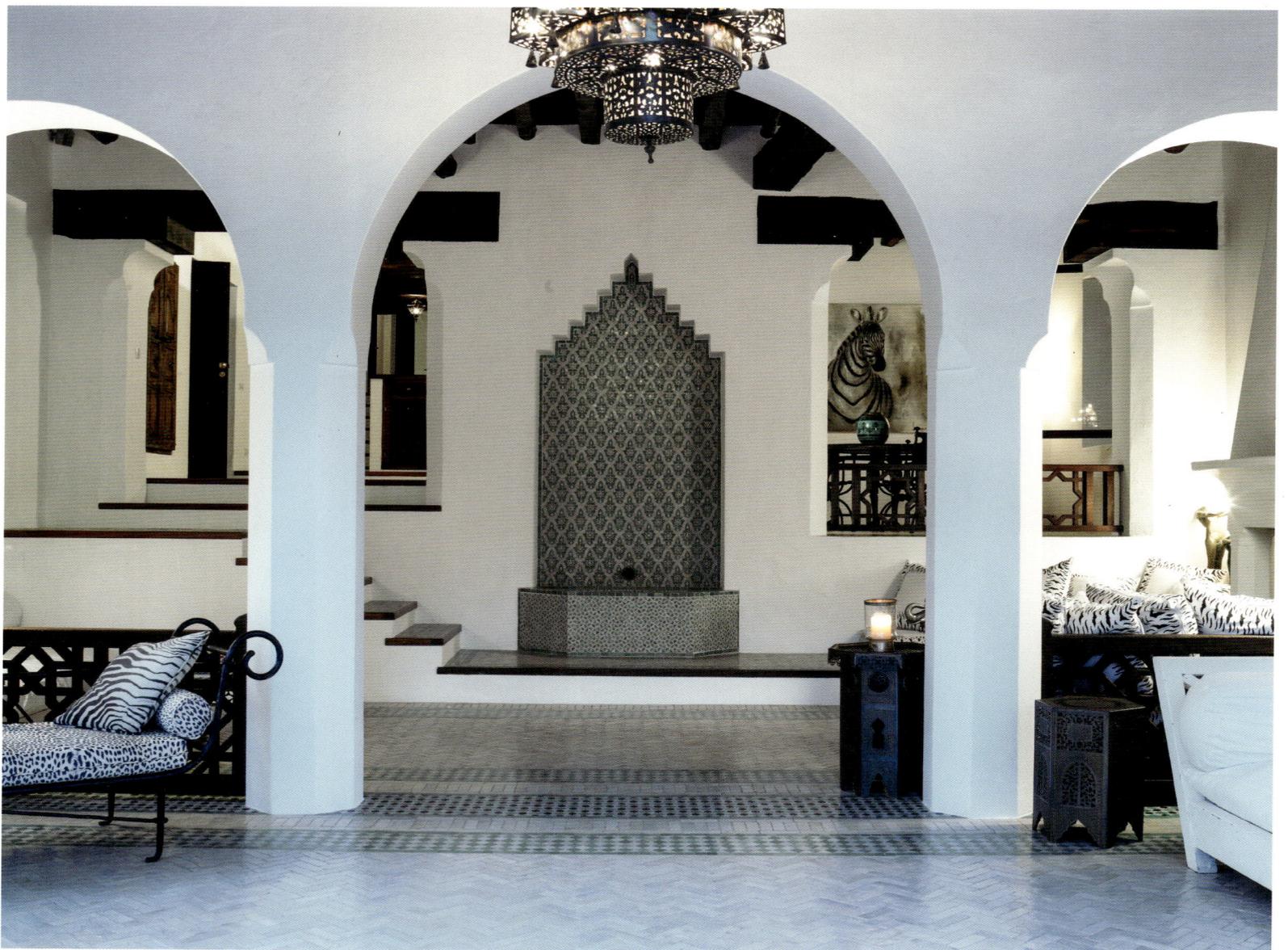

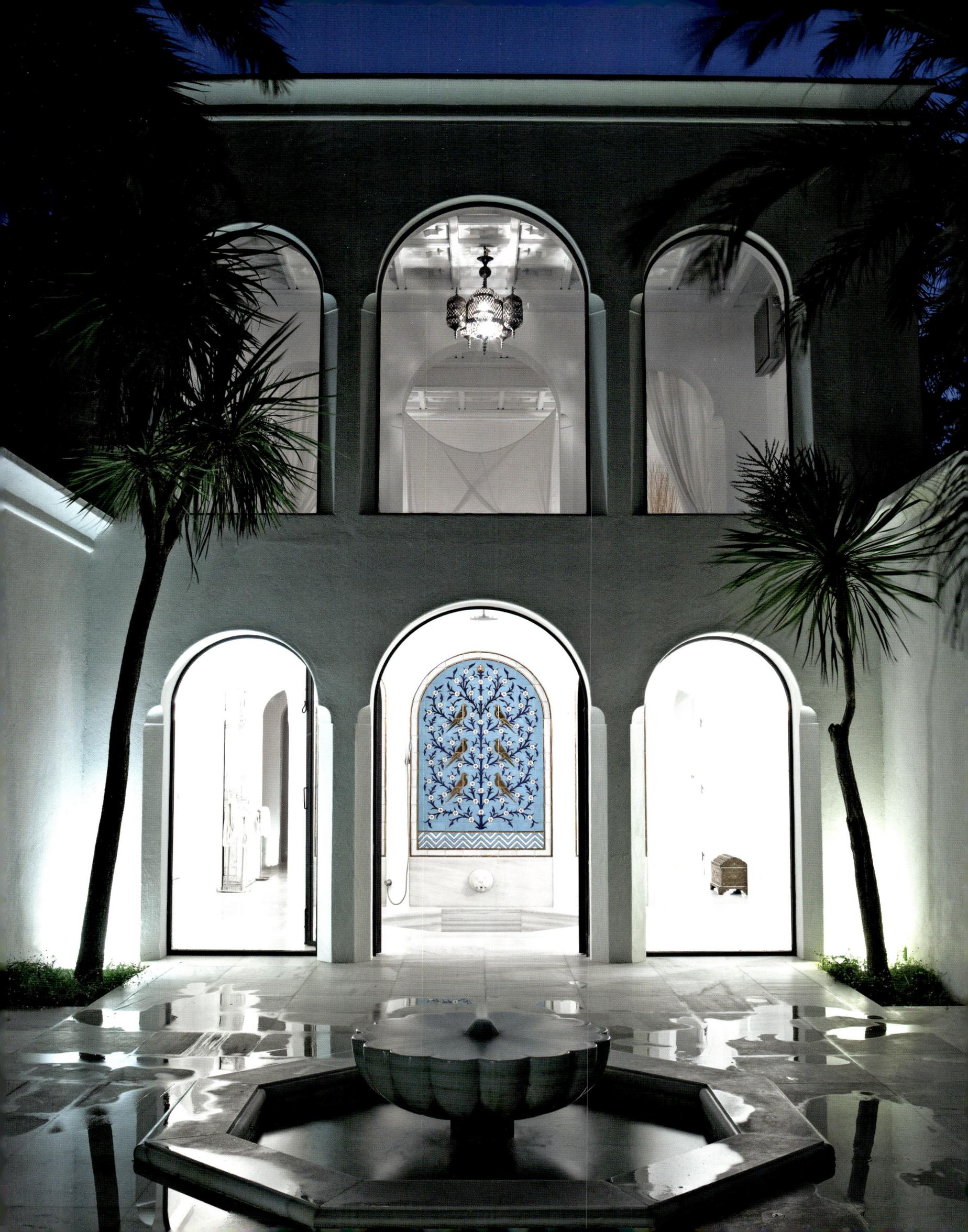

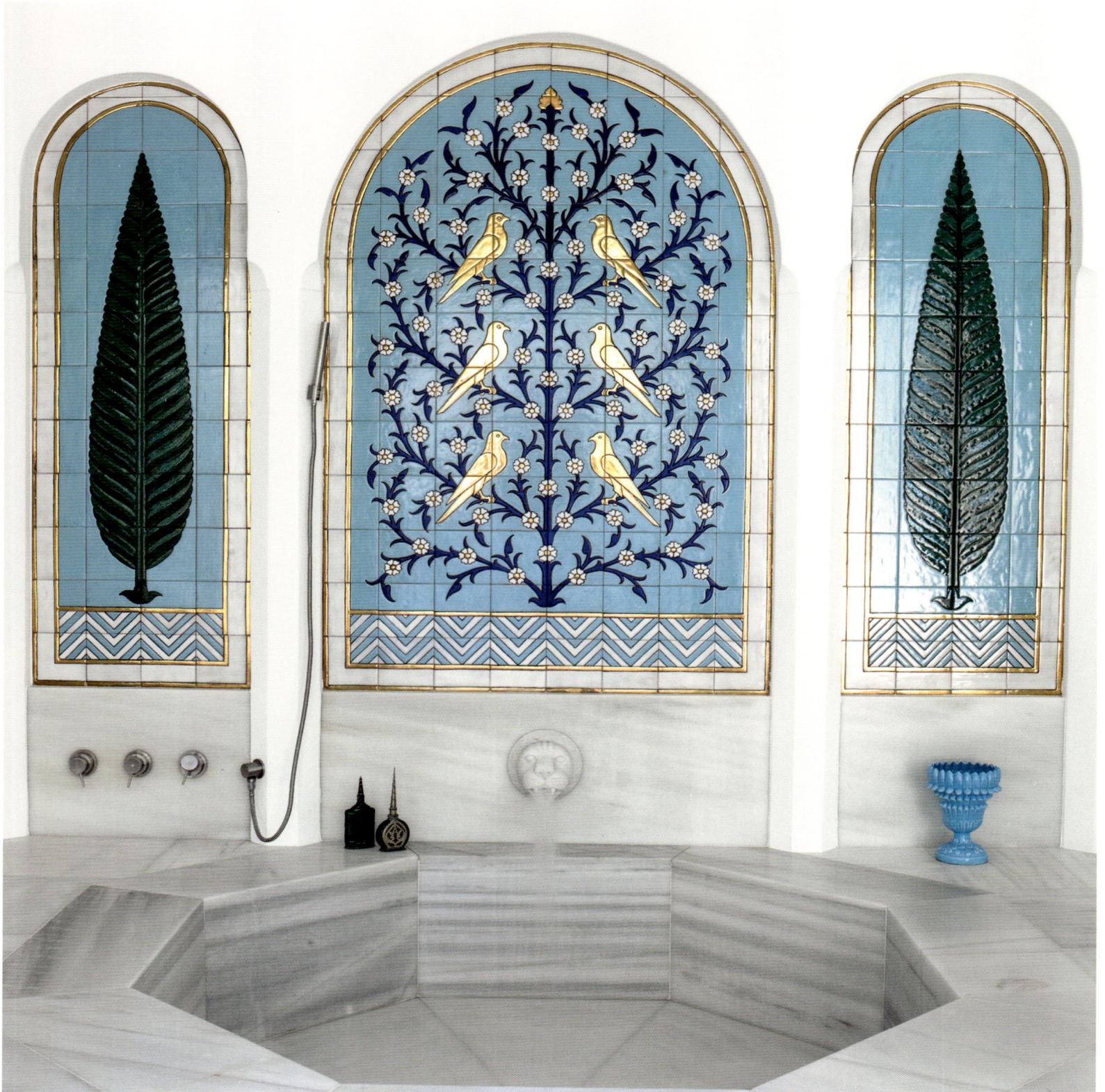

The in-house marble hamam is framed by typical Moorish mosaics in the home's signature turquoise color.

Der hauseigene Marmorhamam wird von typisch maurischen Mosaiken eingerahmt, die die türkise Signaturfarbe des Hauses aufgreifen.

El hamam de la casa está enmarcado en mosaicos típicamente moriscos en los que se prolonga el característico color turquesa de la casa del conjunto.

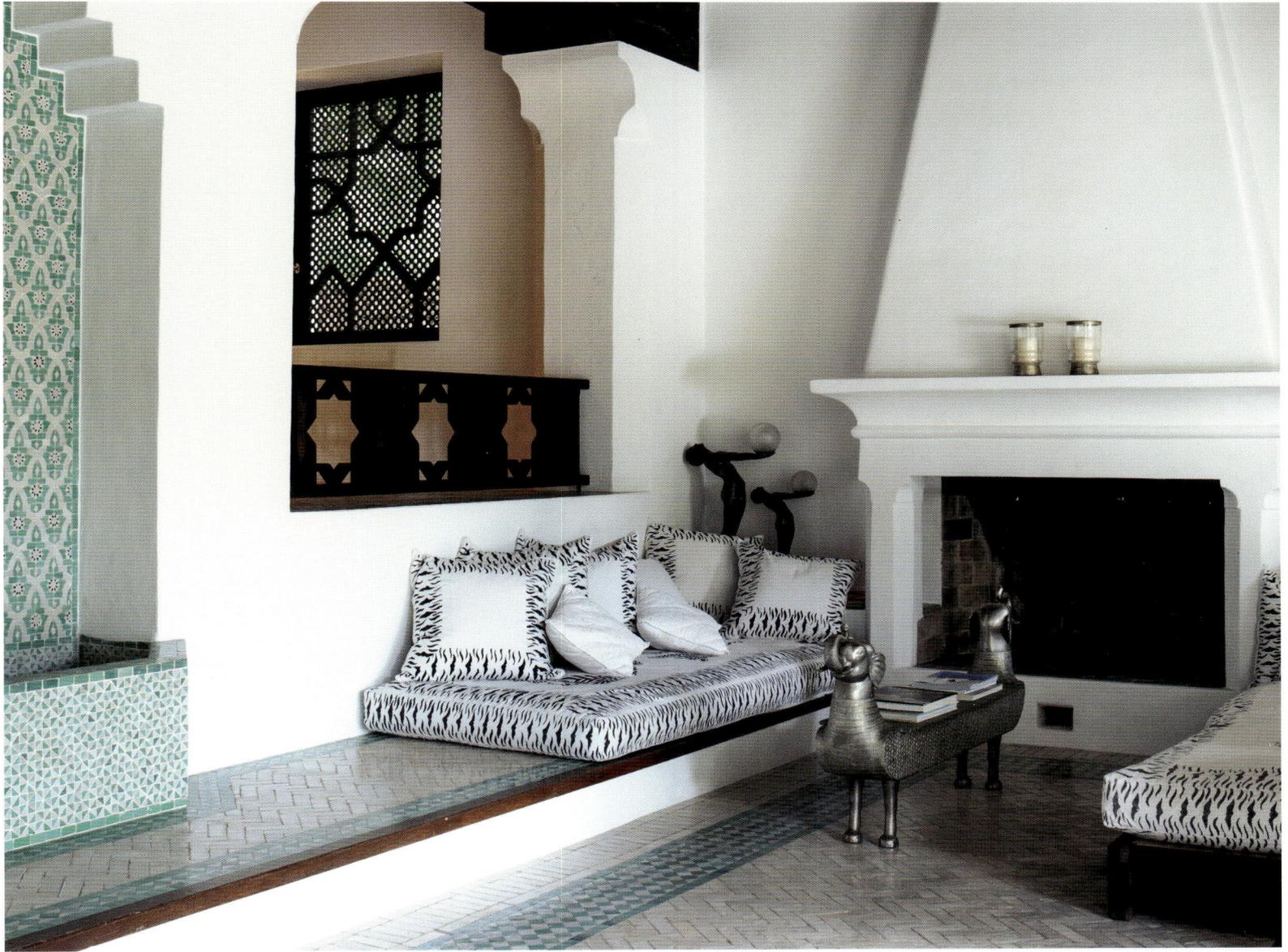

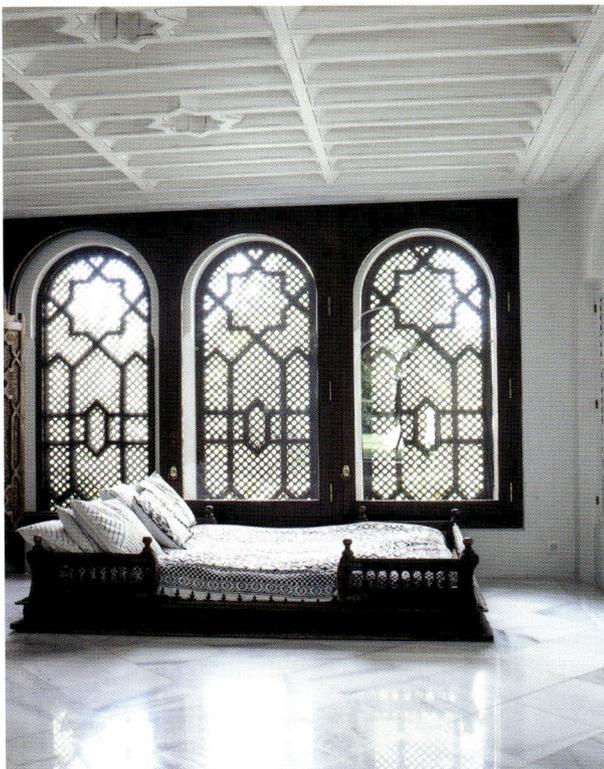

Traditional Moroccan décor elements set the mood in the fireplace nook as well as in the other rooms.

*In der Kaminecke bestimmen – ebenso wie in den anderen Räumen – traditionelle marokkanische Stilelemente das Ambiente.*

*En el rincón de la chimenea, al igual que en el resto de la casa, diversos elementos marroquíes definen el ambiente.*

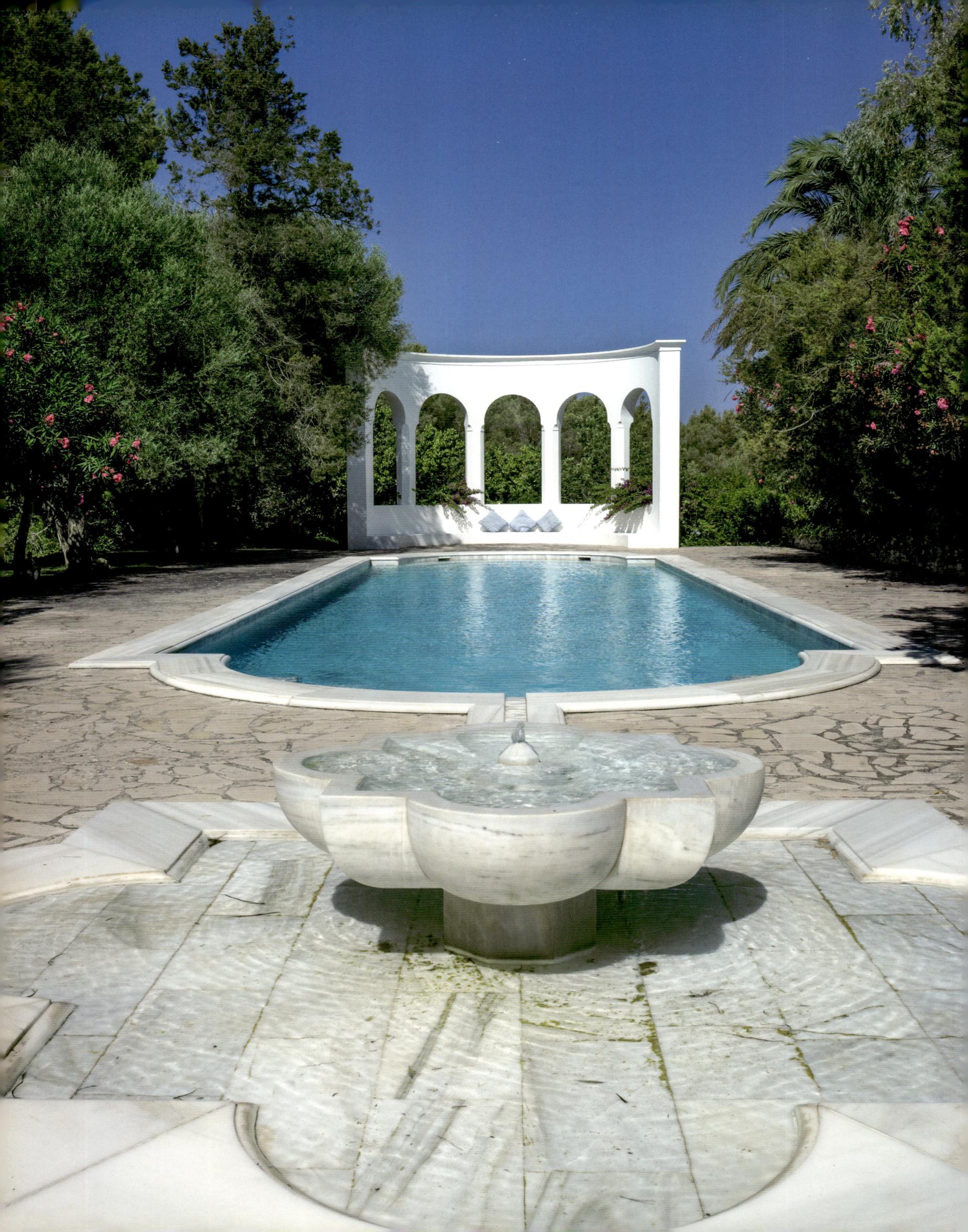

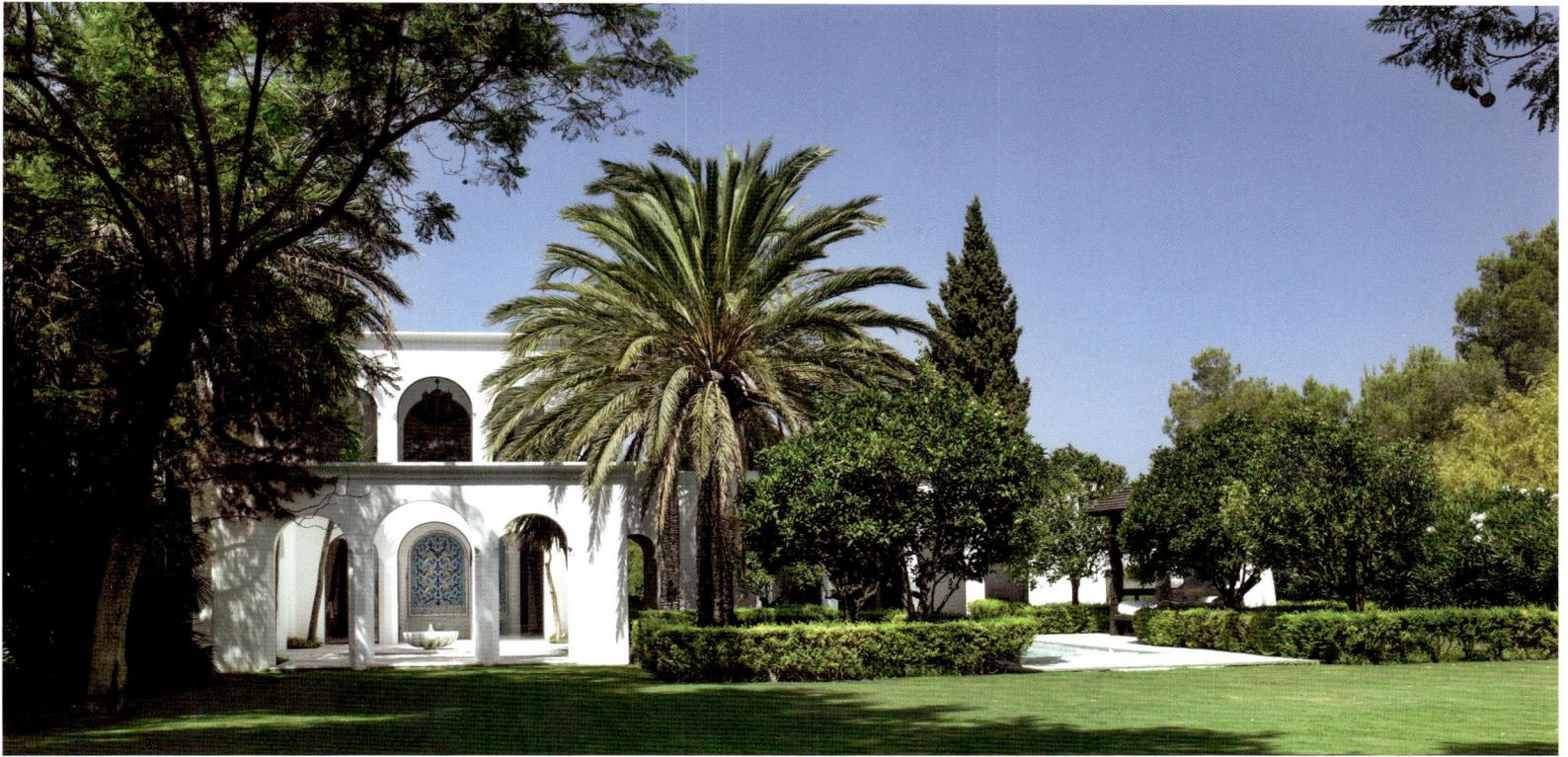

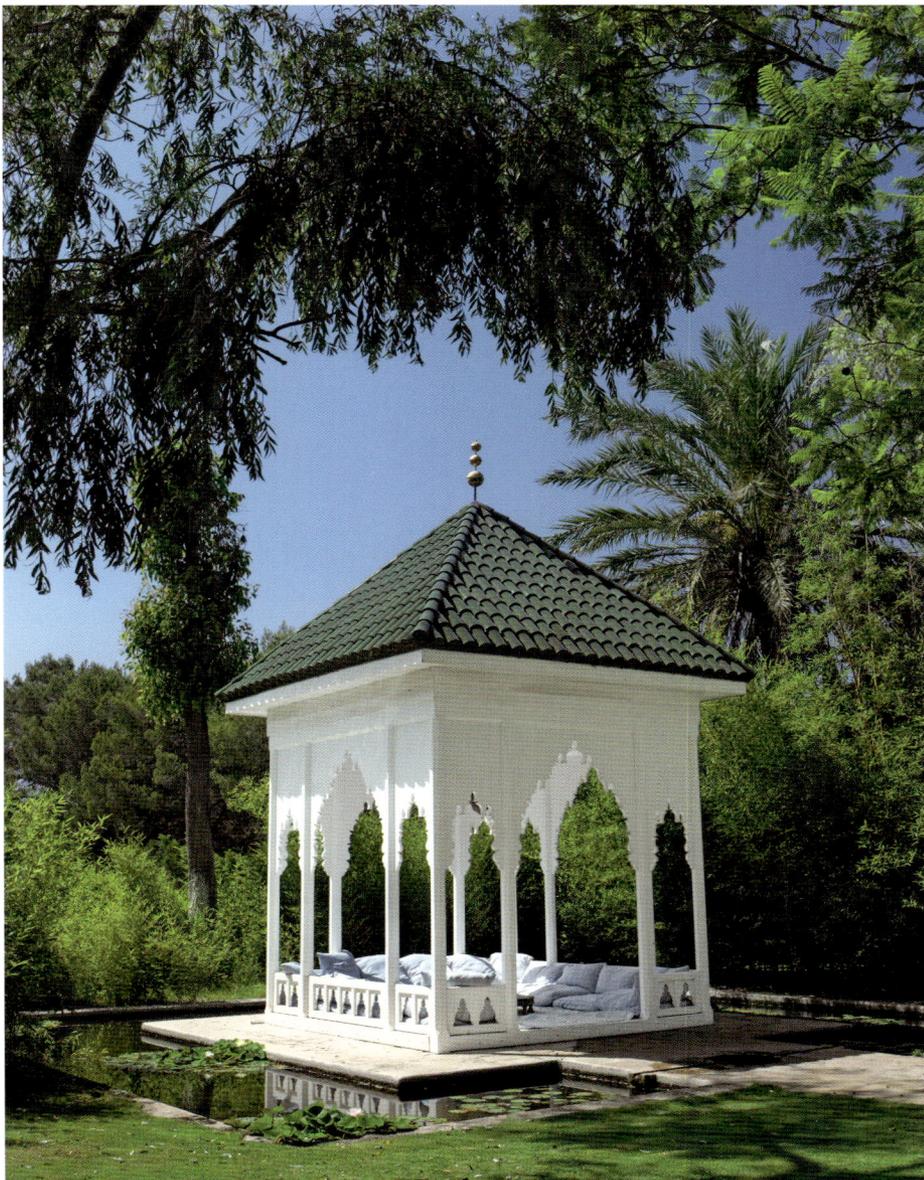

Moorish architectural structures lend an exotic atmos-
phere to the outdoor areas. The small tea house in the
center of a pond is the perfect place for a romantic tryst,
and the water bubbling forth from the marble fountain
symbolizes the source of life.

Maurisch anmutende Architekturstrukturen prägen die
Atmosphäre der Außenanlagen. Das kleine Teehaus im
See bietet einen romantischen Rückzugsort und der
Marmorbrunnen steht mit seinem Wasser als Symbol für
die Quelle des Lebens.

Diversos elementos arquitectónicos moriscos marcan
el tono de las instalaciones exteriores. La casita de té
junto al estanque ofrece un romántico espacio en el que
abstraerse de todo, y el agua que fluye de la fuente de
mármol es símbolo del manantial de la vida.

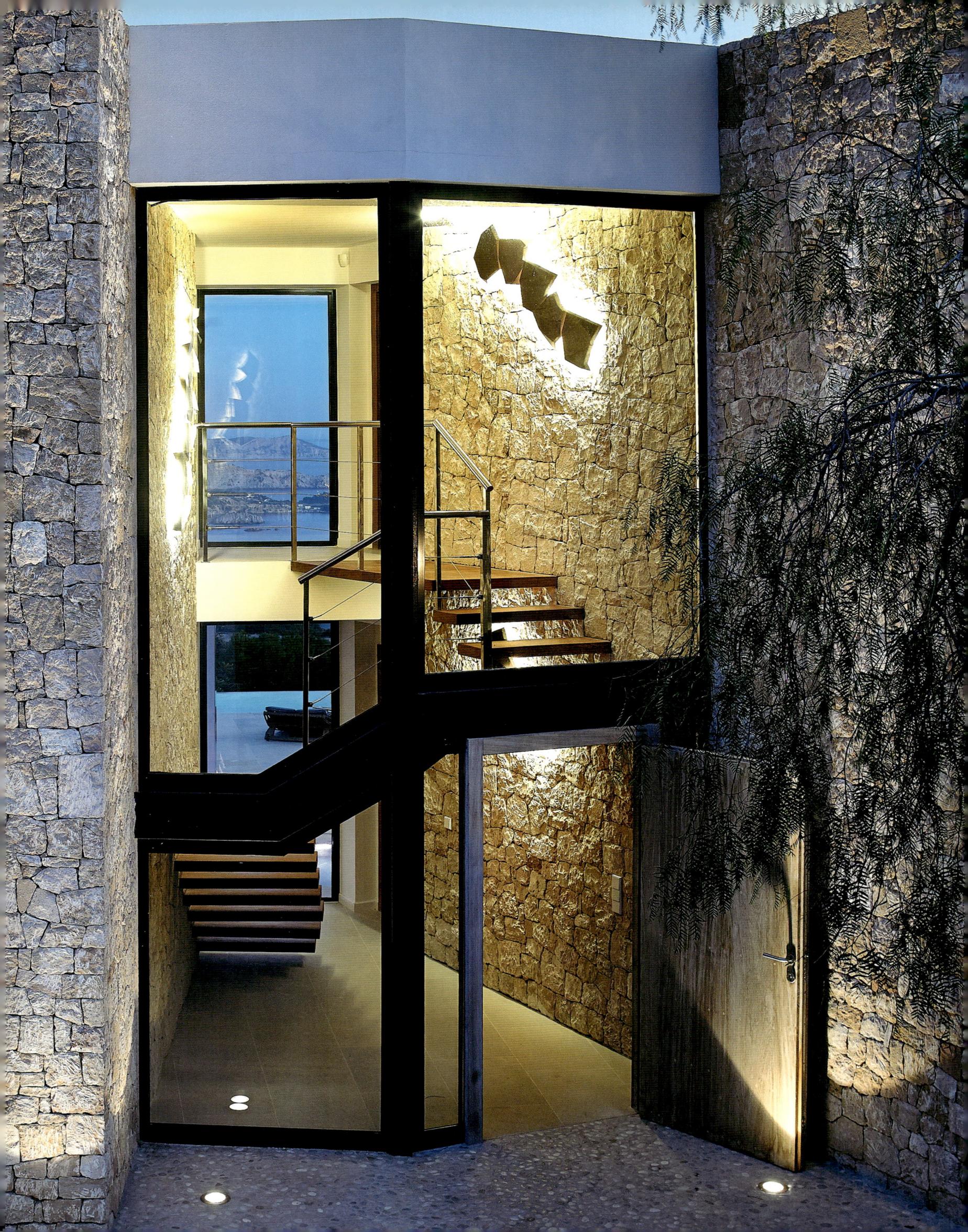

# Can ByG

IN THE 1970s, when the owners built this modern house with its minimalist design, they focused on the natural surroundings, ocean view, and garden rather than on the building itself. The home's location, embedded in the natural beauty of Es Cubells on the island's southern coast, clinched their decision to build here. The interior design is as minimalist as the exterior, and yet the colors and materials create a warm and homey atmosphere. Most of the building materials are traditional to the island, including natural stone and native wood. Designed by Jaime Serra Verdaguer, the building offers an ocean view that feels like an oil painting, whose tonality changes with the position of the sun, depending on the season and time of day. All the trees and plants in the gardens are native to the island.

BEIM BAU DIESES modern-minimalistischen Hauses standen für die Besitzer die Natur, der Meerblick sowie der Garten im Vordergrund und nicht das Gebäude selbst. Als es in den 1970er-Jahren in Es Cubells im Süden der Insel errichtet wurde, spielte die in die Natur eingebettete Lage die Hauptrolle. Die Inneneinrichtung ist ebenfalls minimalistisch, vermittelt aber durch ihre Farben und die Materialwahl Wärme und Wohnlichkeit. Alle Materialien sind größtenteils traditionelle Baustoffe der Insel, wie Natursteine und Hölzer. Das Gebäude ist ein Entwurf von Jaime Serra Verdaguer und die Aussicht aufs Wasser wirkt wie ein Gemälde, dessen Tonalität sich mit dem Stand der Sonne je nach Jahres- und Tageszeit verändert. In den Gartenbereichen finden sich nur Bäume und Pflanzen, die für die Insel typisch sind.

A LA HORA de construir esta casa, minimalista y moderna, los propietarios quisieron ceder protagonismo a la naturaleza, las vistas marinas y el jardín, situando el edificio en un discreto segundo plano. Fue erigida en Es Cubells, en el sur de la isla, en la década de 1970, con la idea de realzar su privilegiada ubicación en plena naturaleza. El interiorismo es igualmente minimalista, pero los materiales y colores escogidos destilan un aire confortable y acogedor. Todos los materiales, como madera y piedra, son los tradicionales de la isla. El edificio es un diseño de Jaime Serra Verdaguer, y las vistas sobre las aguas se antojan casi un cuadro, cuyas tonalidades varían en función de la posición del sol y dela estación del año. El jardín alberga exclusivamente plantas y árboles propios de la isla.

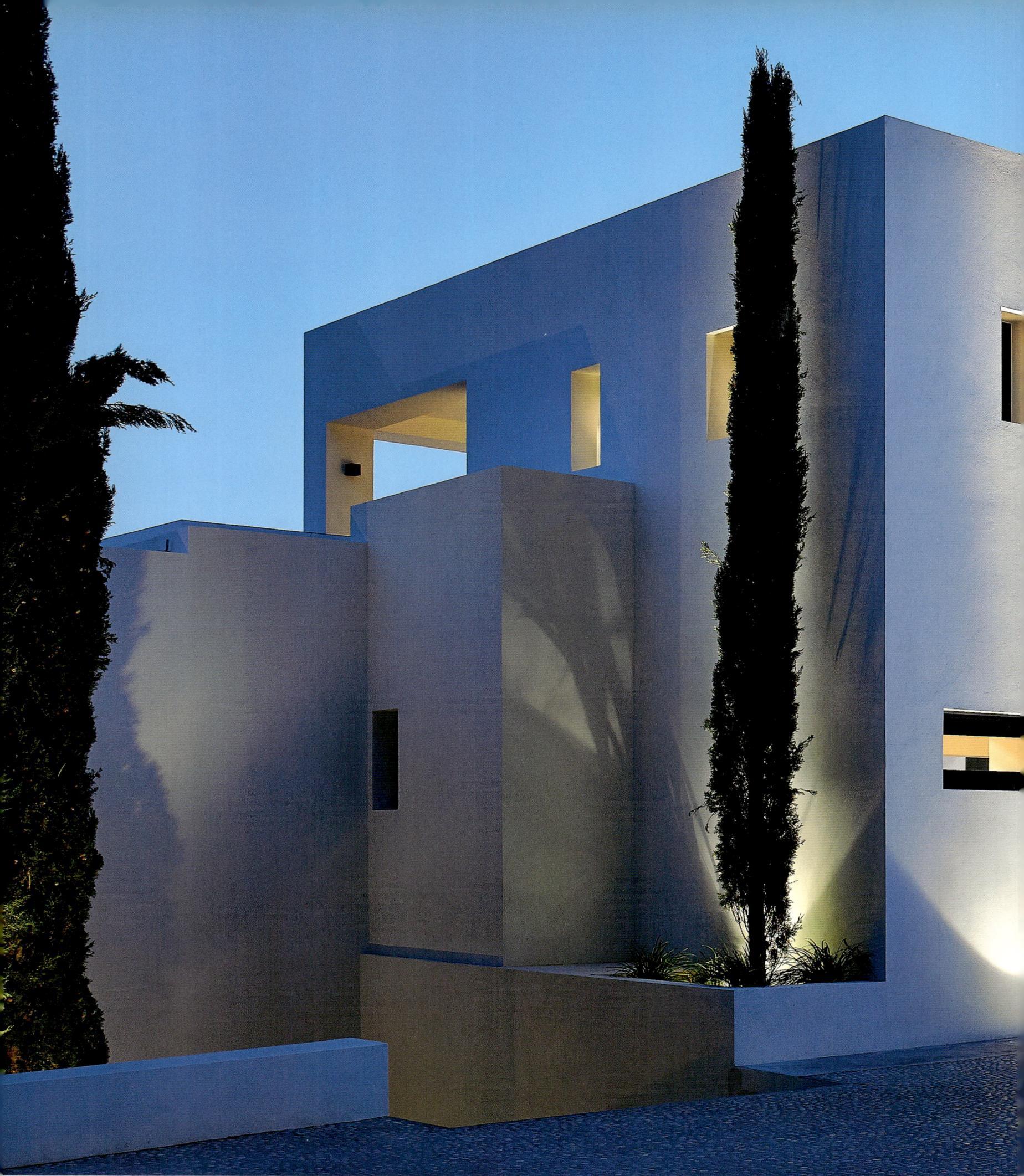

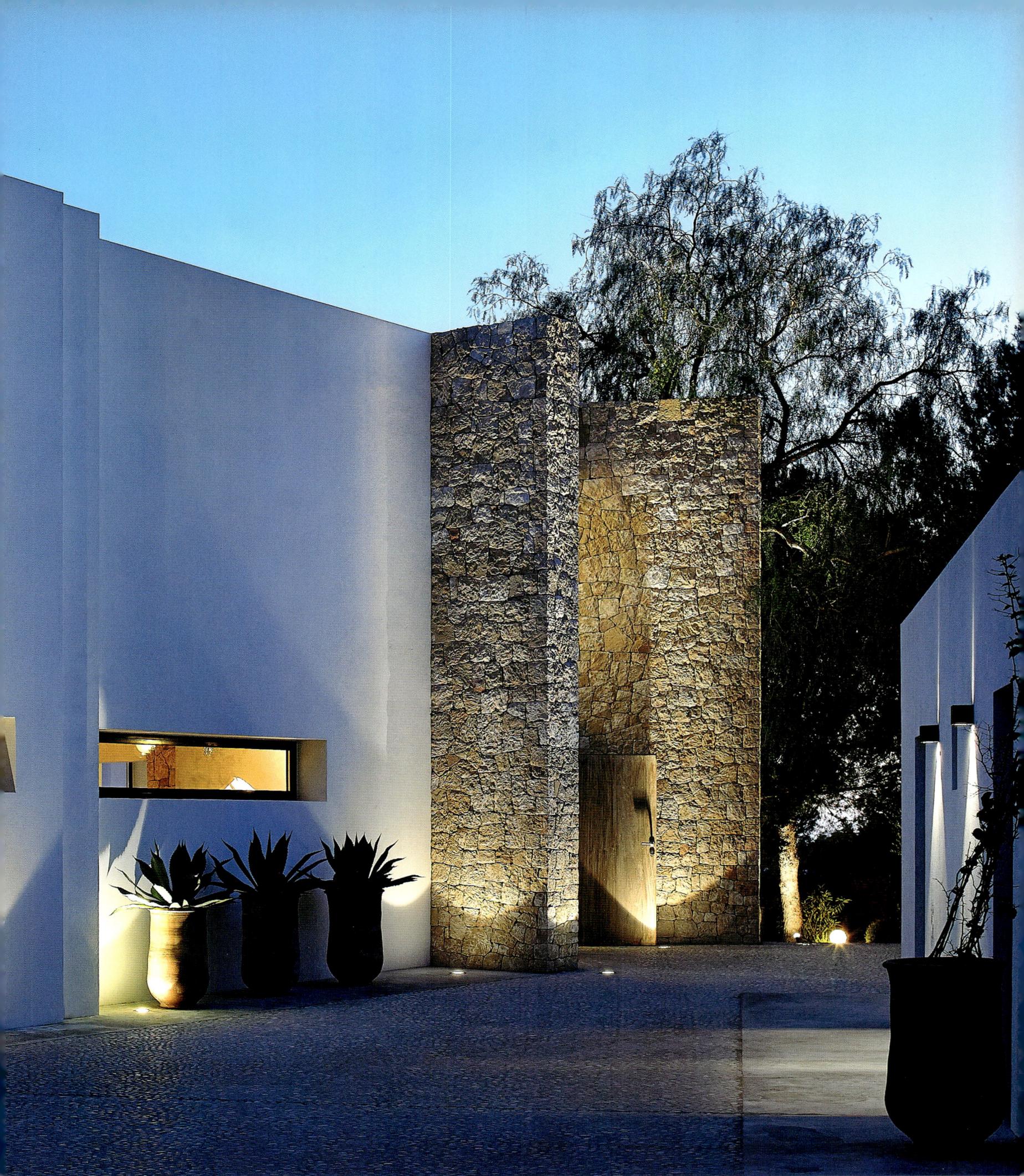

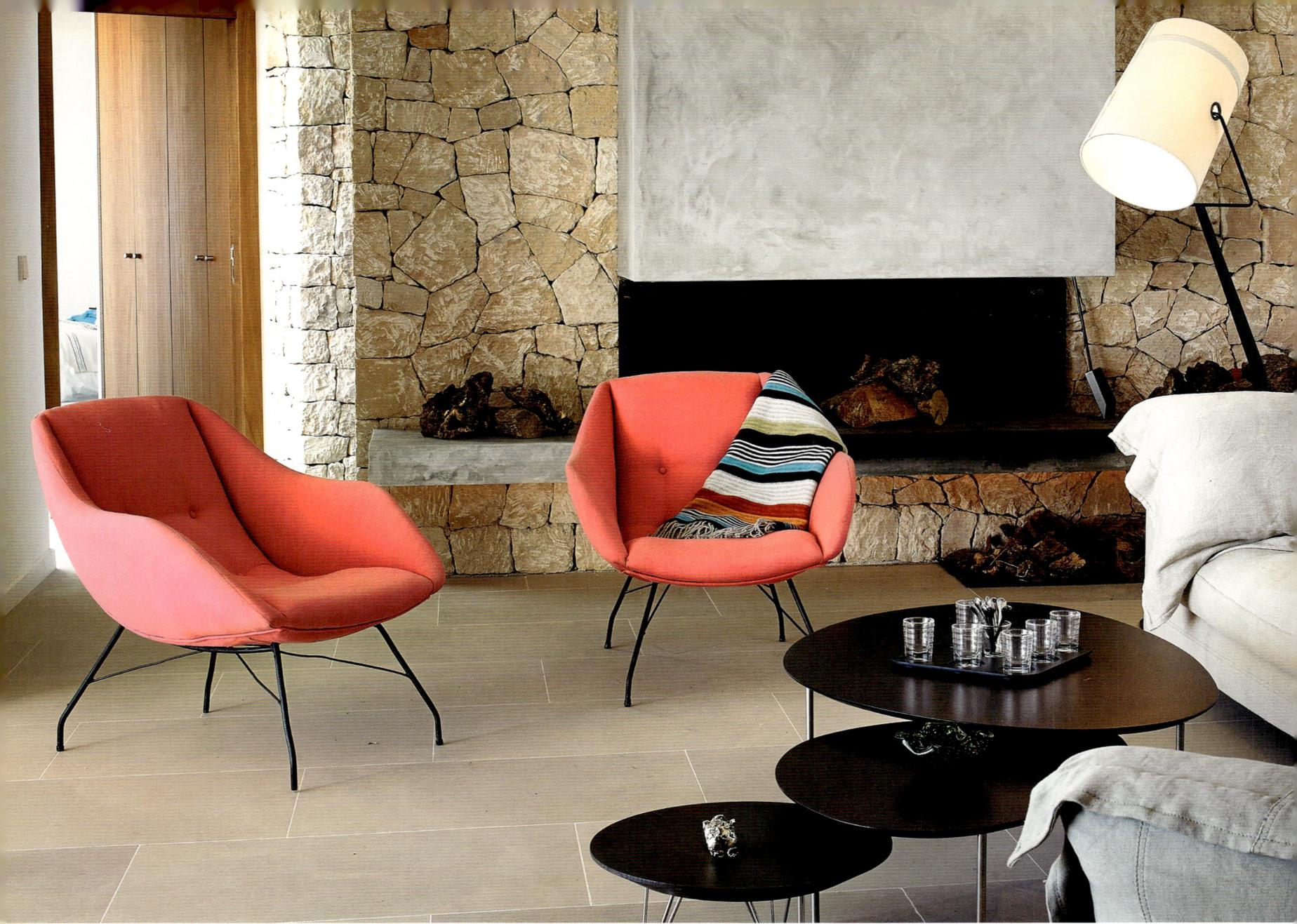

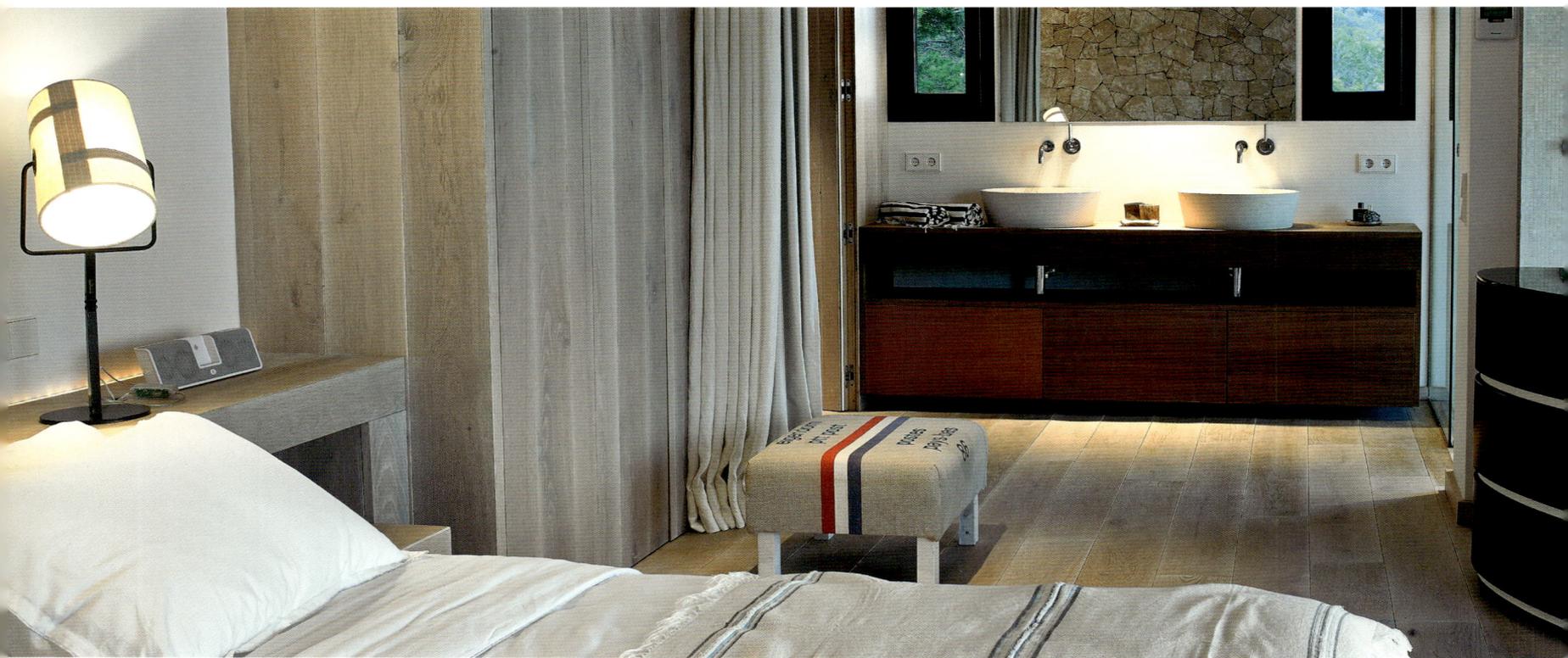

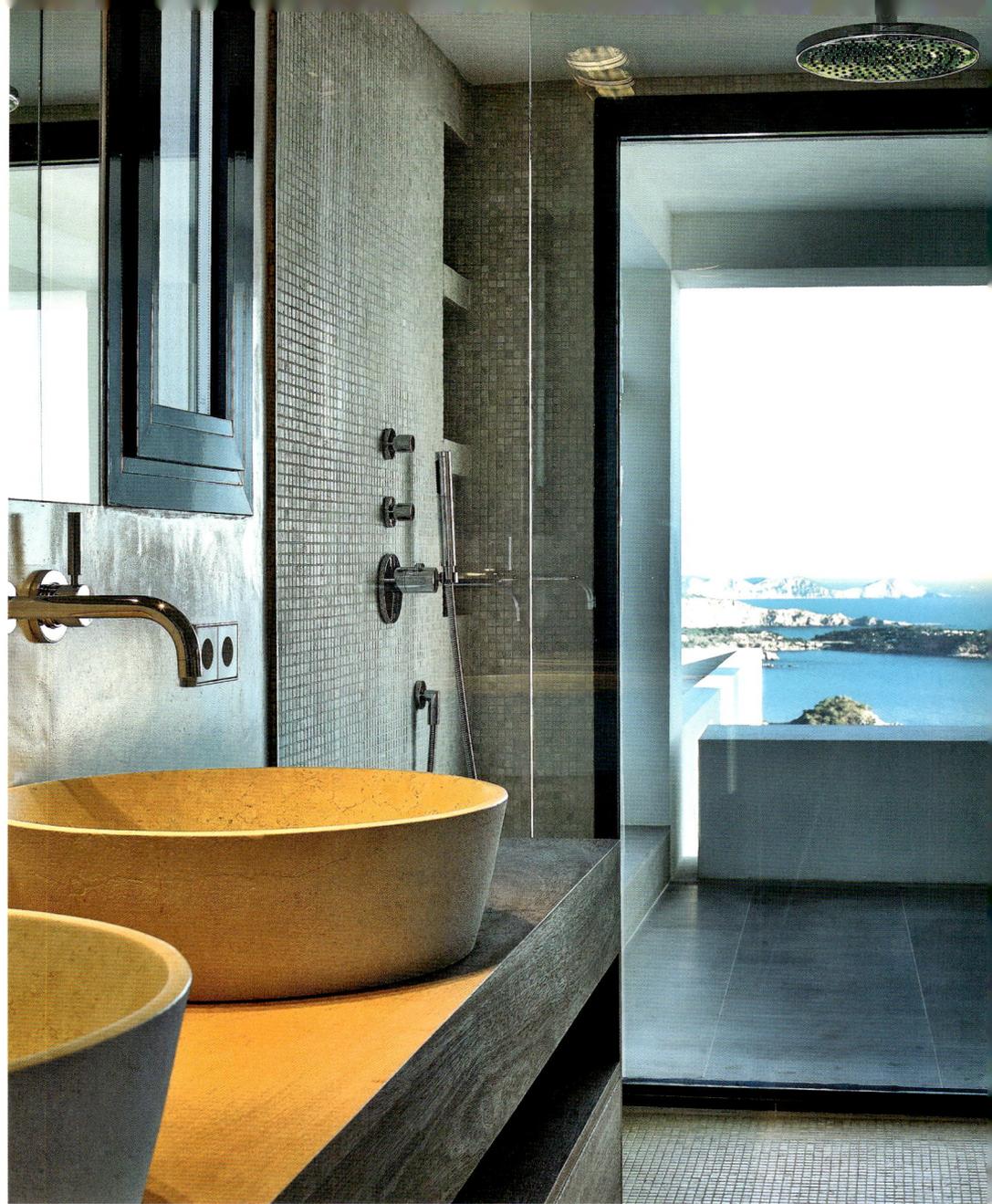

The living areas express a minimalist design vocabulary. The bathroom adjoining the master bedroom has a warm wood interior and an ocean view.

*Minimalistische Formensprache in den Wohnbereichen. An den Masterbedroom angrenzendes Bad mit warmem Holzinterieur und Meerblick.*

*Lenguaje formal minimalista en las áreas comunes. El baño contiguo al dormitorio cuenta con un cálido interior enmaderado y vistas al mar.*

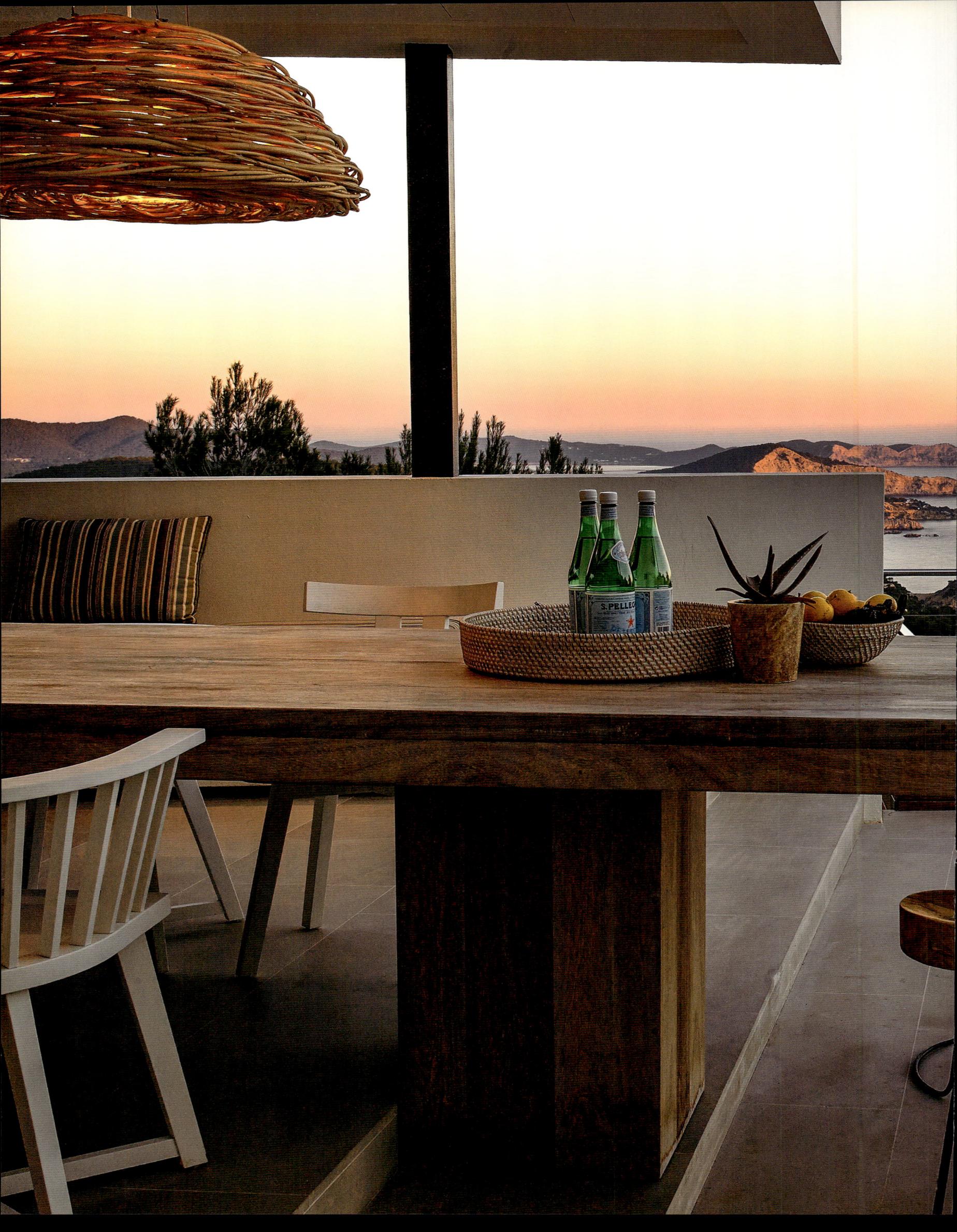

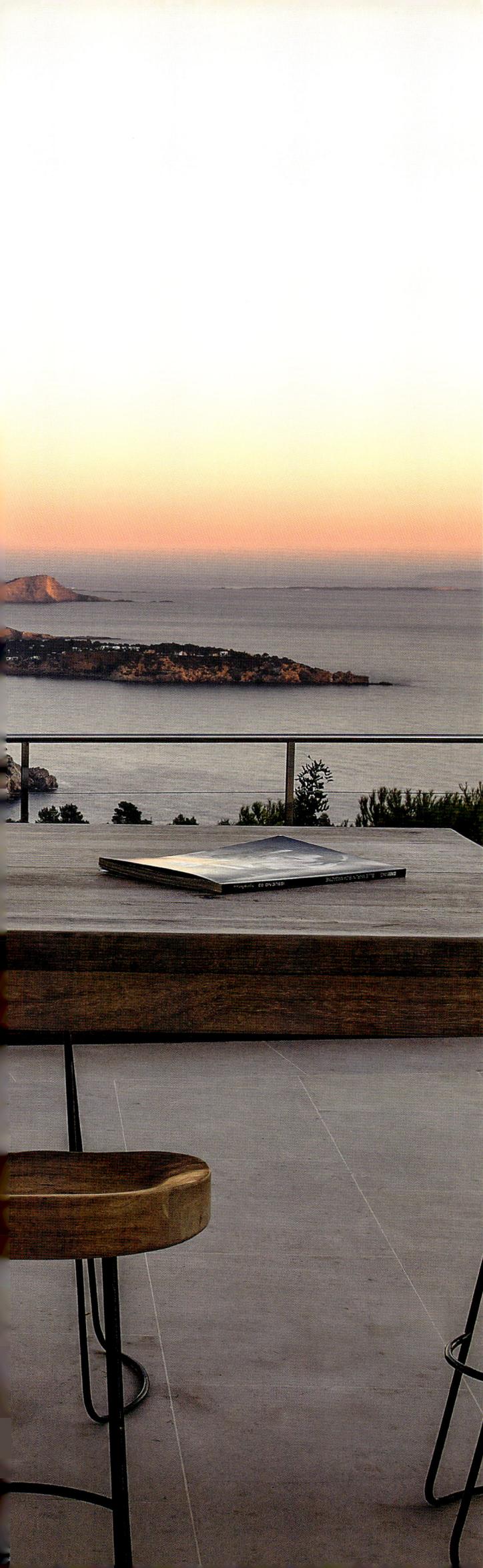

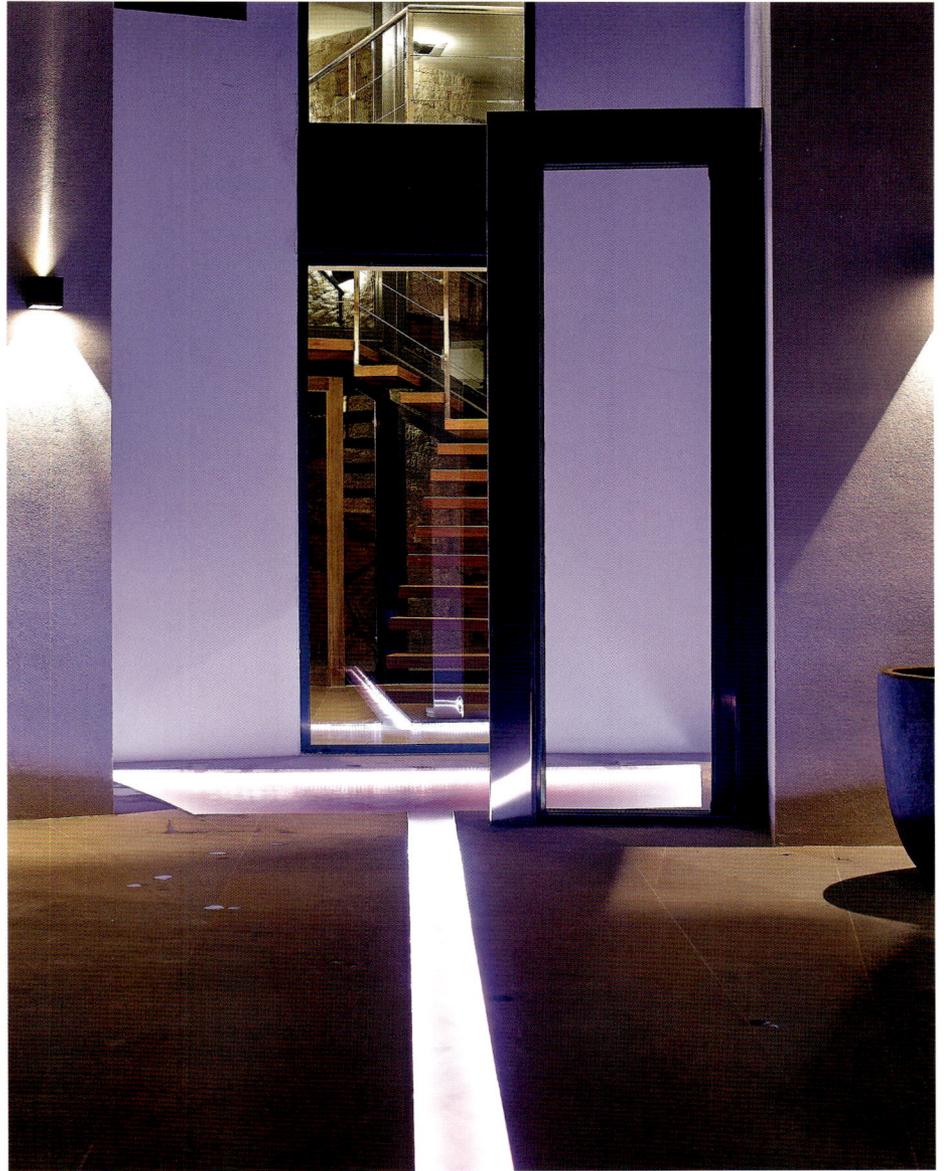

The massive wooden dining table offers spectacular vistas. Openings in the walls and light effects give the architecture a transparent appearance.

*Massiver Holzesstisch mit spektakulärem Weitblick. Durchbrüche und Lichteffekte lassen die Architektur transparent erscheinen.*

*Espectacular panorámica la que se ofrece desde la mesa maciza del comedor. Diversas aperturas y efectos de iluminación confieren cierta transparencia al conjunto.*

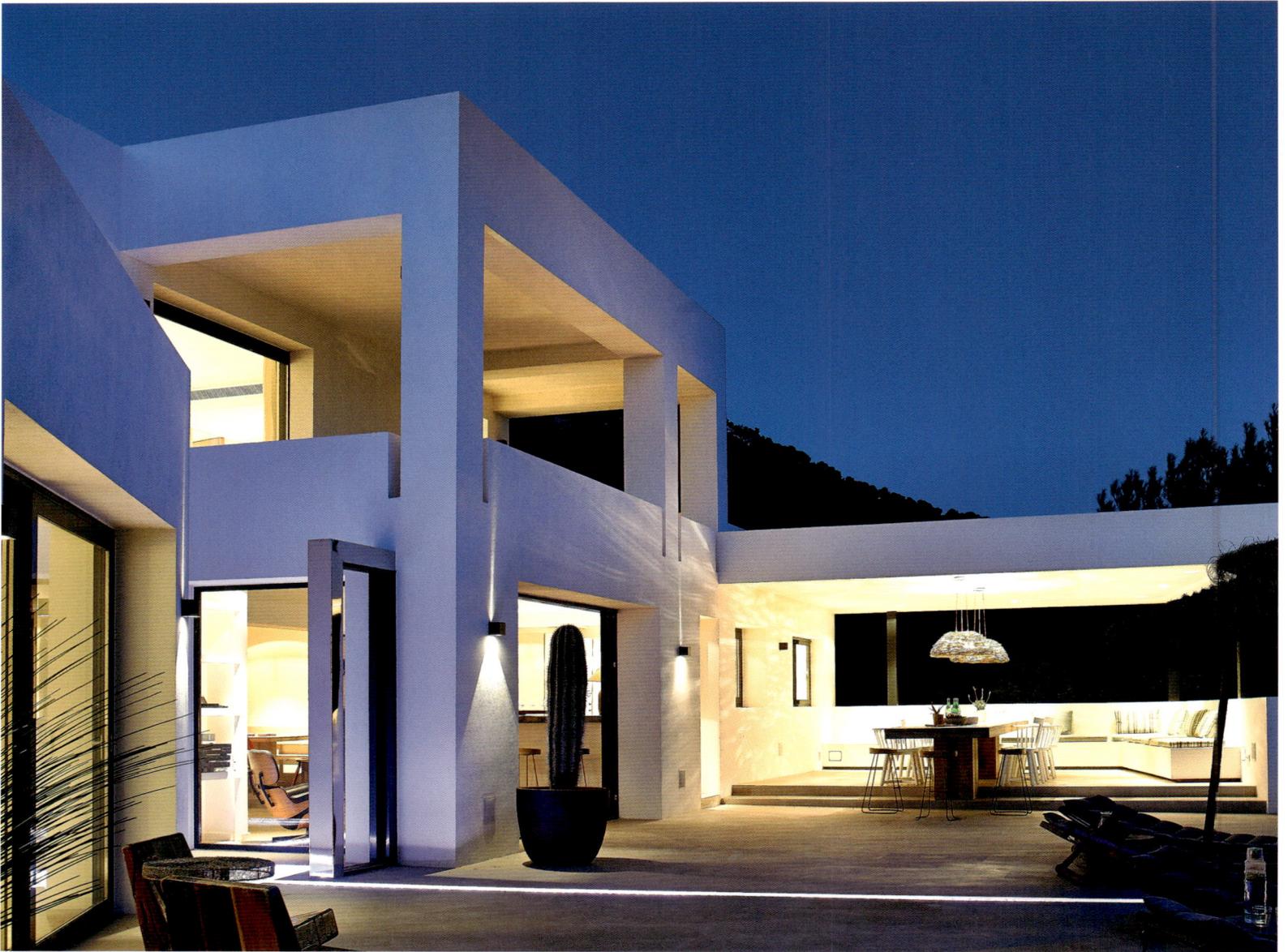

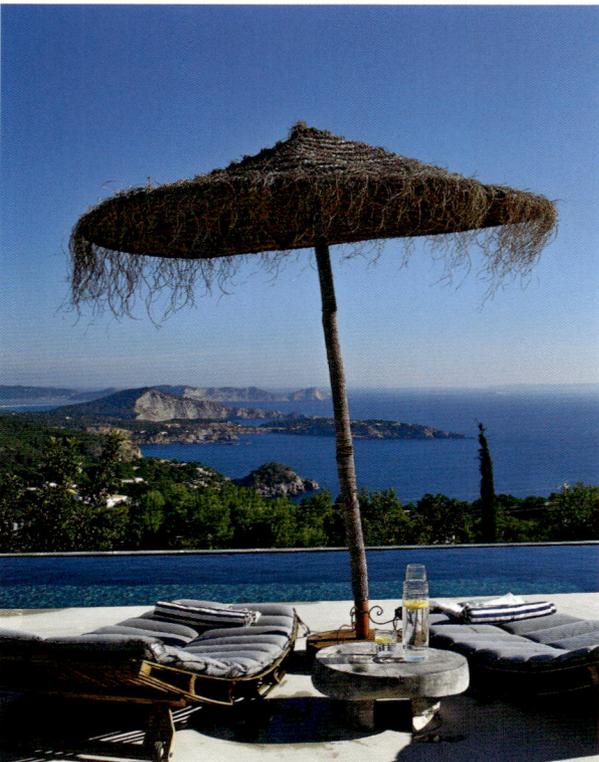

Classic Mediterranean beach umbrellas stand around the pool. LED lamps bathe the outdoor areas in ethereal blue light.

*Klassisch mediterrane Strandschirme um den Poolbereich. Blaue LED-Beleuchtung illuminiert die Außenbereiche.*

*Clásicas sombrillas de playa mediterráneas junto a la piscina. Lámparas LED azules iluminan los espacios exteriores.*

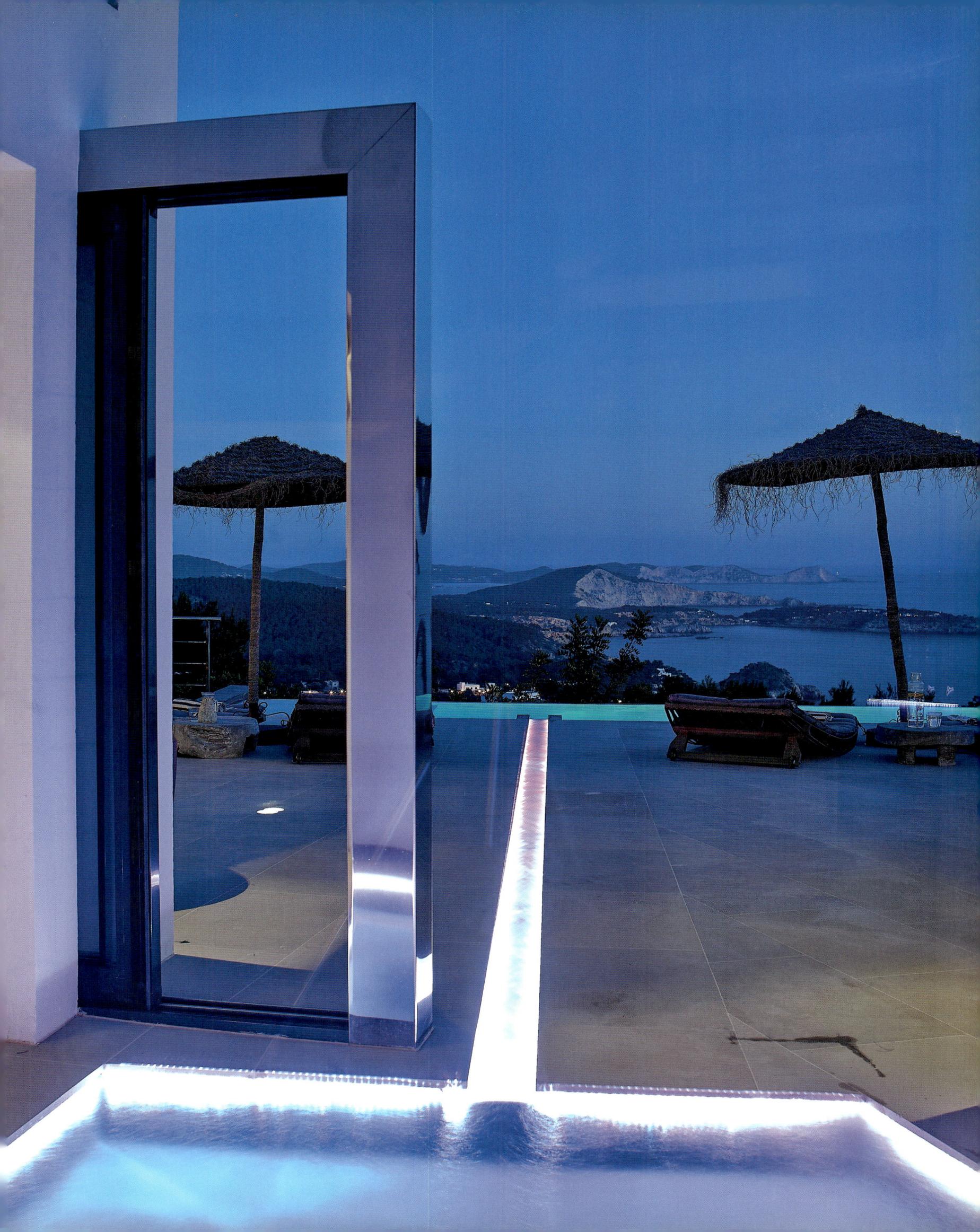

# Palacio Bardaji

WHEN THE CURRENT owners bought this city palace in Ibiza's historic center, the 10,764-foot mansion housed an electrician's workshop with countless numbers of tiny rooms. A monumental restoration project lasting four years returned the palace to its original form with the benefit of 21st century technology and design. The project required renovating 80 percent of the roof structure. All changes to the exteriors followed UNESCO guidelines in order to preserve the medieval skyline of the dalt vila (upper town). The end result was a unique space where history contrasts with modern design. Thanks to the palacio's exposed location at the highest point in the historic city center, the 2,368-foot terraces are hidden from view, guaranteeing absolute privacy while providing a view of the sea and Ibiza's marina.

ALS DIE JETZIGEN Eigentümer den Stadtpalast in Ibizas Altstadt übernahmen beherbergten die ca. 1.000 m² eine Elektrowerkstatt mit unzähligen kleinen Räumen. In einer monumentalen, vierjährigen Restaurierungsarbeit wurde der Palast in seine ursprüngliche Form zurückgeführt und Technik und Ästhetik des 21. Jahrhunderts integriert. 80 Prozent der Deckenkonstruktionen mussten erneuert werden, dabei unterlagen alle Veränderungen an den Außenbauten den Richtlinien der UNESCO, um die mittelalterliche Skyline des *Dalt Vila* (Obere Stadt) zu erhalten. Entstanden sind einzigartige Räume, in denen sich Geschichte und Design gegenüberstehen. Mit ihrer exponierten Lage auf dem höchsten Platz der Altstadt sind die 220 m² großen Terrassen uneinsehbar und garantieren absolute Privatheit mit gleichzeitigem Blick aufs Meer und die Marinas von Ibiza.

CUANDO LOS ACTUALES dueños de este palacete situado en el casco antiguo de Ibiza adquirieron el inmueble, sus aproximadamente 1000 m² albergaban un taller eléctrico y un sinfín de habitacioncitas. A lo largo de un monumental trabajo de restauración, prolongado durante cuatro años, el edificio recuperó su esplendor original y ganó además la tecnología y la estética del siglo XXI. Fue preciso renovar el 80 por ciento de los tejados, respetando siempre las directrices de la UNESCO relativas a las fachadas para preservar las líneas medievales de Dalt Vila. El resultado son unos espacios únicos en los que la historia y el diseño conviven armoniosamente. Pese a su ubicación central en la plaza más alta del casco antiguo, las terrazas, de 220 m², mantienen una completa privacidad, al tiempo que permiten disfrutar de extraordinarias vistas del mar y las marinas de Ibiza.

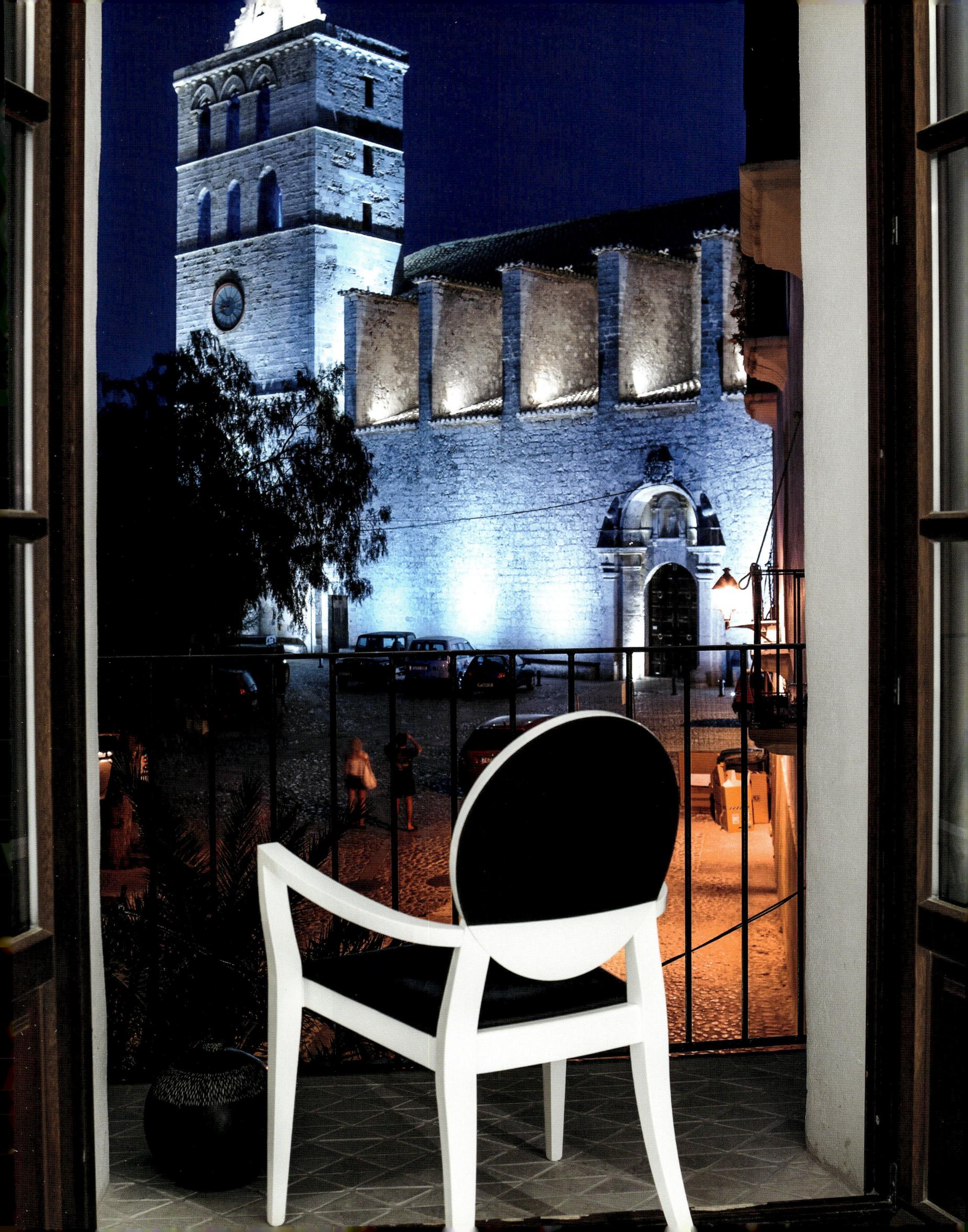

Modern design in monochrome hues that repeat throughout the house contrasts with medieval structural elements in the reception areas and the dining room.

In den Empfangsräumen und im Esszimmer kontrastiert modernes Design in den Hausfarben Schwarz und Weiß mit den mittelalterlichen Bauelementen.

En el vestíbulo y en el comedor, el diseño moderno en blanco y negro contrasta con el medieval entorno arquitectónico.

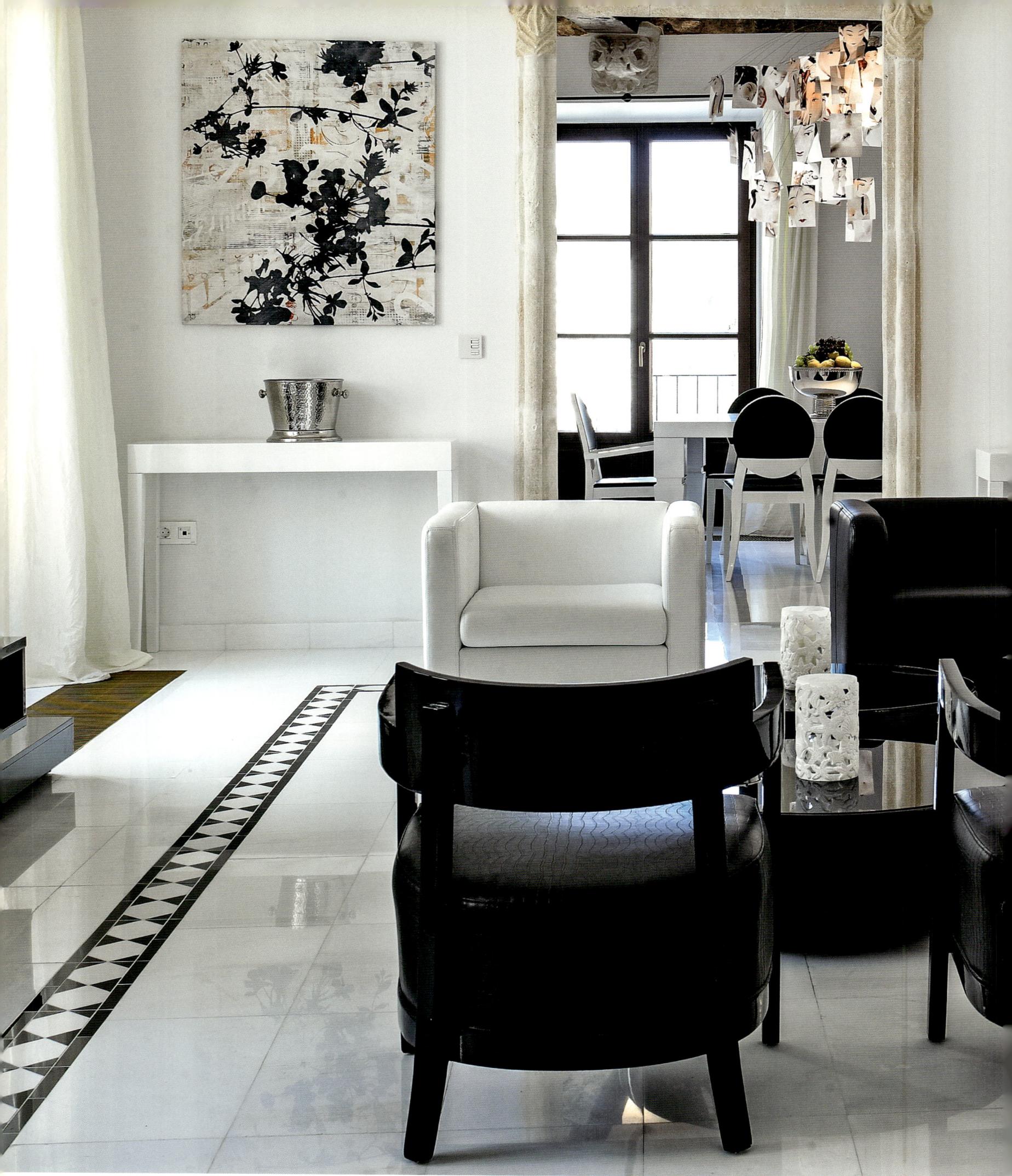

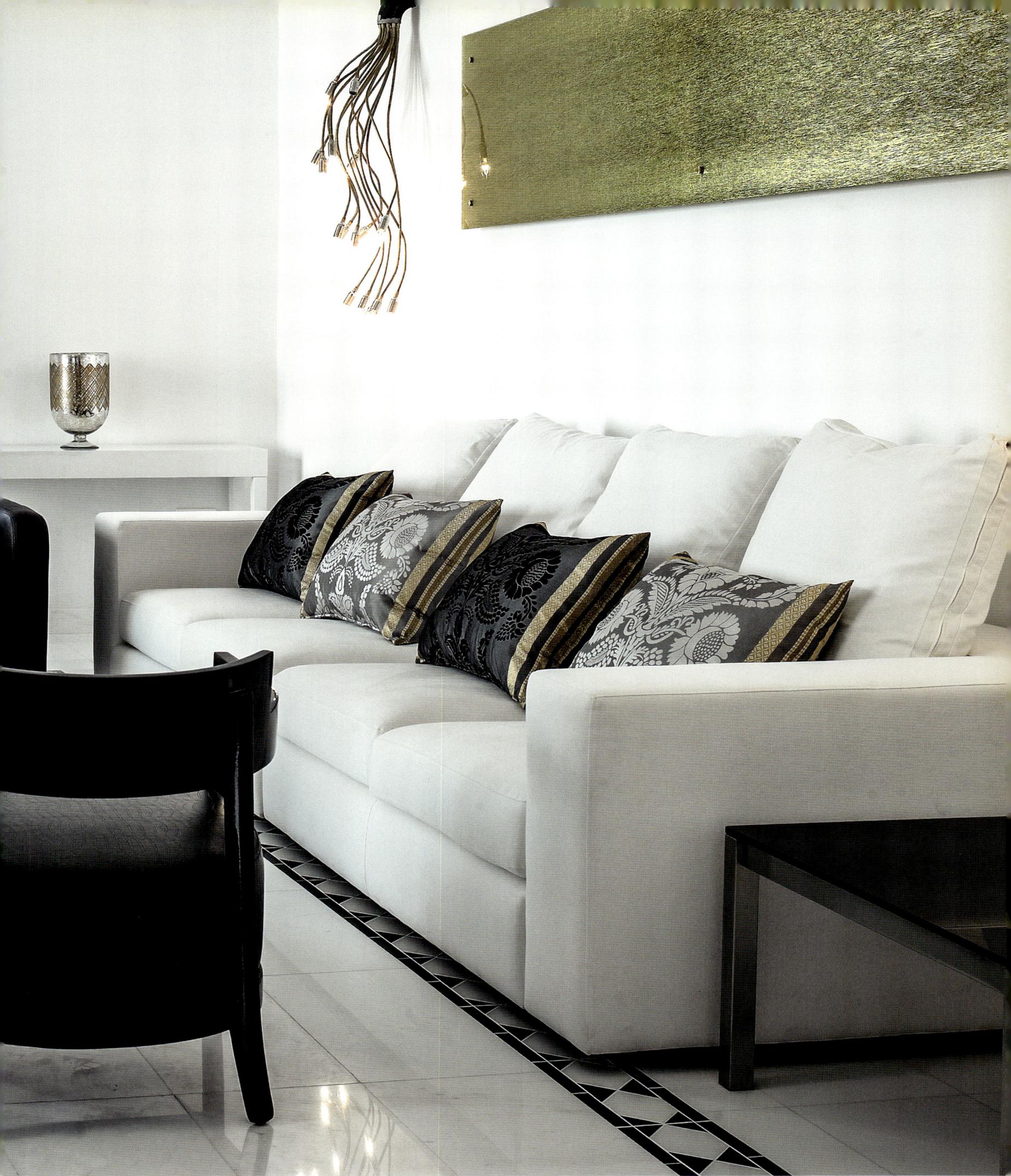

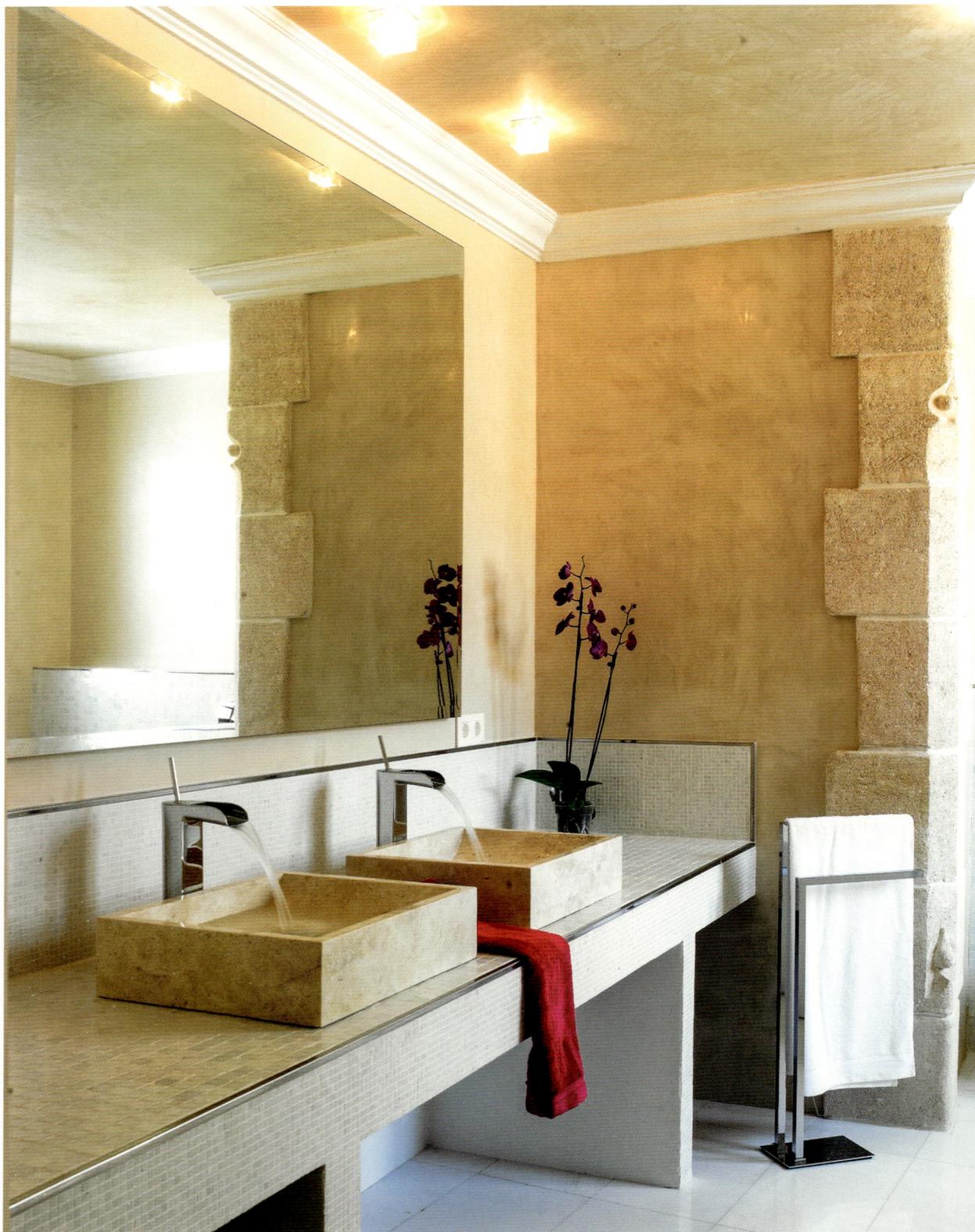

The home's clean lines continue in the bathrooms, while a clear esthetic emphasizes the integrated sections of the historic building. The bedroom décor pairs classic design elements with a Venetian mirror.

*Die klare Linienführung setzt sich in den Bädern fort. Die pure Ästhetik unterstreicht die integrierten historischen Gebäudeteile. Design-Klassiker im Schlafzimmer neben venezianischem Spiegel.*

*La claridad de líneas tiene su continuación en los baños, una estética luminosa que subraya la integración de las partes históricas del edificio. En el dormitorio, clásicos del diseño junto a un espejo veneciano.*

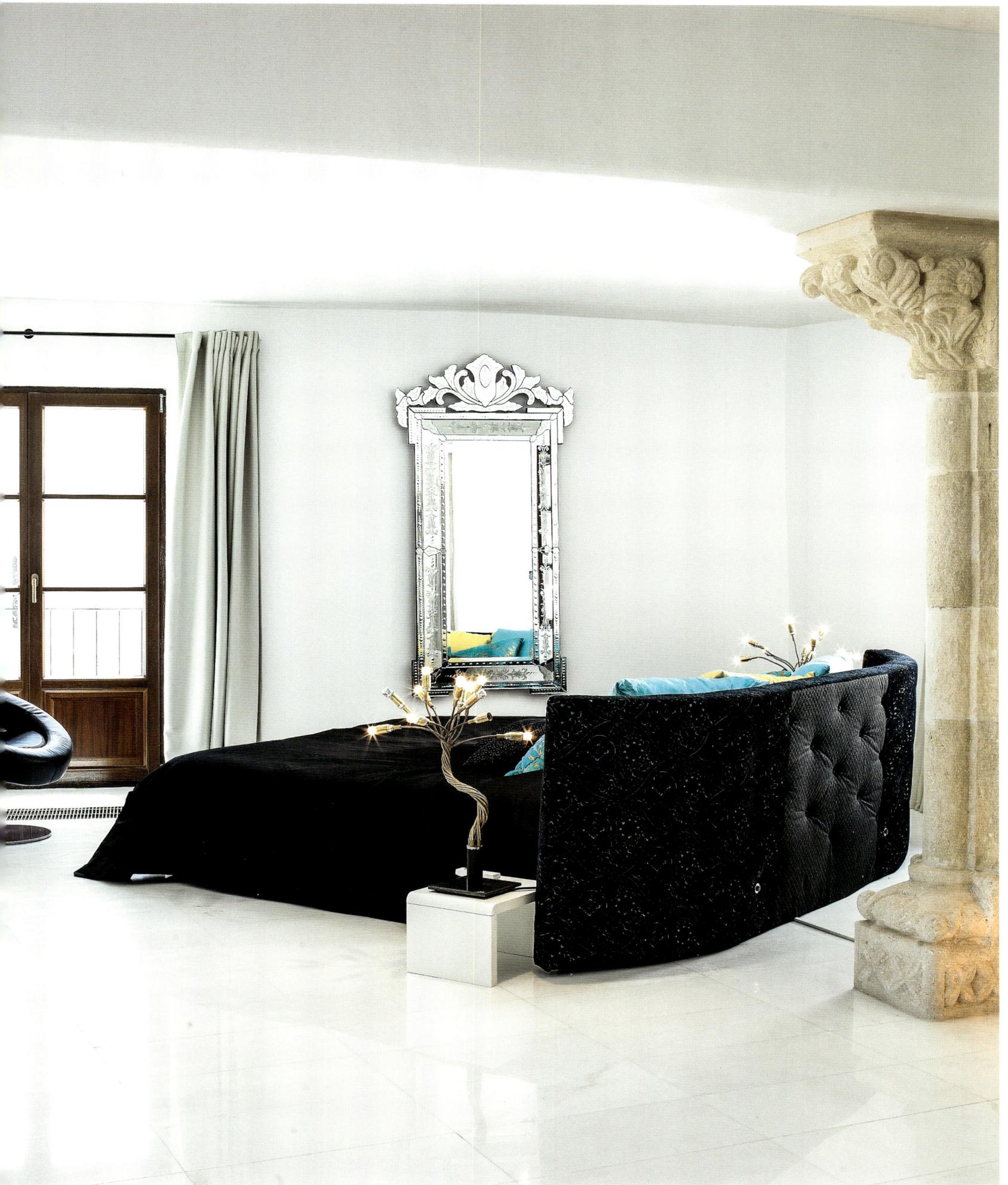

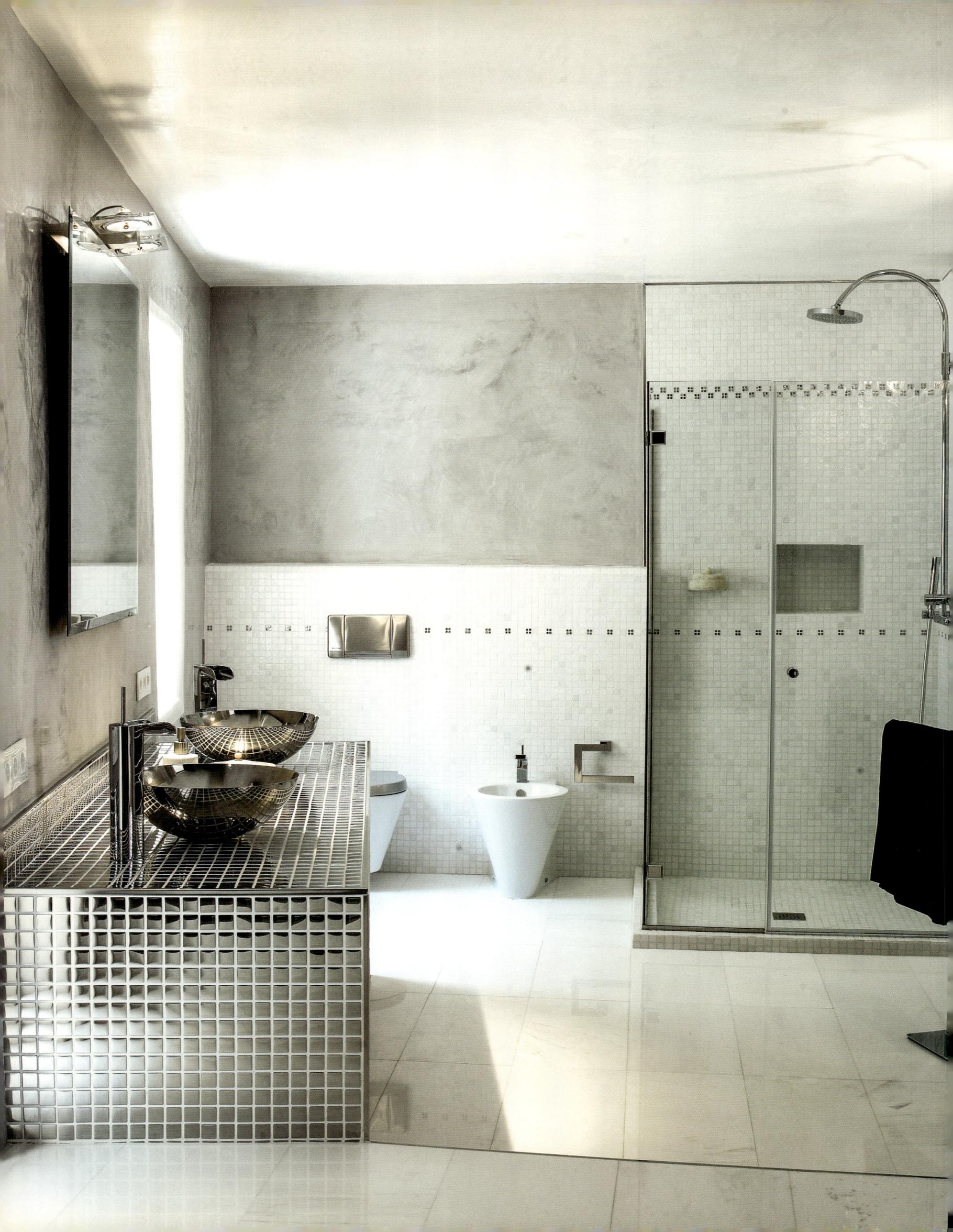

A modern bathroom features polished steel sinks and the cool silver hue of Bisazza mosaic tiles.
Contemporary accessories and red accents brighten the reception area.

Modernes Bad mit polierten Stahlwaschbecken und Bisazza-Mosaik in kühlem Silber.
Zeitgenössische Accessoires und rote Farbakzente im Empfangsraum.

Baño moderno con lavabo de acero pulido y mosaico de Bisazza en fríos tonos plateados.
En el vestíbulo, accesorios contemporáneos y alguna pincelada de rojo.

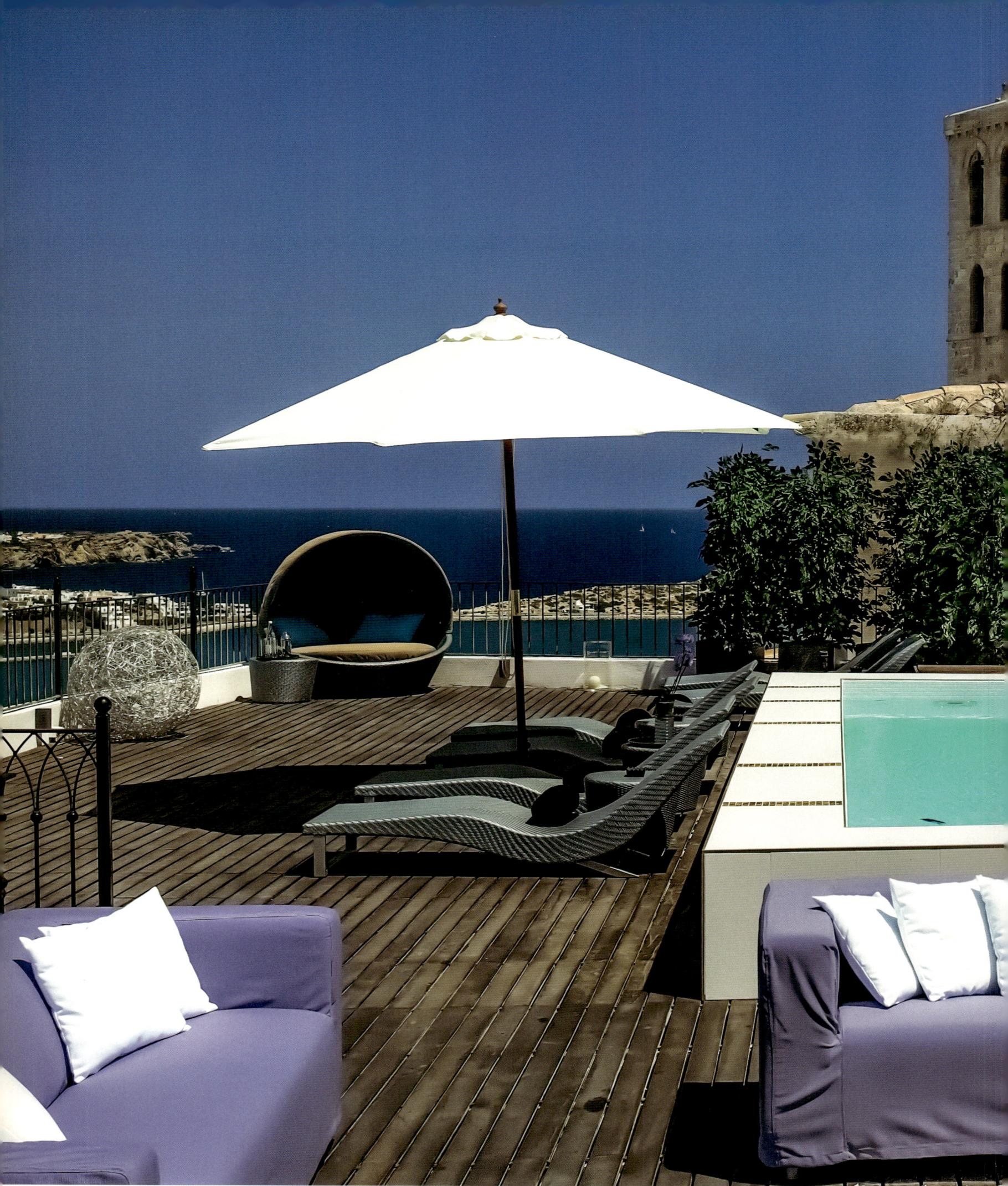

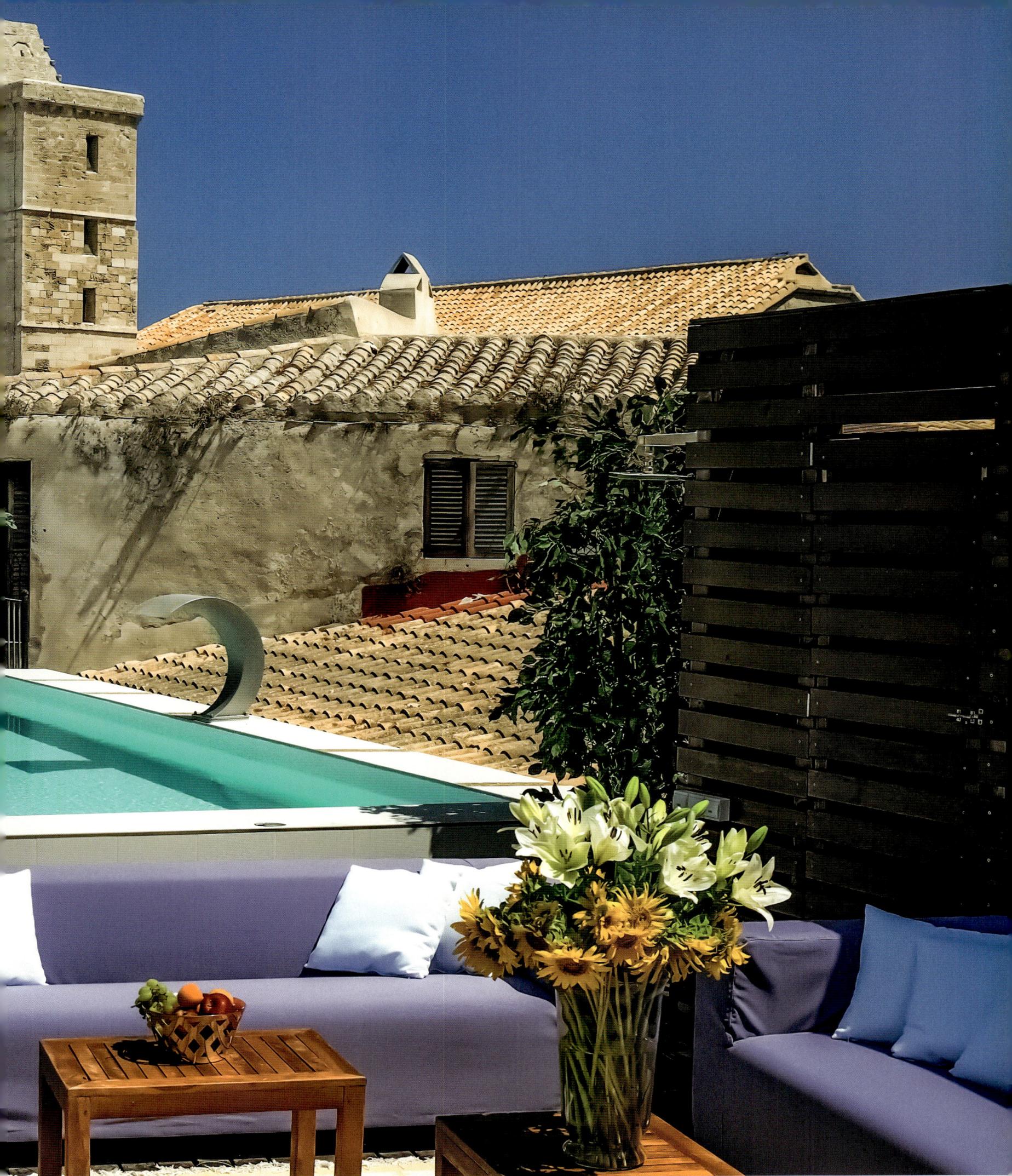

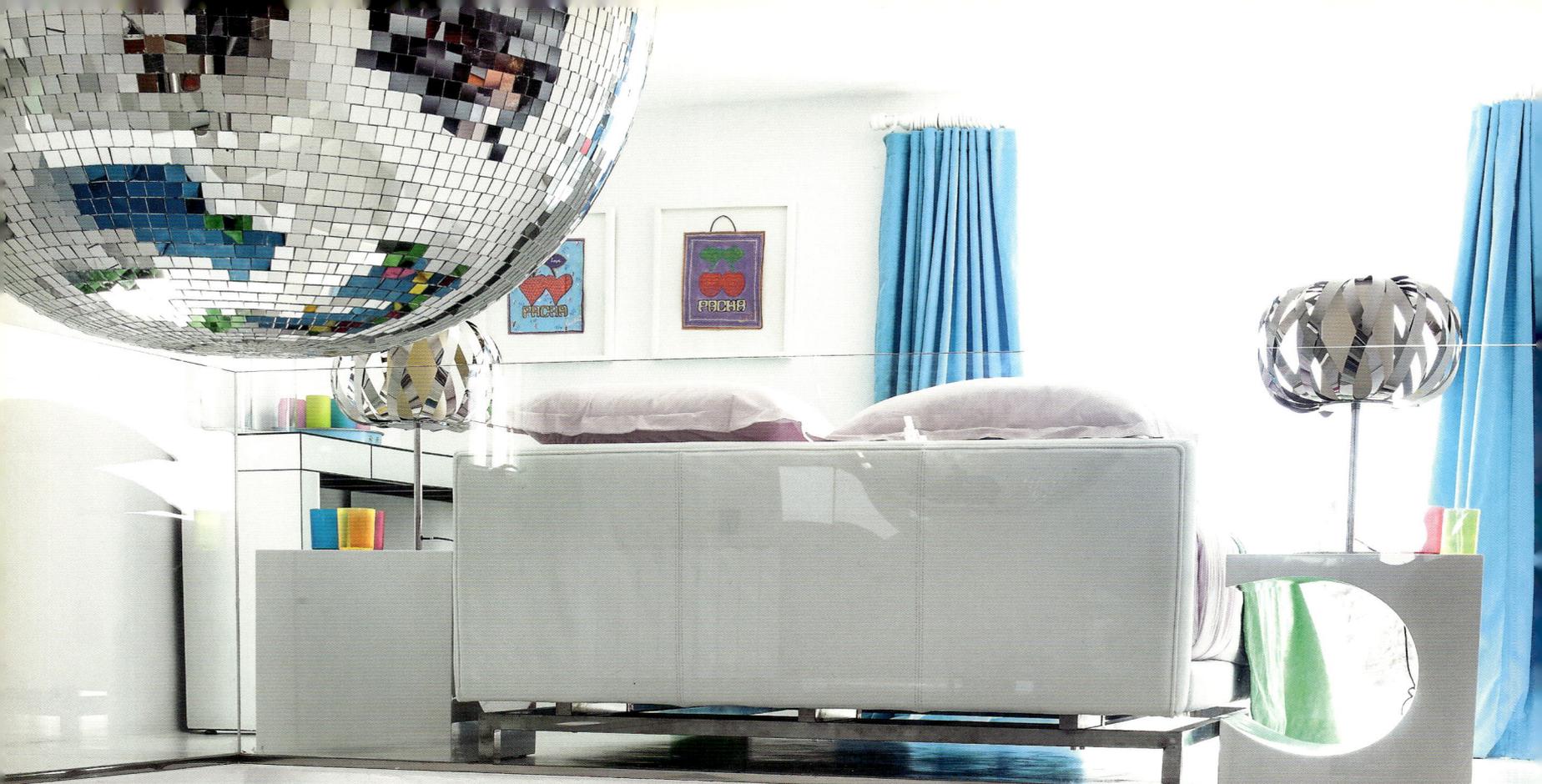

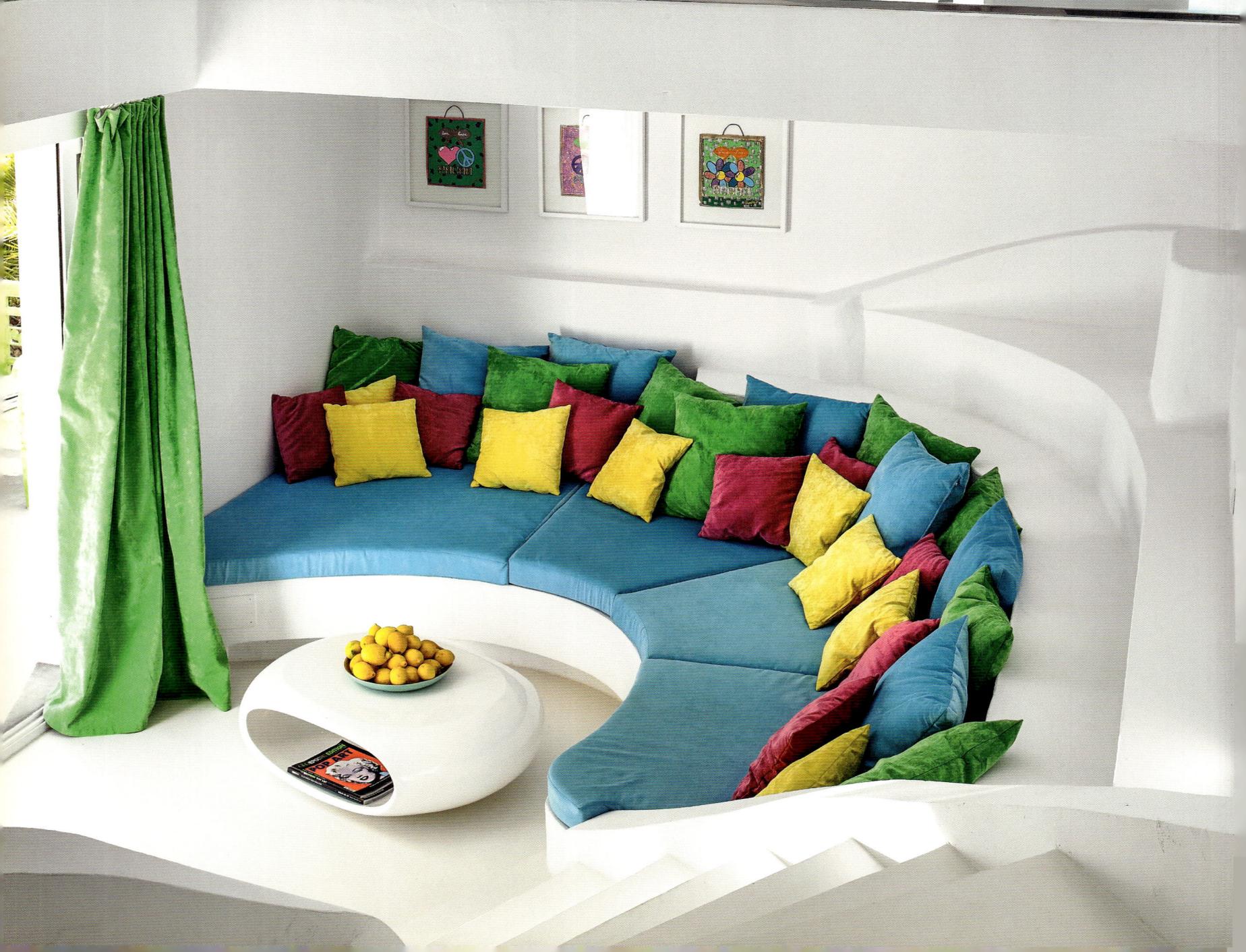

# Can Barad Dur

FUNKY HIPPIE CHIC meets Austin Powers. Anke Rice renovated and designed the interiors of this home, creating the kind of living space and lifestyle one would expect to find on an international party island. The removal of 48 pine trees allowed the breathtaking view to show itself to full advantage. Dominated by pink oleander, bamboo, flowering bushes, and pampas grass, the terraced gardens have natural stone retaining walls and cover multiple levels. The home offers a bird's eye view all the way to Cala Llonga, Sol de Serra, Formentera, and even Roca Llisa. In summer, the temperature in this exposed, mountaintop location is always several degrees cooler than at lower elevations. There may not be any neighbors close by, but you can watch the bustle of island life in the valley below.

IM FUNKY HIPPIE Chic goes Austin Powers hat dieses von Anke Rice umgebaute und eingerichtete Haus alles, was man sich auf einer internationalen Party-Insel an Lebensstil und -räumen vorstellt. Das Potenzial der atemberaubenden Aussicht kam erst zum Vorschein, als man 48 Pinien gefällt hatte. Der durch Natursteinmauern terrassierte Garten erstreckt sich jetzt auf mehreren Ebenen und wird von pinkfarbenen Adelfas, Bambus, blühenden Büschen und Pampasgräsern beherrscht. In der Weite kann man wie von einem Adlerhorst auf Cala Llonga, Sol de Serra, Formentera bis hin nach Roca Llisa blicken. Im Sommer ist es auf der exponierten Lage auf der Bergspitze immer einige Grad kühler und, obwohl fernab von Nachbarn, kann man das Inseltreiben im Tal beobachten.

ANKE RICE REMODELÓ y decoró esta casa en la que el estilo *hippie* más chic va de la mano del mismísimo Austin Powers para ofrecer todo cuanto cabe esperar, cuando no soñar, de una residencia en la isla de la fiesta más internacional. Las posibilidades panorámicas de su emplazamiento se hicieron evidentes tras la tala de 48 pinos. La terraza ajardinada, rodeada de muros de piedra natural, se extiende a varios niveles dominados por adelfas, cañizales, arbustos en flor y yerbas de las pampas. Desde esta posición privilegiada pueden verse a lo lejos Cala Llonga, Sol de Serra, Formentera e incluso Roca Llisa. En verano, la cima del monte, expuesta a los elementos, resulta algo más fresca que su entorno, y pese a su apartado emplazamiento es posible seguir desde ella el ir i venir de los habitantes del valle.

Pop art picture of "Jack," Sluiz Gallery Ibiza. Armchair from the flea market with cartoon patterns revamped by Sluiz Ibiza. Ultra-sleek design in the bathroom.

Popart-Bild von „Jack", Sluiz Gallery Ibiza. Sessel vom Trödelmarkt mit Comic-Muster revamped von Sluiz Ibiza. Bad im Ultra-sleek-Design.

Cuadro pop-art de "Jack", Sluiz Gallery Ibiza. Sillón de mercadillo con tapizado de cómic, restaurado por Sluiz Ibiza. Diseño ultraelegante en el cuarto de baño.

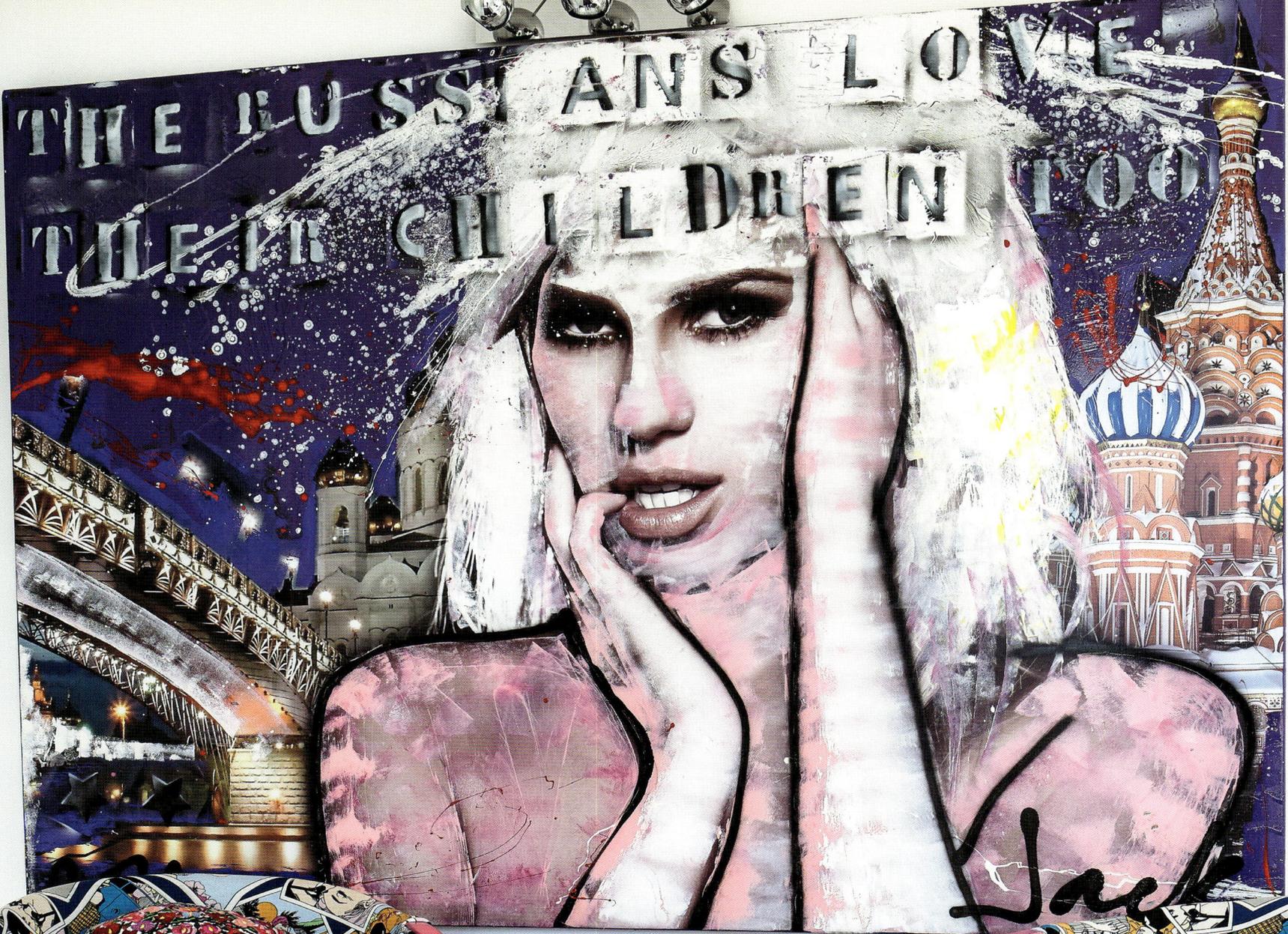
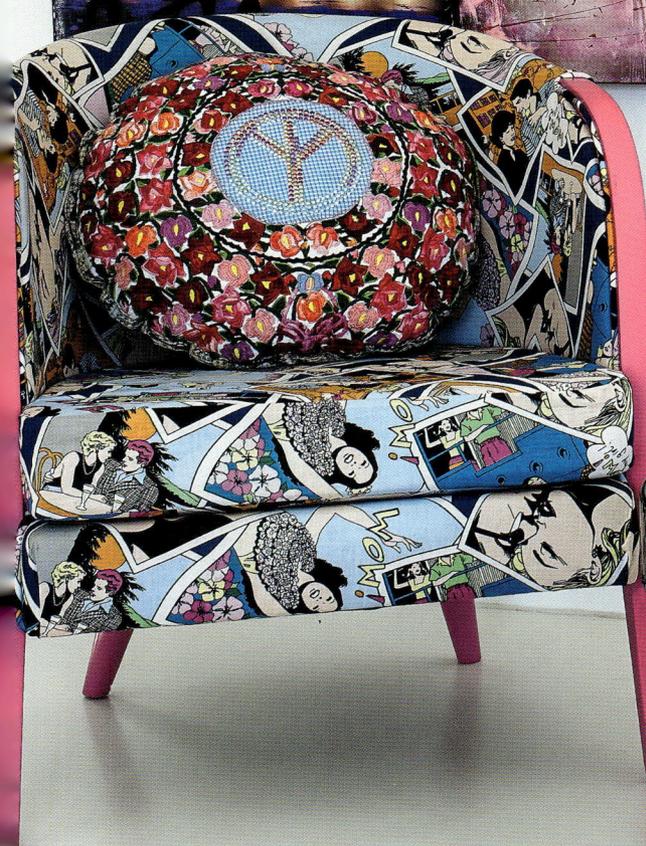

LIVING IN STYLE NEW YORK

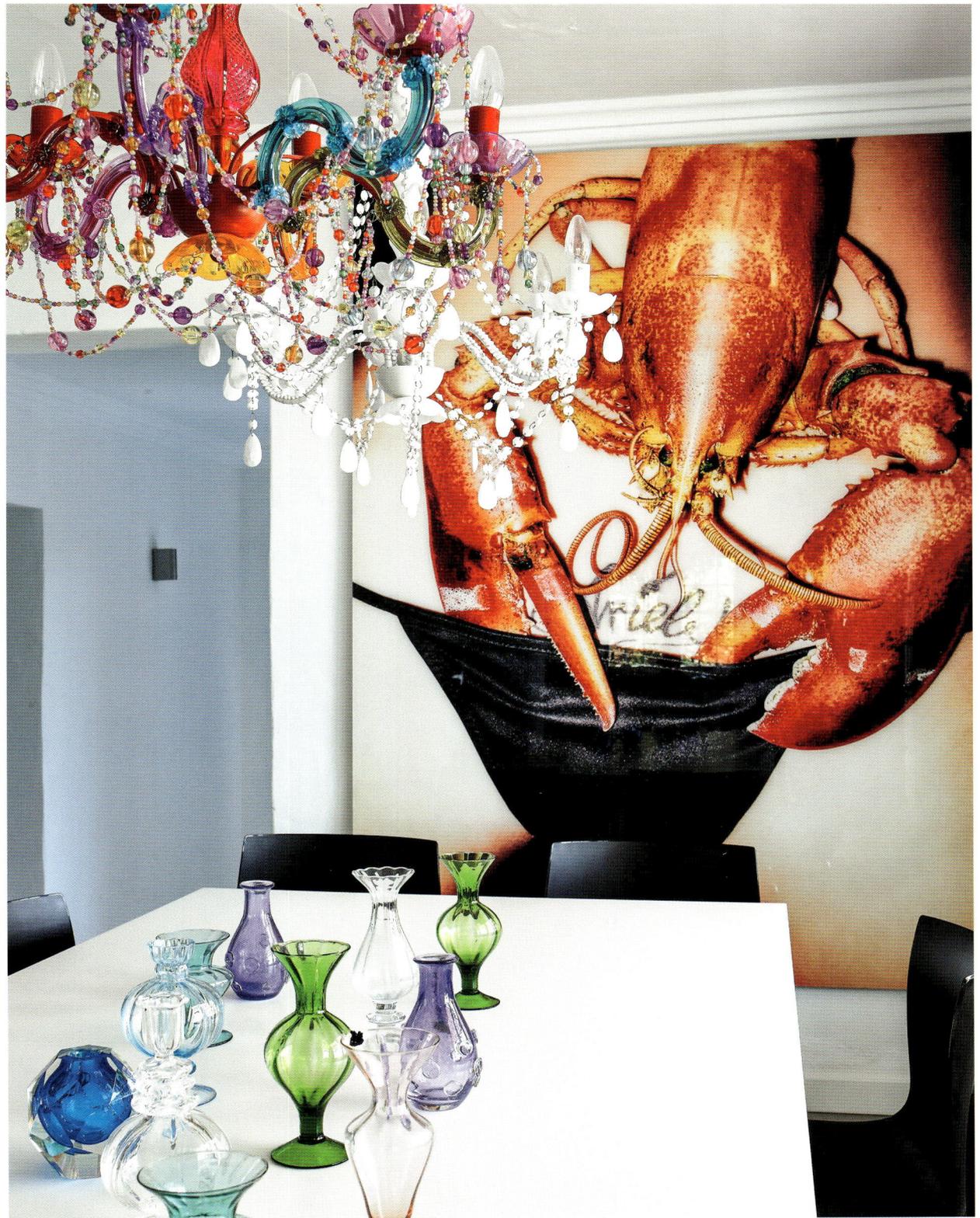

Chill-out nook with "Cow Girl" photo by Tony Kelly. The cushions were made by Sluiz Ibiza based on Anke Rice's designs. Silver paint rejuvenated the old Indian coffee table. Dining table from Lago beneath a photo by Tony Kelly. Glass vases from the Paris Flea Market.

Chill-Ecke mit Fotografie „Cow Girl" von Tony Kelly. Die Kissen wurden nach Entwürfen von Anke Rice von Sluiz Ibiza angefertigt. Der alte indische Coffeetable wurde mit Silberfarbe reanimiert. Esstisch von Lago unter Foto von Tony Kelly. Glasvasen vom Flohmarkt in Paris.

"Cow Girl", fotografía de Tony Kelly en un rinconcito para descansar. Los cojines son obra de Sluiz Ibiza a partir de diseños de Anke Rice. La vieja mesita india de café ha revivido con una capa de pintura plateada. Mesa de Lago bajo fotografía de Tony Kelly. Jarrones de vidrio encontrados en un mercadillo parisino.

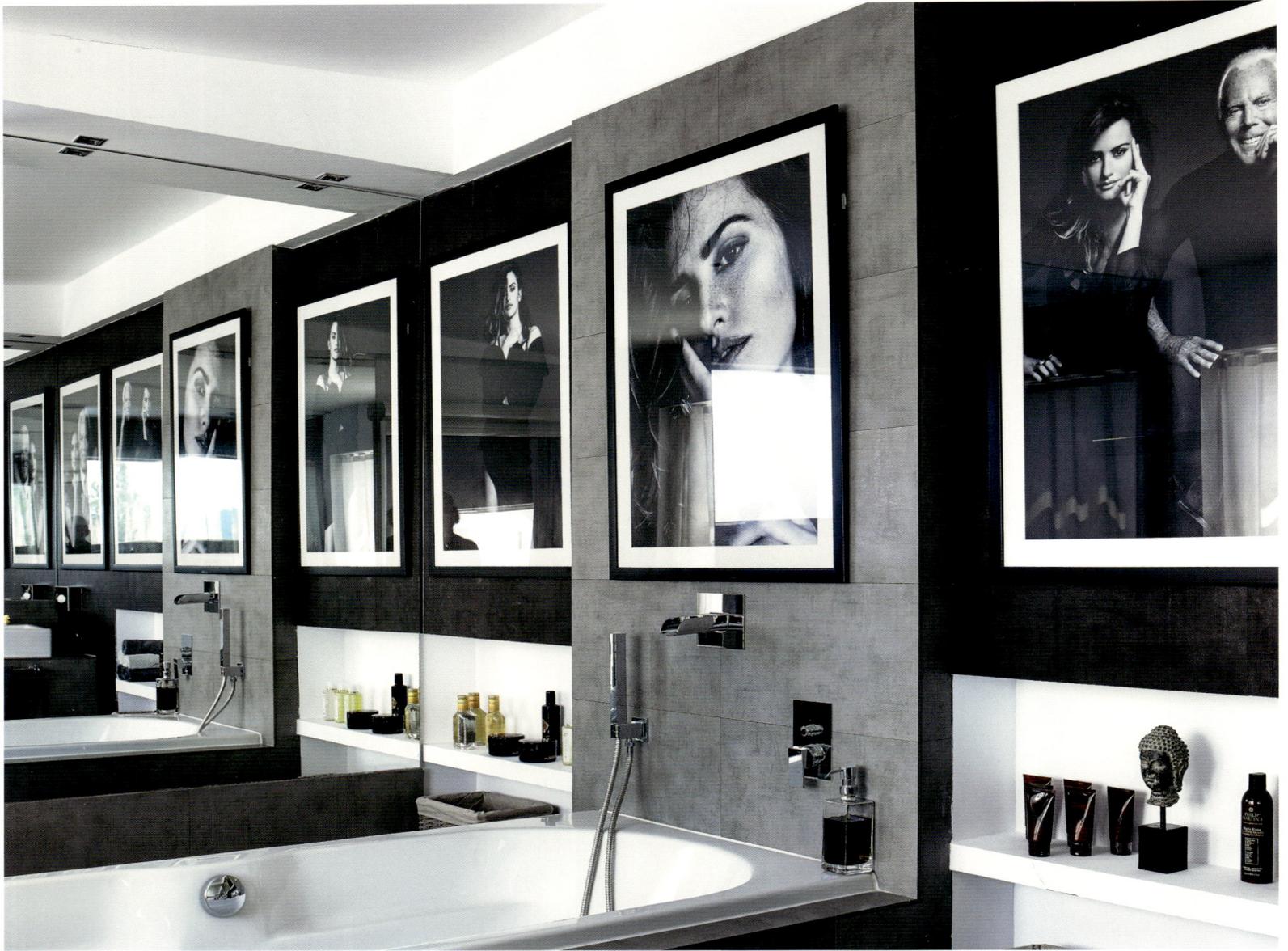

"Armani & Penelope", a black-and-white photo by Nico Bustos, in the bathroom. Black/white/ red décor in the master bedroom. Feather lamps from Maison d'Elephant. Barcelona bed, Mies van der Rohe, and decorative objects from Lotus Ibiza. "Cherry Ebony," a photo by Jordi Gomez.

Schwarz-Weiß-Foto „Armani & Penelope" von Nico Bustos im Bad. Master Bedroom dekoriert in schwarz/weiß/rot. Federlampen vom Maison d'Elephant. Barcelona Bett, Mies van der Rohe, und Deko von Lotus, Ibiza. Fotografie von Jordi Gomez „Cherry Ebony".

"Armani & Penelope", fotografía en blanco y negro de Nico Bustos en el baño. Dormitorio principal decorado en negro, blanco y rojo. Lámpara de Maison d'Elephant. Cama Barcelona de Mies van der Rohe y decoración de Lotus (Ibiza). "Cherry Ebony", fotografía de Jordi Gómez.

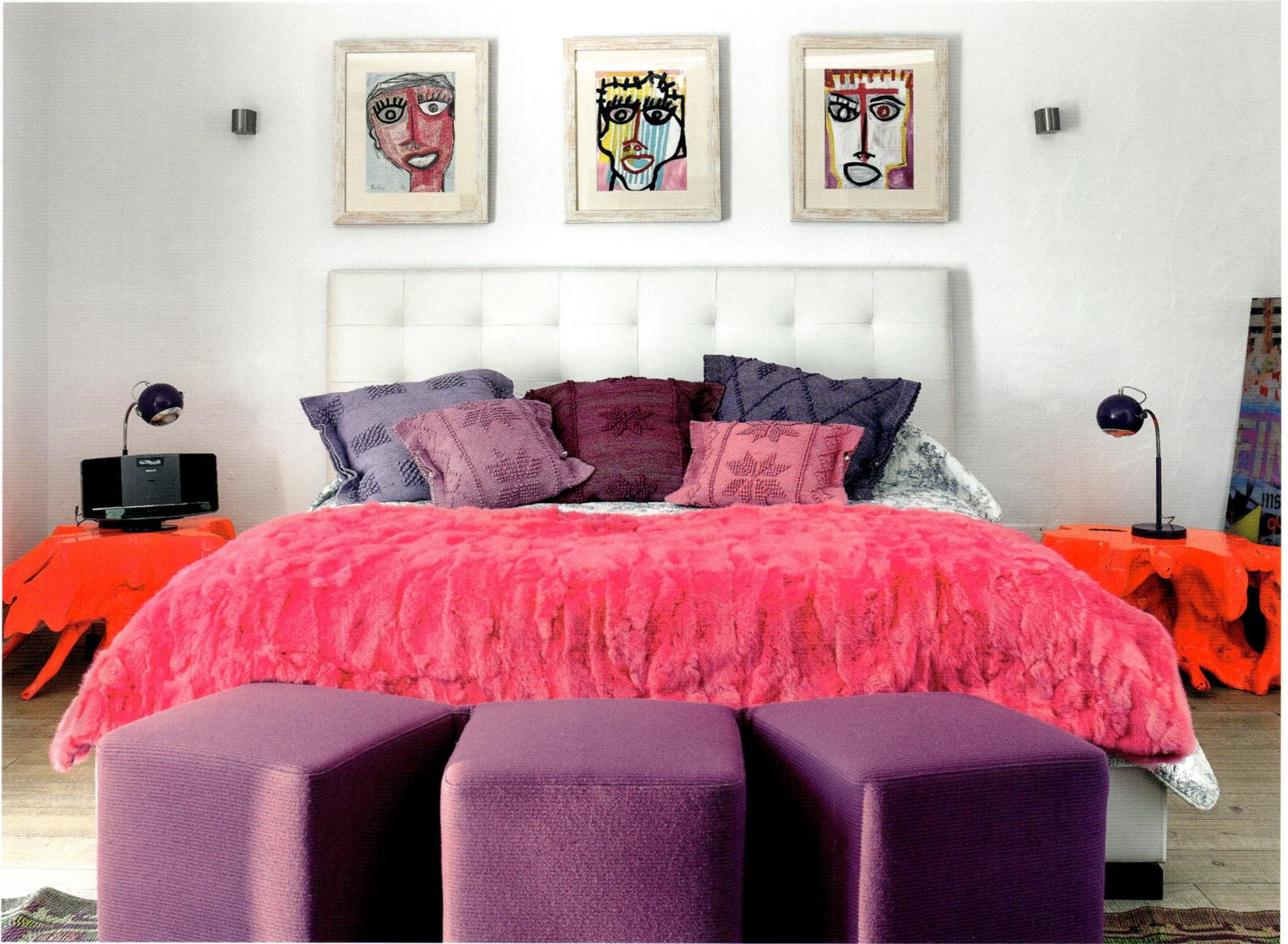

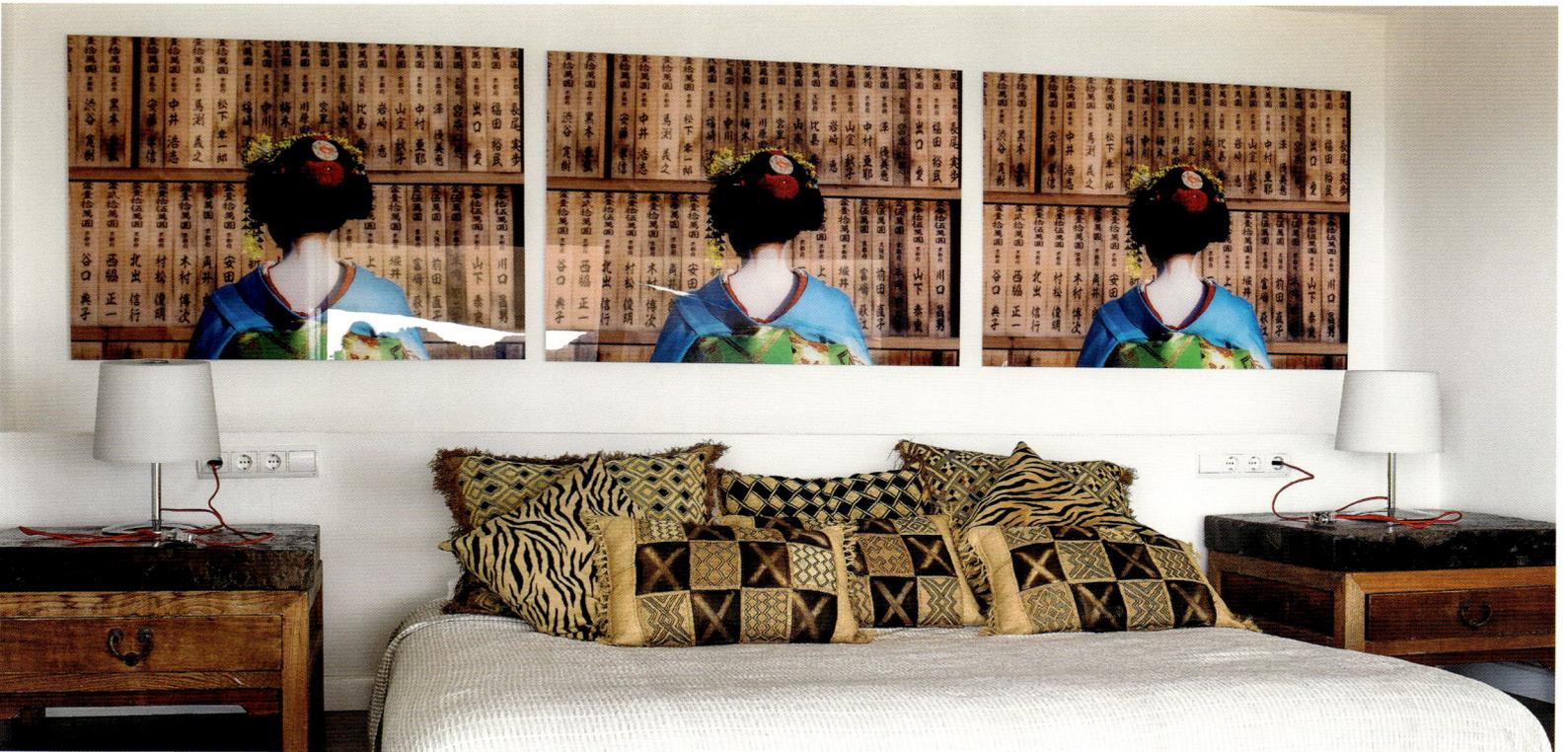

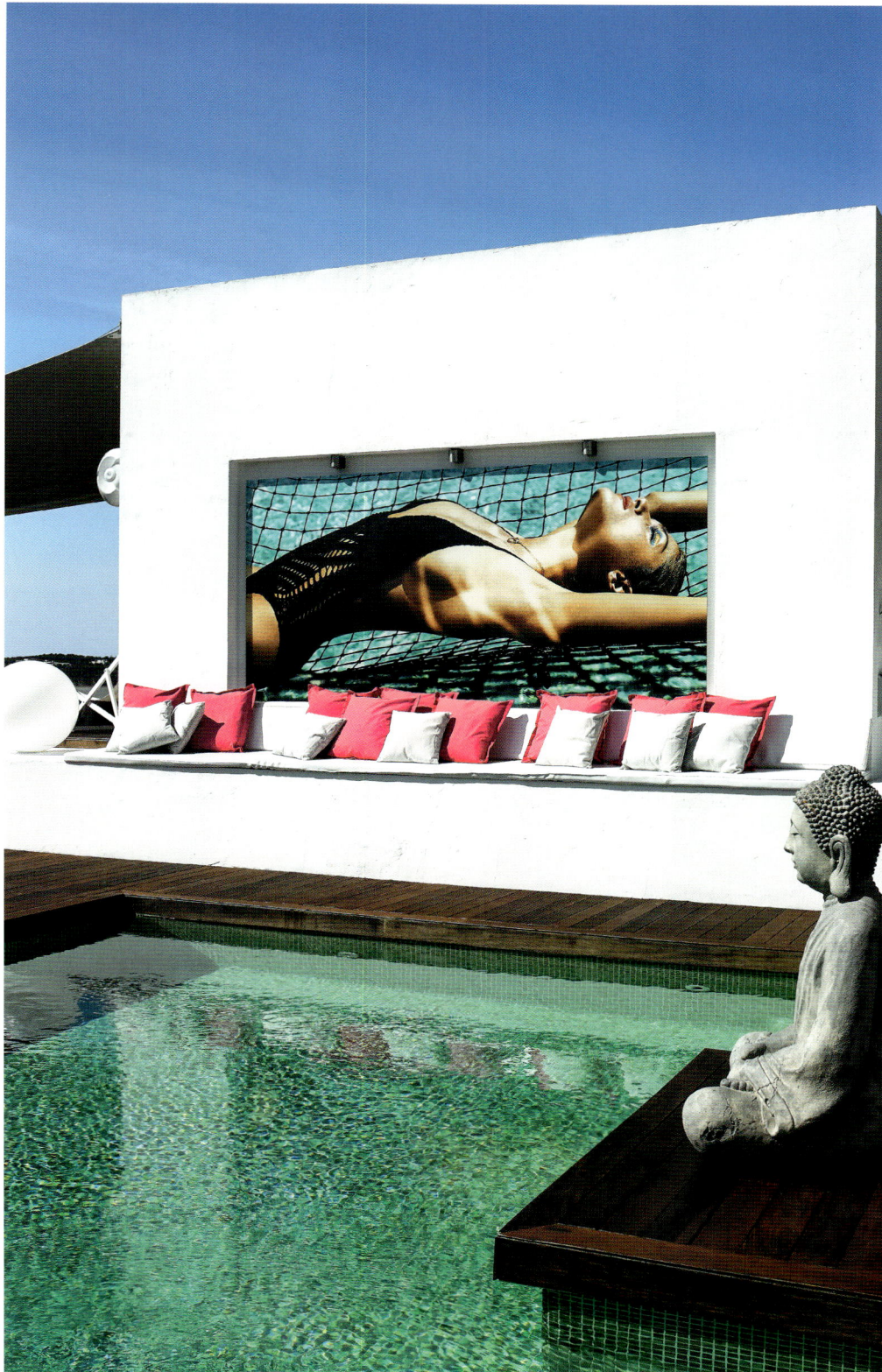

Triptych photos from Lumas. Antique nightstands from China. Cushions made of old African fabrics that the homeowner brought back from her many travels. Lamps from Biosca & Botey Barcelona. The photo in the pool area is by Nico Bustos and was taken specifically for this space.

Tryptichon-Fotos von Lumas. Antike Nachttische aus China. Kissen aus alten afrikanischen Stoffen, mitgebracht von den vielen Reisen der Hausherrin. Lampen Biosca & Botey Barcelona. Die Fotografie am Pool von Nico Bustos, wurde extra für das Haus fotografiert.

Tríptico fotográfico de Lumas. Antigua mesita de noche china. Almohadones de viejas telas africanas, obtenidas durante los múltiples viajes de la dueña de la casa. Lámparas de Biosca & Botey (Barcelona). La fotografía de la piscina, obra de Nico Bustos, fue creada especialmente para la casa.

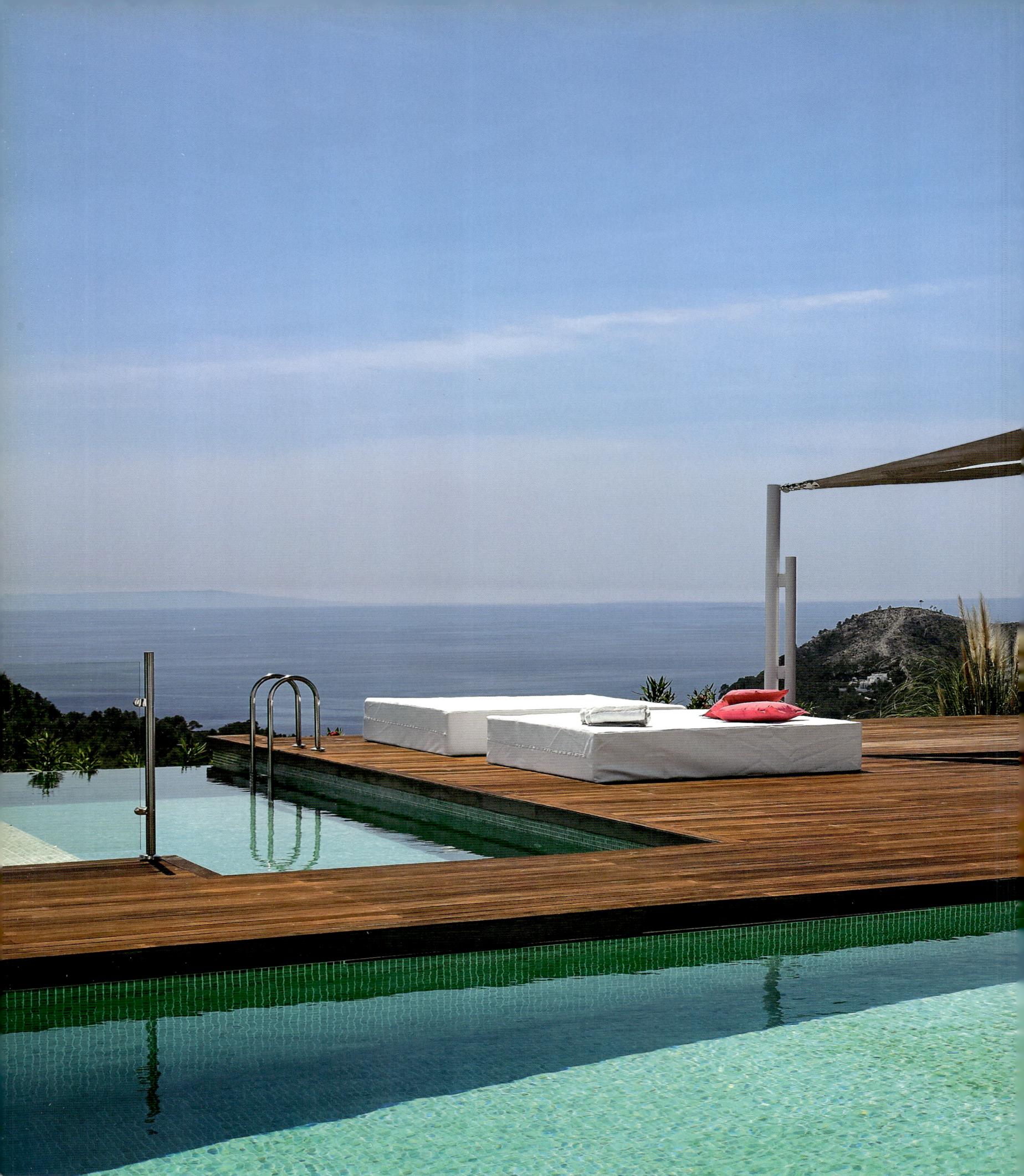

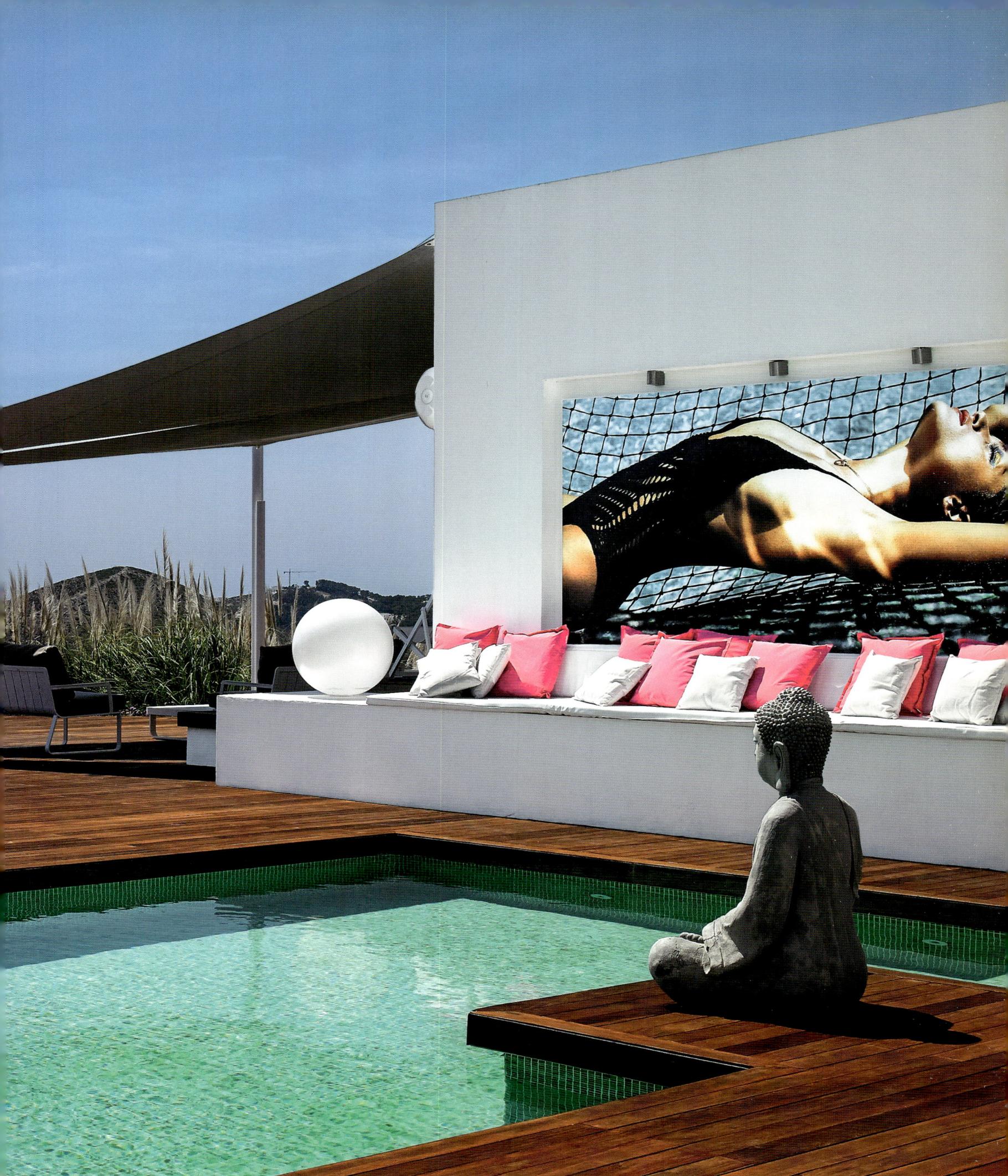

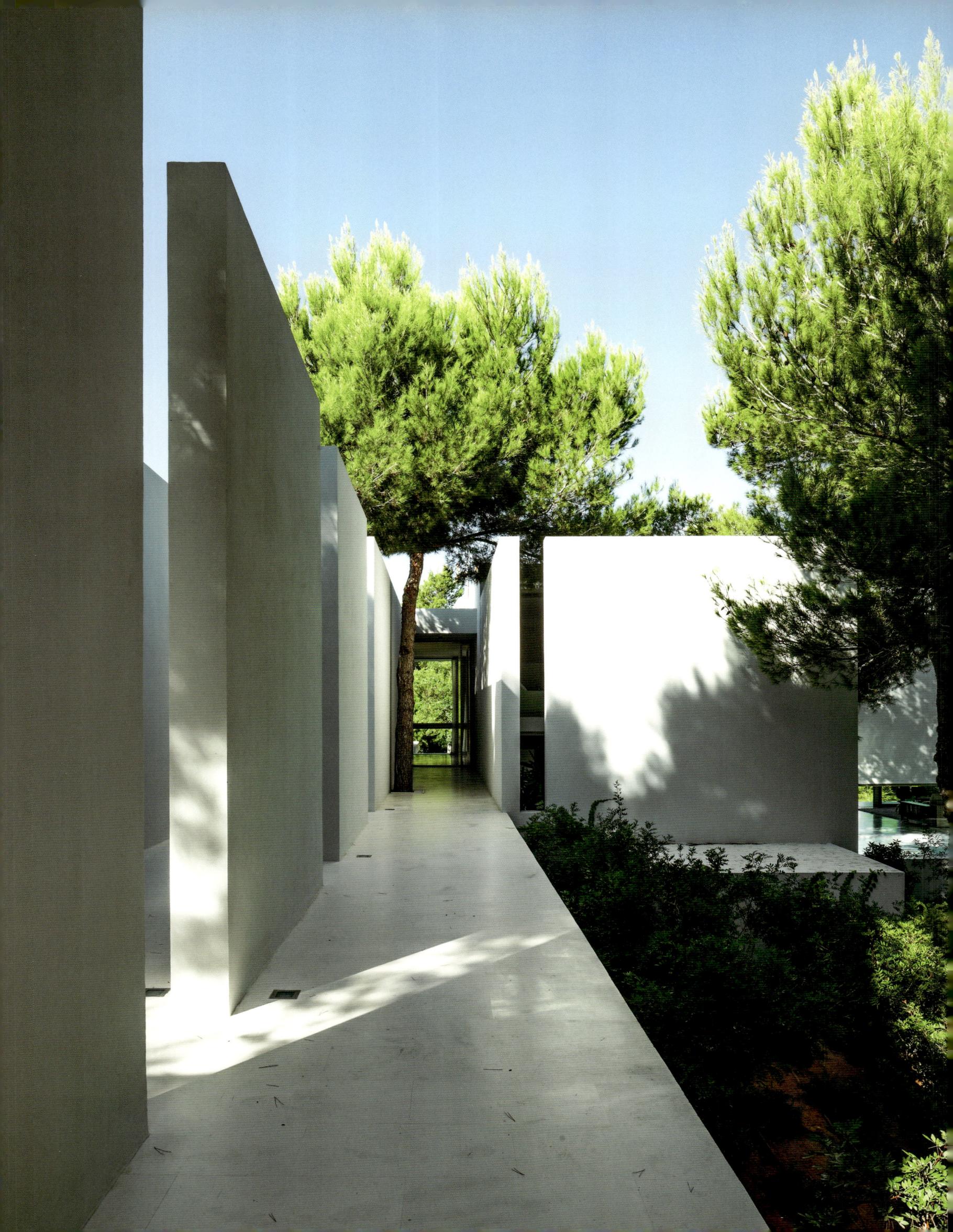

# Can Nou

THE HOUSE BLENDS in with the Mediterranean landscape like a live-in sculpture. It was built to the owner's specifications in partnership with the Bruno Erpicum architectural firm, based on the idea of interpreting, respecting, and complementing nature. White walls connect the three main buildings and form a single unit. The architecture is designed to offer views of the enchanting natural surroundings, coastline, and ocean from many different angles. The grounds reflect the typical Mediterranean atmosphere of Roman gardens, with their separate areas and beds of fragrant, climate-tolerant plants, surrounded by stone walls and extending all the way to the pool. The indoor and outdoor areas flow into each other through a bank of windows that stretch from floor to ceiling.

WIE EINE BEWOHNBARE Skulptur fügt sich das Haus in die mediterrane Landschaft ein. Die Landschaft zu interpretieren, zu respektieren und zu ergänzen war hierbei die Grundlage für den Bau des Projektes, das nach Vorgaben der Besitzer zusammen mit dem Architekten Bruno Erpicum realisiert wurde. Die drei Hauptgebäude werden durch weiße Mauern miteinander verbunden und bilden so eine Einheit. Aus den verschiedenen Winkeln der Architektur kann man in der Ferne die faszinierende Natur, die Küste und das Meer sehen. Die Außenanlagen mit ihren verschiedenen Bereichen und ihren widerstandsfähigen, duftenden Pflanzen, die von Natursteinmauern begrenzt werden und sich bis zum Pool ziehen, spiegeln die typisch mediterrane Atmosphäre römischer Gärten wider. Durch die deckenhohen Fensterflächen gehen Innen- und Außenbereiche fließend ineinander über.

LA CASA SE integra en el paisaje mediterráneo como una escultura habitable. A la hora de acometer el proyecto, tanto los propietarios como el arquitecto Bruno Erpicum se propusieron firmemente interpretar, respetar y complementar el entorno del edificio. Varios muros blancos vinculan entre sí los tres edificios principales de la propiedad, confiriéndole un aire unitario. A través de los diversos ángulos del complejo se abren fascinantes vistas de la naturaleza circundante, la costa y el mar. Los espacios exteriores, sus diversos ambientes y las resistentes y aromáticas plantas que los pueblan hasta el borde mismo de la piscina reflejan el estilo mediterráneo de los jardines romanos. La transición entre interior y exterior es muy fluida gracias a los altísimos ventanales de la casa.

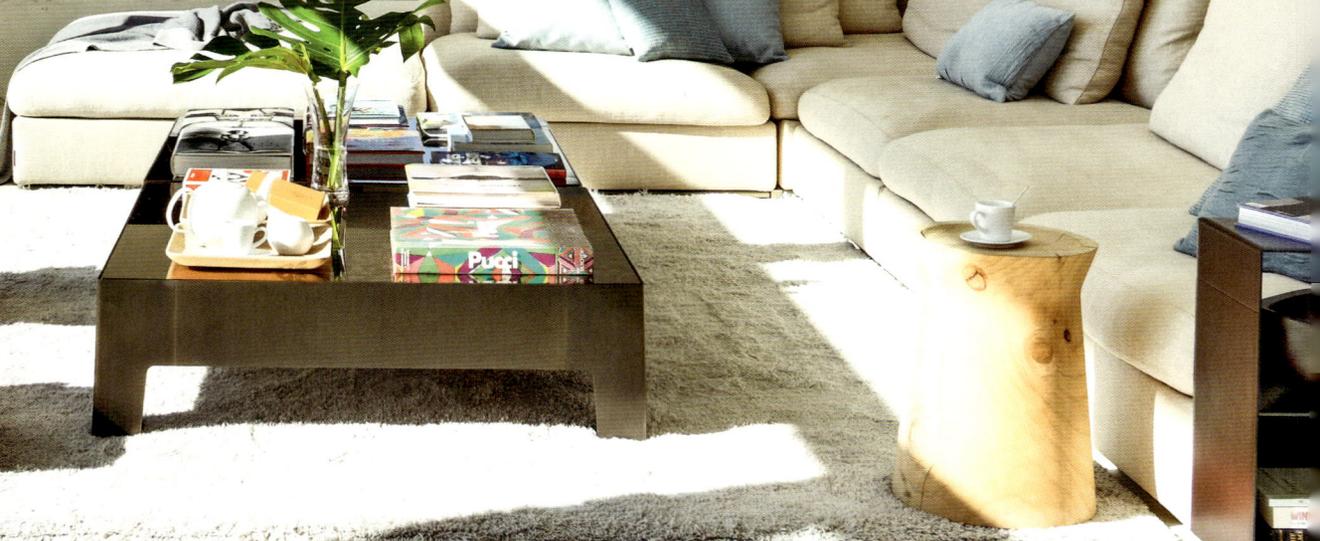

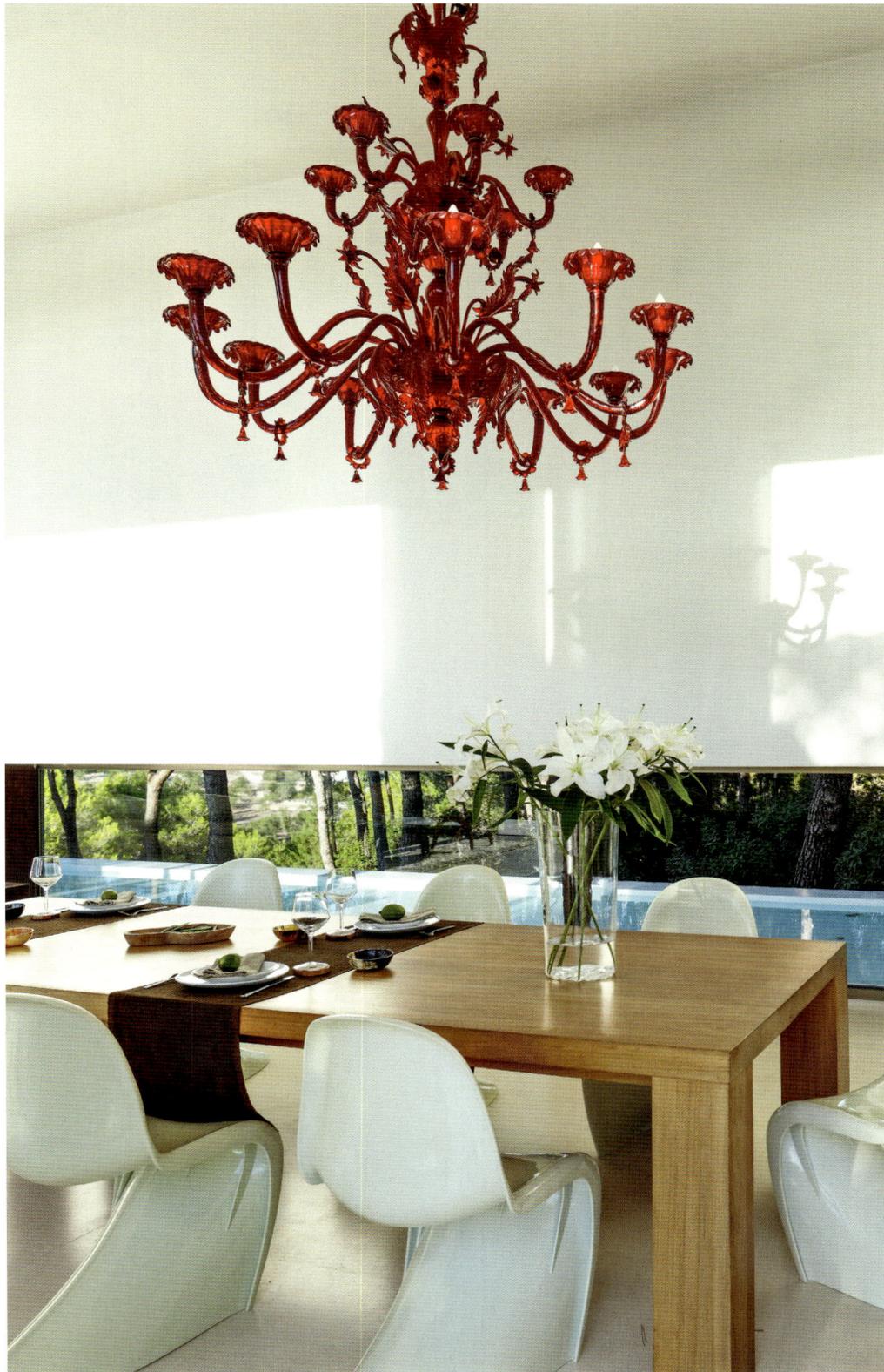

*A red Murano chandelier hangs above the dining table, from where lush vegetation can be seen through a horizontal opening in the wall. Red, turquoise, and wooden accessories add color to the monochrome décor.*

*Roter Muranoleuchter über dem Esstisch, von dem man durch einen horizontalen Mauerdurchbruch in die üppige Vegetation schaut. Rote, türkise und Holzaccessoires unterbrechen die monochrome Ästhetik.*

*Lámpara roja de cristal de Murano sobre la mesa del comedor, desde la que una abertura horizontal del muro permite ver la densa vegetación. Diversos accesorios de madera, rojos y turquesas interrumpen la monocromía del conjunto.*

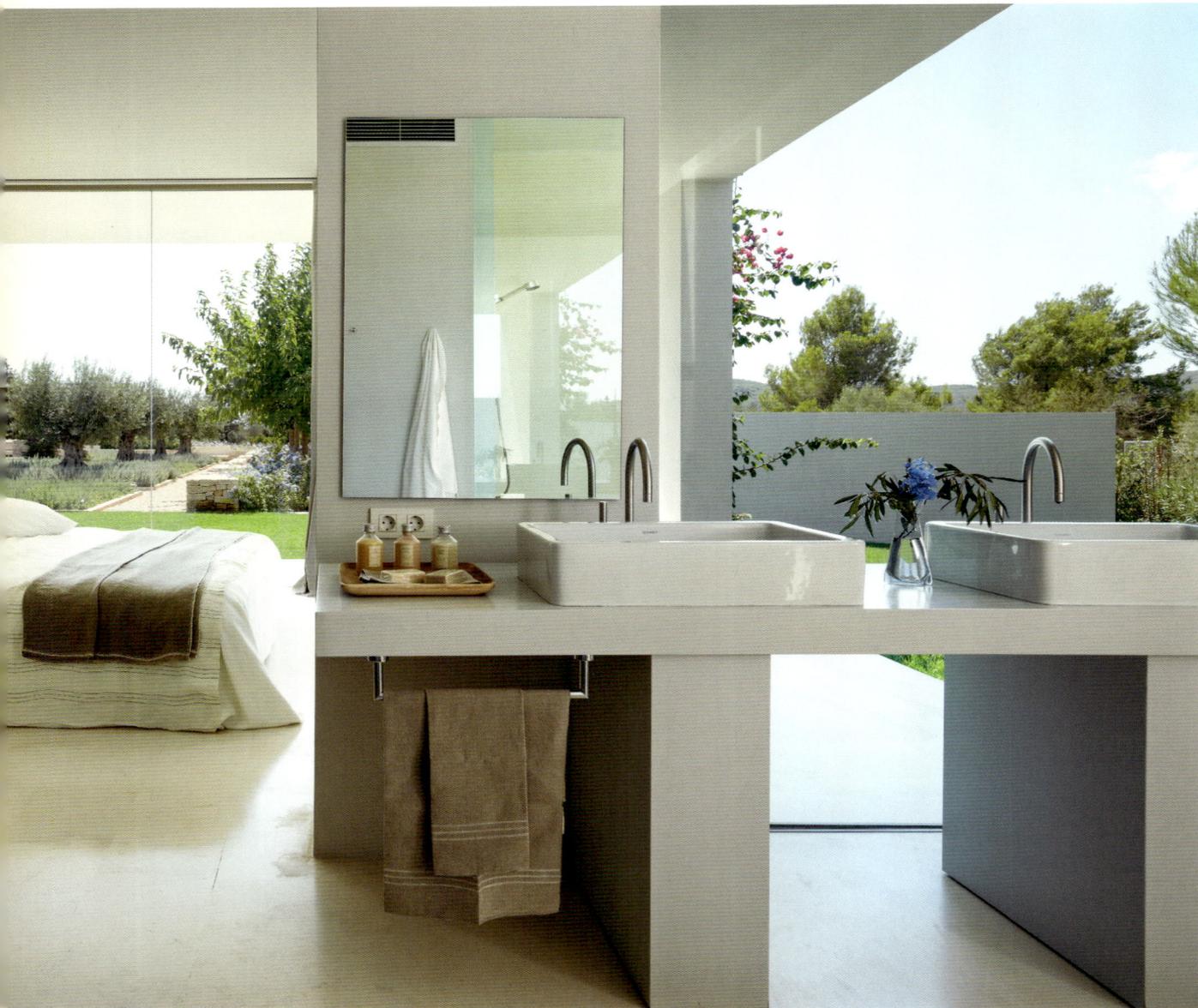

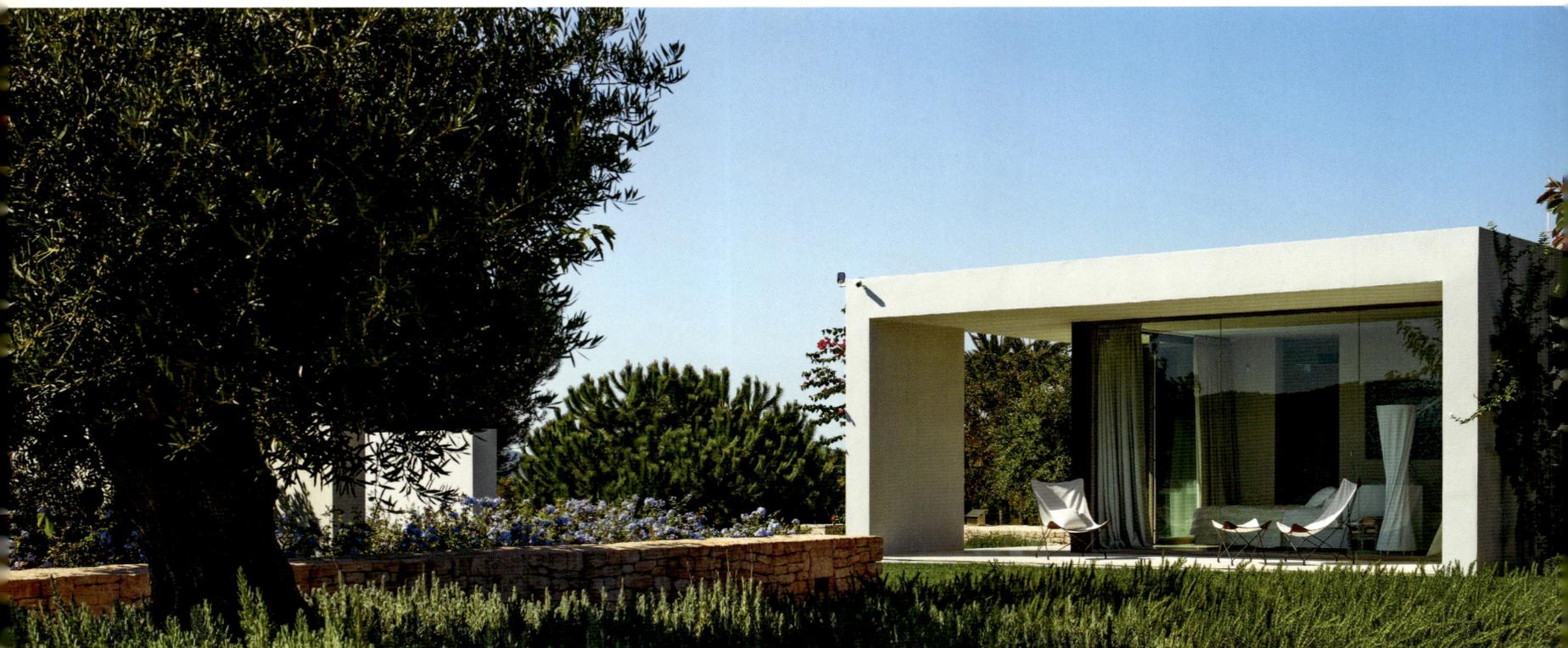

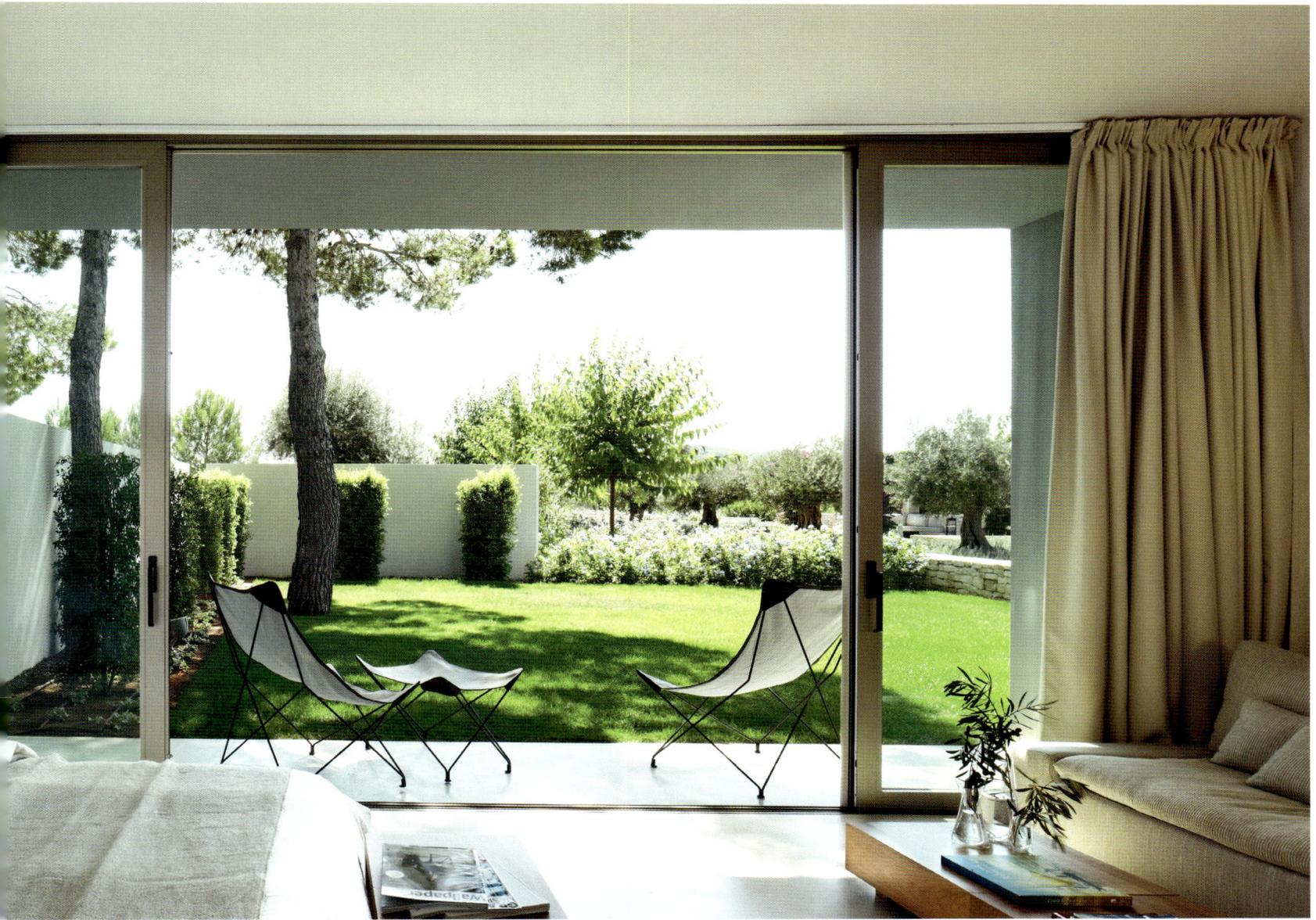

*Butterfly chairs stand on one of the lower guest terraces. Continuous glass façades in the adjacent bathroom provide an unobstructed view of the gardens.*

*Butterfly Chairs auf einer der unteren Gästeterrassen. Vom angeschlossenen Bad geben die durchgehenden Glasfronten den Blick frei auf die Gartenanlagen.*

*Sillas mariposa en una de las terrazas inferiores de huéspedes. Desde el baño contiguo, los ventanales abren una amplia panorámica del jardín.*

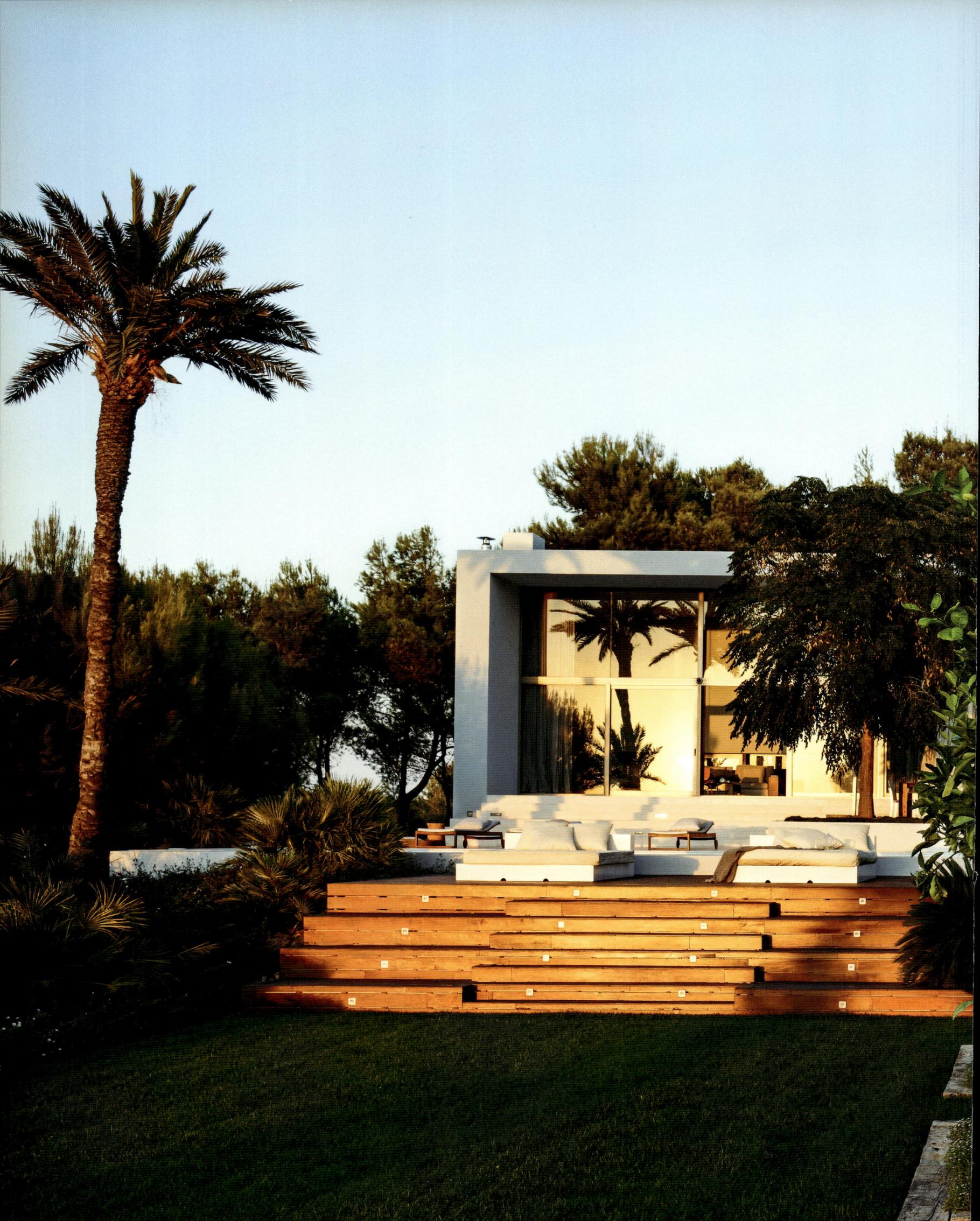

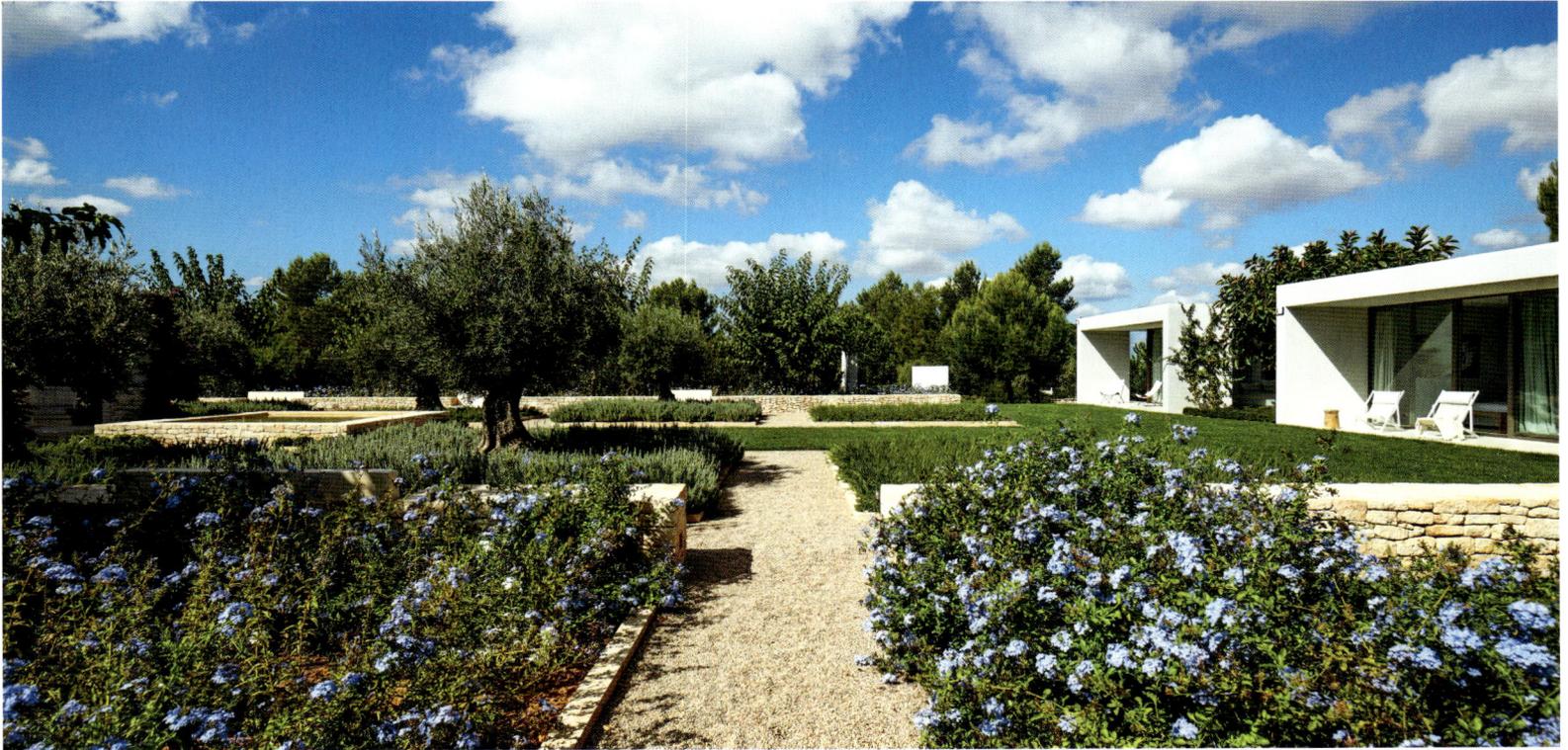

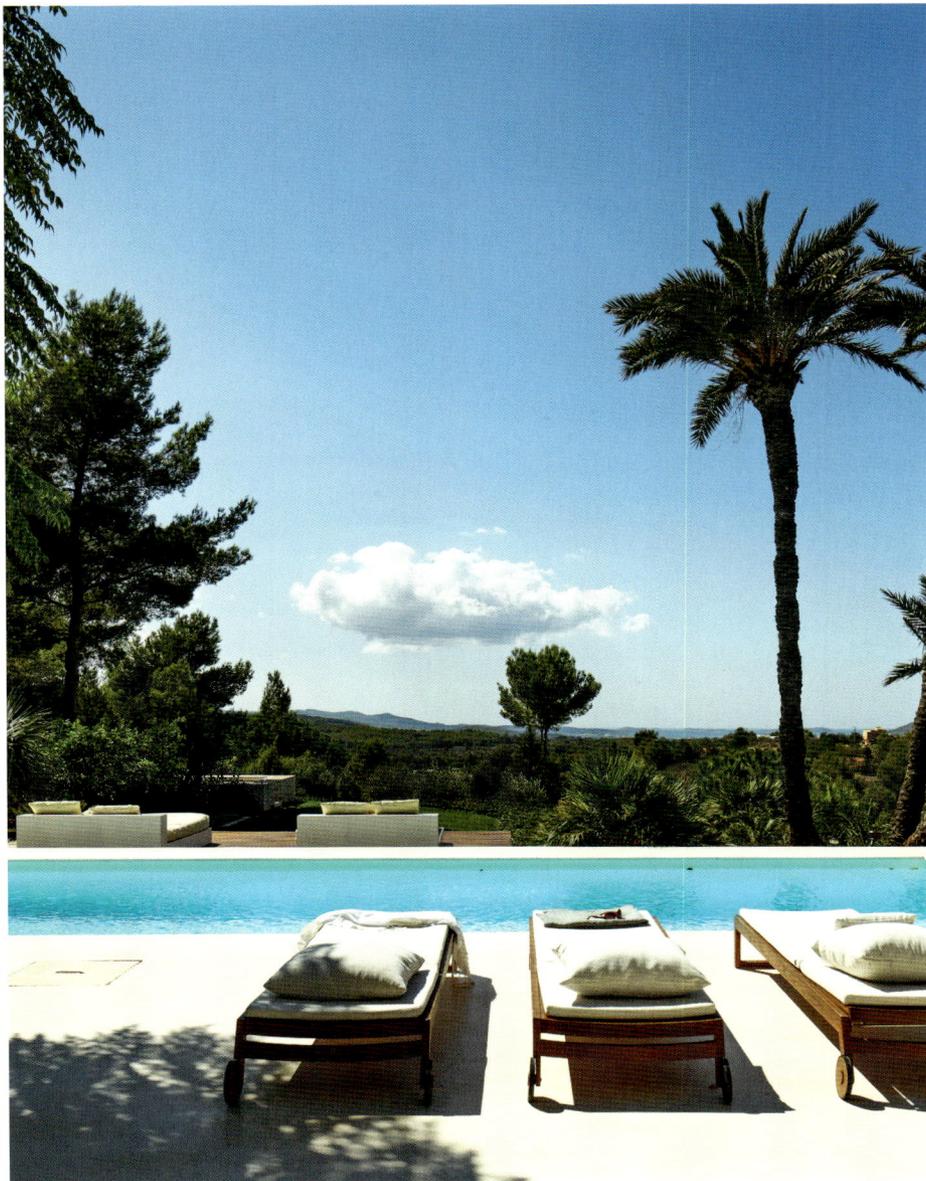

A wooden staircase leads to the main terrace with its double daybeds for sunbathing. Secret hideaways that invite you to sit and relax can be found all over the property.

*Eine Holztreppe führt zur Hauptterrasse mit doppelten Sun-Daybeds. Auf dem ganzen Grundstück findet man abgeschiedene Refugien zum Entspannen.*

*Una escalera de madera conduce a la terraza principal, dotada de diversas tumbonas dobles. En toda la propiedad pueden encontrarse recoletos remansos de tranquilidad y relax.*

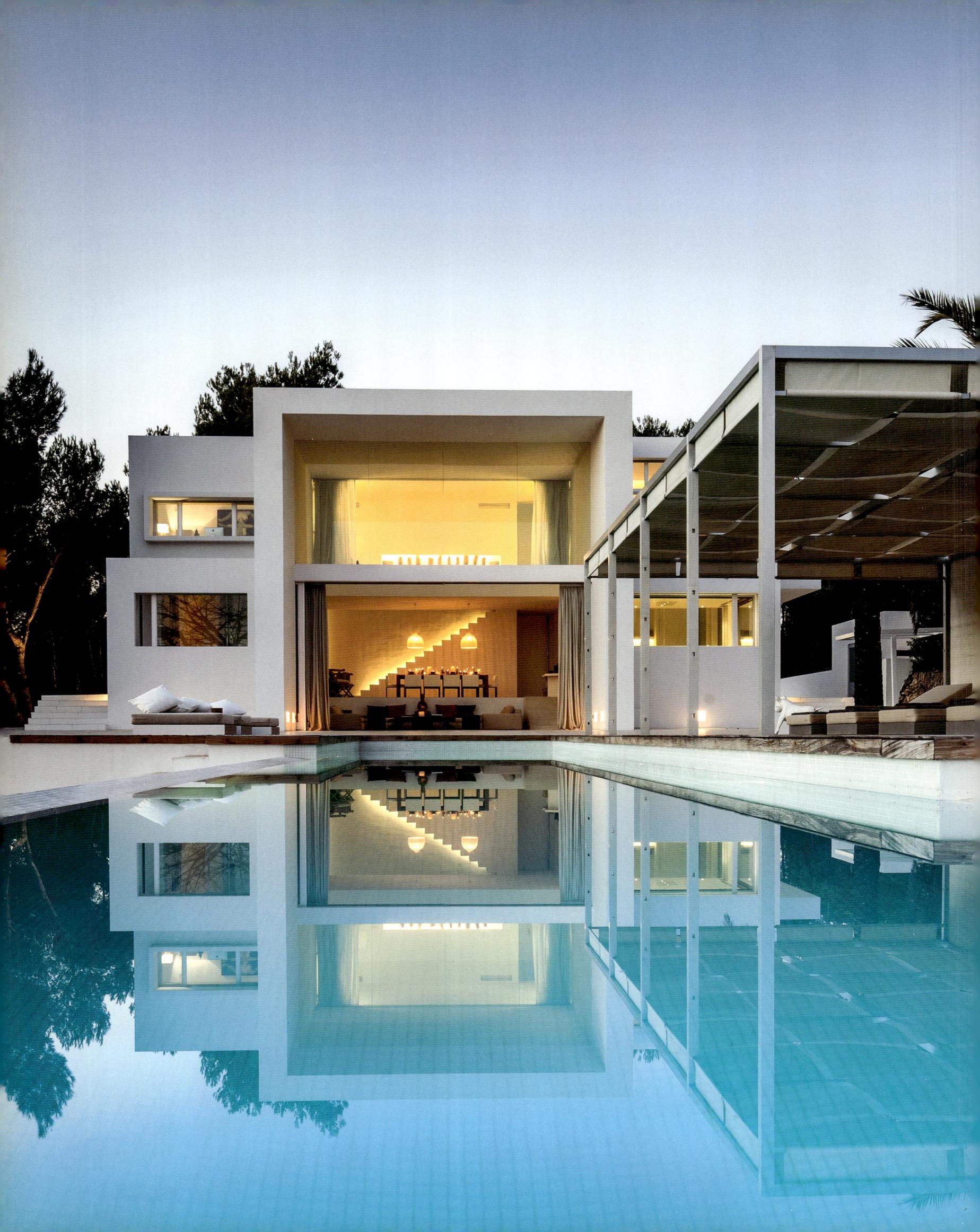

# Casa Libelai

THIS MODERN COUNTRY estate near Santa Gertrudis de Fruitera is the perfect antithesis to the Spanish finca of long-standing tradition and stands out in stark contrast to the surrounding pine forests. Reminiscent of Miami in the 1970s, the home's ambience is sheer minimalism, with open-plan living and dining rooms that open onto a narrow, 66-foot pool, transparent Plexiglas dining chairs, white, futuristic furniture and palm trees in the garden. The four bedrooms offer delightful views of Ibiza's landscape and its sister island Formentera. Built in 2004 by a Spanish architect, the house was completely renovated in futuristic style and furnished in state-of-the-art comfort—the work of London-based interior designer Karina Kieffer. The living area in the main house features two-story ceilings and a glass façade with sliding doors, while the 1,076-square-foot master suite opens onto a spacious terrace with an outdoor shower and a view of Formentera.

DAS MODERNE LANDANWESEN in der Nähe von Santa Gertrudis de Fruitera stellt die komplette Antithesis zur klassisch-traditionellen spanischen Finca dar und steht in starkem Kontrast zu den umliegenden Pinienwäldern. Mit seinem Look des Miami der 1970er ist es Minimalismus pur: Open-Plan-Wohn- und Essbereiche, die auf den 20 Meter langen, schmalen Pool hinausführen, durchsichtige Perspex-Essstühle, weiße, futuristische Möbel und Palmen im Garten. Aus den vier Schlafzimmern genießt man die Aussicht auf die ibizenkische Landschaft und die Nachbarinsel Formentera. 2004 von einem spanischen Architekten gebaut, wurde das Haus 2012 in einem futuristischen Stil komplett renoviert und mit State-of-the-art-Komfort neu ausgestattet. Hierfür zeichnet sich die in London ansässige Interior Designerin Karina Kieffer verantwortlich. Doppelte Deckenhöhe und eine Glasfront mit Schiebetüren zeichnen den Wohnbereich im Haupthaus aus. Die Mastersuite mit ihren 100 m$^2$ bietet eine weitläufige Terrasse mit Außendusche und Blick auf Formentera.

ESTA MODERNA MANSIÓN rural en las proximidades de Santa Gertrudis de Fruitera constituye la más completa antítesis de la finca española tradicional y se alza en marcado contraste con los pinares que la rodean. Su absoluto minimalismo es reminiscente del Miami de los años setenta, con un comedor y una sala de estar fundidos en un amplísimo espacio abierto hacia la estrecha piscina de 20 metros de largo, sillas de comedor de Perspex, futuristas muebles blancos y palmeras en el jardín. Desde los cuatro dormitorios es posible disfrutar del paisaje ibicenco, y se divisa incluso la vecina isla de Formentera. Construida en 2004 por un arquitecto español, la casa fue sometida en 2012 a una completa y futurista renovación que la dotó de las últimas comodidades. La responsable del proyecto: la interiorista Karina Kieffer, cuyo despacho tiene su sede en Londres. Las zonas comunes del edificio principal se caracterizan por sus altísimos techos y el enorme ventanal de puertas correderas. La suite principal tiene 100 m$^2$ de superficie e incluye una amplísima terraza con ducha exterior y vistas a Formentera.

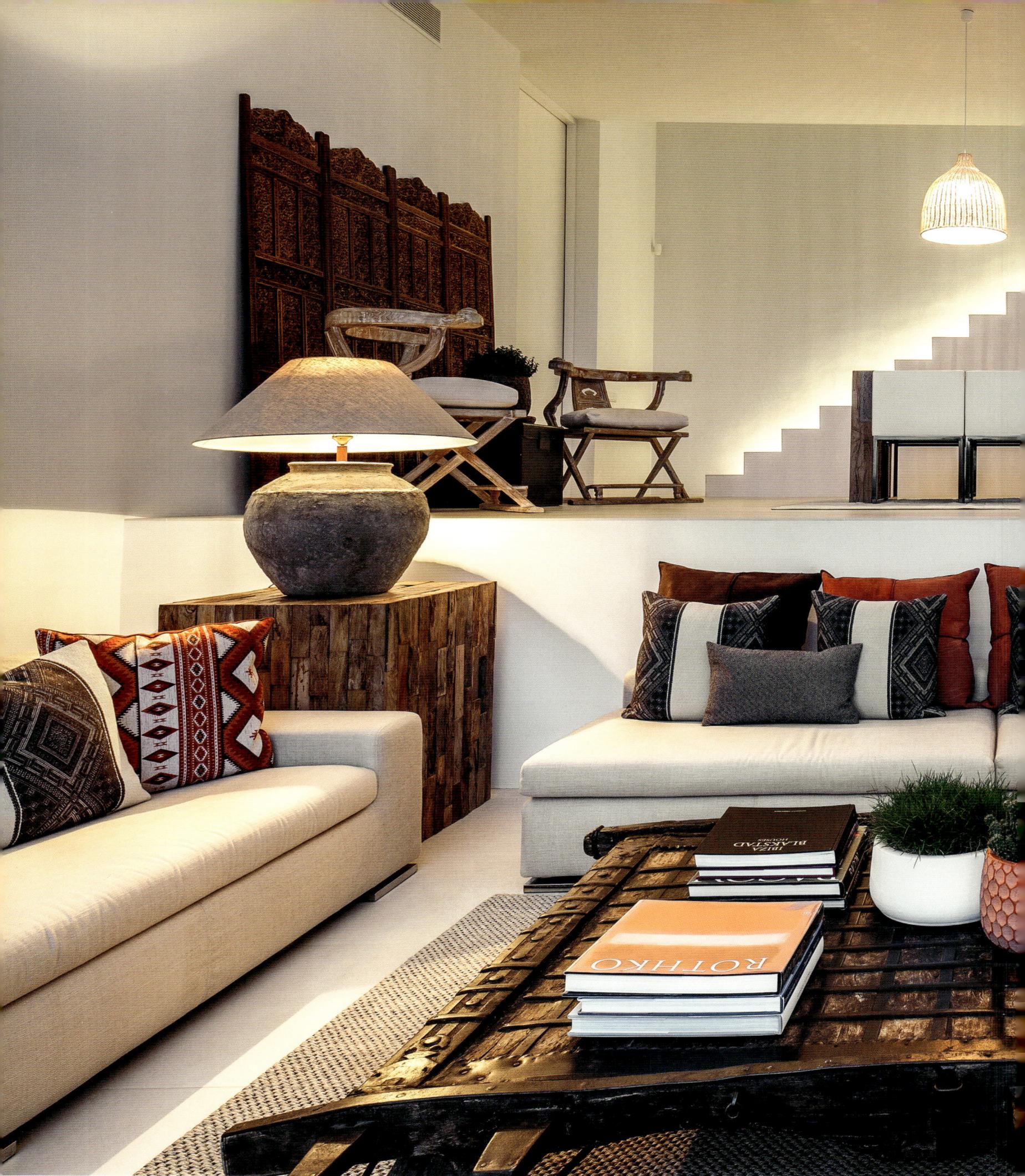

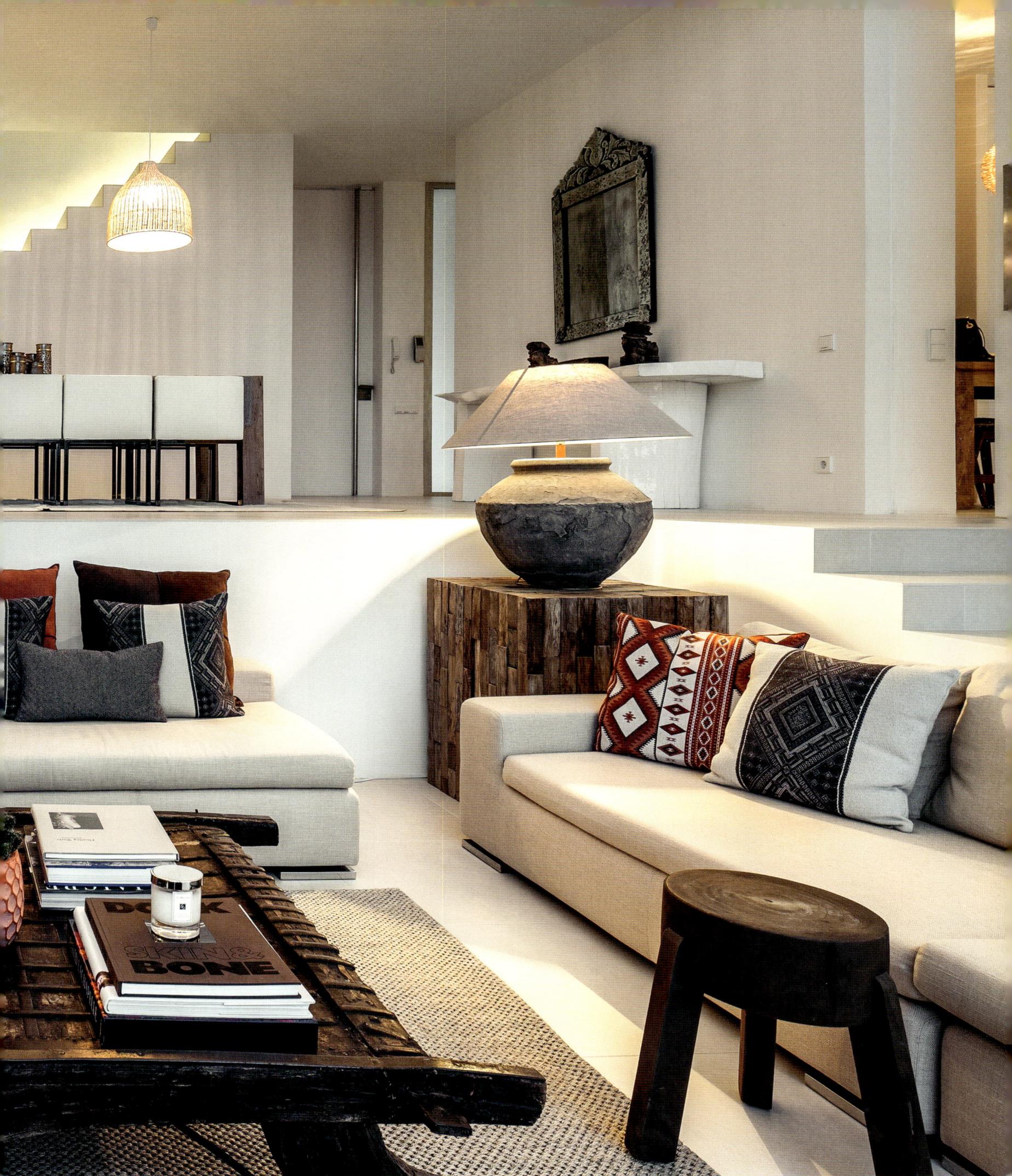

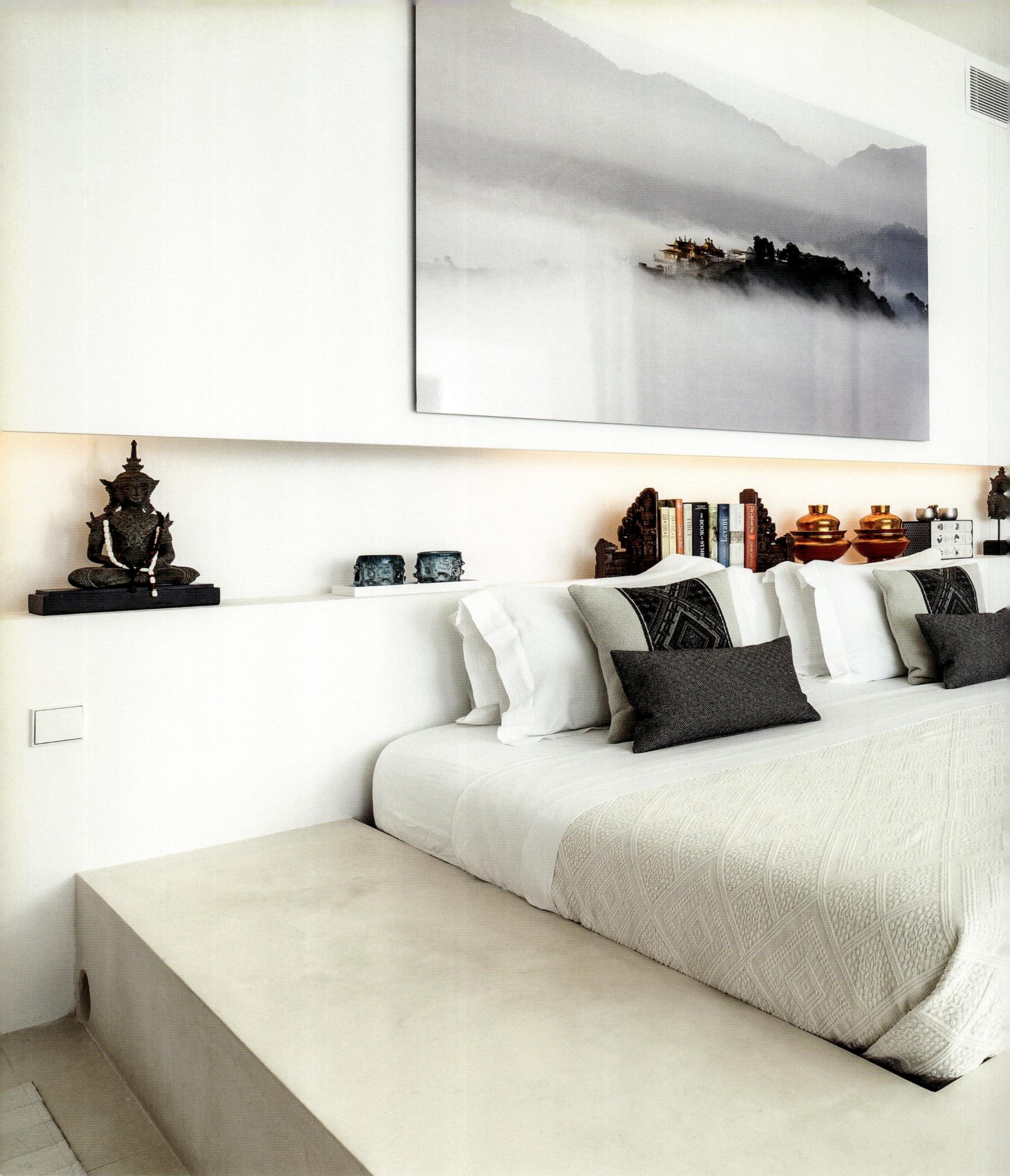

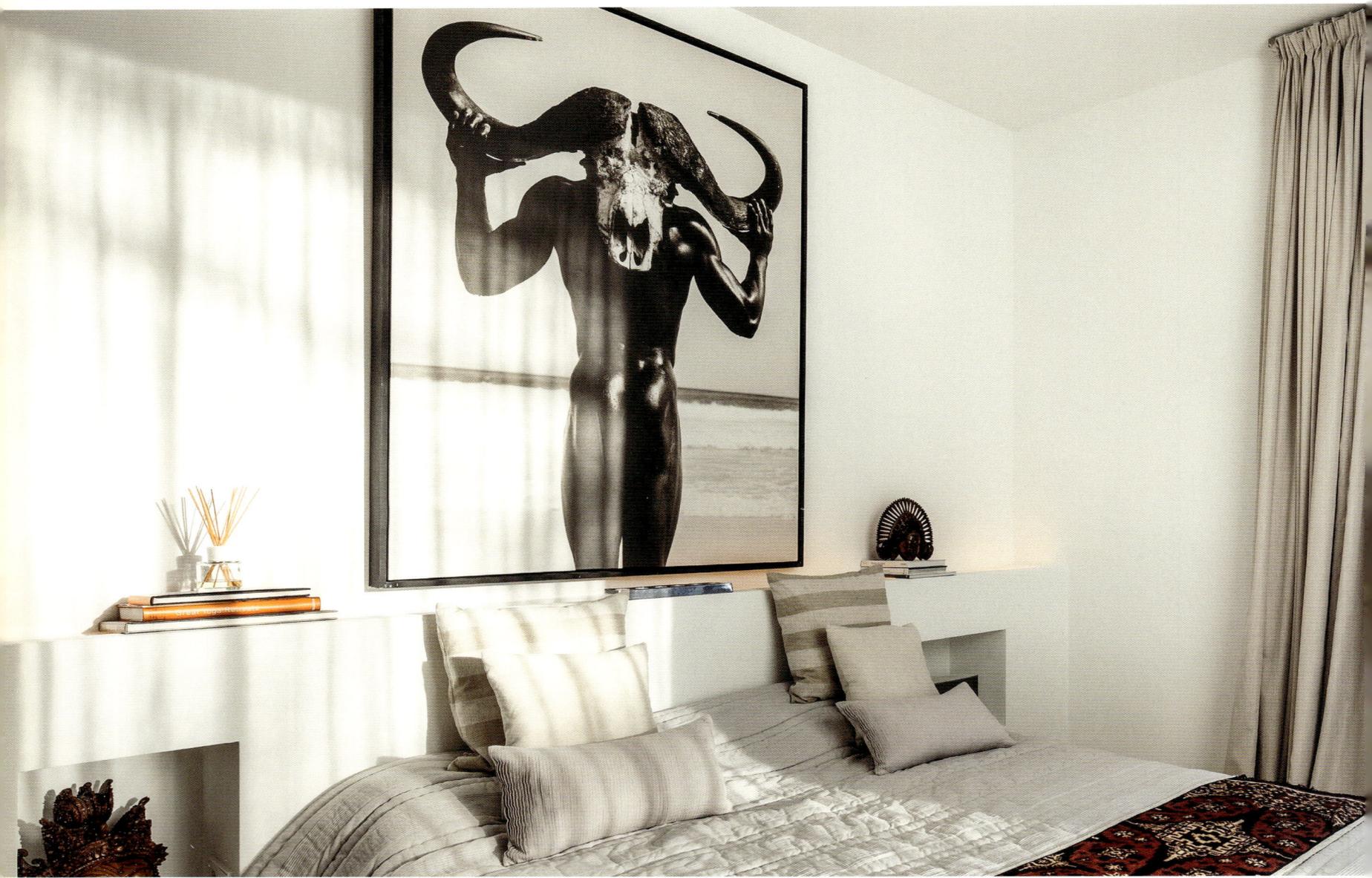

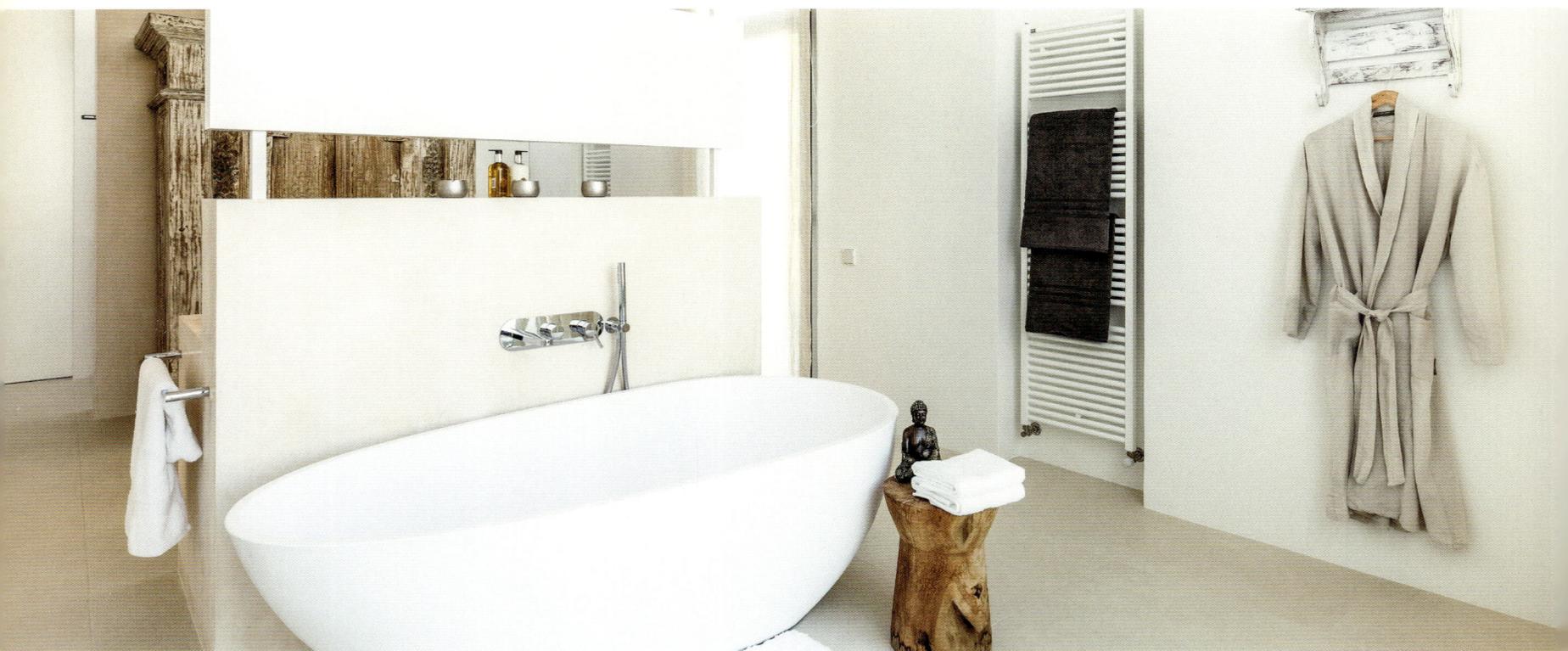

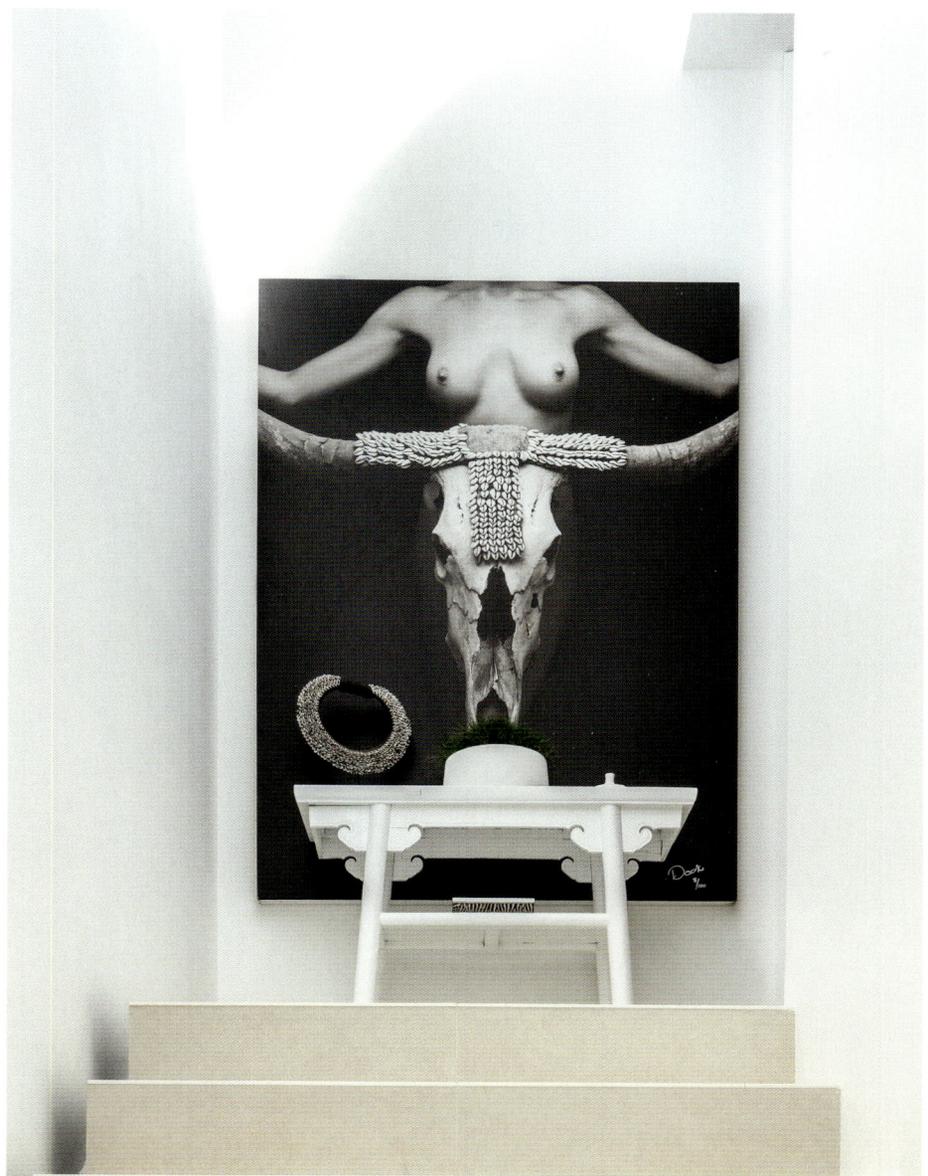

Purist lines and built-in furniture. Archaic art photography from Dook's "Skin and Bone" collection hang above the staircase, and ethnic décor elements dominate the bedroom.

Puristische Linienführung und gemauerte Möbel. Archaische Fotokunst von Dook aus der „Skin and Bone"-Kollektion finden sich im Aufgang und im Schlafzimmer herrschen Dekoelemente im Ethnostil vor.

Purismo en las líneas y muebles de obra. Una fotografía arcaizante de la colección "Skin and Bone" de Dook preside la escalera. En el dormitorio predominan los elementos de decoración étnicos.

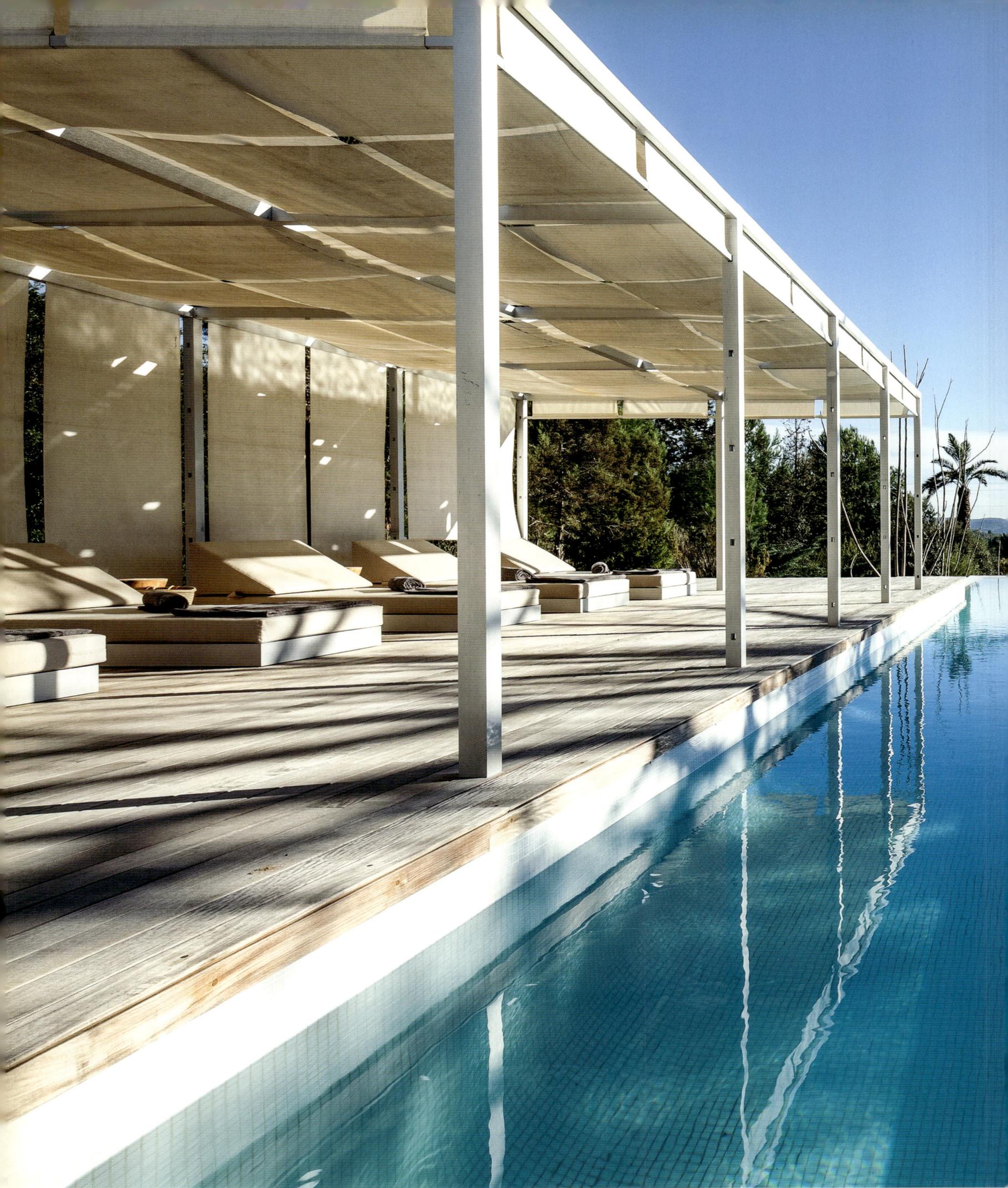

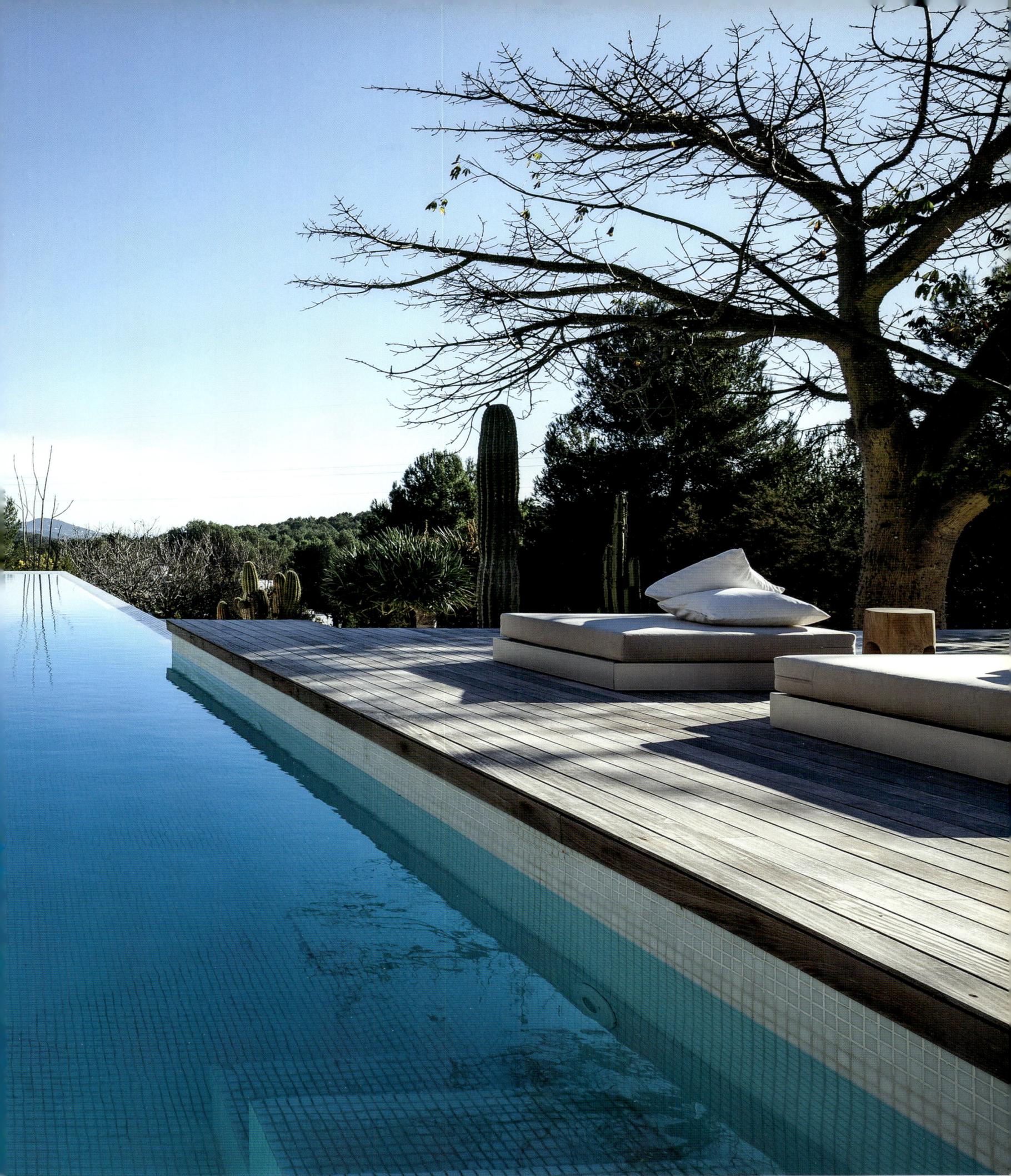

# Neverland

LOCATED NEAR IBIZA'S natural harbor, this house has an utterly unique, futuristic design. Its hedonistic concept incorporates naturalistic elements and provides the perfect setting for impromptu pool parties with an electro dance beat. The architecture's steel construction pushes the boundaries of the ordinary and blends smoothly with the home's hillside location among old-growth pine groves. Green and turquoise, the home's signature colors, repeat throughout all indoor and outdoor areas and re-interpret the hues of the Mediterranean Sea. The modern interior design also reflects the house's ultra-sleek style, with wood elements providing the occasional contrast.

DAS HAUS IM einzigartigen futuristischen Design liegt in der Nähe des Naturhafens von Ibiza. Das hedonistische Konzept des Hauses verbindet Naturalismus und Impromptu-Elektromusik-Partys am Pool. Mit ihrer Stahlkonstruktion geht die Architektur an die Grenzen des Gewohnten und wurde so perfekt in die Hanglage zwischen den alten Pinienbestand eingepasst. Mit den beiden Farben Grün und Türkis, die sich durch alle Innen- und Außenbereiche ziehen, werden die Töne des Mittelmeers neu interpretiert. Auch in der modernen Inneneinrichtung findet sich das Ultra-sleek-Design wieder, das nur vereinzelt durch Holzelemente aufgebrochen wird.

CERCA DEL PUERTO natural de Ibiza se alza esta casa de futurista diseño. El hedonismo que se respira en su mismo concepto aúna naturalidad y espontáneas fiestas *tecno* en torno a la piscina. La estructura de acero lleva el diseño arquitectónico hasta los límites de lo habitual y se encuadra perfectamente en la ladera abierta en la antigua pineda. Dos colores, verde y turquesa, definen tanto el exterior como el interior de la casa y redefinen las tonalidades del Mediterráneo en un diseño ultra-atrevido e interrumpido sólo aquí y allá por elementos de madera.

The kitchen/dining area reflects the home's signature colors. The stainless steel columns emphasize its futuristic design. Art photography hangs in the bedroom, and classic design elements create an unusual color palette.

*Küche mit Essbereich in den Hausfarben. Das futuristische Design wird durch die Edelstahlträger noch verstärkt. Fotokunst im Schlafzimmer und Designklassiker in ungewohnter Farboptik.*

*Cocina y área de comidas en los colores de la casa. Las vigas de acero no aleado refuerzan el aire futurista del diseño. En el dormitorio, fotografías y clásicos del diseño de colorido poco habitual.*

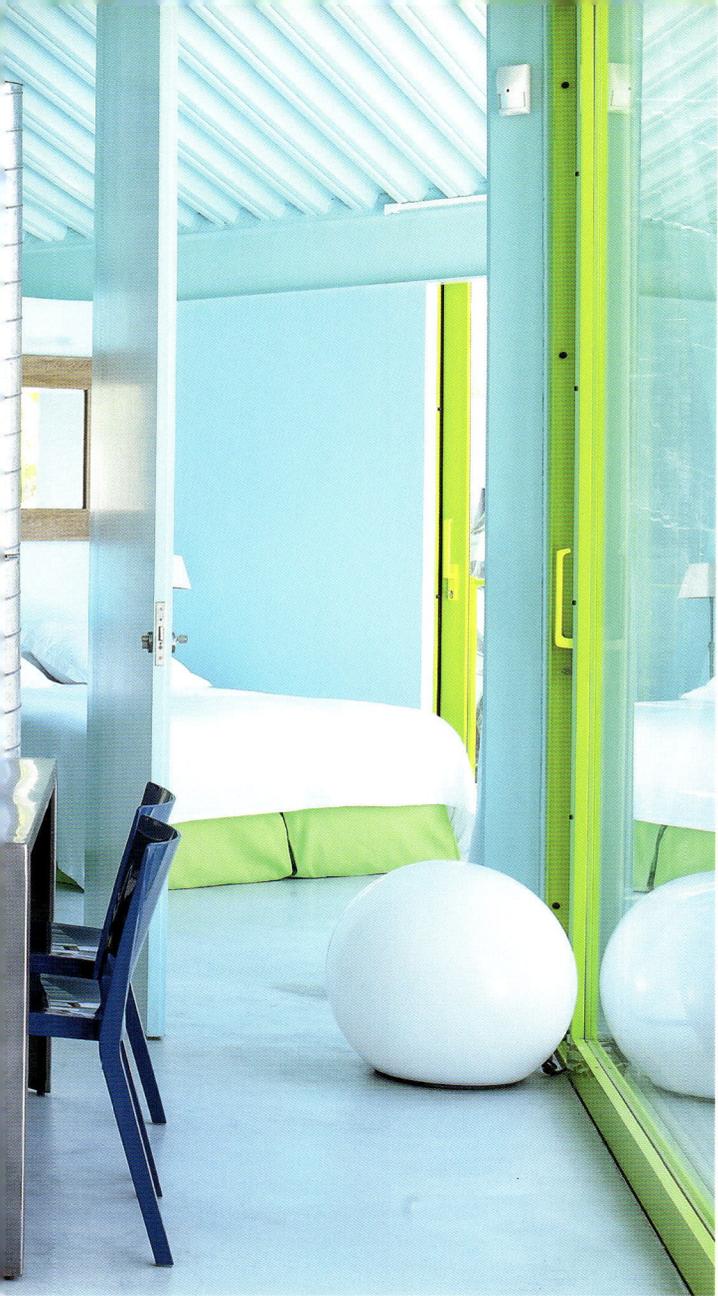
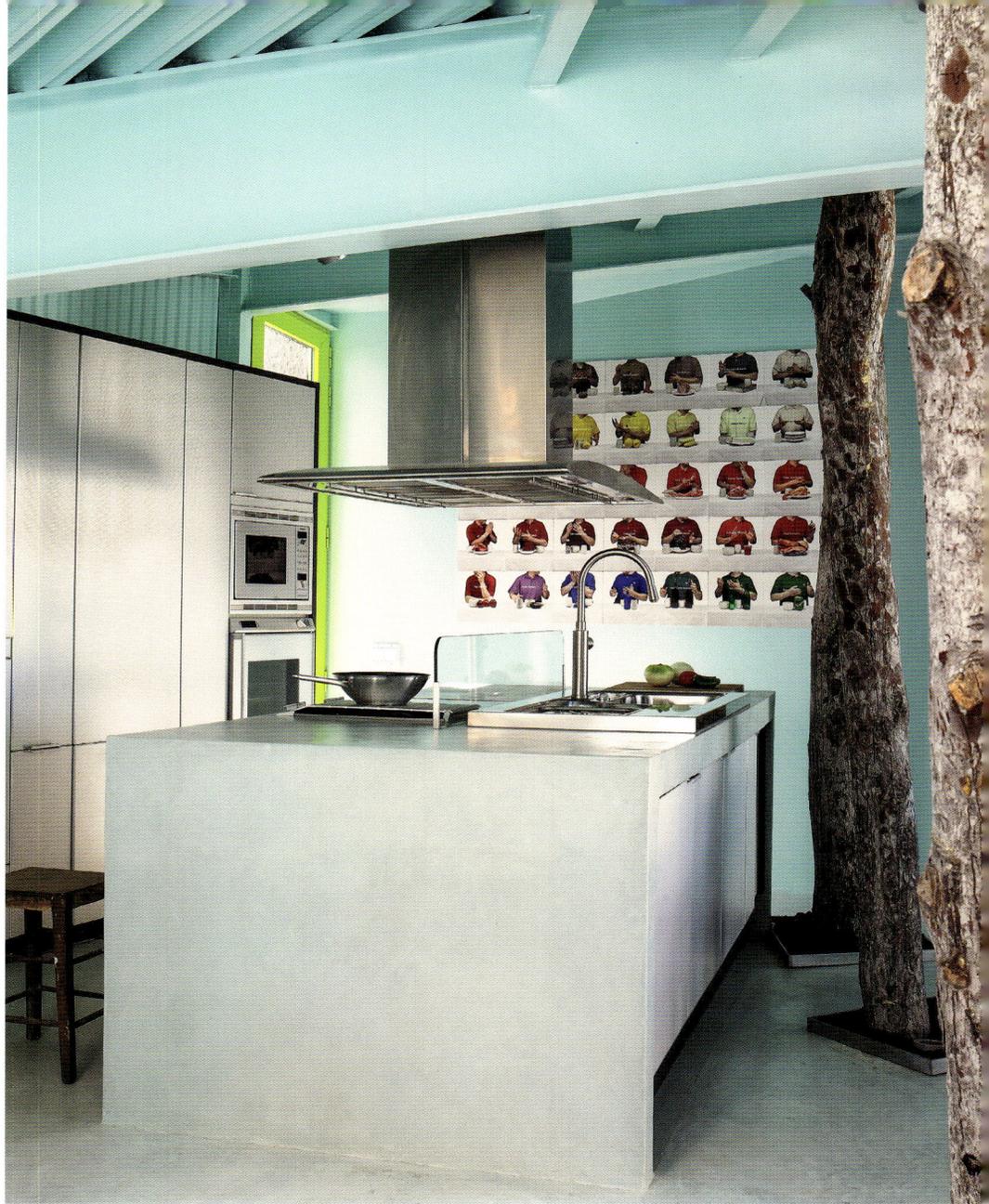
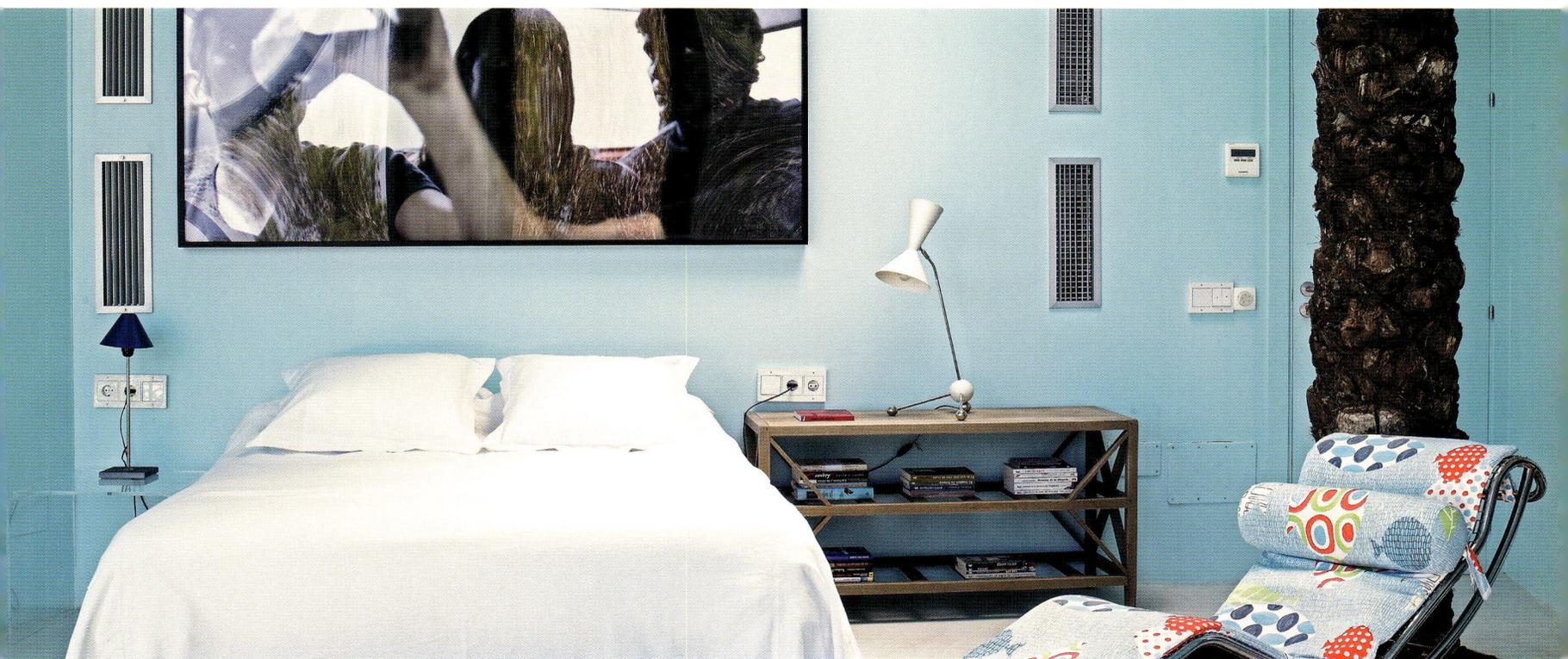

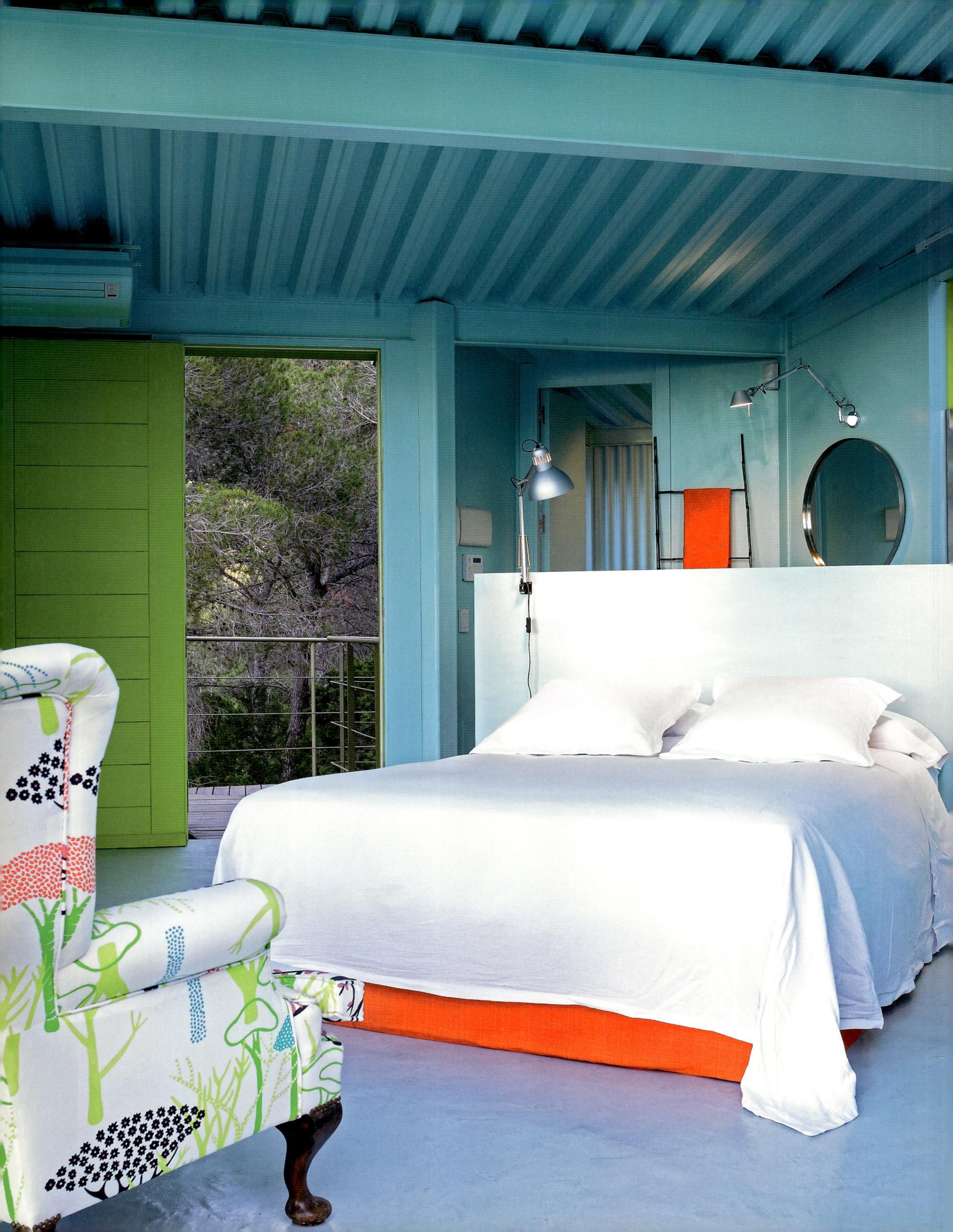

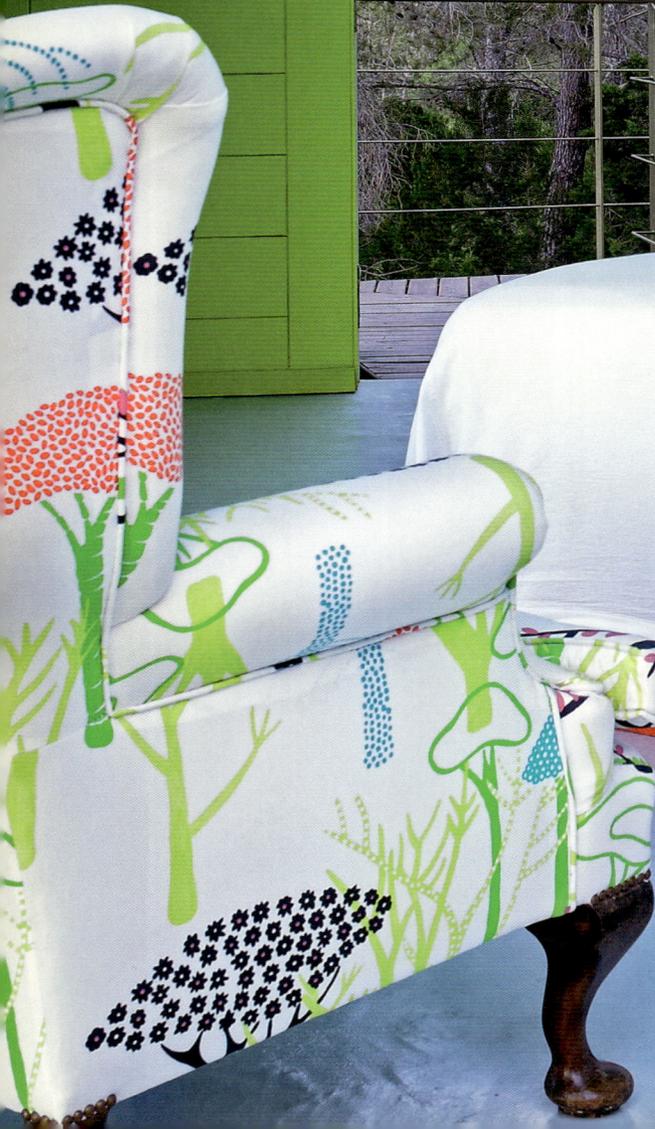

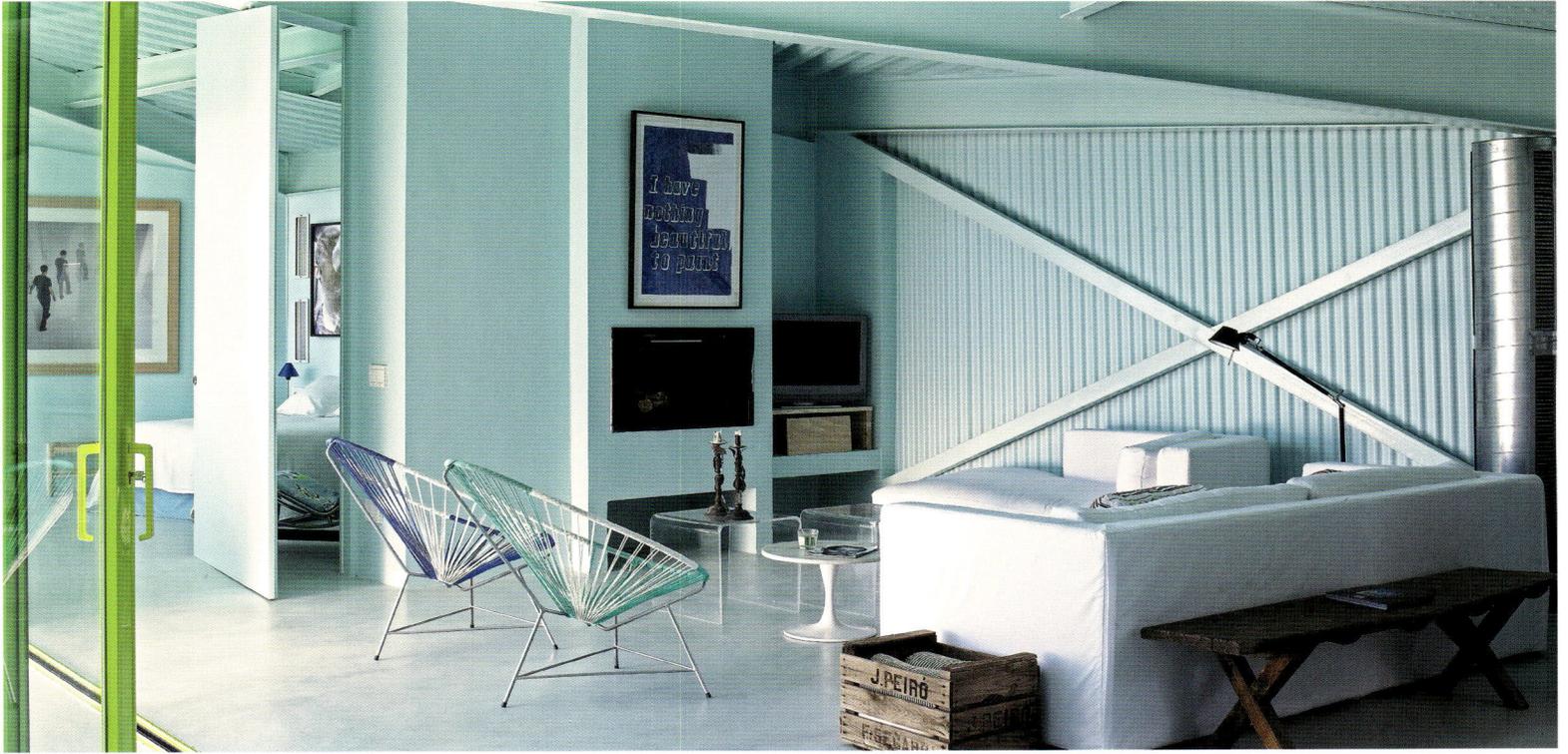

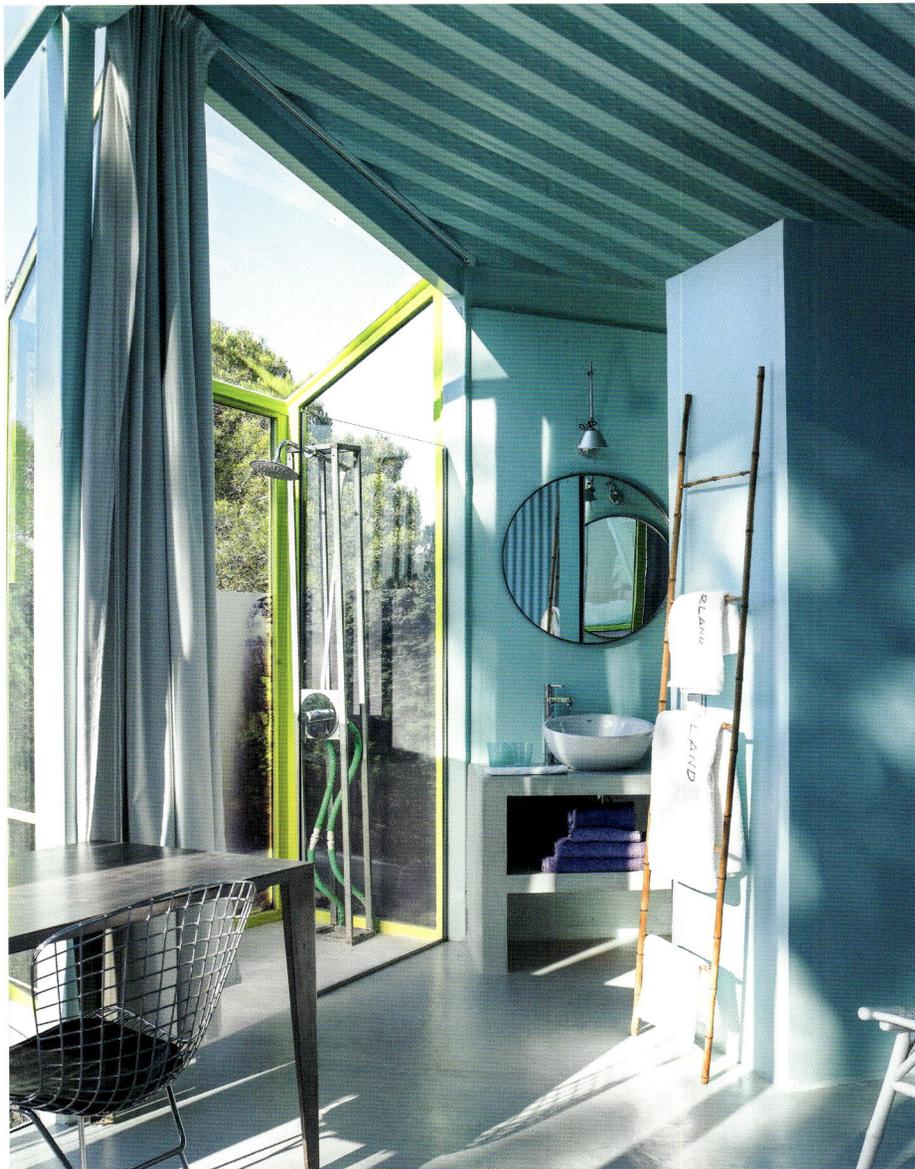

Like elsewhere in the house, the bedroom and its integrated bathroom blend the interior spaces with the outdoors. Standing in the shower, you feel enveloped by nature.

Im Schlafzimmer mit integriertem Bad gehen die Innen- und Außenbereiche – wie im ganzen Haus – fließend ineinander über. Die Dusche vermittelt das Gefühl, in der Natur zu stehen.

En el dormitorio (con baño integrado), interiores y exteriores se funden en un todo fluido. La ducha transmite la impresión de encontrarnos en un entorno natural.

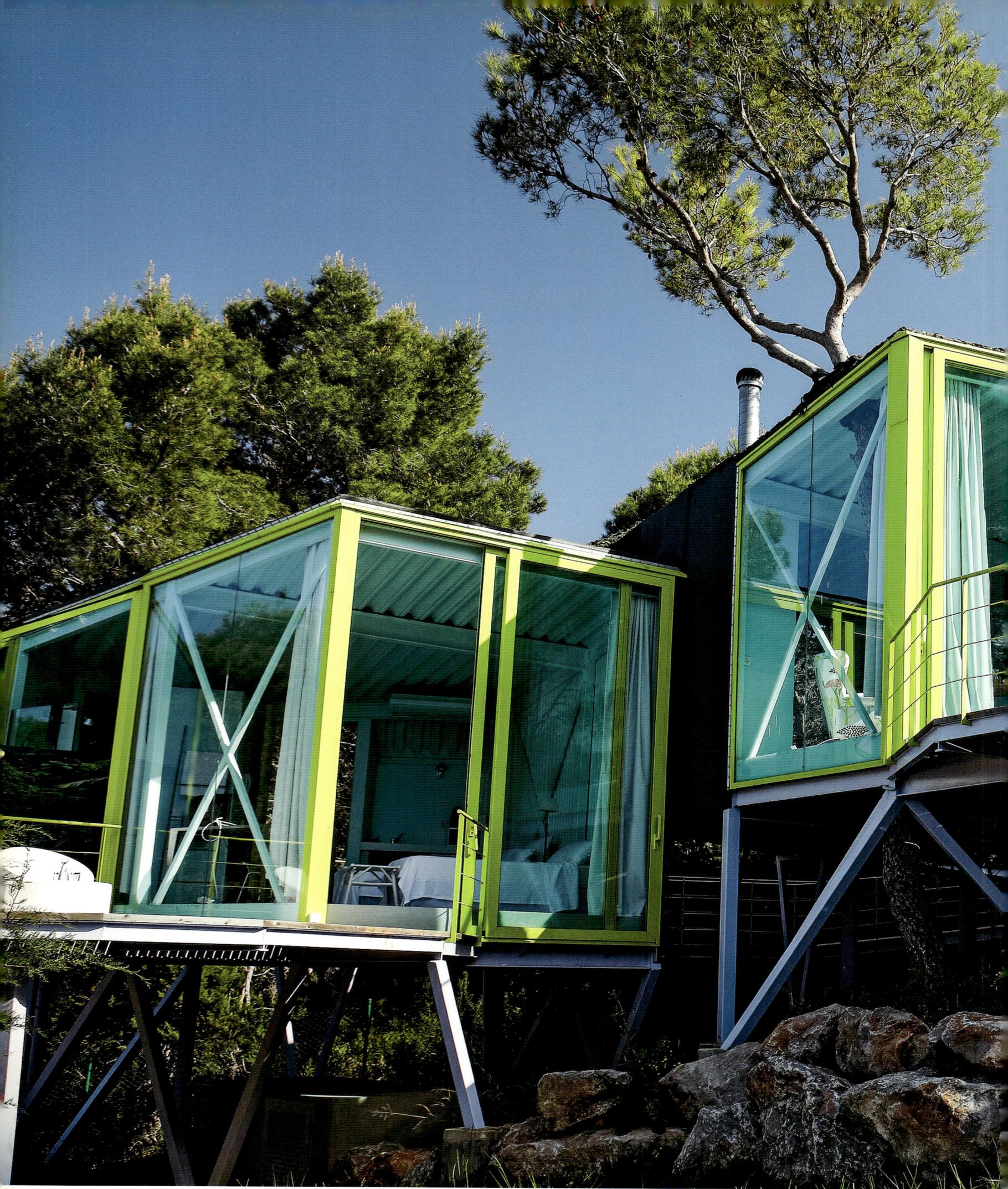

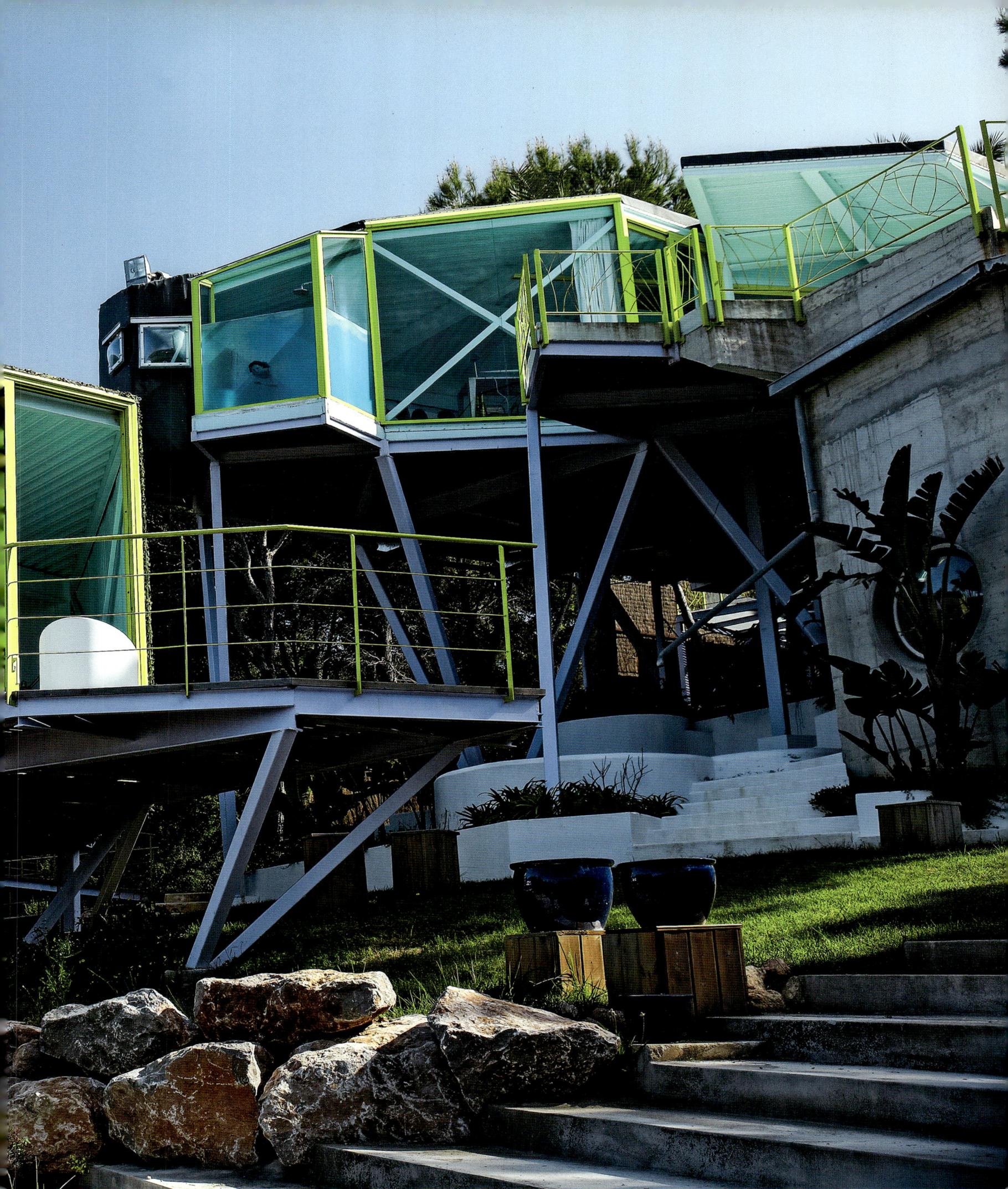

# KavaKava

THE OWNER OF this property dreamed of creating his own idyllic retreat on the island. The home's interior combines modern influences with Spanish elements alongside Asian art. Situated in the middle of lush, almost tropical gardens, the house is a secluded oasis of tranquility. Shady terraces surround crystal-clear, blue pools and a lovingly landscaped garden. The spacious interior rooms are framed by paneling made of warm tropical wood, and the extensive art collection features Asian, African and contemporary art.

DER TRAUM DER Besitzer war es, einen idyllischen Rückzugsort auf der Insel zu schaffen. Das Interieur verbindet modernistische Einflüsse mit spanischen Elementen sowie asiatischer Kunst. Inmitten seiner üppigen, fast tropischen Gartenvegetation ist das Haus eine Oase der absoluten Zurückgezogenheit und Stille. Die kristallblauen Pools und der liebevoll angelegte Garten sind von Schatten spendenden Terrassen umgeben. Die weitläufigen Innenräume werden durch Vertäfelungen aus warmem Tropenholz eingerahmt und die umfangreiche Kunstsammlung durch asiatische, afrikanische und zeitgenössische Kunst bestimmt.

EL PROPIETARIO DE la casa soñaba con crear un idílico refugio en la isla. En el interior se combinan influencias modernistas y elementos hispanos con obras de arte asiático. Rodeada por un jardín de vegetación exuberante, casi tropical, la residencia es un oasis de recogimiento y silencio. Las cristalinas piscinas y el cuidadísimo jardín están rodeados por terrazas en las que descansar a la sombra. Los amplios espacios interiores están rematados por cálidas paredes recubiertas de maderas tropicales, y la extensa colección de arte incluye piezas asiáticas, africanas y contemporáneas.

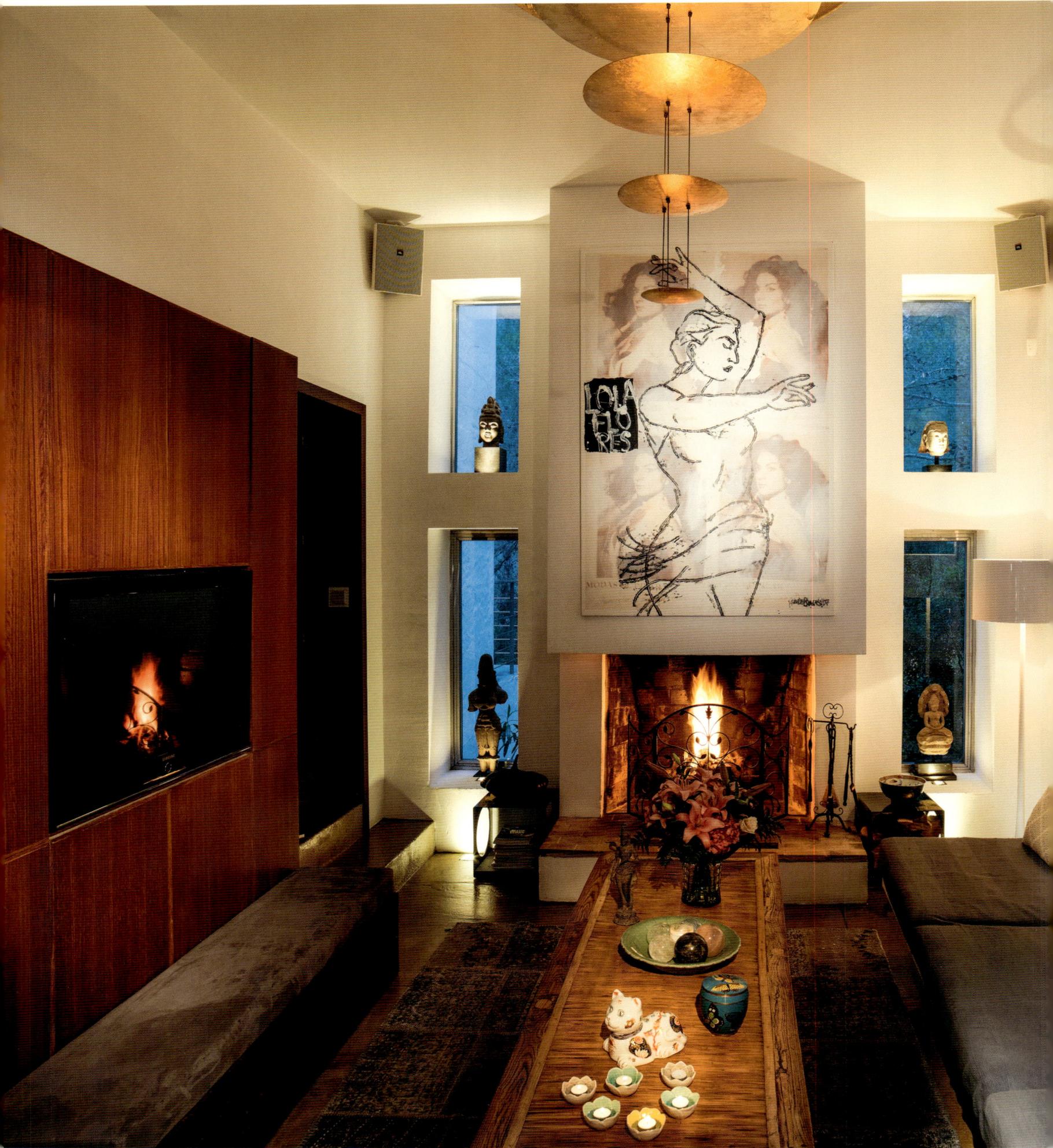

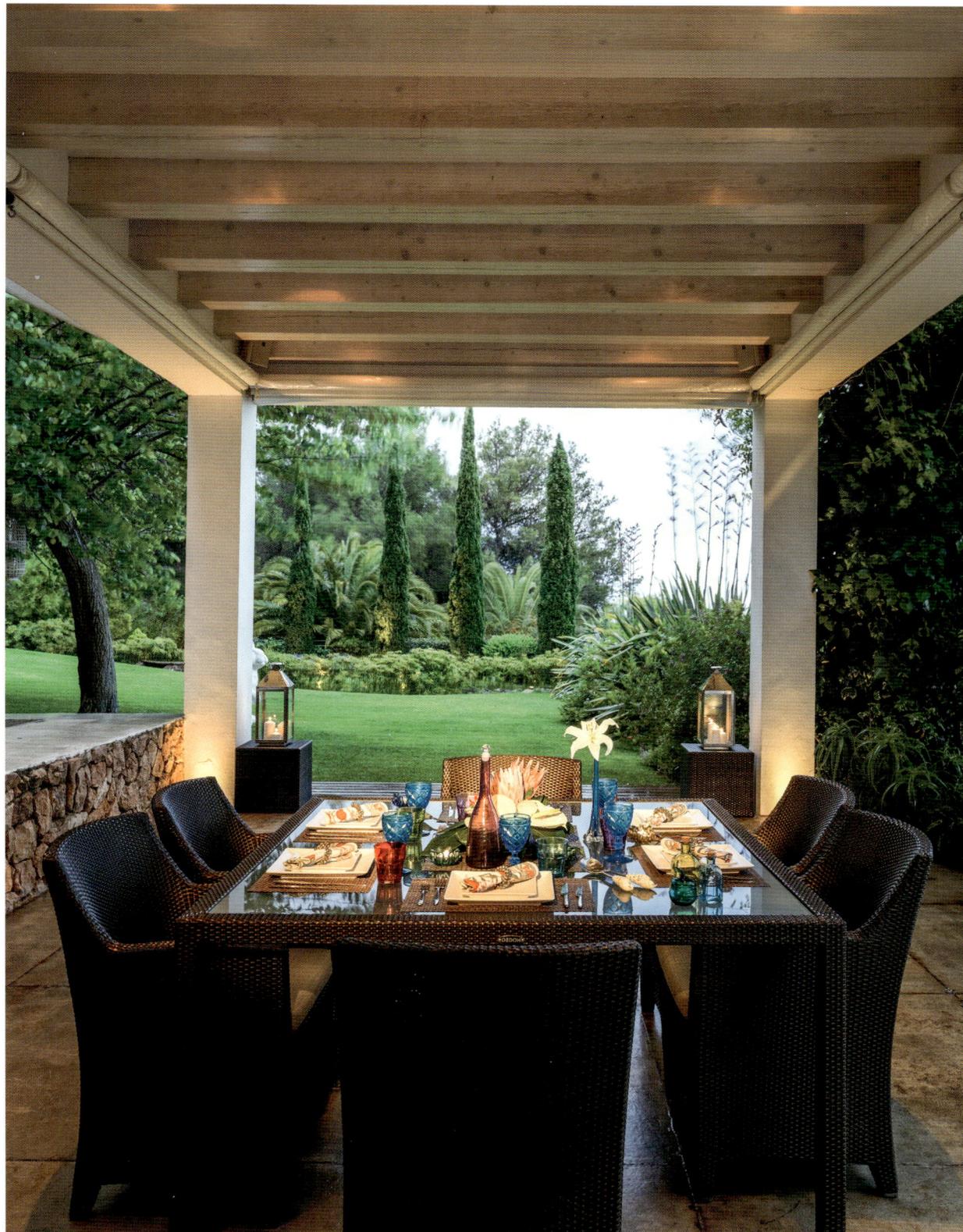

A shady pergola stands in the garden, and the fireplace lounge is decorated in warm wood hues. Contemporary art from the owner's collection hangs above the fireplace.

*Schatten spendende Pergola im Garten und das Kaminzimmer in warmen Holztönen. Über dem Kamin ein zeitgenössisches Bild aus der Sammlung des Besitzers.*

*Una pérgola en el jardín en la que relajarse a la sombra; en el interior, una sala enmaderada y de cálidos tonos alberga el hogar. Sobre la chimenea pende un cuadro contemporáneo de la colección del propietario.*

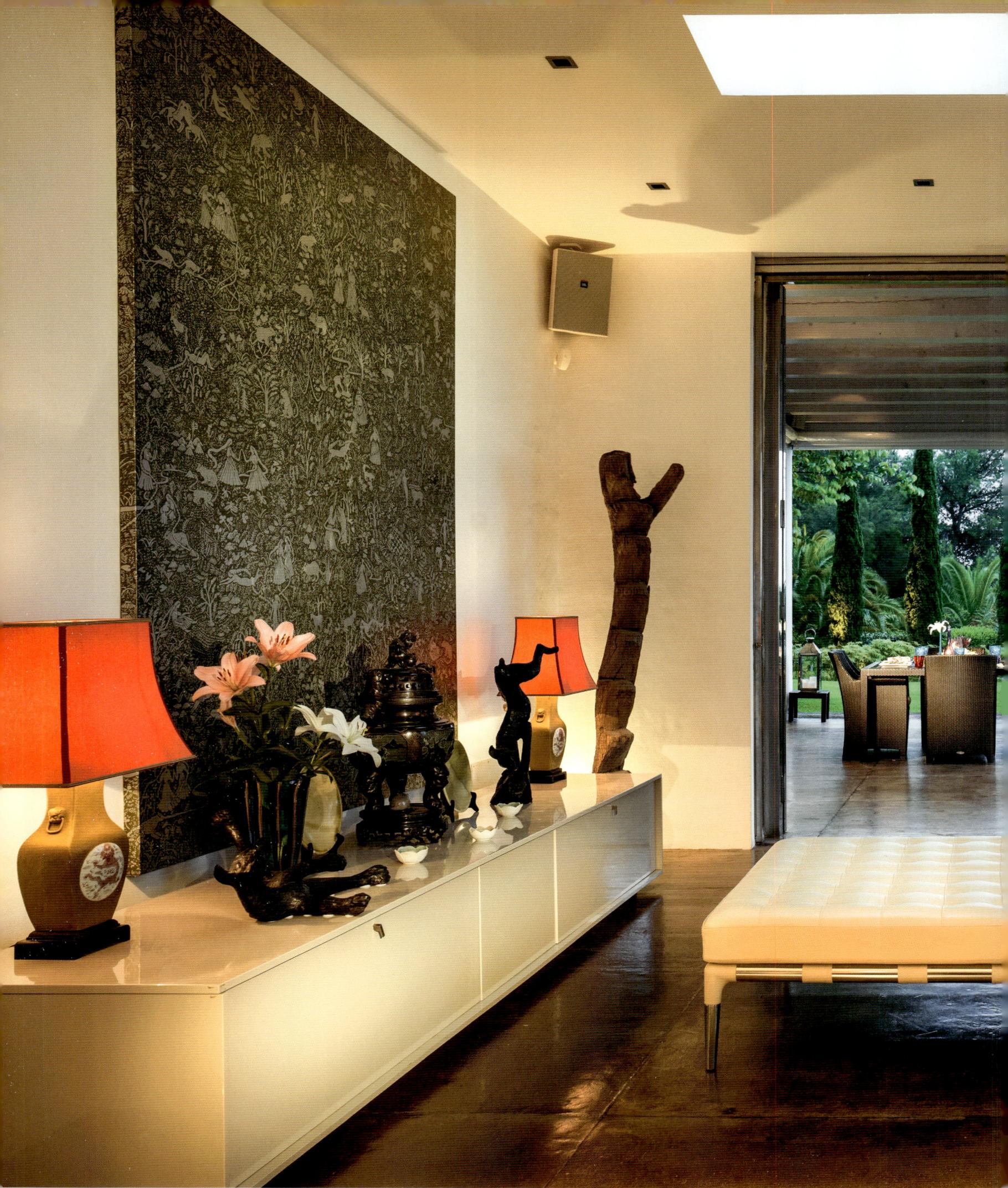

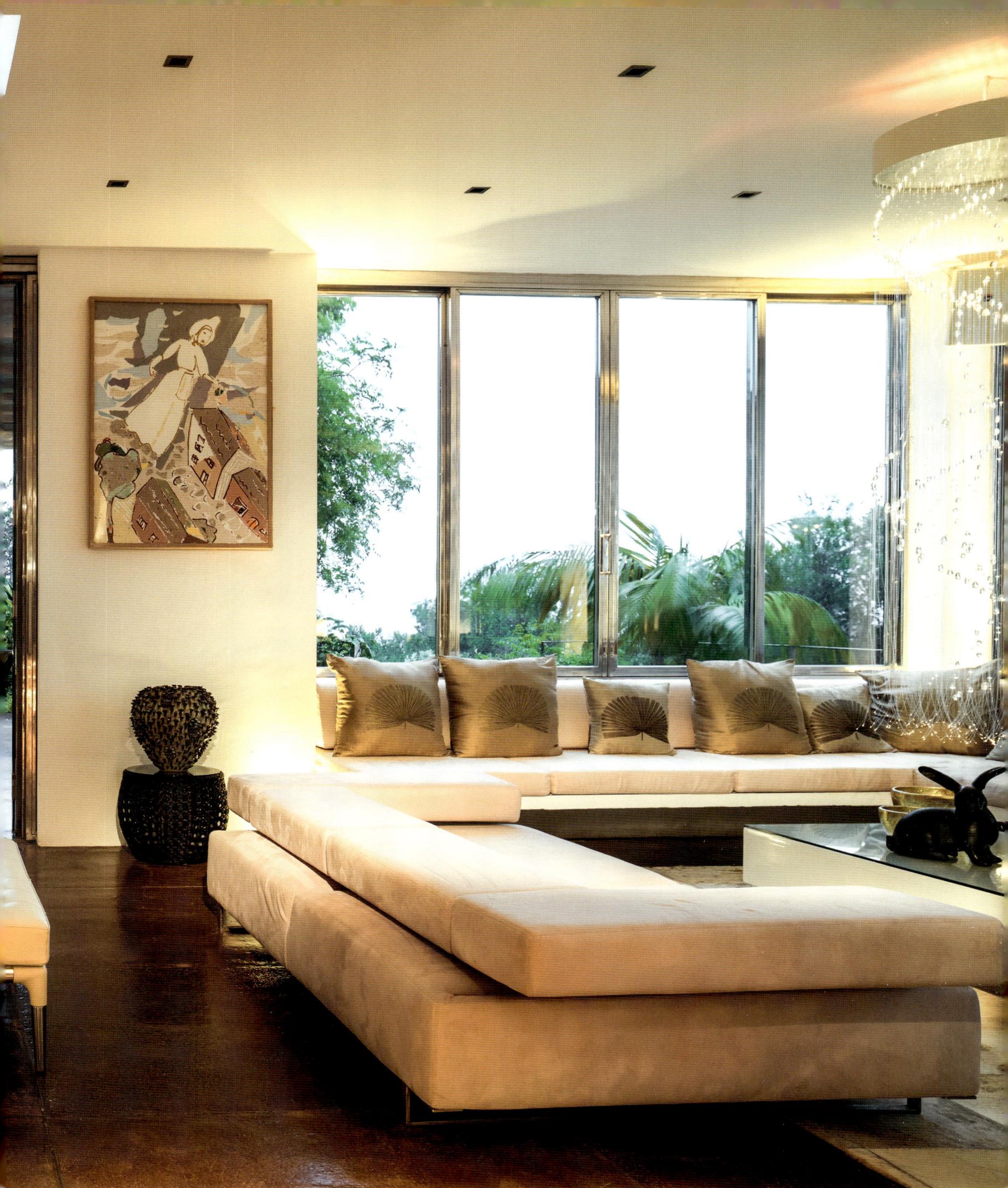

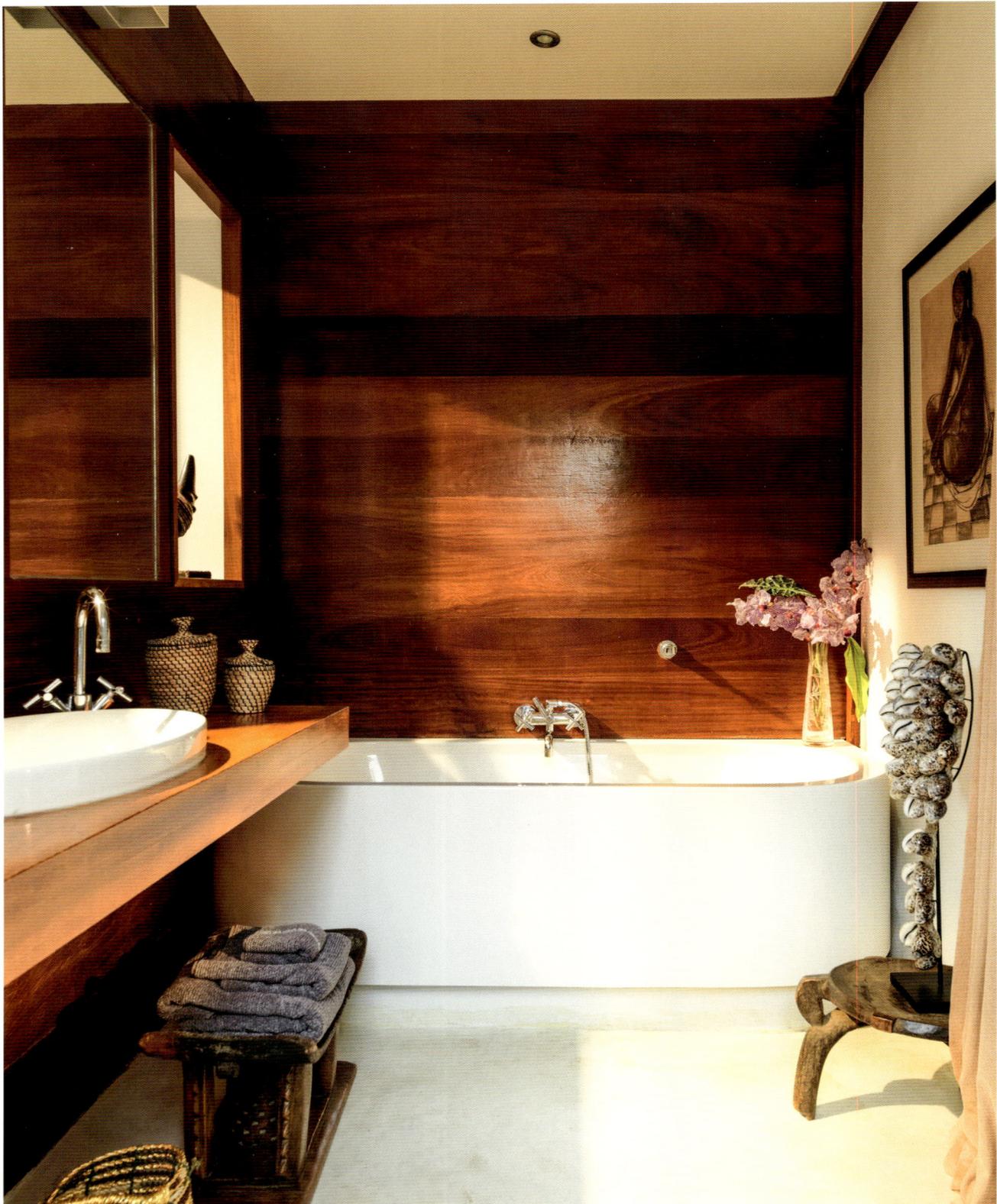

*Tropical woods and other natural materials lend warmth to the rooms. African and Asian exhibits decorate the bathroom and bedroom.*

*Die Verwendung von Tropenhölzern und anderen Naturmaterialien verleiht den Räumen Wärme. Afrikanische und asiatische Exponate dekorieren Bad und Schlafzimmer.*

*El uso de maderas tropicales y otros materiales naturales crea un ambiente cálido en las estancias. Piezas africanas y asiáticas decoran baños y dormitorios.*

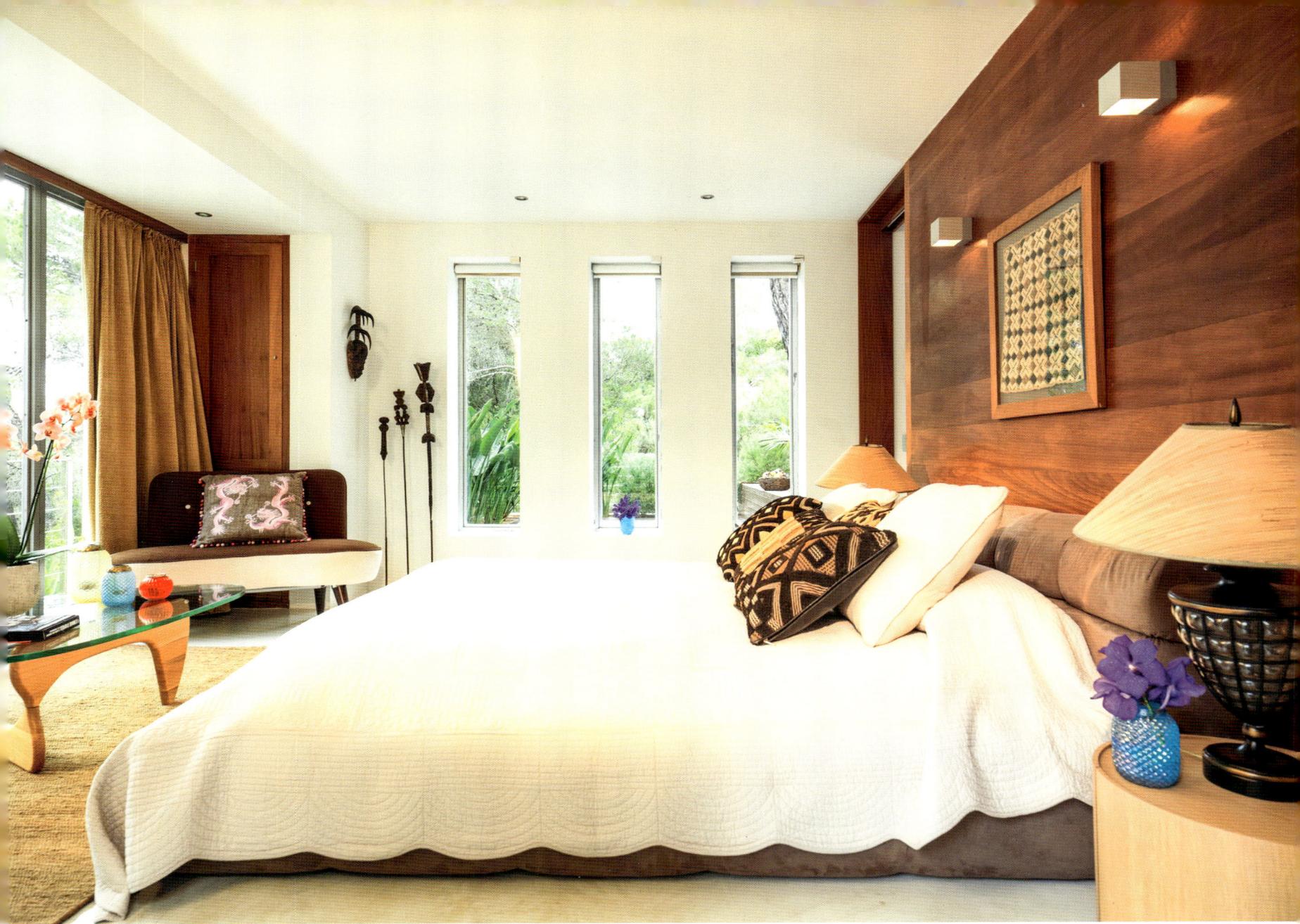
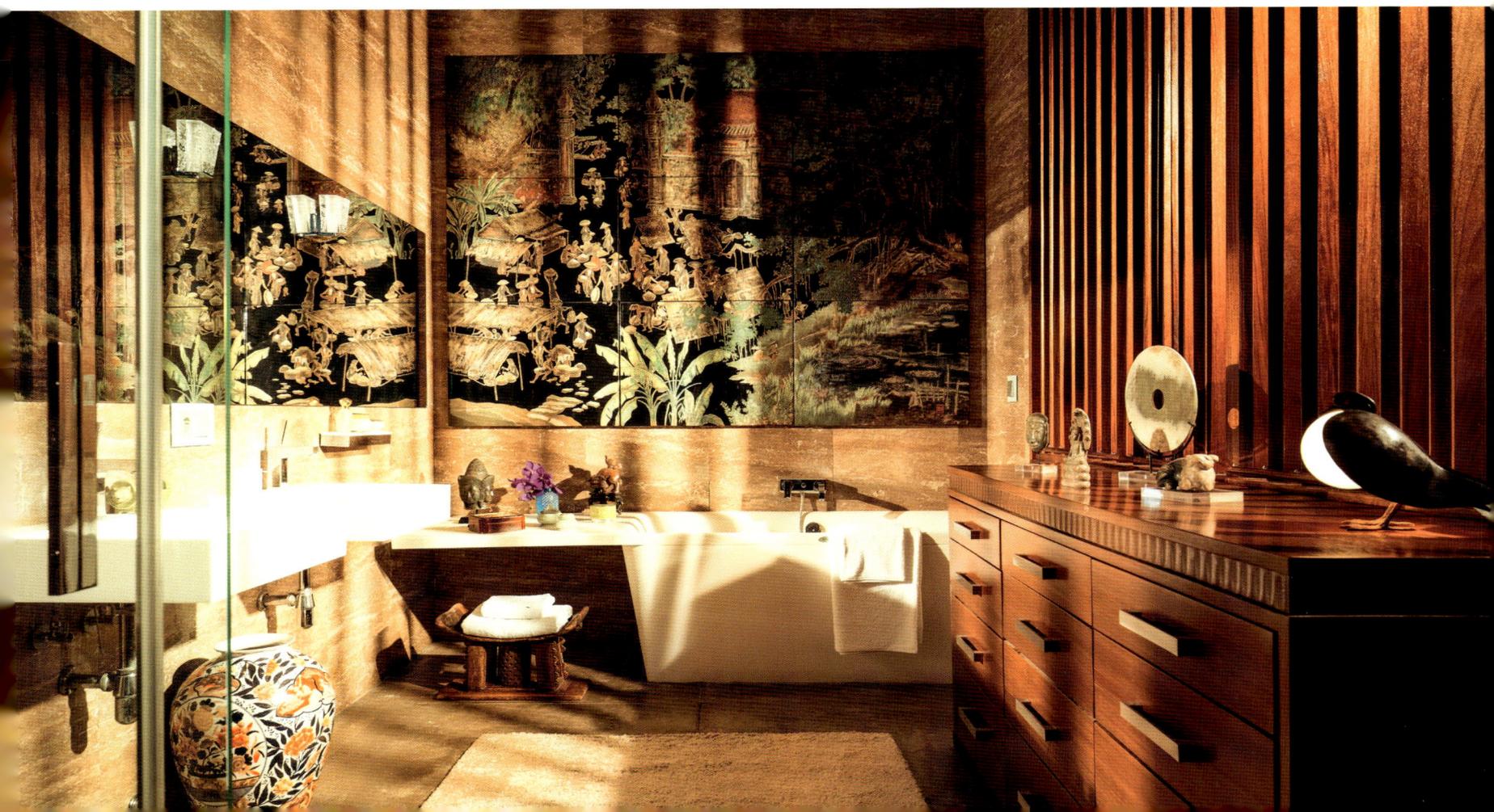

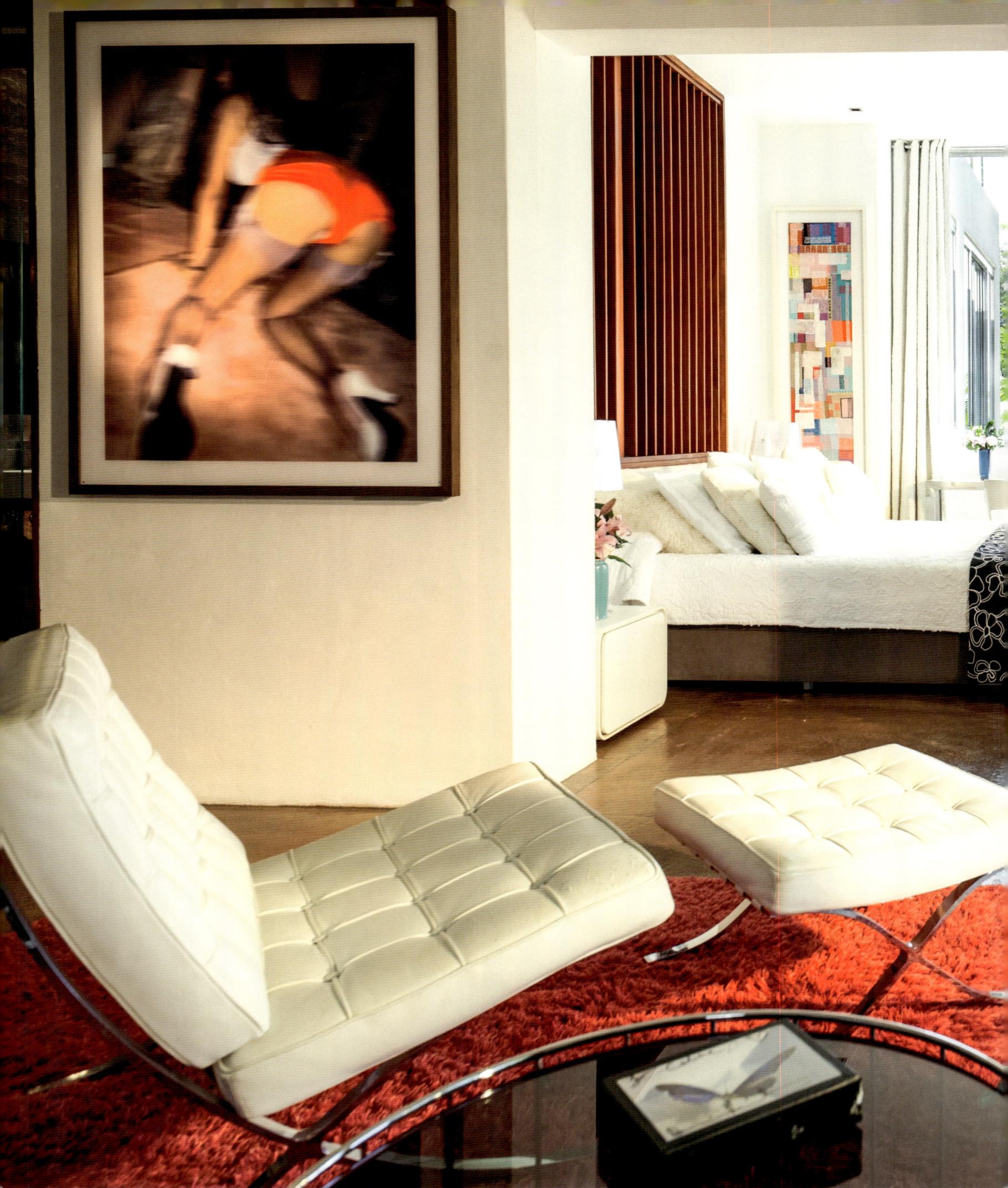

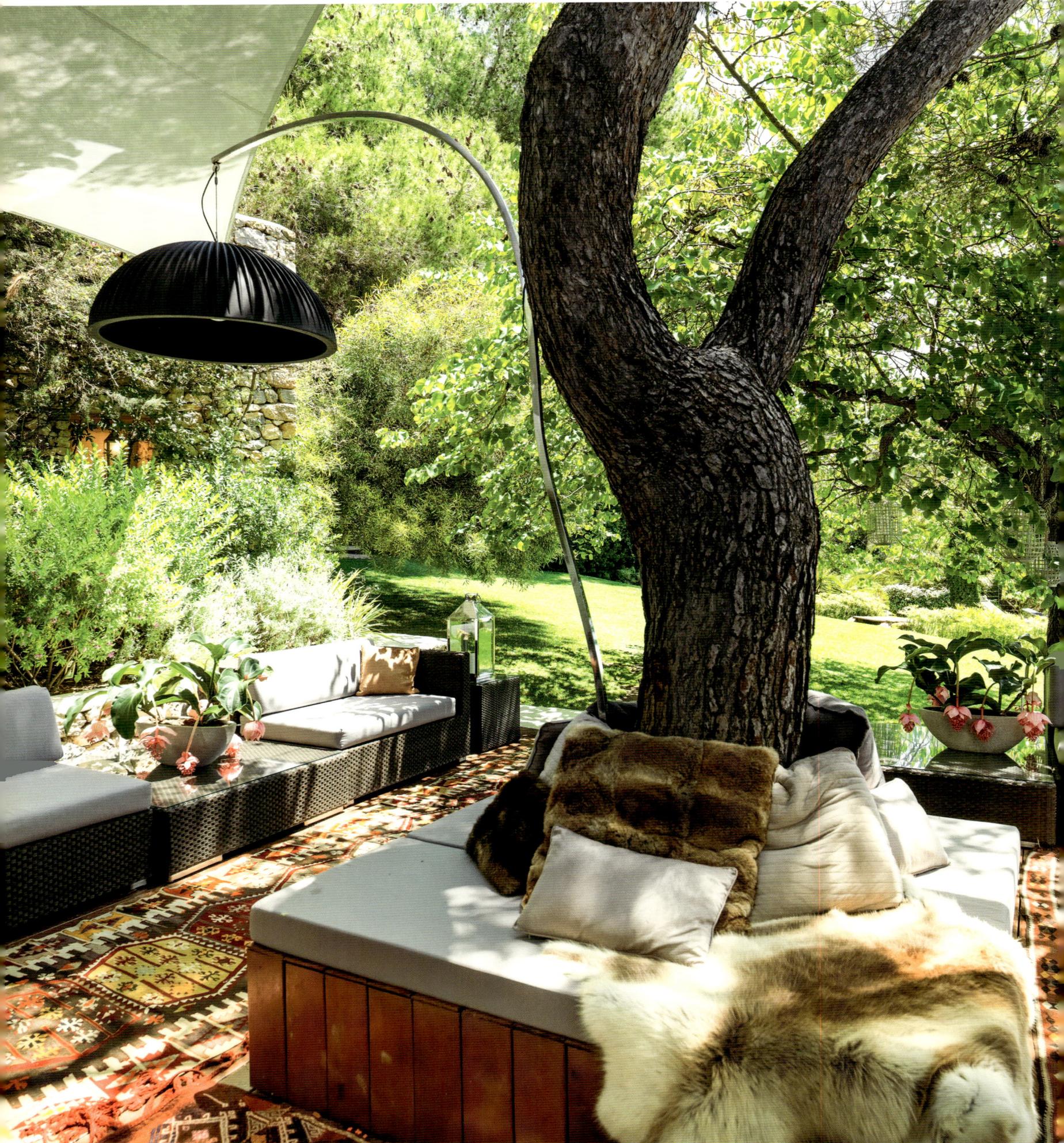

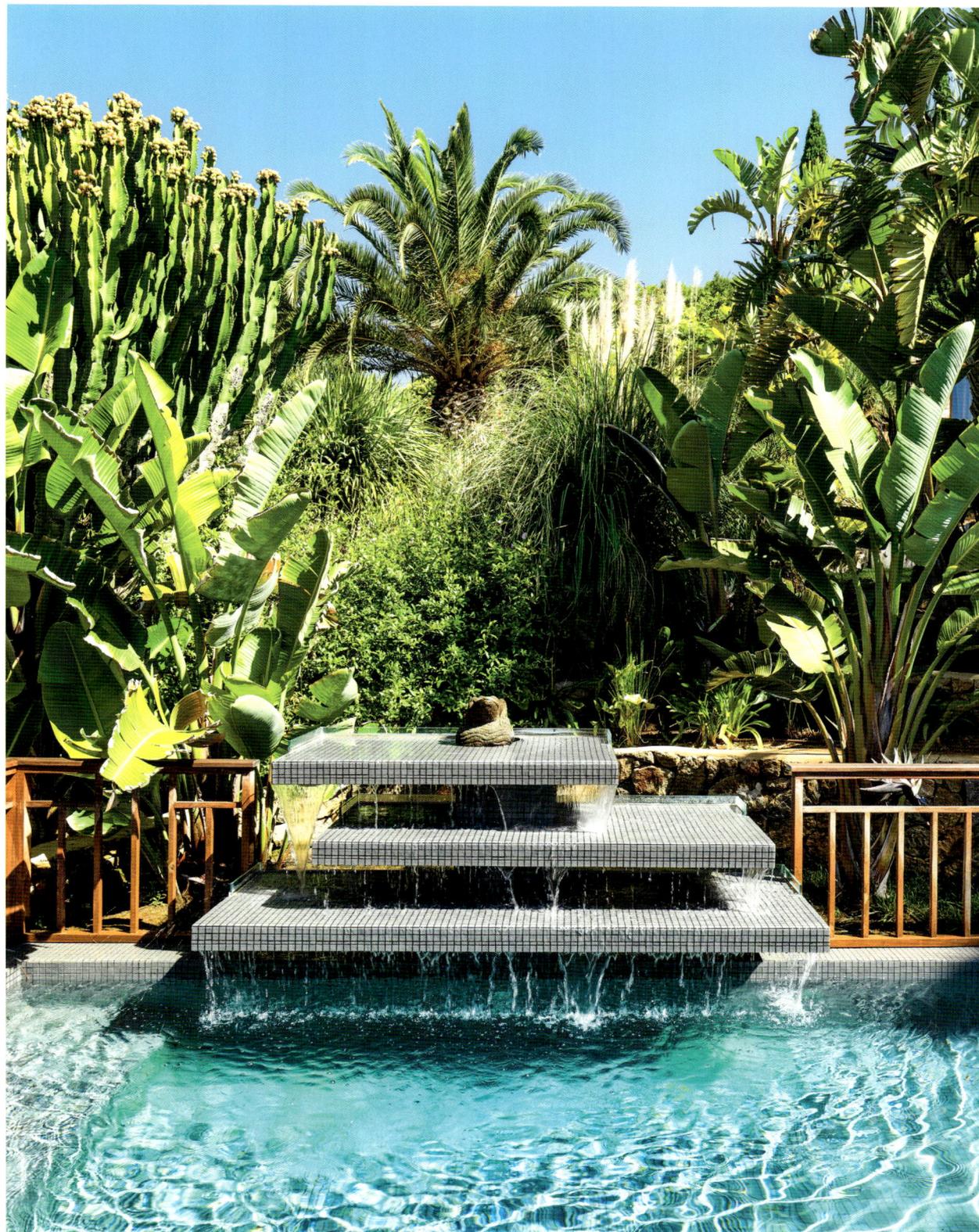

*Every surface was designed with serenity and tranquility in mind.*

*Jede Fläche wurde im Hinblick auf Ruhe und Stille gestaltet.*

*Cada superficie ha sido diseñada para fomentar el silencio y la serenidad.*

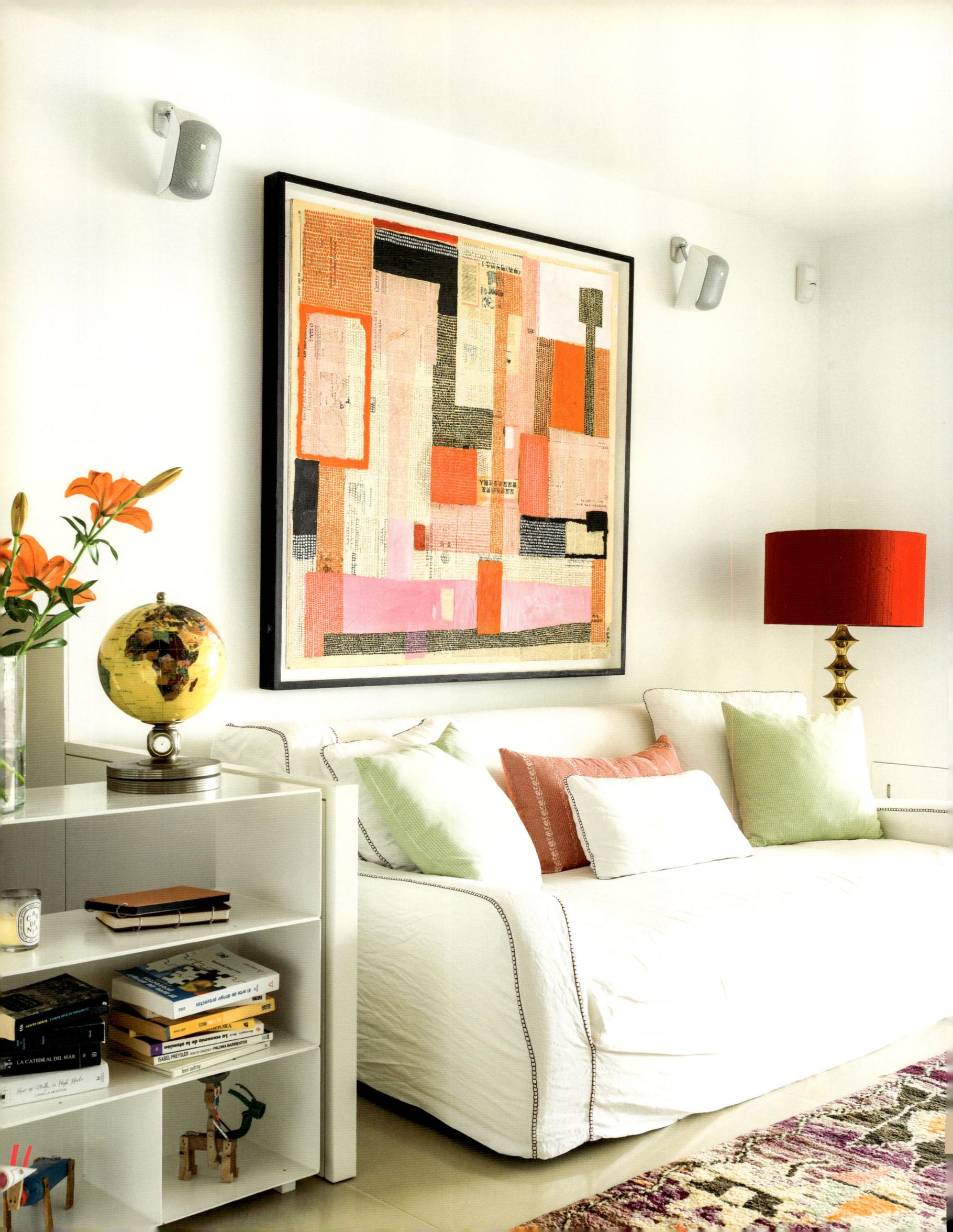

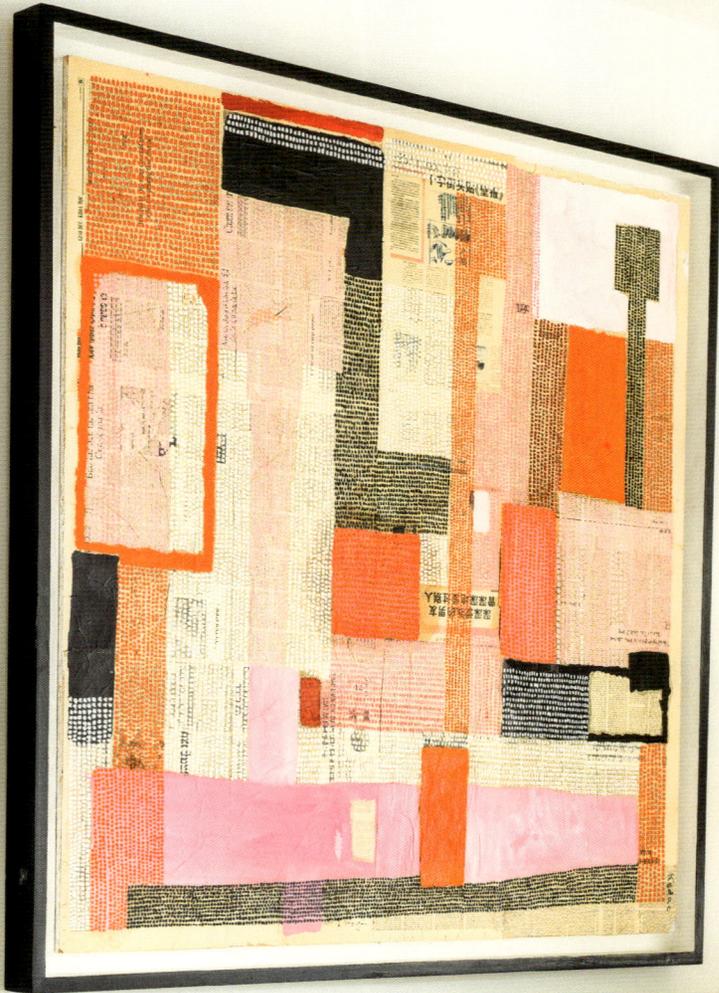

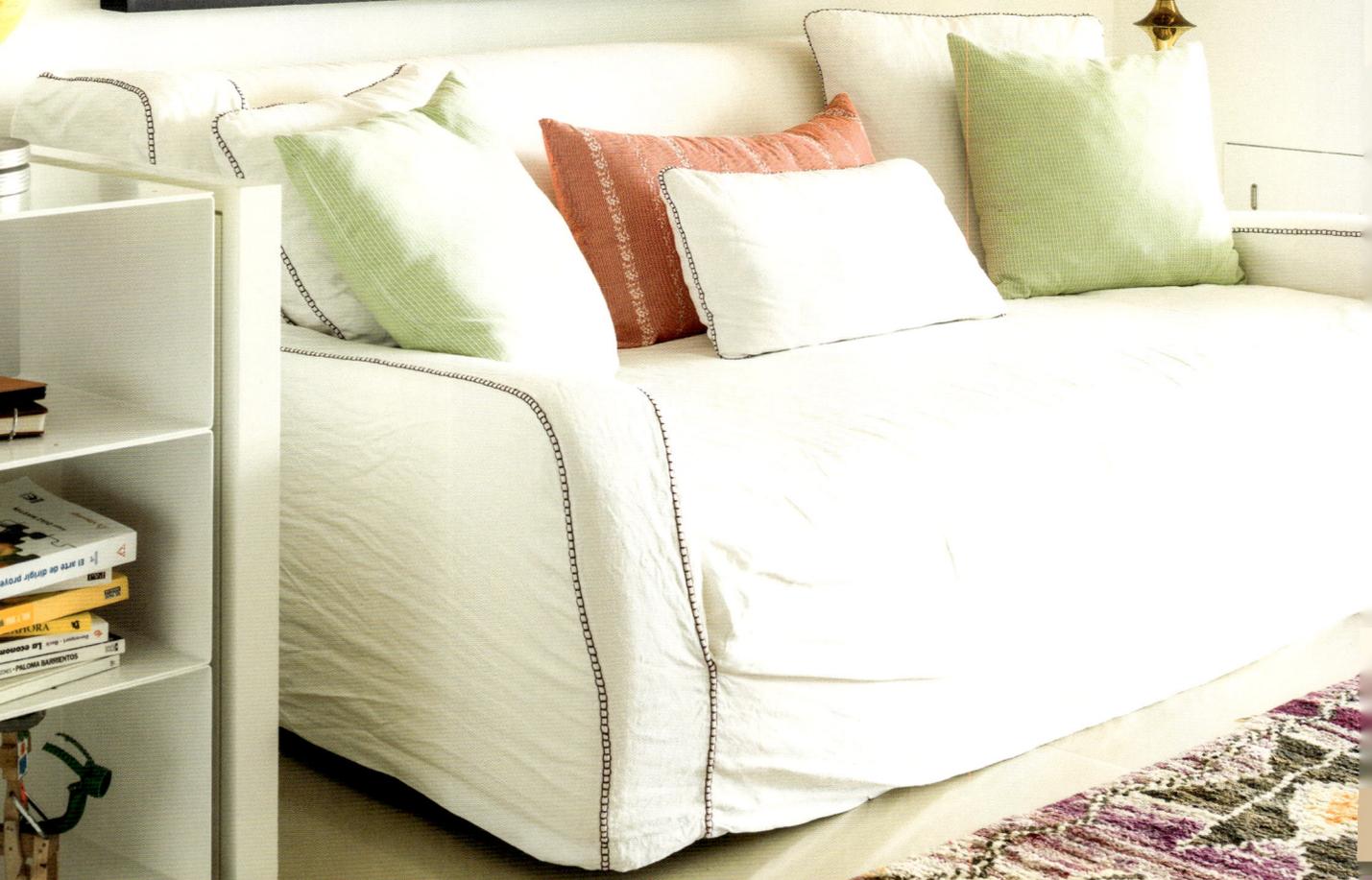

# Can Pep Simó

THE HOME OF architect Jaime Romano and his wife Roberta Jurado is situated in the Urbanización Can Pep Simó housing development, which was founded in 1964 opposite Ibiza Town. The original house underwent a complete renovation, and the rooms are now filled with light and transparency, resulting in a spacious townhouse whose lower patio merges with a gallery. Traditional Spanish tiles from the 1950's are found throughout the house, while esparto blinds on the terrace shade the teak-framed pool. The furnishings reflect the owners' everyday lives. They brought back many elements of the décor from family trips: driftwood from Pacific beaches and a marlin on the veranda that represents the Ecuadorian fishing tradition. Family photos and mementos collected from the island's many markets bear witness to the owners' highly individual lifestyle.

DAS HAUS DES Architekten Jaime Romano und seiner Frau Roberta Jurado liegt in der Urbanización Can Pep Simó, die 1964 gegenüber von Ibiza-Stadt gegründet wurde. Das ursprüngliche Haus wurde vollständig renoviert, um den Räumen Licht und Transparenz zu geben. Entstanden ist ein großzügiges Familienstadthaus, dessen unterer Patio in eine Galerie übergeht. Im ganzen Haus wurden traditionelle spanische Fliesen aus den 1950er-Jahren verwendet. Auf der Terrasse spenden Persiana aus Espartogras Schatten am Teakholz gerahmten Pool. Die Einrichtung steht im Bezug zum täglichen Leben der Eigner. Die vielen persönlichen Dekorationselemente stammen von Familienreisen. Neben Treibholz von den Stränden des Pazifiks verweist der Speerfisch auf der Veranda auf die Tradition des Marlinfangs in Ecuador. Familienfotos und Fundstücke von den zahlreichen Inselmärkten sind Zeugen eines sehr individuellen Lebensstils.

LA CASA DEL ARQUITECTO Jaime Romano y su esposa Roberta Jurado se encuentra en la urbanización Can Pep Simó, fundada en 1964 frente a la ciudad de Ibiza. La casa original fue sometida a una reforma completa para dotarla de mayor luminosidad y transparencia. El resultado es una residencia familiar urbana de generosas proporciones, cuyo patio inferior da paso a una galería. En toda la casa se han empleado azulejos españoles tradicionales de la década de 1950. En las terrazas, las persianas de esparto arrojan algo de sombra sobre los suelos de teca que rodean la piscina. El diseño interior está estrechamente relacionado con la vida cotidiana de los propietarios. Los distintos elementos decorativos permiten reconstruir los viajes familiares. Tanto la madera de las playas del Pacífico como el pez espada que adorna la veranda aluden a la tradición de la pesca de este animal en Ecuador. Las fotos de la familia y las piezas adquiridas en los mercadillos de la isla dan fe de un estilo de vida muy individual.

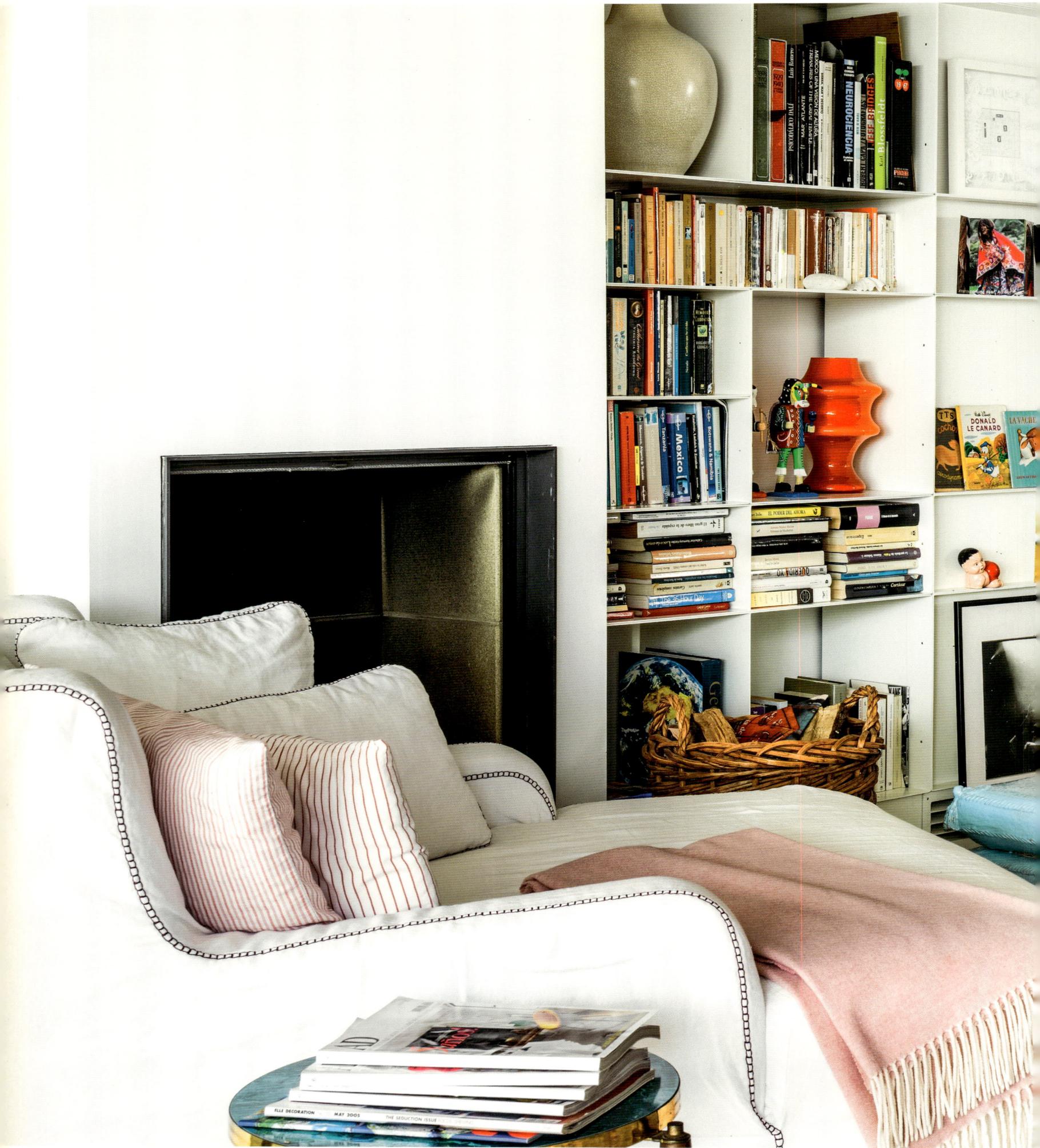

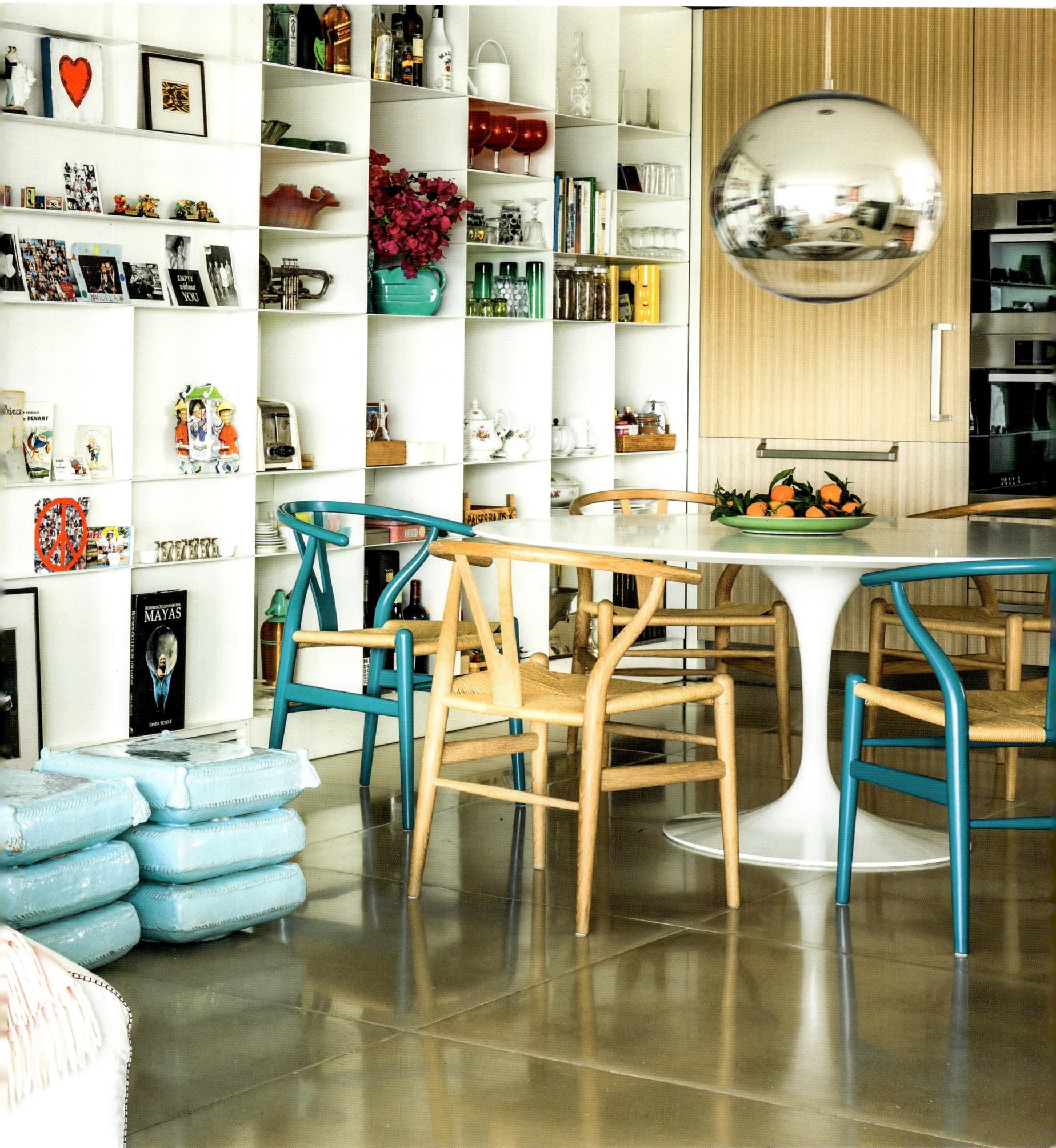

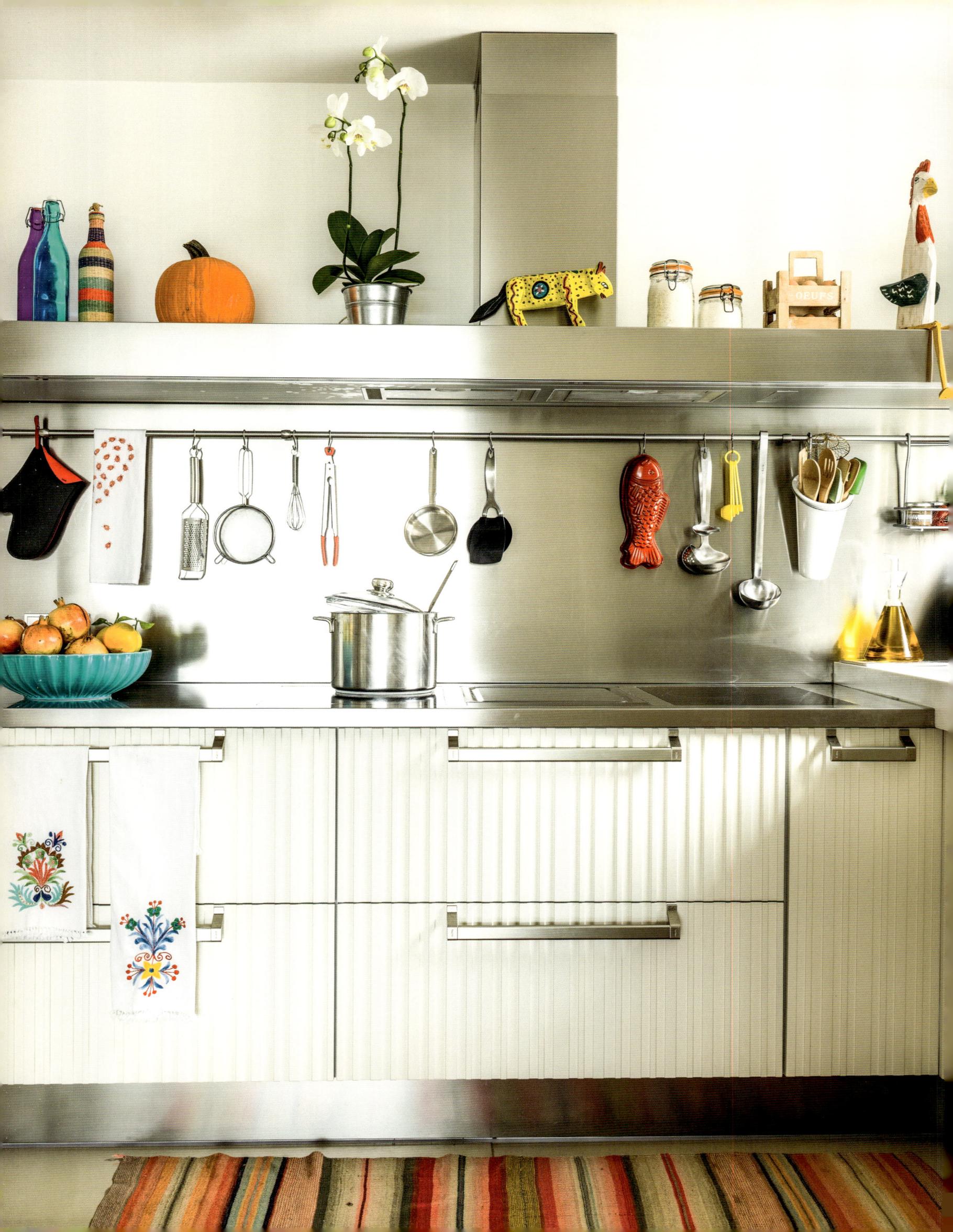

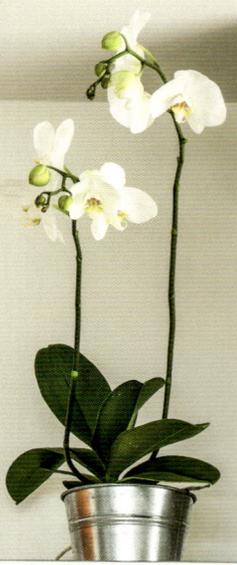

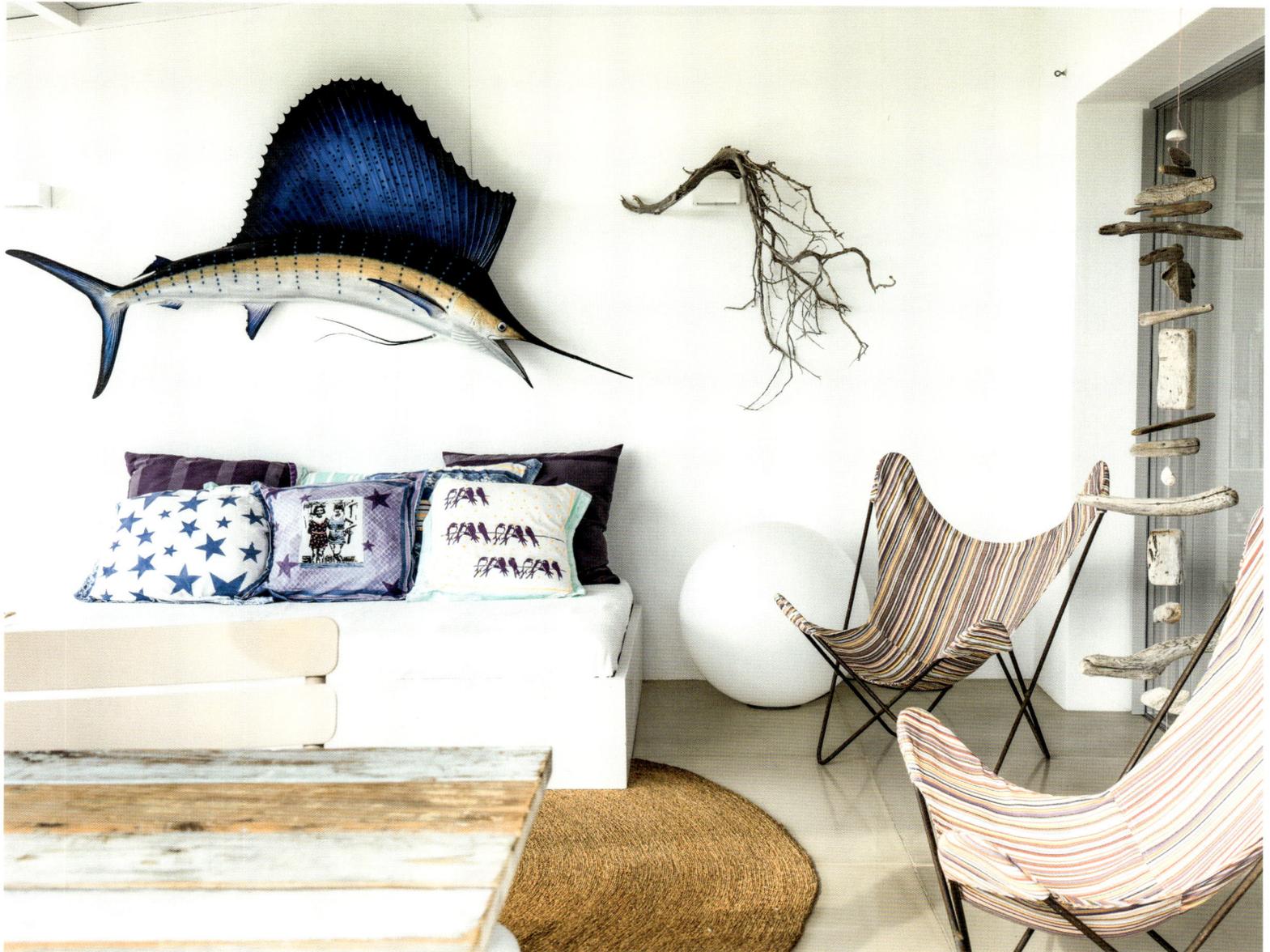

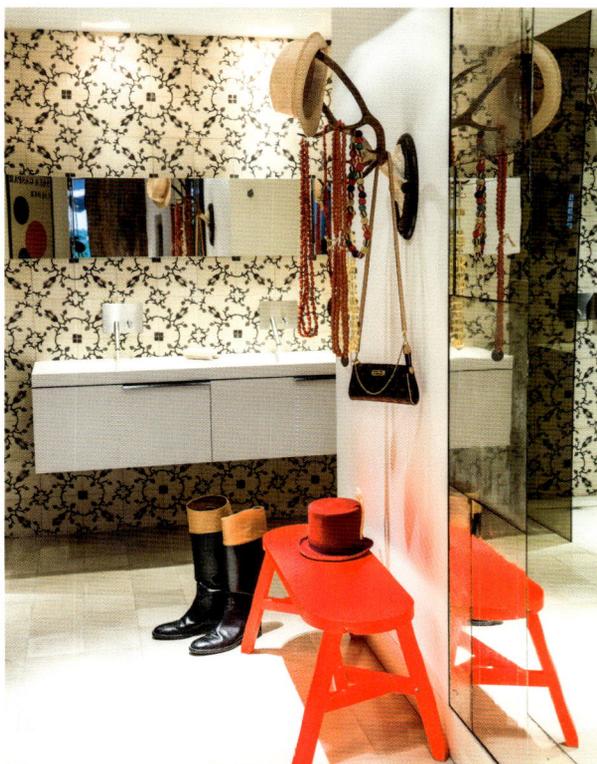

Arclinea kitchen with an Inox countertop and a Peruvian rug. Butterfly chairs, a blue marlin, driftwood table, and hand-painted cushions by the Ibizan artist Miamaria on the veranda. Traditional tiles and flea market finds in the entrance area.

Arclinea-Küche mit Inox-Arbeitsplatte und peruanischem Teppich. Auf der Veranda Butterfly-Sessel, Blue Marlin, Treibholztisch und handbemalte Kissen der ibizenkischen Künstlerin Miamaria. Traditionelle Fliesen und Flohmarkt-fundstücke im Eingangsbereich.

La cocina Arclinea con superficie de trabajo de acero inoxidable y alfombra peruana. En la veranda, sillas mariposa, un pez espada azul, una mesa de madera rescatada y cojines pintados a mano por la artista ibicenca Miamaria. En el vestíbulo, baldosas tradicionales y hallazgos de mercadillo.

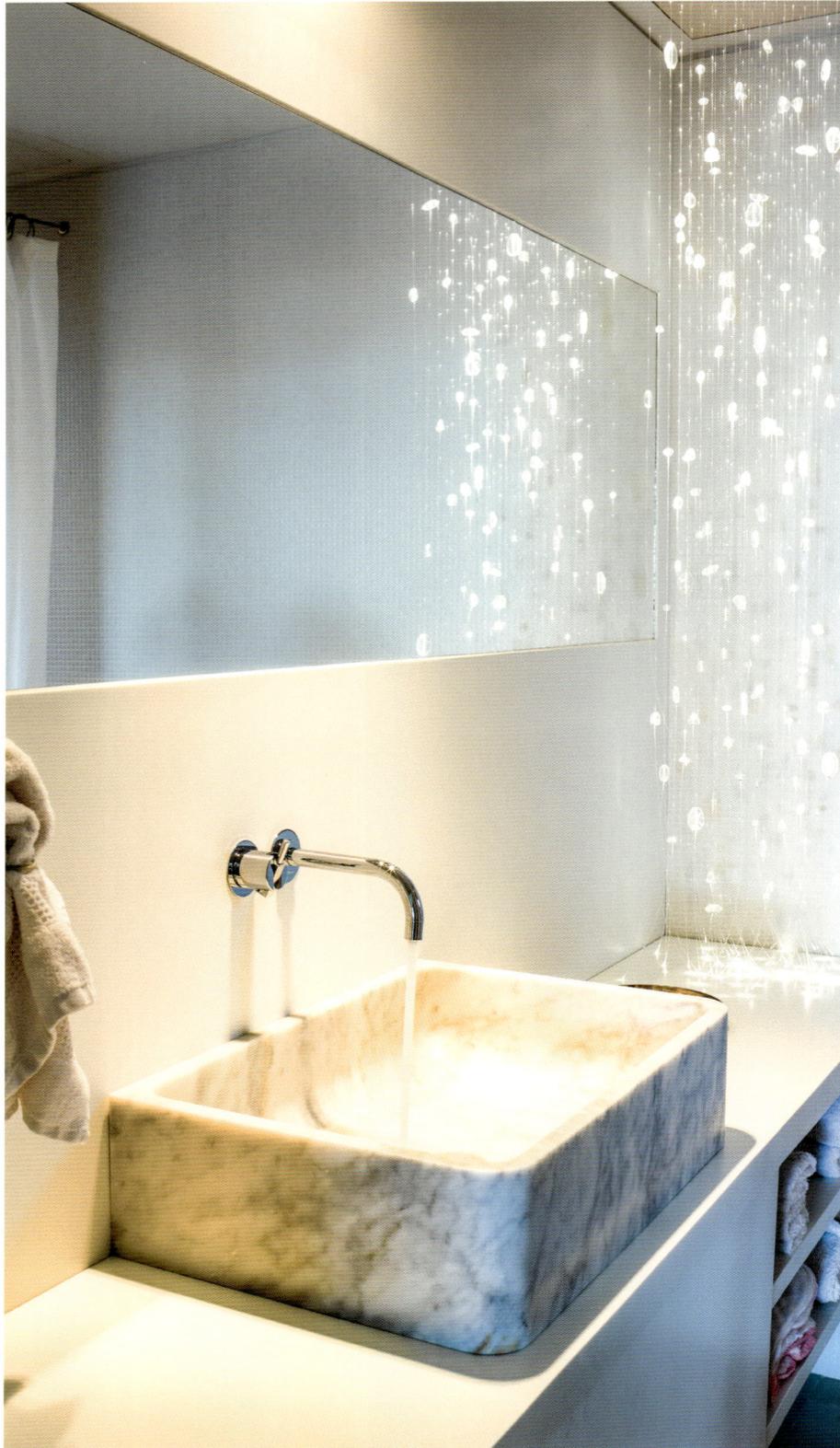

*A marble sink by Agape and a quartz crystal lamp by Ibiza's own Roseline de Thélin in the bathroom. Sliding doors made of recycled wood, Missoni cushions, yellow Saarinen chairs, and a painting by the Italian artist Rosanna Cassano in the bedroom.*

*Im Bad Marmorwaschbecken von Agape und Lampe aus Bergkristallen von Roseline de Thélin aus Ibiza. Im Schlafzimmer Schiebetüren aus recyceltem Holz, Missoni-Kissen, gelbe Saarinen-Stühle und ein Bild der italienischen Künstlerin Rosanna Cassano.*

*En el baño, bacina de mármol, de Agape, y lámpara de cristal de roca de Roseline de Thélin. En el dormitorio, puertas correderas de madera reciclada, almohadas de Missoni, sillas amarillas Saarinen y un cuadro de la artista italiana Rosanna Cassano.*

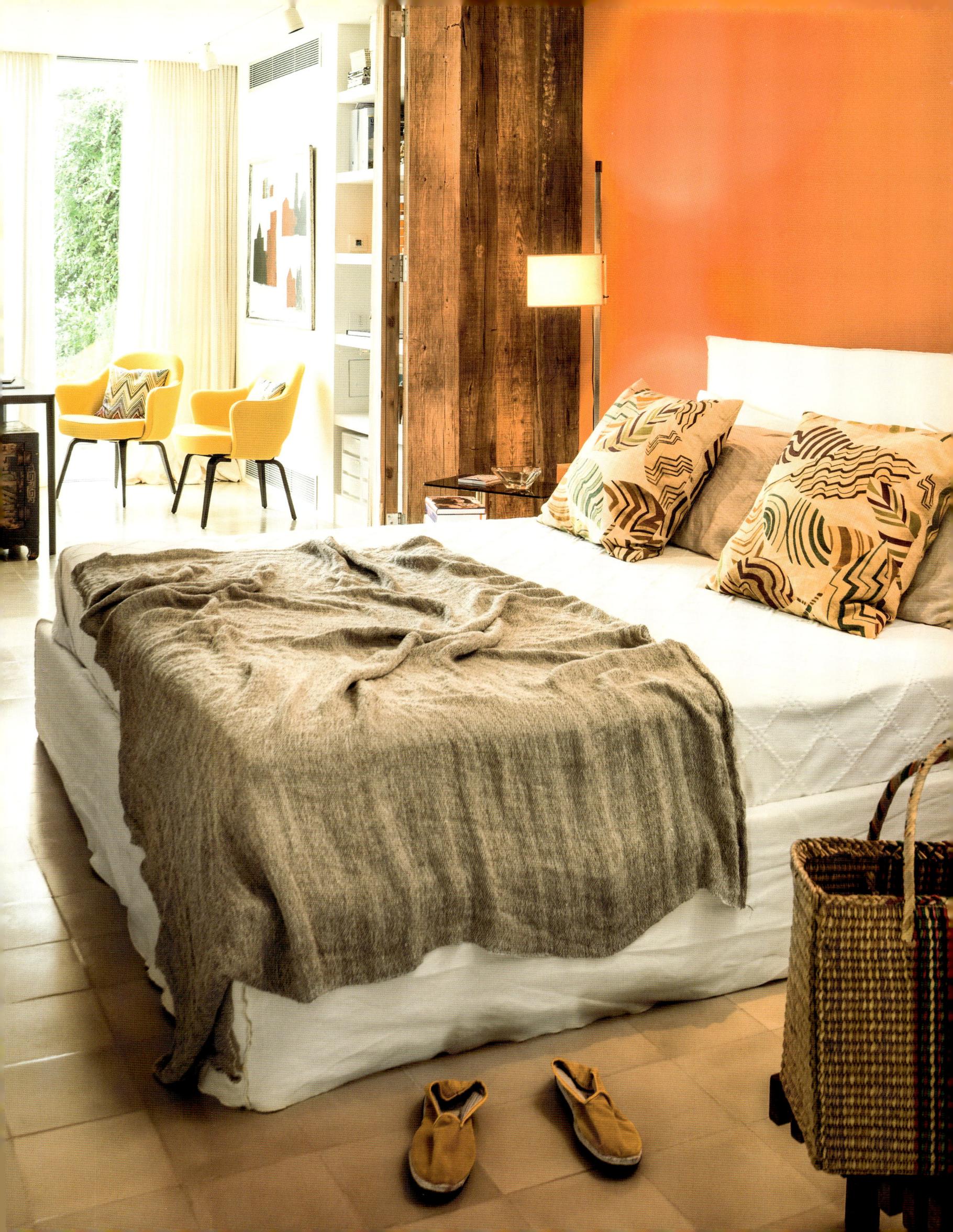

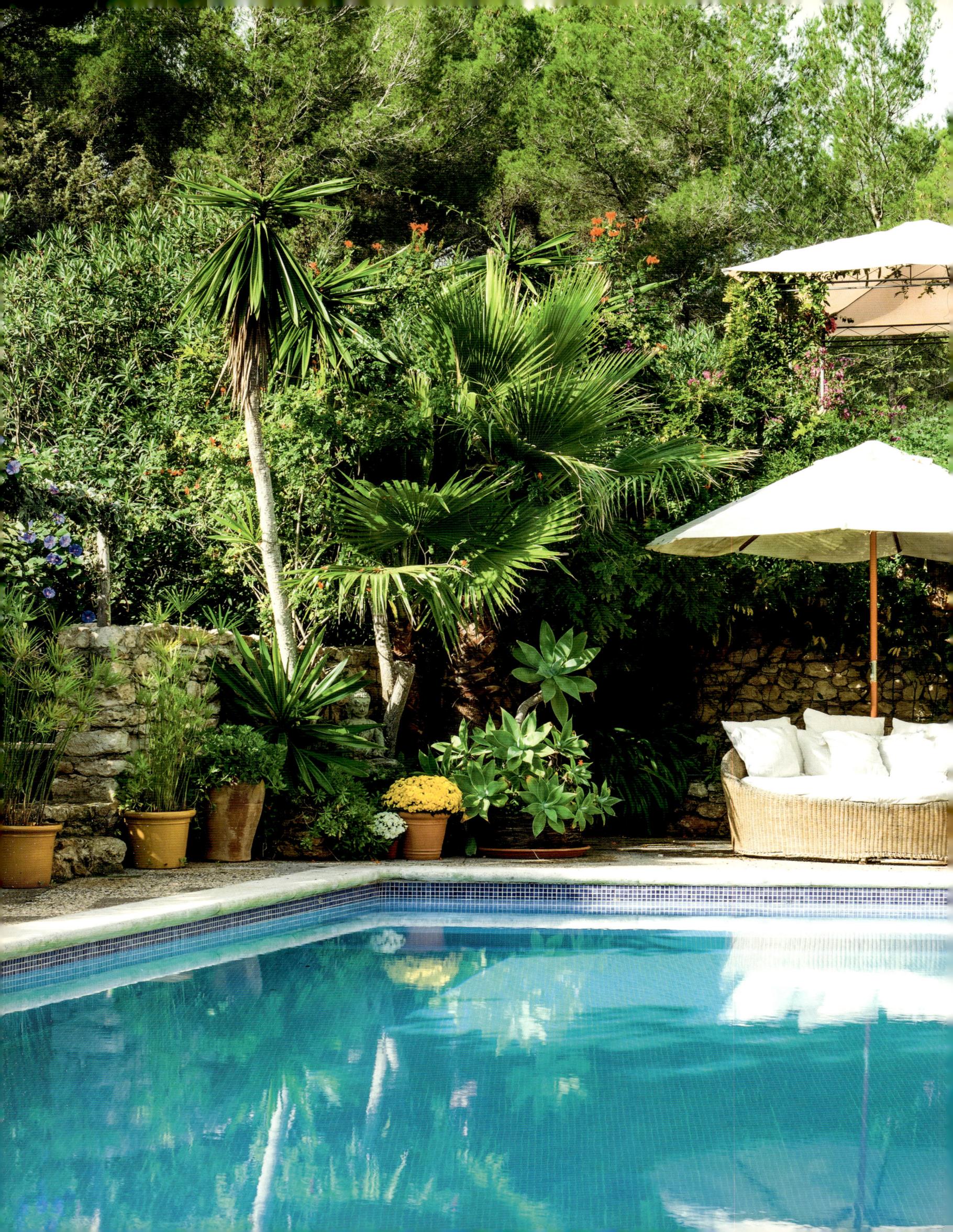

# Can Torres

THIS 400-YEAR-OLD COUNTRY estate has a long tradition of oil production. Its British owners restored the property for the first time in the 1950s and surrounded the house with extensive gardens lovingly landscaped in the British style. In the 1970s, an aristocratic family from southern Italy purchased the estate, filling the home with antiques and heirlooms that lend it an air of casual *grandezza*. The Italians also added a swimming pool and tennis court. The room layout and historic structural elements are clear reminders of the estate's aristocratic past. The home combines a mix of styles—furniture from the time of Napoleon III, rustic décor, oriental accessories, and modern art—all of which radiates a very special ambience of peace and relaxation.

DAS 400 JAHRE alte Landgut wurde traditionell zur Ölgewinnung genutzt und erstmalig in den 1950er-Jahren von seinen englischen Besitzern restauriert. Aus dieser Zeit stammen auch die weitläufigen und mit britischer Liebe zur Gartenkunst angelegten Grünflächen, die das Haus umgeben. In den 1970er-Jahren wurde das Anwesen dann von einer süditalienischen Adelsfamilie gekauft, die dem Haus mit ihren Antiquitäten und Erbstücken eine lässige Grandezza verlieh. Außerdem wurden ein Swimmingpool und ein Tennisplatz hinzugefügt. An der Raumaufteilung und alten Bauelementen lässt sich noch gut erkennen, dass dies ein ehemals herrschaftliches Landgut war. Mit seinem Stilmix – Möbel aus der Zeit Napoleons III. neben Landhausstil, orientalischen Accessoires und Modern Art – strahlt das Haus eine ganz besondere Atmosphäre der Ruhe und Entspanntheit aus.

TRADICIONALMENTE, ESTA EDIFICACIÓN con más de 400 años de historia estuvo dedicada a la elaboración de aceite, y sólo en la década de 1950 sus nuevos propietarios ingleses decidieron restaurarla. De aquella época datan también las extensas y cuidadas superficies verdes de inconfundible estilo británico que rodean la casa. Durante los setenta, una familia de la nobleza italiana adquirió la propiedad, a la que confirieron nueva grandeza con sus antigüedades y muebles cargados de historia. Igualmente, añadieron una piscina y una pista de tenis al conjunto. La distribución de los espacios y los antiguos elementos arquitectónicos no dejan lugar a dudas de que esta fue en tiempos residencia rural de terratenientes. La combinación de estilos (muebles de la era de Napoleón III que conviven con piezas rústicas, accesorios orientales y arte moderno) confiere a la casa un ambiente de calma y serenidad muy particular.

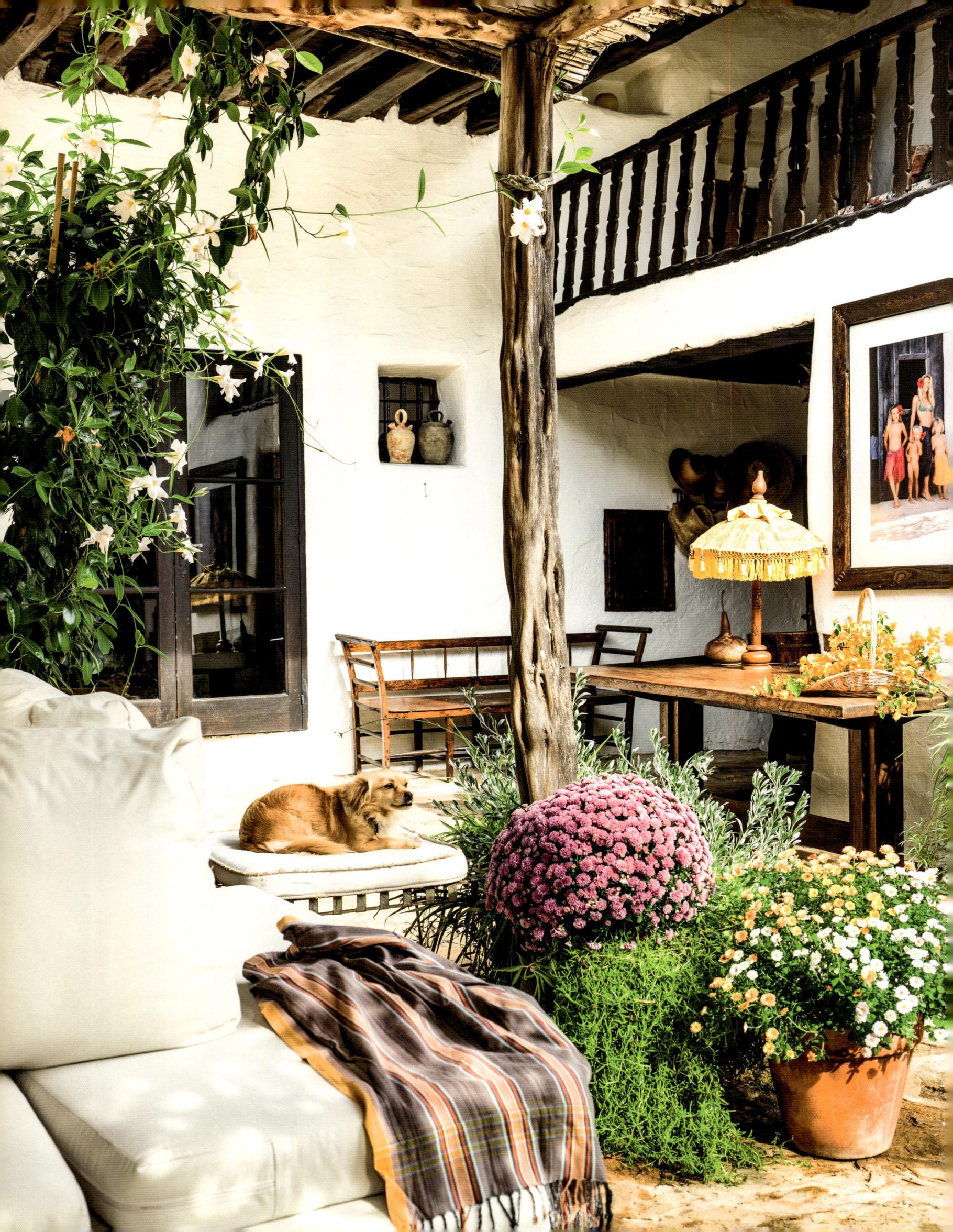

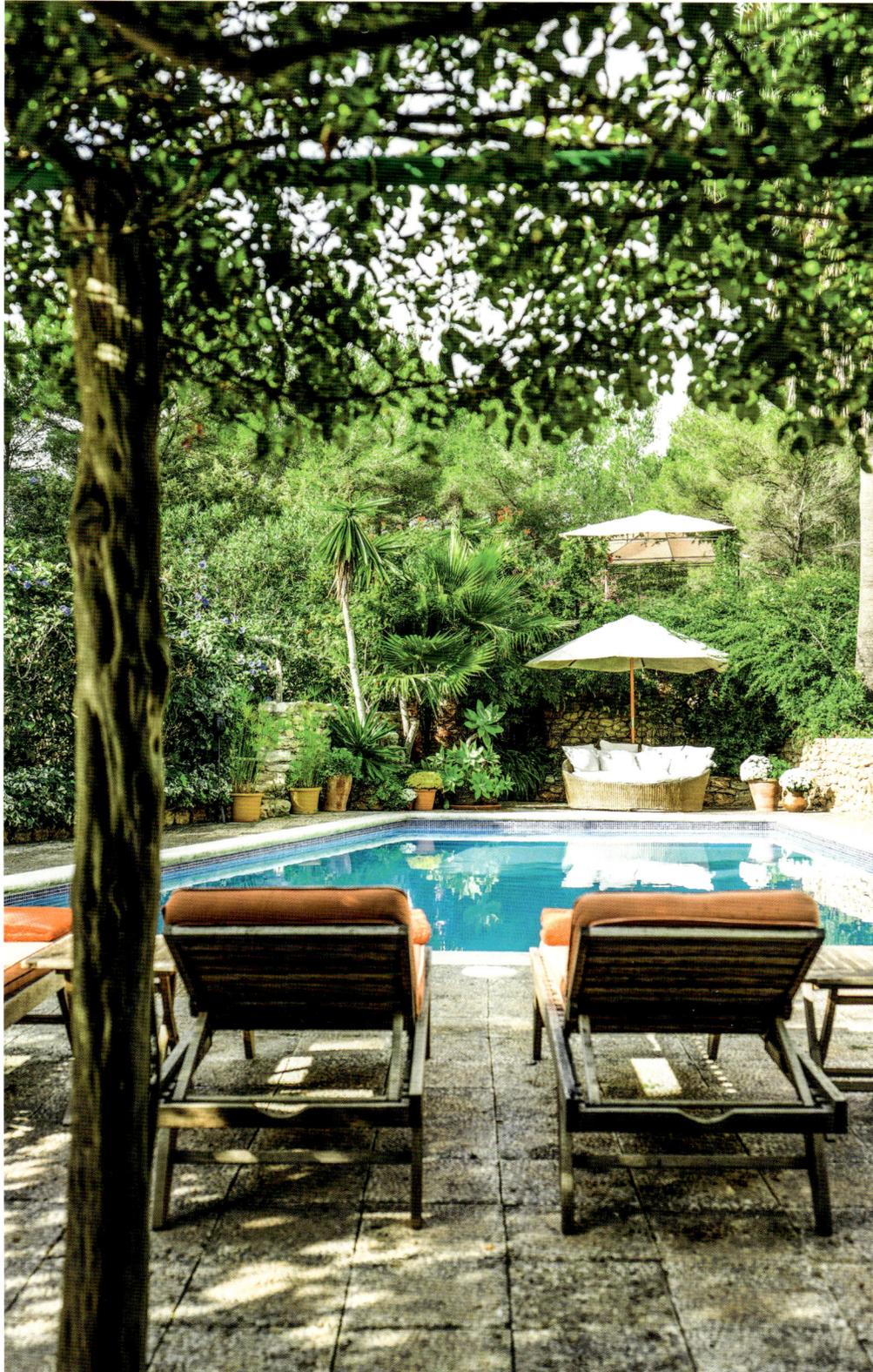

Shady outdoor spaces are surrounded by typical Mediterranean vegetation. Antique oil
vessels reflect the property's historic past.

Schattige Außenplätze inmitten typisch mediterraner Vegetation. Alte Ölgefäße
erinnern an die Geschichte des Hauses.

Espacios exteriores sombreados y rodeados de vegetación típicamente mediterránea.
Las antiguas ánforas de aceite recuerdan la historia de la casa.

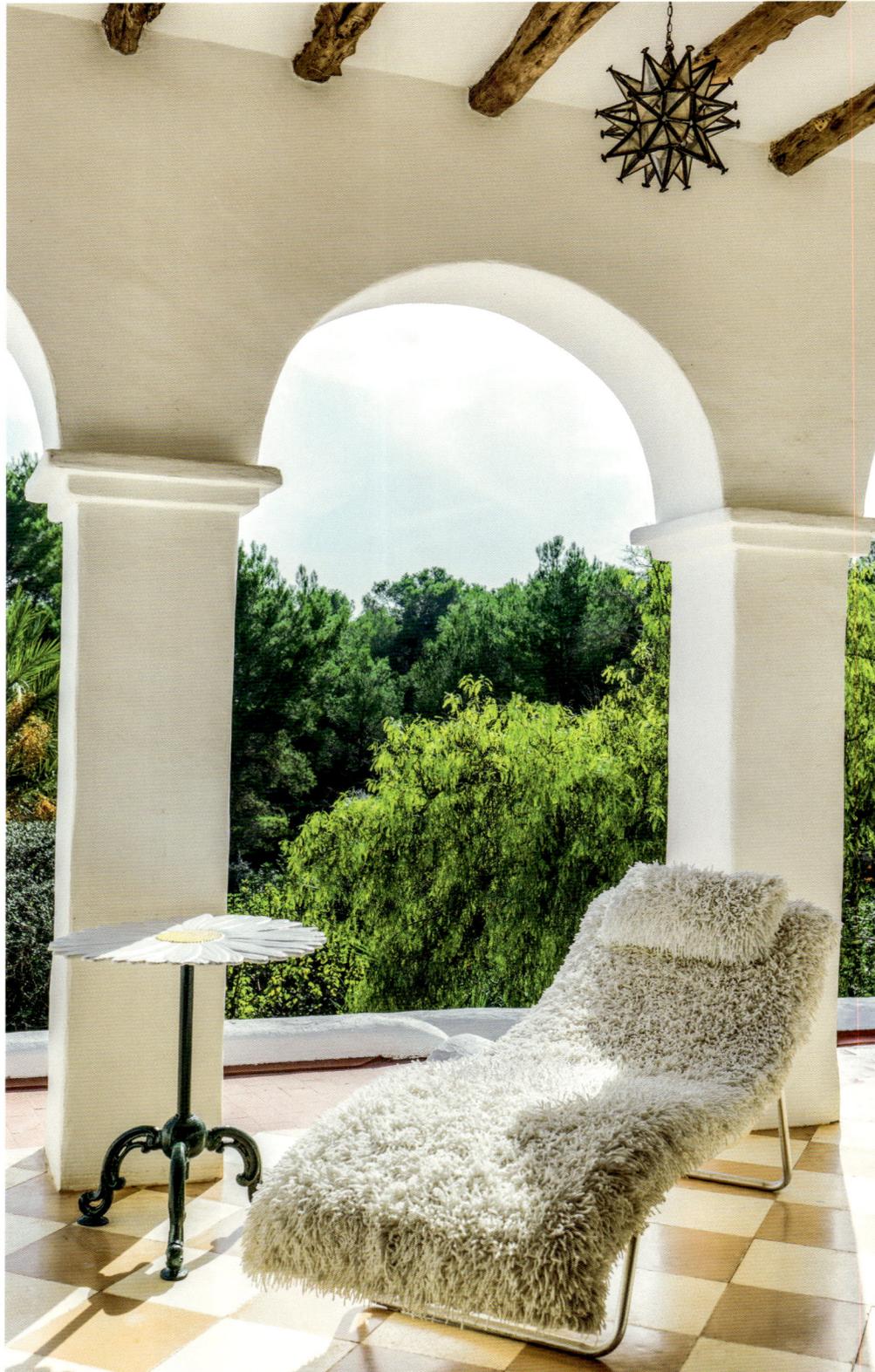

*Antiques from different periods contrast with modern pieces. A built-in bookshelf holds a collection of Italian glassware.*

*Antiquitäten aus verschiedenen Epochen gemischt mit modernen Einzelstücken. In dem gemauerten Regal Stücke aus einer italienischen Glassammlung.*

*Antigüedades de distintas épocas, combinadas con elementos modernos. En las estanterías de obra, piezas de una colección de cristal italiano.*

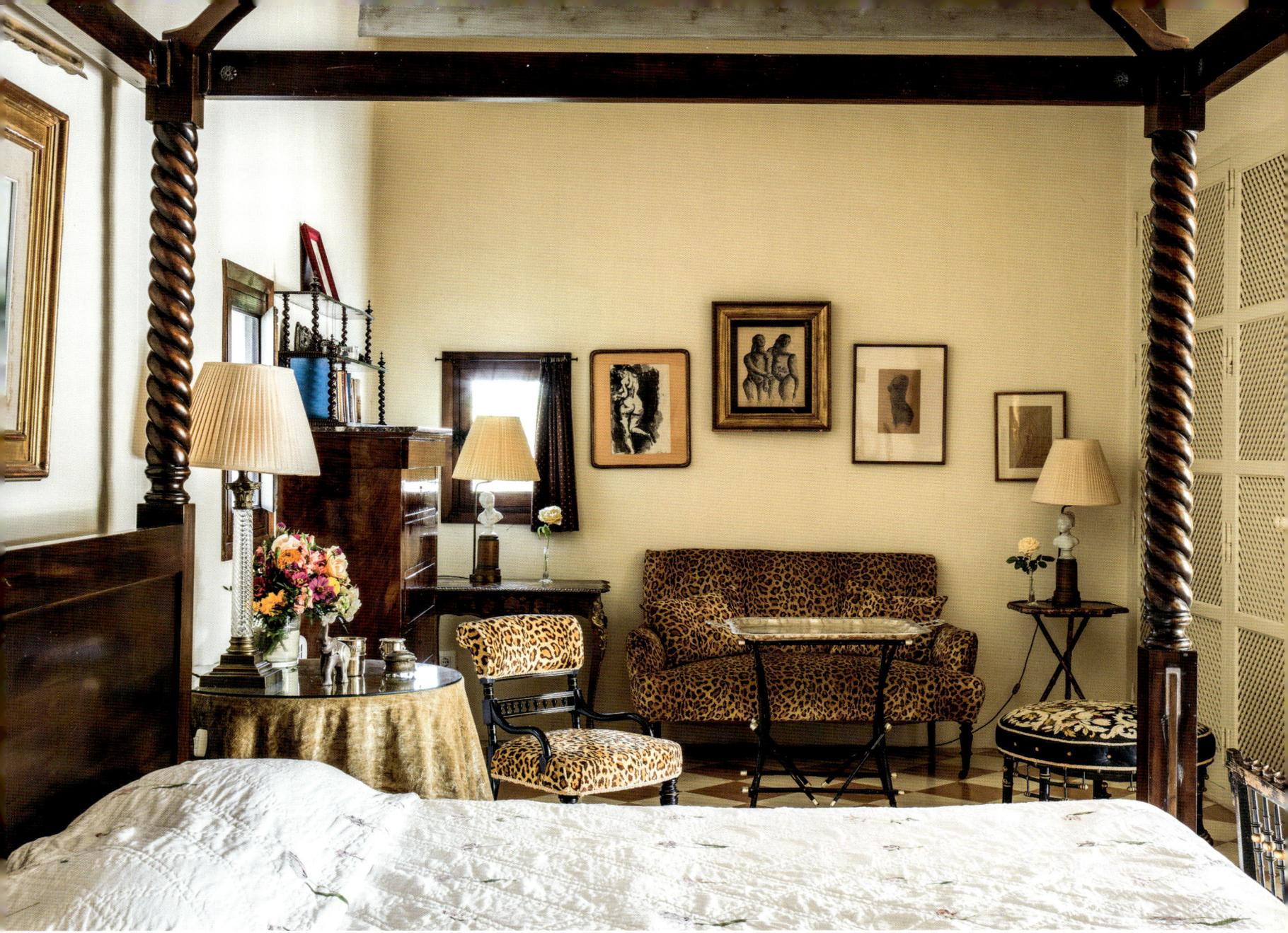
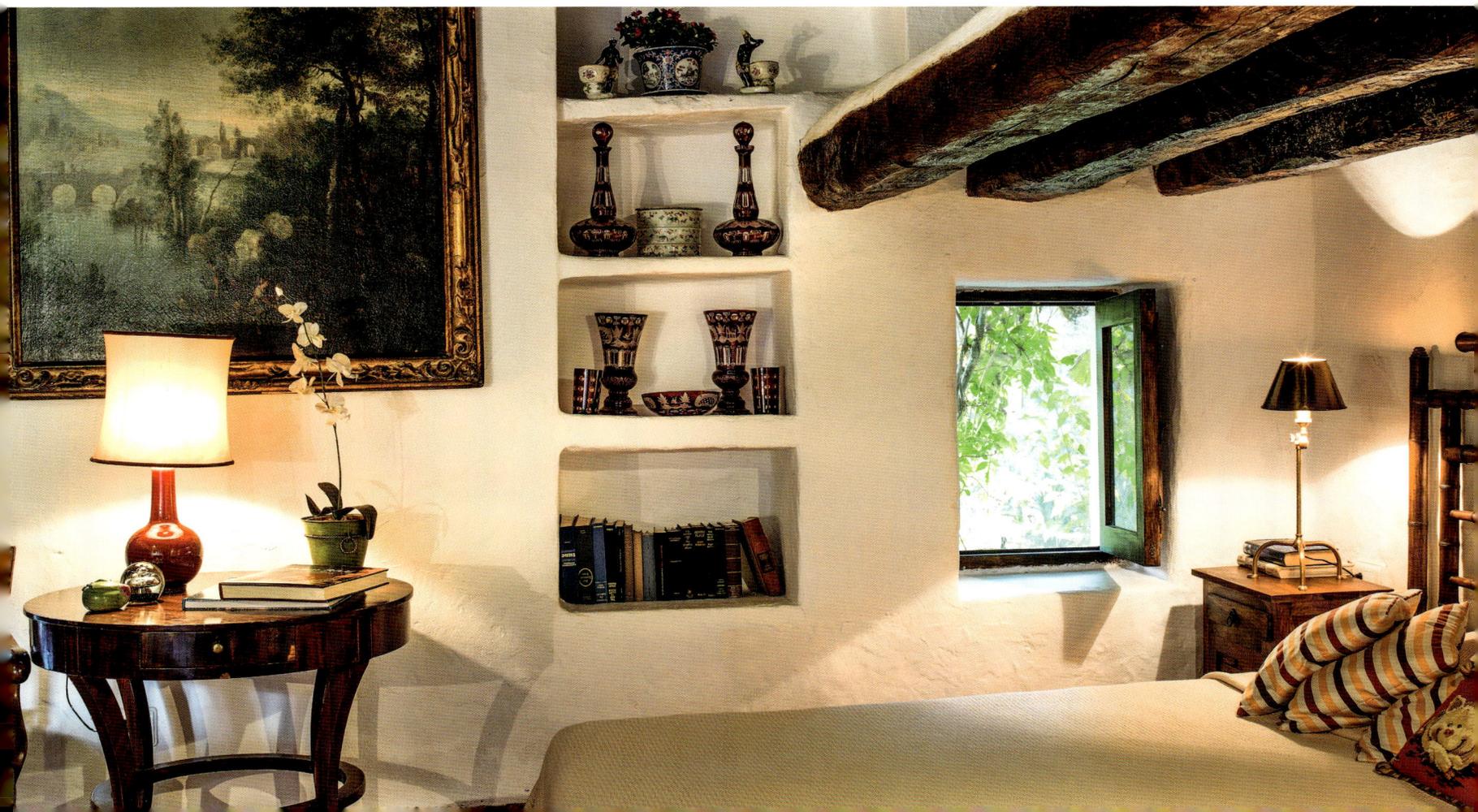

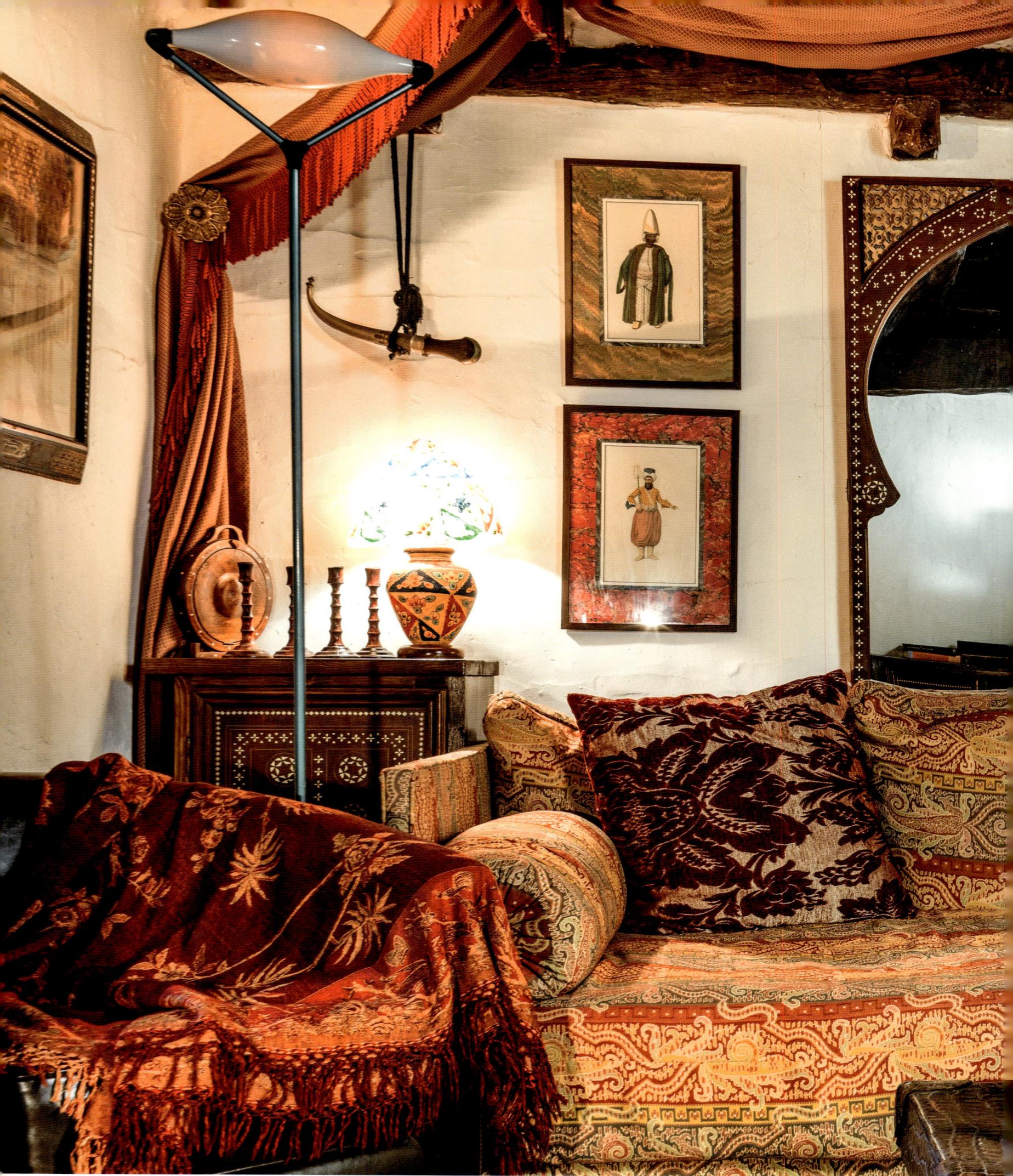

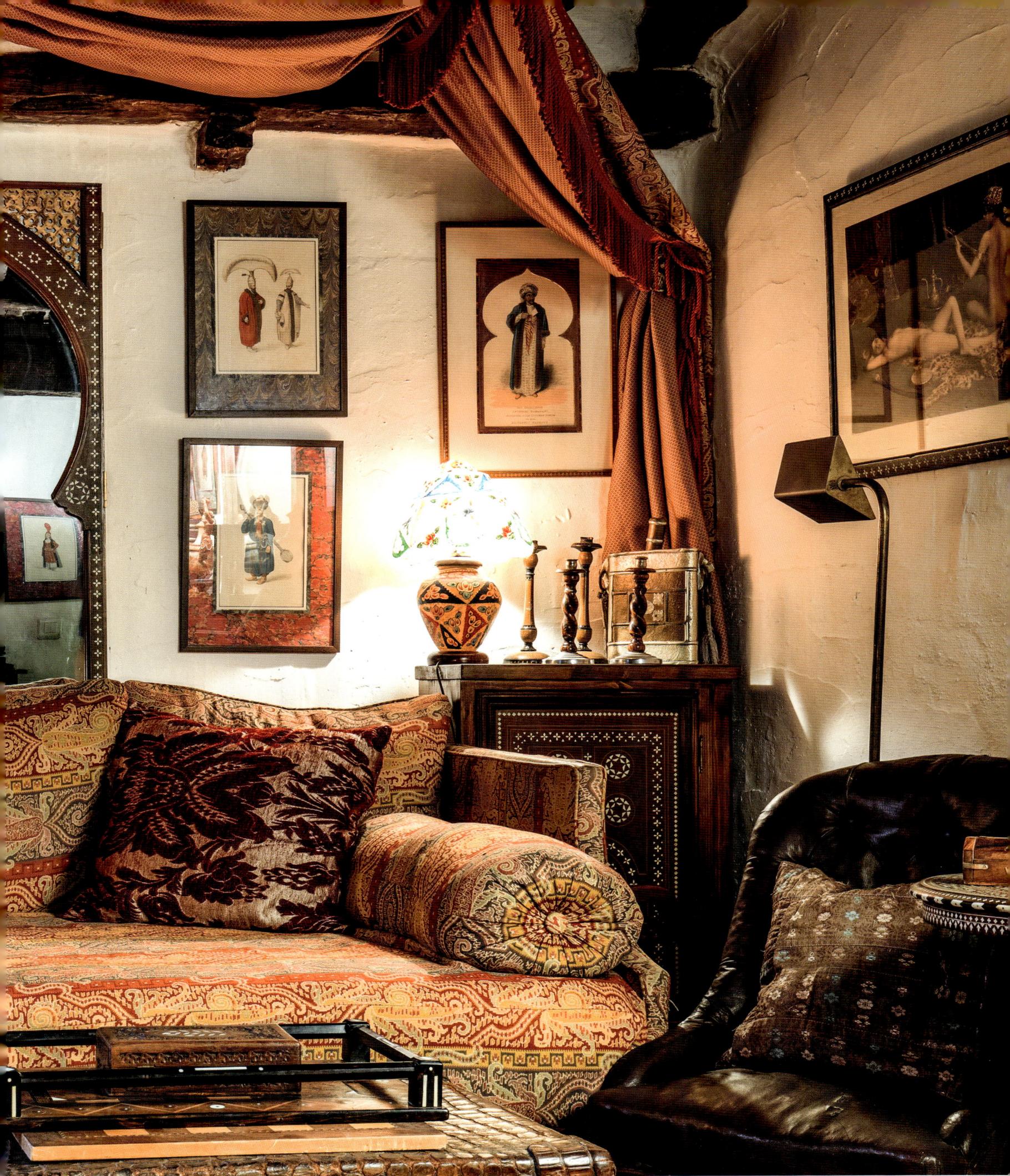

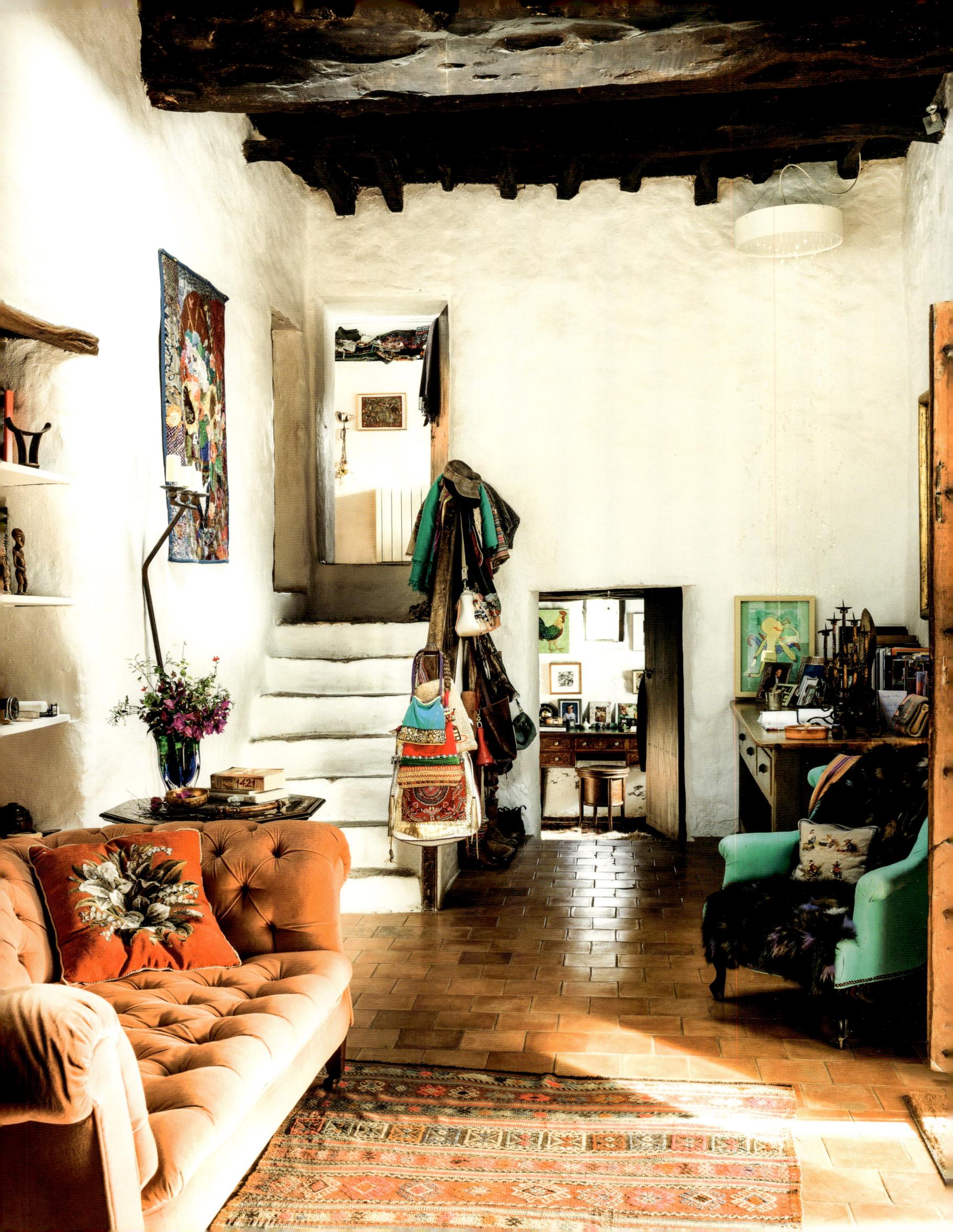

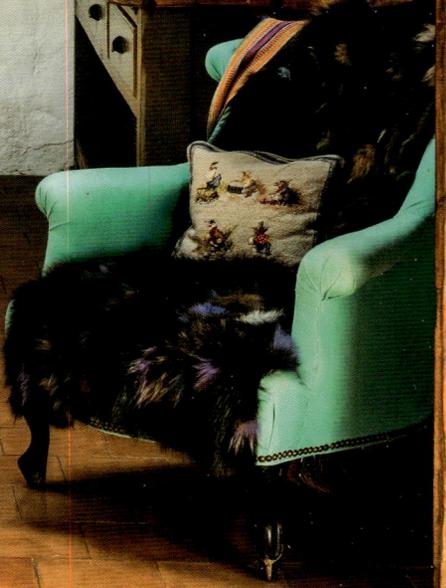

# Es Pouas

BUILT IN 1640, this country home rises from the top of a hill in the pristine region surrounding Santa Agnes. Designer Victoria has decorated the home she shares with her family in an eclectic mix of modern, exotic, and antique styles, combined with regional handicrafts. The rooms are filled with mementos and souvenirs that her husband, a UNICEF doctor, brought home from his travels, creating a funky, hippie chic style that is unique to Ibiza. In the 17 years that they have lived here, the couple has renovated the finca with loving care and turned it into a relaxing family refuge. A great many spots for relaxing and dreaming the day away are scattered throughout the property, surrounded by olive, fig, and almond groves. The terraces and balconies offer spectacular views across the red-earth fields and surrounding nature deep into the valley. The hacienda once belonged to a family that owned most of the region until 1830, when they lost much of the valley to their neighbors in a wager.

AUF DER SPITZE eines Berges in der unberührten Gegend rund um Santa Agnes thront dieses Landhaus von 1640. Das Haus der Designerin Victoria und ihrer Familie ist in einem eklektischen Mix aus modernen, exotischen und antiken Stilelementen eingerichtet, zwischen denen sich handgearbeitete Einzelstücke aus der Region befinden. Die Räume im funky Ibiza-Hippie-Chic sind angefüllt mit Reiseandenken und Fundstücken ihres Mannes, der als Arzt für UNICEF arbeitet. In den 17 Jahren, in denen sie die Finca bewohnen, haben sie diese behutsam renoviert und in ein entspanntes Familienrefugium verwandelt. Umgeben von Oliven-, Feigen- und Mandelbäumen verstecken sich unzählige Plätze zum Entspannen und Träumen. Die Aussicht von den Terrassen und Balkonen ist spektakulär: Man blickt über roterdige Felder und die umgebende Natur weit hinaus ins Tal. Den ehemaligen Haciendabesitzern gehörte ursprünglich der vorherrschende Teil der Gegend, bis sie 1830 infolge einer Wette einen Großteil des Tals an die Nachbarn verloren.

LA CASA SEÑORIAL de 1640 se yergue orgullosa sobre la cima de una loma en las proximidades de Santa Agnès. La casa de la diseñadora Victoria y su familia ha sido decorada con una ecléctica mezcla de elementos modernos, exóticos y antiguos, entre los que se han enhebrado piezas de artesanía de la región. Las habitaciones, de inconfundible y alegre estilo *hippie* ibicenco, están repletas de recuerdos de viaje y hallazgos de su marido, que trabaja como médico para UNICEF. Instalados en la casa desde hace 17 años, han dedicado todo este tiempo a renovarla cuidadosamente, transformándola en un plácido refugio familiar. Entre olivos, higueras y almendros se ofrecen innumerables rincones en los que sentarse a descansar y soñar. La vista desde las terrazas y balcones sobre la tierra roja de los campos y la naturaleza del valle es espectacular. Los anteriores propietarios de la hacienda eran también dueños de buena parte de los terrenos de la zona, hasta que en 1830, como consecuencia de una apuesta, tuvieron que ceder la propiedad a sus vecinos.

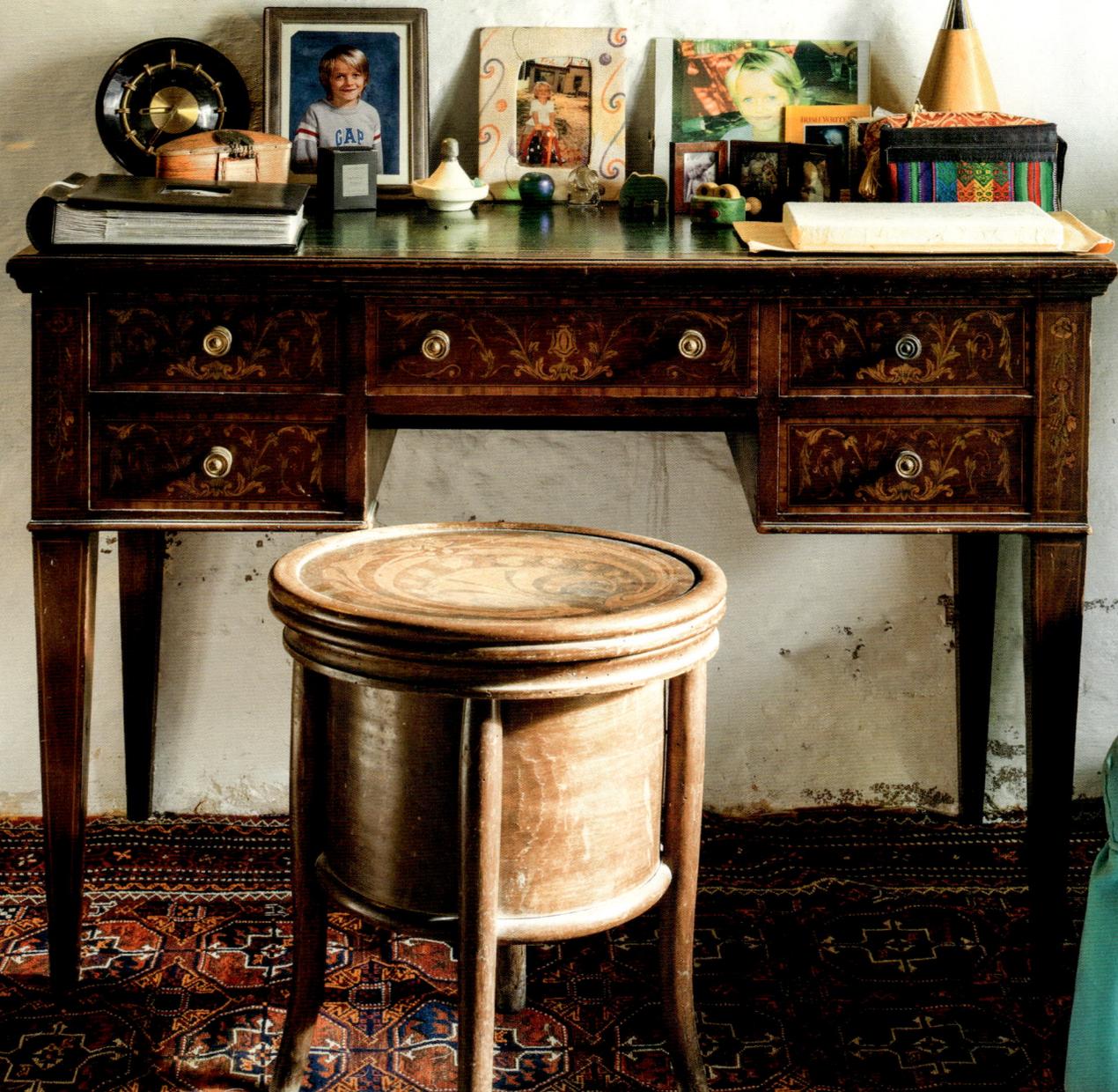

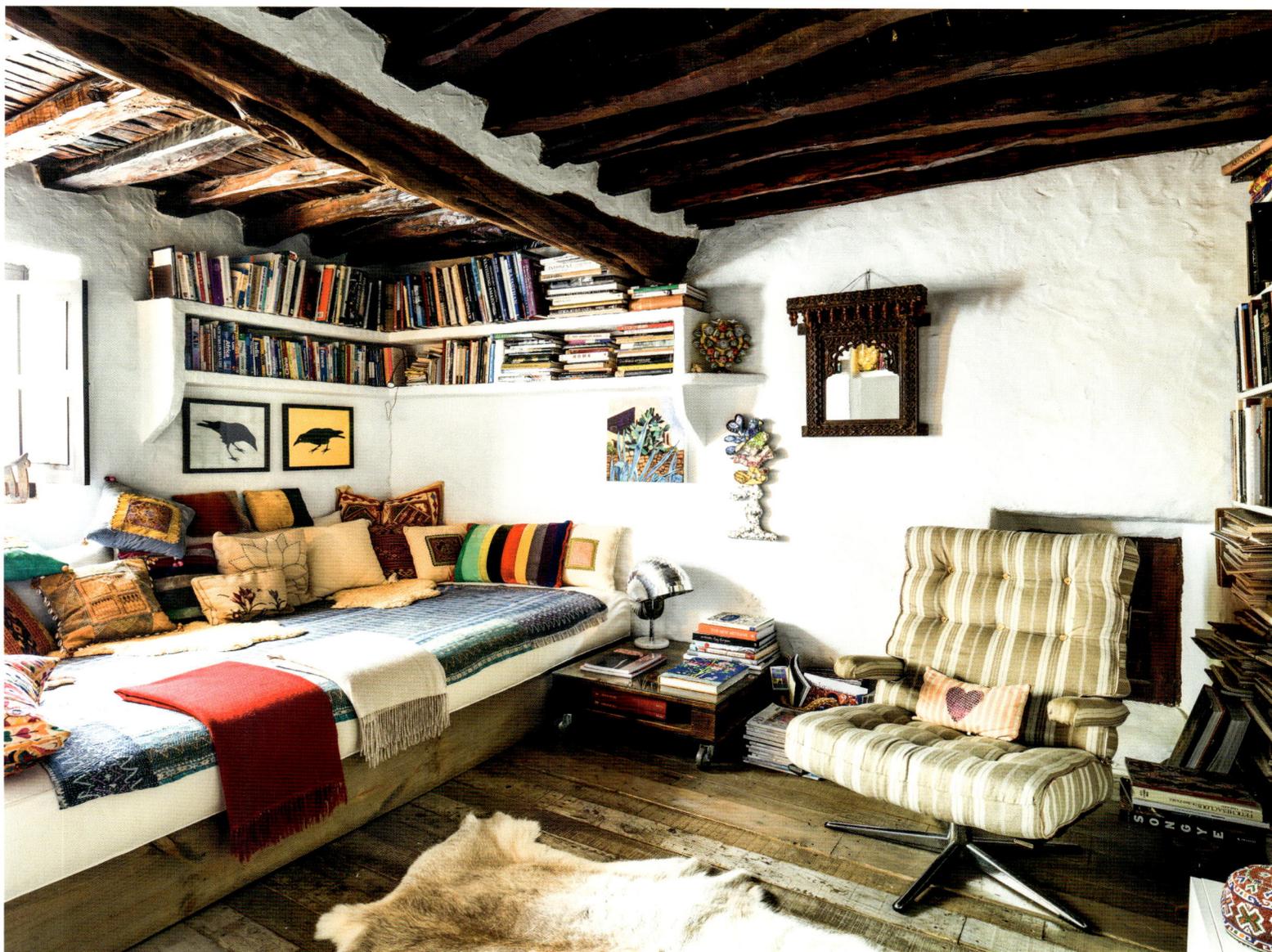

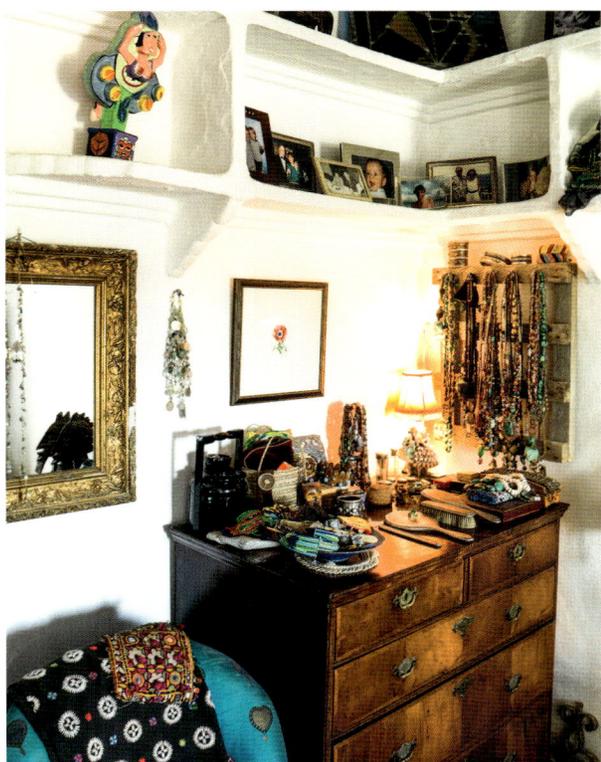

An eclectic mix of colors, materials and styles combine with family photographs to create an artful paradise.

Der kunterbunte Mix aus unterschiedlichen Materialien, Farben und Stilen ergibt zusammen mit den Familienbildern ein kunstvolles Paradies.

La variopinta mezcla de materiales, colores y estilos, combinada con las fotografías familiares, a como resultado un artístico paraíso.

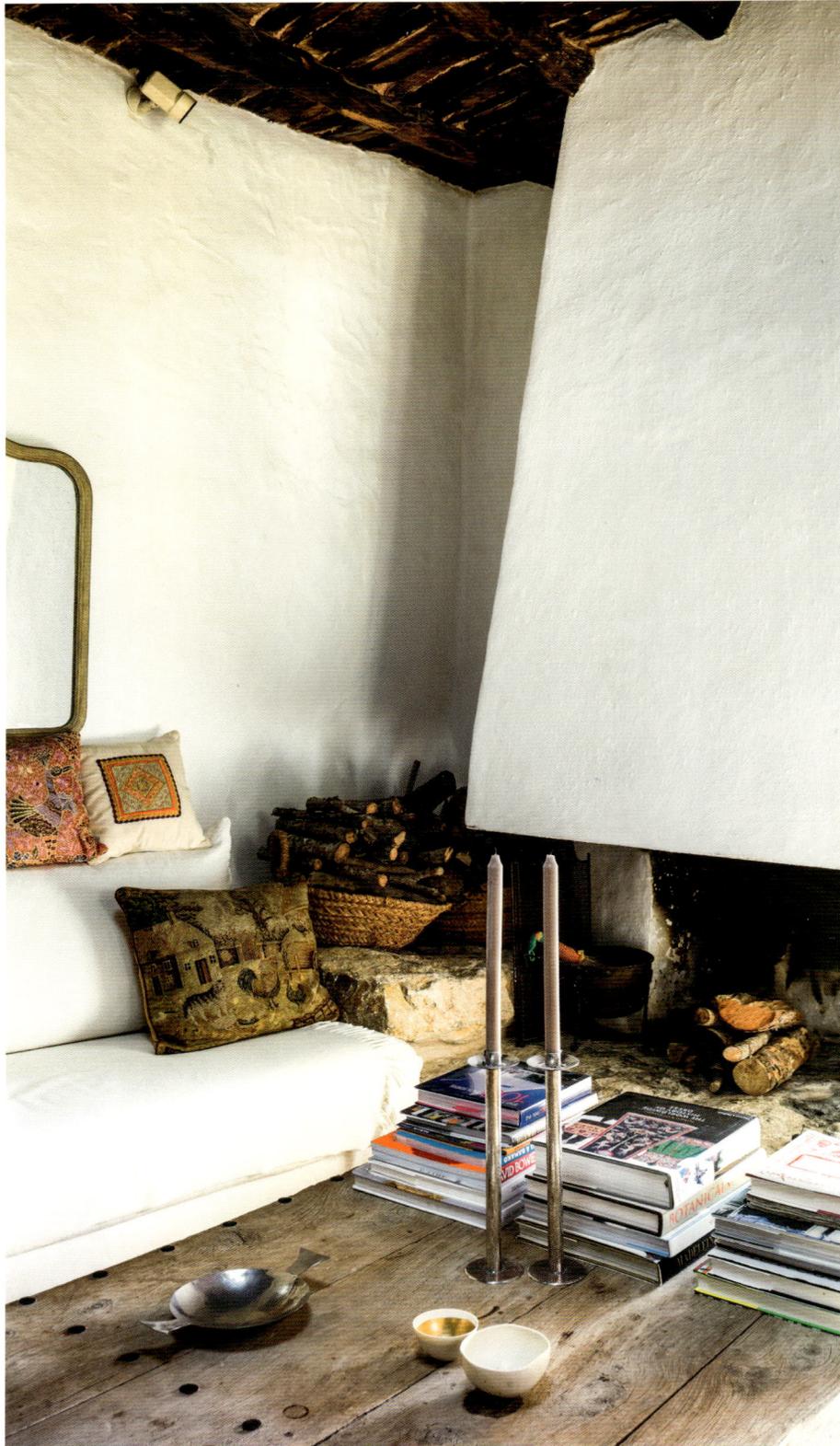

Traditional building materials, built-in furniture, and antique wood provide an ideal backdrop for a wide range of decorations and colors.

Traditionelle Baustoffe, gemauerte Möbel und altes Holz schaffen den idealen Hintergrund für eine Vielzahl an Dekorationen und Farben.

Materiales de construcción tradicionales, muebles de obra y maderas antiguas crean un trasfondo ideal para la amplia variedad de colores y elementos decorativos.

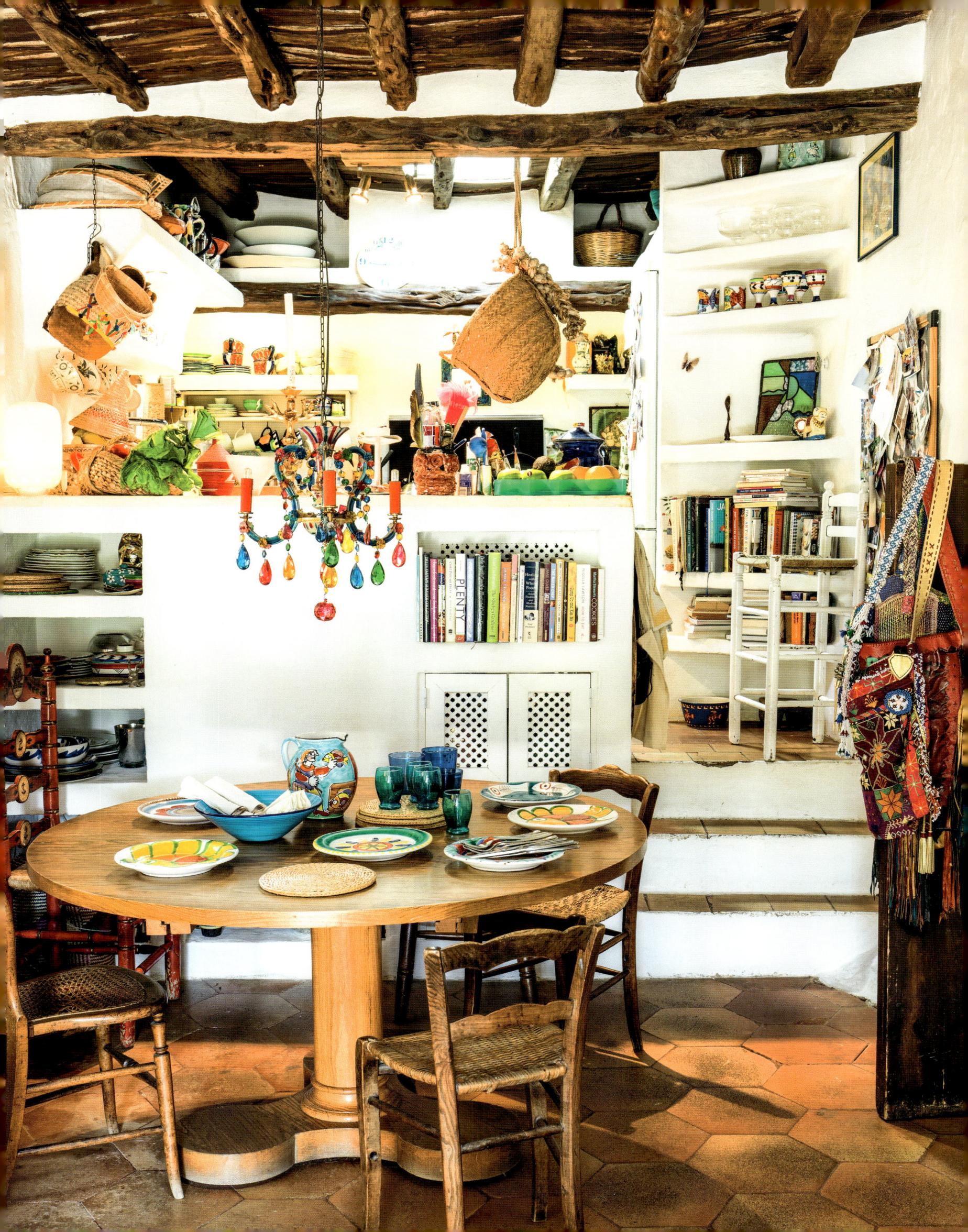

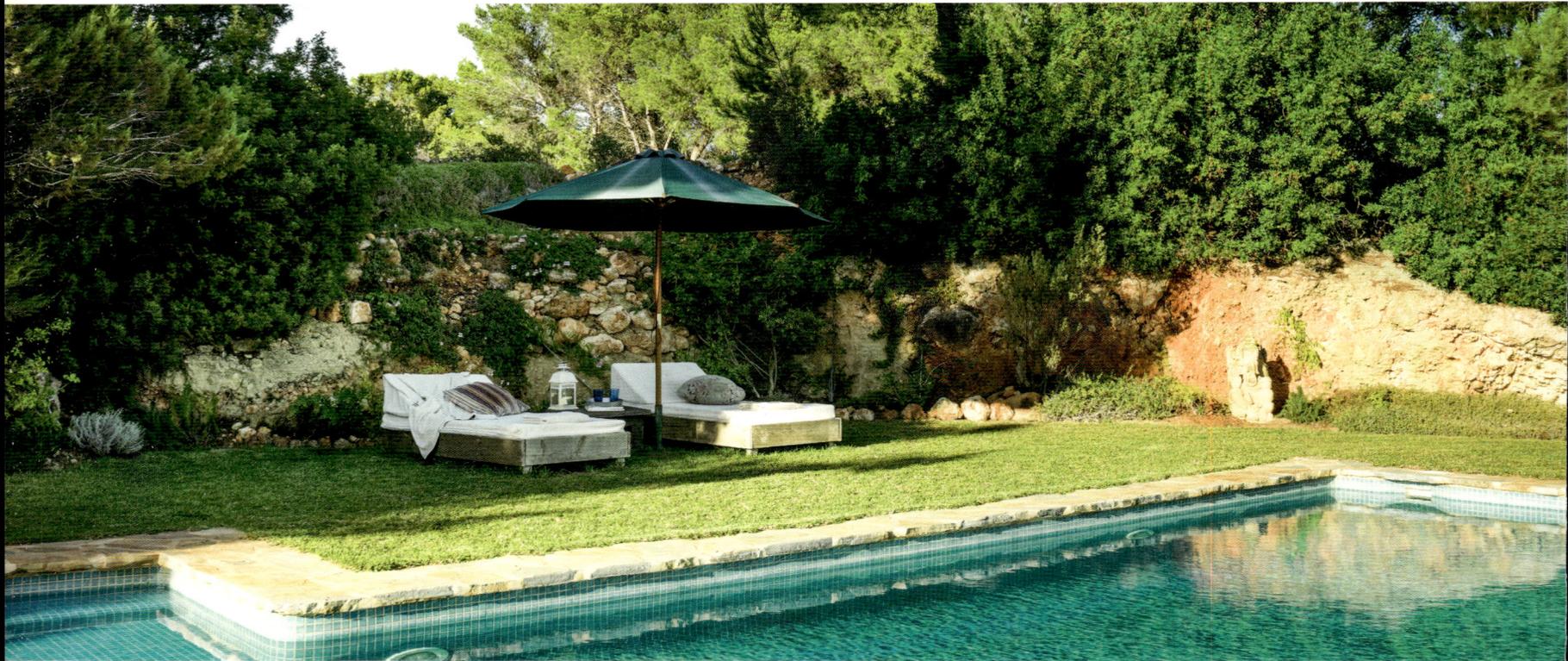

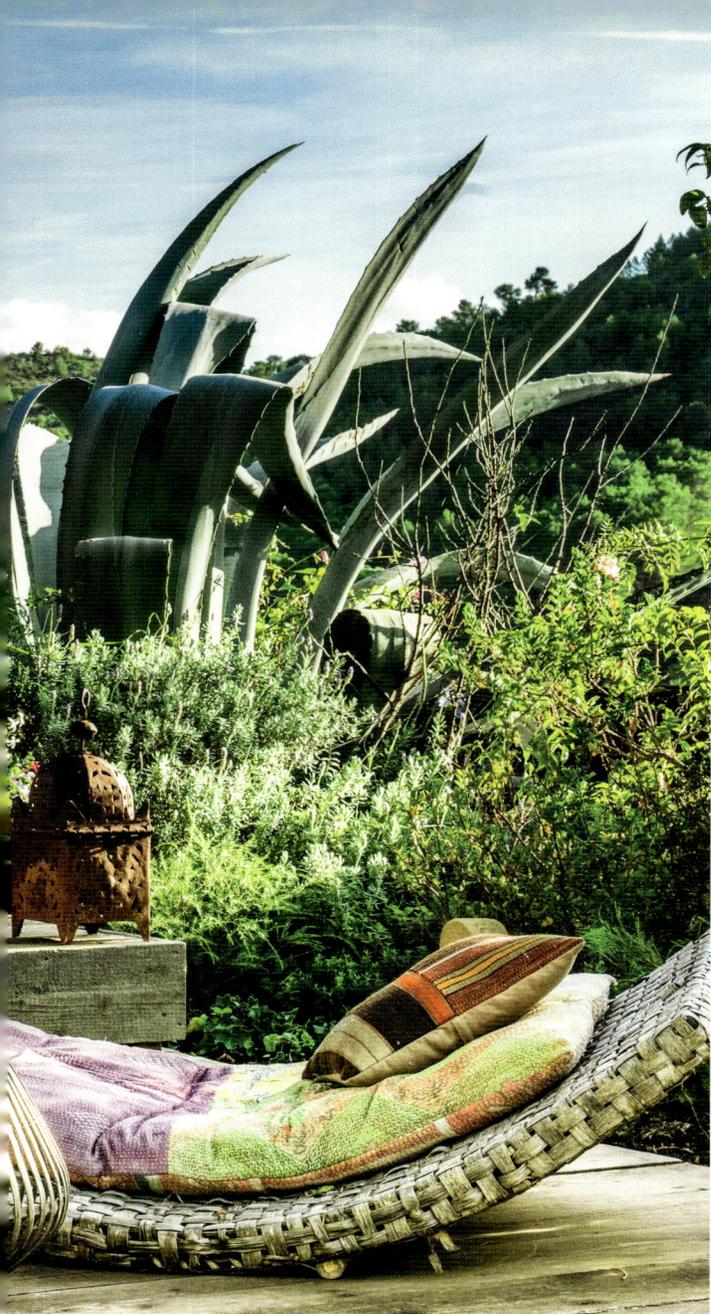

A casual lounge area, surrounded by lush bougainvillea and agave plants. Like the natural materials, the colors blend with the vegetation.

Lässige Loungeecke umgeben von üppigen Bougainvilleen und Agaven. Die Farbtöne passen sich ebenso wie die Naturmaterialien in die Vegetation ein.

Buganvillas y agaves flanquean el plácido saloncito esquinero. Los colores escogidos casan a la perfección con la vegetación circundante, al igual que los materiales naturales.

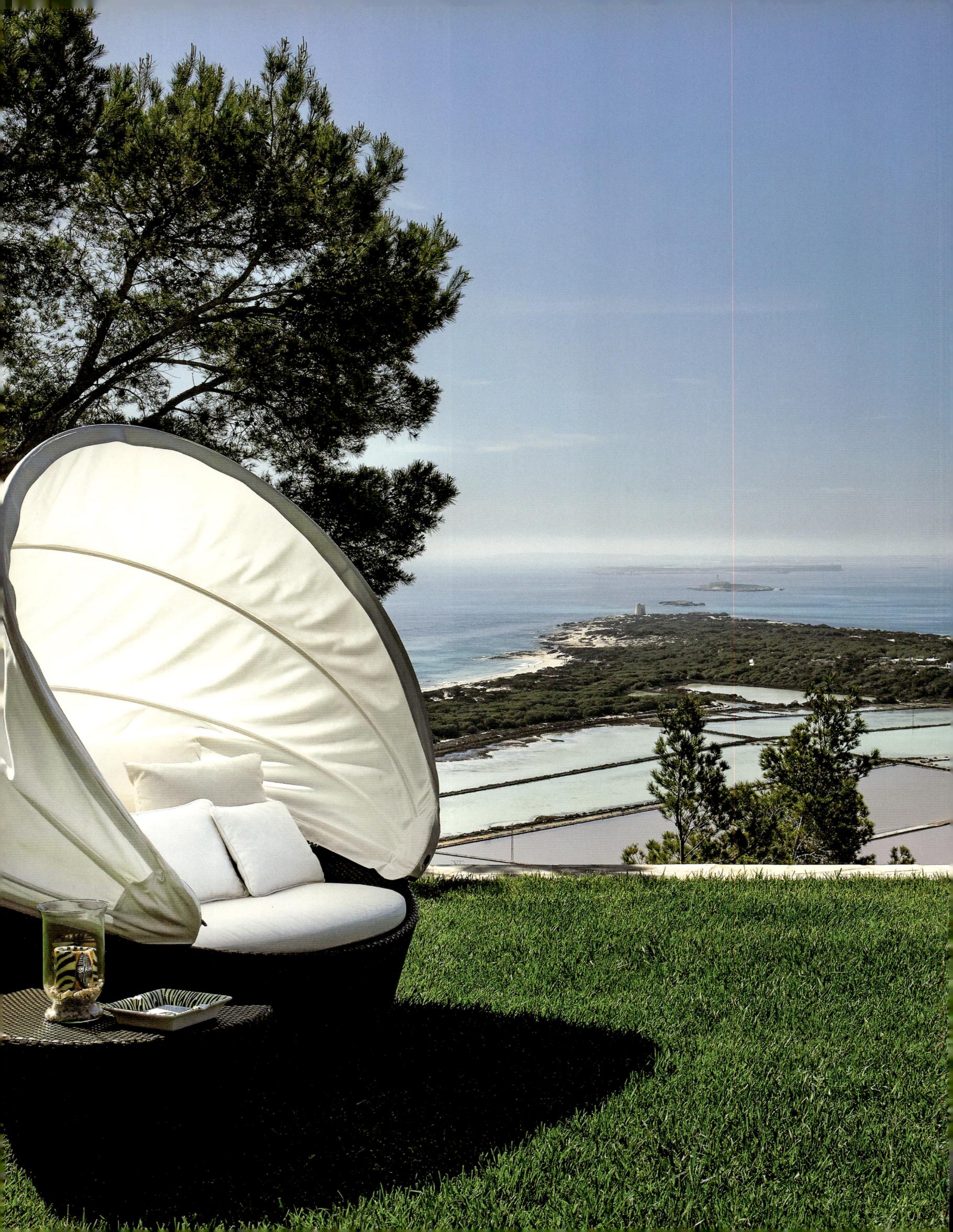

# Can Niri

INSPIRED BY THE spirit of Africa, the house sits atop a hill overlooking Las Salinas and offers a panoramic view of Es Vedra, a rocky island steeped in legend. The cosmopolitan owner has created a magical space that hints of sub-Saharan Africa by decorating her home with animal prints, a palette of nuanced beige tones and well placed décor elements. Throughout the property, African trophies, fabrics, and patterns dominate the atmosphere both indoors and out. The south-facing house, with its view of Formentera and the African coast beyond, creates the feeling that you are very close to the cradle of humanity—especially in August, when the flamingos arrive to build their nests in the saline flats.

INSPIRIERT VOM AFRIKA-SPIRIT zeigt sich das Haus auf der Bergspitze über Salinas mit Panoramablick bis hin zur sagenumwogenen Steininsel Es Vedra. Mit Animal-Prints, einer nuancenreichen Beigepalette und gezielt eingesetzten Dekorationen wird von der kosmopolitischen Besitzerin der Flair des Schwarzen Kontinents hervorgezaubert. Die Omnipräsenz afrikanischer Trophäen, Stoffe und Muster bestimmt die Atmosphäre der Außenanlagen und der Innenräume. Durch die Südausrichtung des Hauses mit Blick auf Formentera und die dahinterliegende afrikanische Küste hat man das Gefühl, der Wiege der Menschheit ganz nahe zu sein, vor allem, wenn sich im August die Flamingos in den Salinen niederlassen.

ÁFRICA ESTÁ muy presente en esta casa situada en la cima sobre Ses Salines, desde la que se abre una enorme panorámica hasta el legendario islote de Es Vedra. La cosmopolita propietaria ha conseguido conjurar la esencia del continente negro mediante estampados animales, una paleta de *beiges* muy rica en matices y diversos elementos decorativos seleccionados con mimo. La omnipresencia de trofeos, telas y patrones africanos traza el ambiente de los espacios exteriores e interiores. La casa está orientada hacia el sur, hacia Formentera, y más allá hacia la costa africana; tiene uno así la sensación de estar muy próximo a la cuna de la humanidad, en particular en agosto, cuando los flamencos se instalan en las salinas.

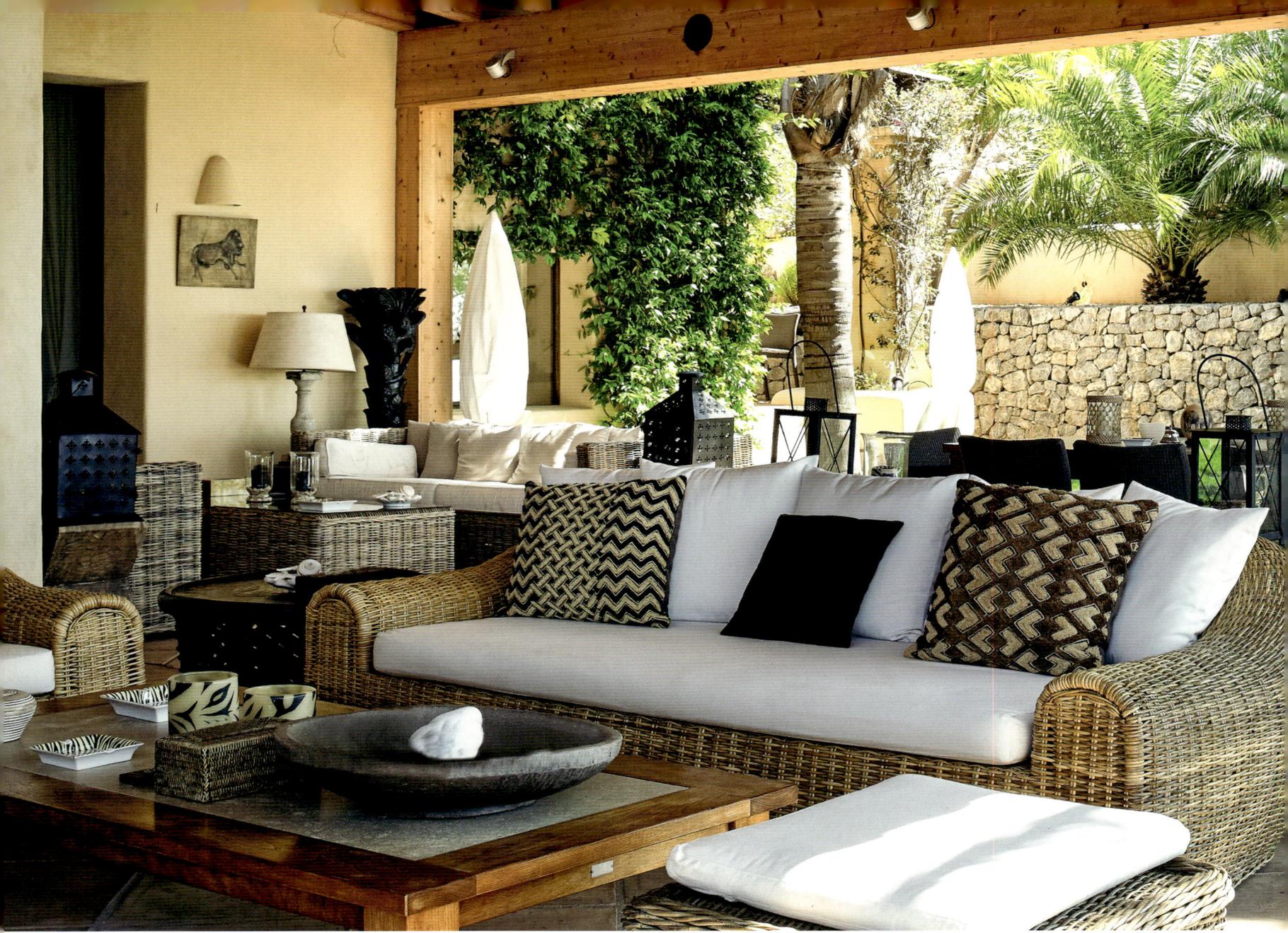

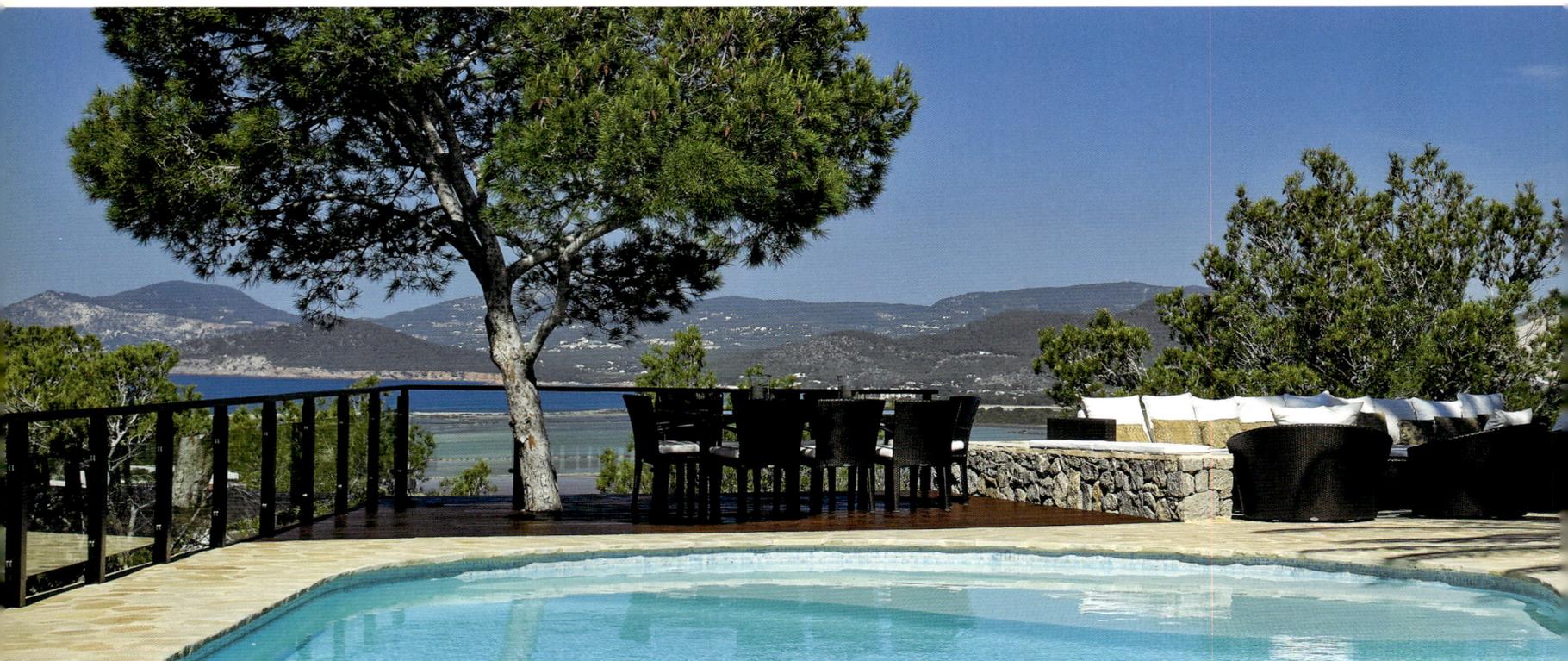

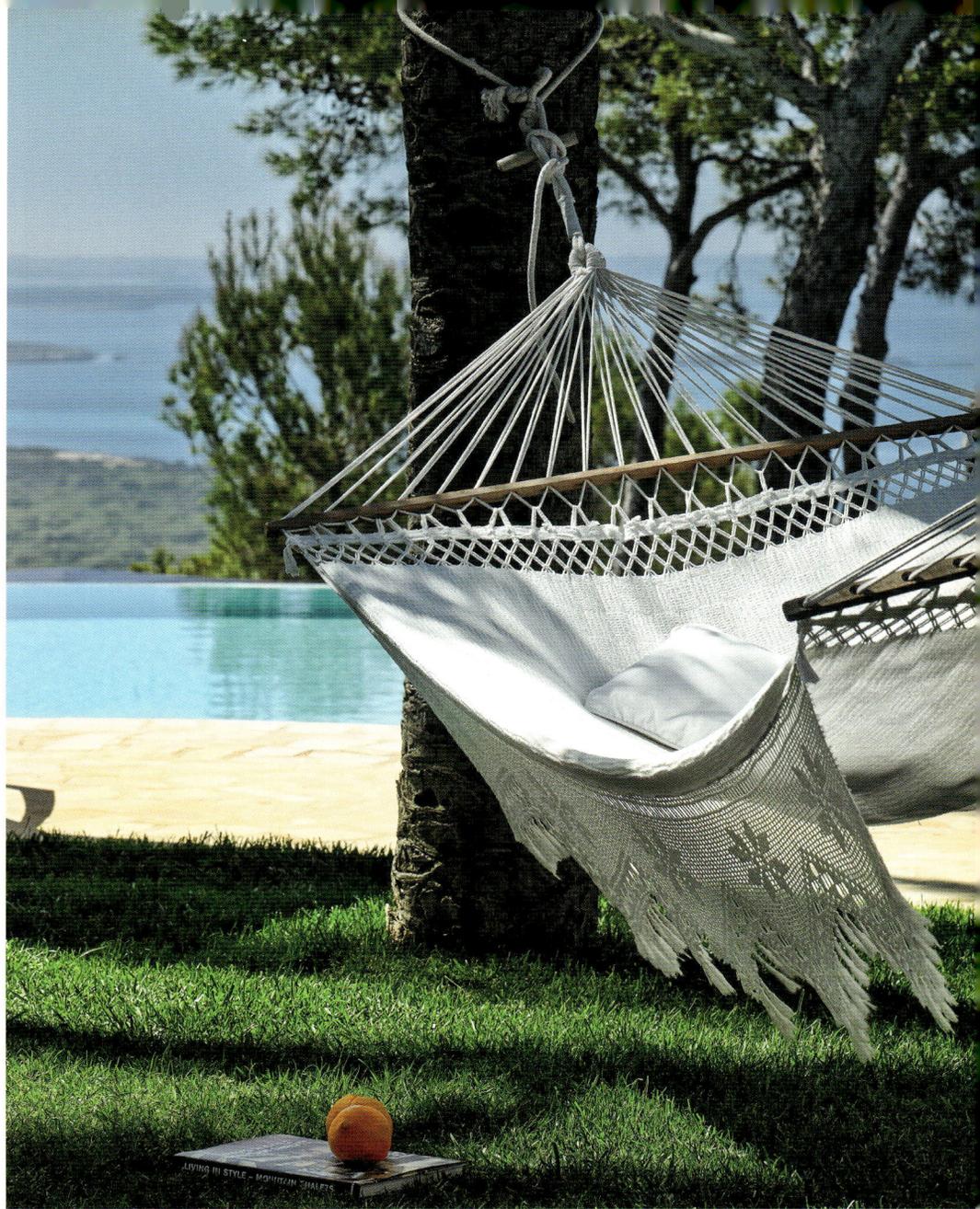

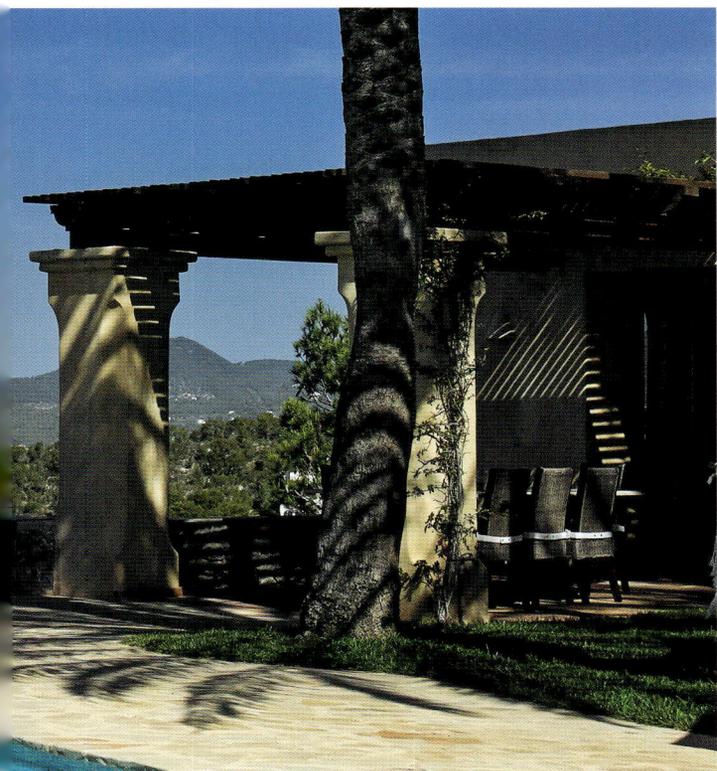

Fabrics that create an ethnic look, natural materials, and beige tones on the terraces. African patterns in the living room.

Stoffe im Ethno-Look, Naturmaterialien und Beigetöne auf den Terrassen. Afrikanische Muster auch im Wohnzimmer.

Telas de aire étnico, materiales naturales y tonos beige en las terrazas. Las pinceladas africanas está presentes también en el salón.

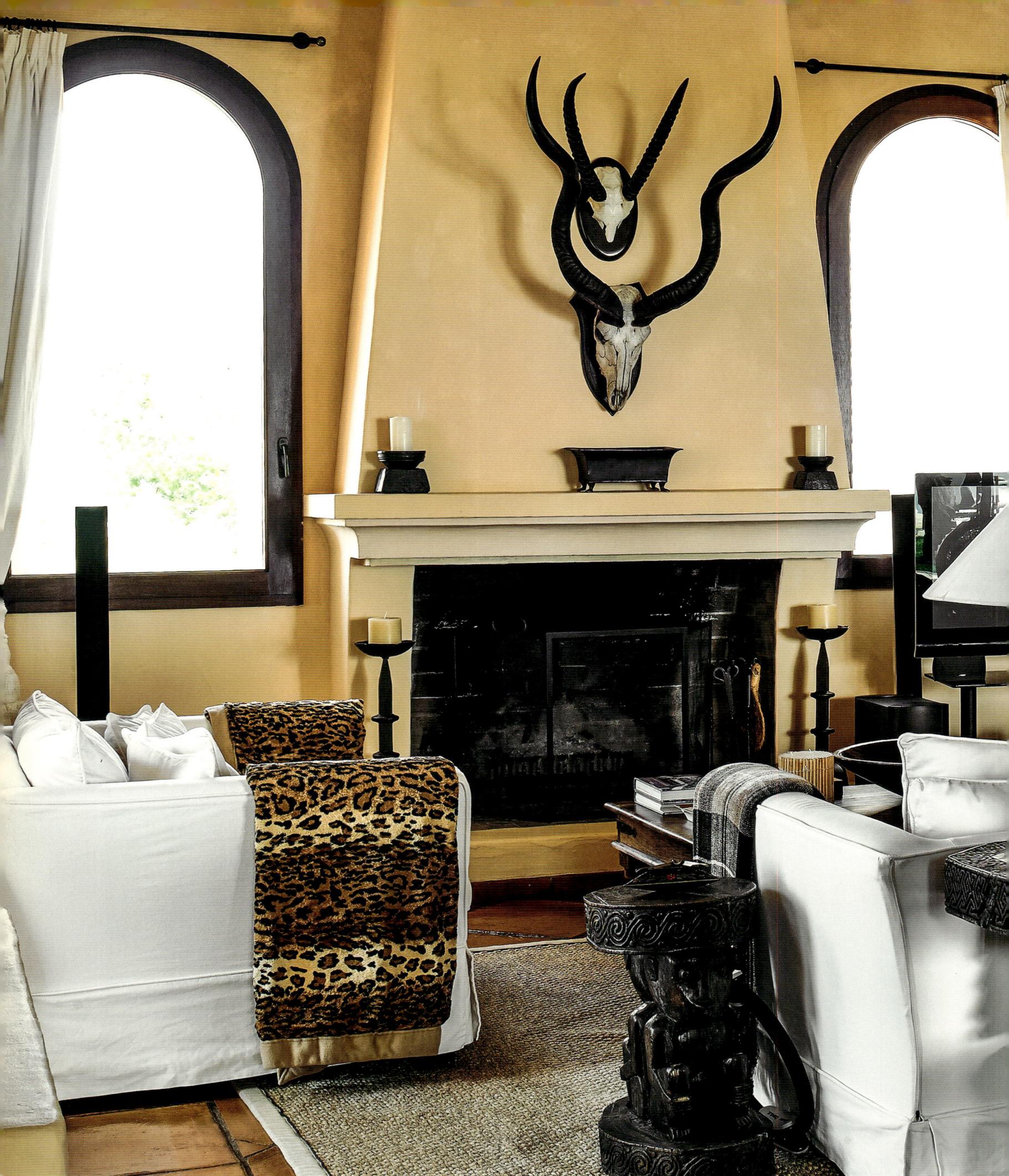

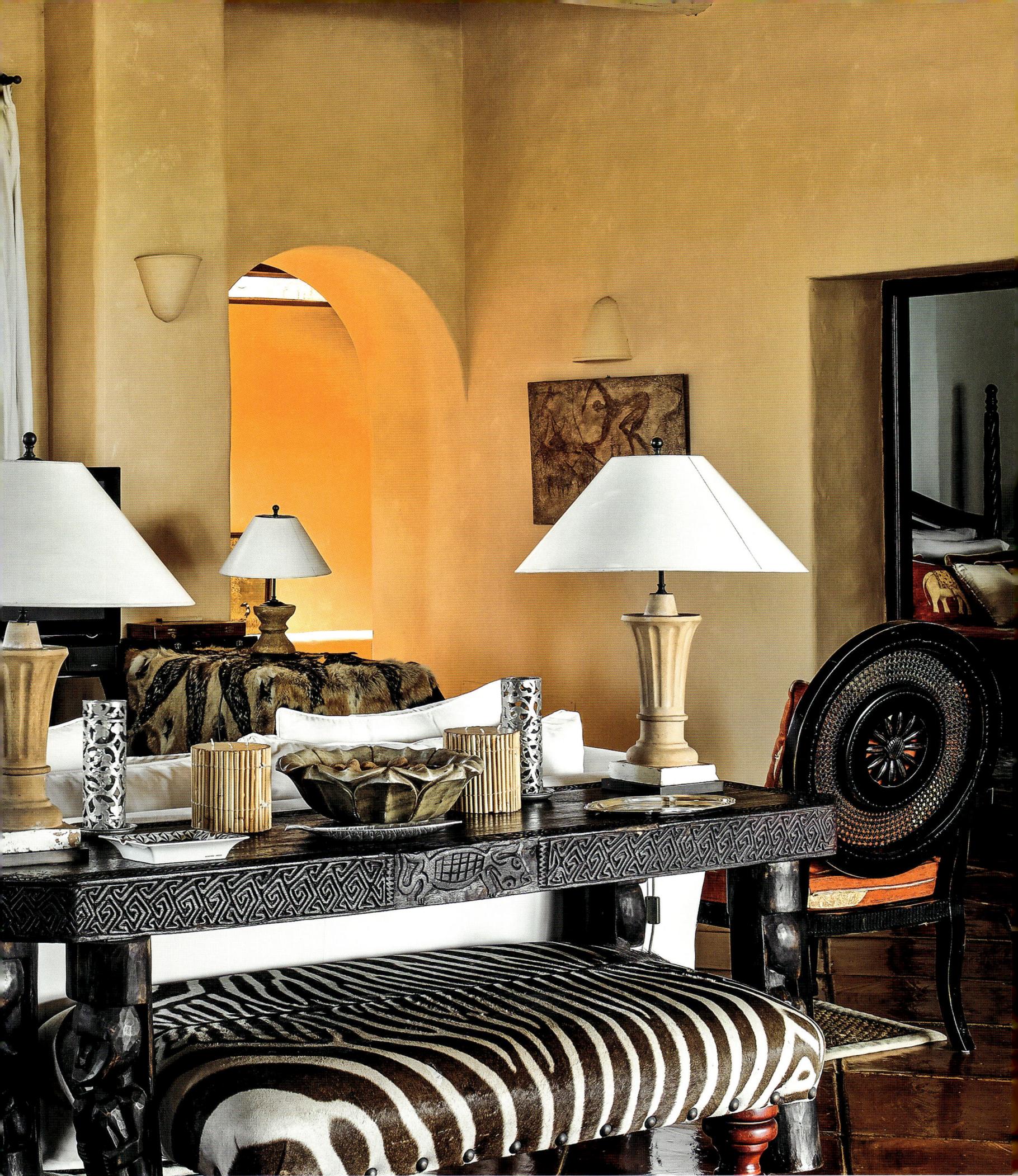

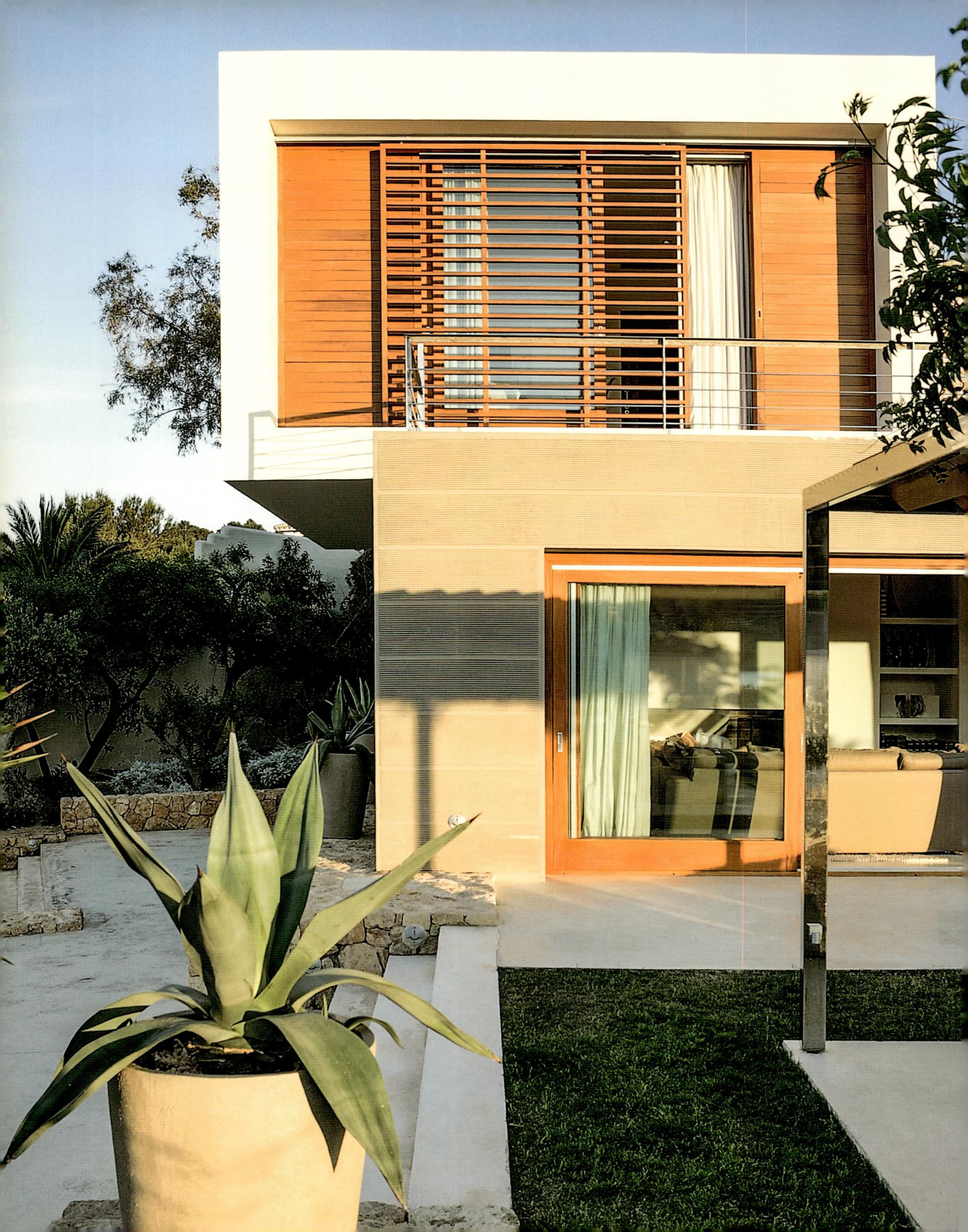

# Casa Tipaza

THREE CUBES MAKE up this modern house located on a peninsula in Ibiza's southern coastal region. This captivating home on the cliffs overlooking Porroig Bay was designed by Jaime Romano and features clean lines and an ambience of serene seclusion. The architect drew inspiration from the *embarcaderos* (Ibizan boathouses) on the shore below. The pool area, terraces, and gardens offer an unobstructed view of Es Cubells Bay. The home's contemporary design provides the perfect setting for furniture from Europe, Asia, and the Americas. The interior is decorated in restful monochrome colors that create a sense of tranquility. The entire property, from the infinity pool with its bar to the expansive, open living areas and outdoor spaces, forms a sublime panorama. The house is framed by a pine forest, and the Venetian sliding doors made of iroko wood fill the spaces and give the architecture its distinctive character.

DAS AUS DREI Kuben bestehende moderne Haus liegt auf einer Halbinsel an der Südküste von Ibiza. Von Jaime Romano entworfen und auf den Klippen oberhalb der Bucht von Porroig errichtet besticht es durch seine klare Linienführung und unaufgeregte Zurückgenommenheit. Dabei hat sich der Architekt von den darunterliegenden *embarcaderos*, den ibizenkischen Bootshäusern, inspirieren lassen. Vom Poolbereich, den Terrassen und Gartenanlagen hat man freie Sicht auf die Bucht von Es Cubells. In zeitgenössischem Design ist das Haus mit Möbeln aus Europa, Asien und Amerika eingerichtet. Die ruhige monochrome Farbenwelt des Interieurs schafft eine Welt der Ruhe. Der Infinity Pool mit eigener Bar sowie die weitläufigen, offenen Wohnbereiche und Außenplätze garantieren alle ein grandioses Panorama. Das Haus ist eingerahmt von einem Pinienwald und die flächenfüllenden Jalousie-Schiebetüren aus Irokoholz geben der Architektur ihr Gesicht.

LA MODERNA CASA, compuesta de tres cubos, se alza sobre una península en la costa sur de Ibiza. Diseñada por Jaime Romano para ser construida sobre el acantilado de la bahía de Porroig, llama la atención por la claridad de sus líneas y la placidez que destila. El arquitecto buscó inspiración para la casa en los típicos embarcaderos de la costa ibicenca. Desde la piscina, las terrazas y el jardín es posible disfrutar de vistas sobre Cala d'es Cubells. La casa ha sido decorada en estilo contemporáneo con muebles procedentes de Europa, Asia y América. La serenidad monocroma del interior genera una burbuja de tranquilidad. La piscina de desborde tiene un bar propio, y tanto desde ella como desde las espaciosas salas comunes de la casa y los espacios exteriores las vistas están garantizadas. Una pineda rodea la casa, y las amplias celosías correderas de madera de iroko aportan un elemento muy distintivo al conjunto arquitectónico.

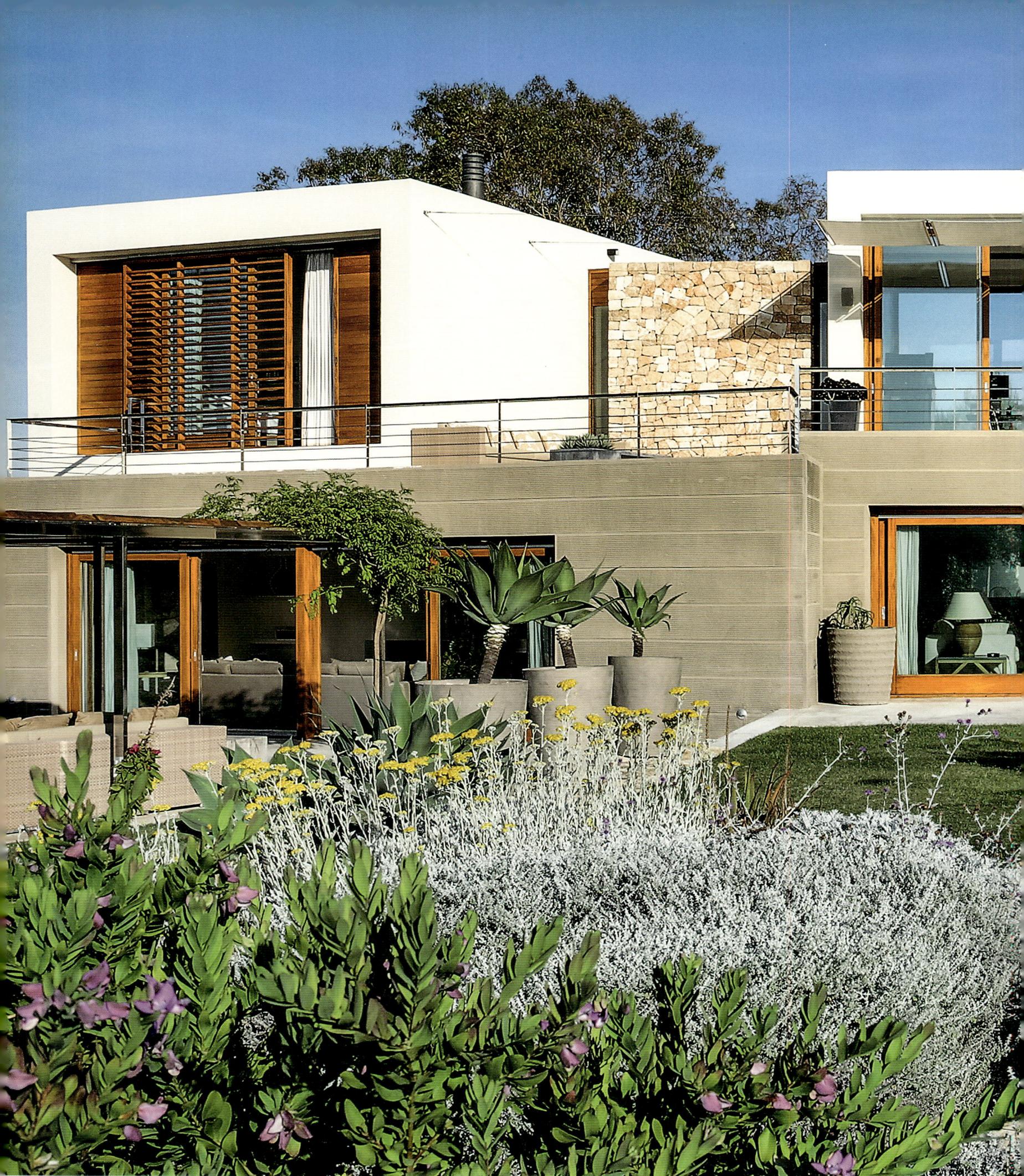

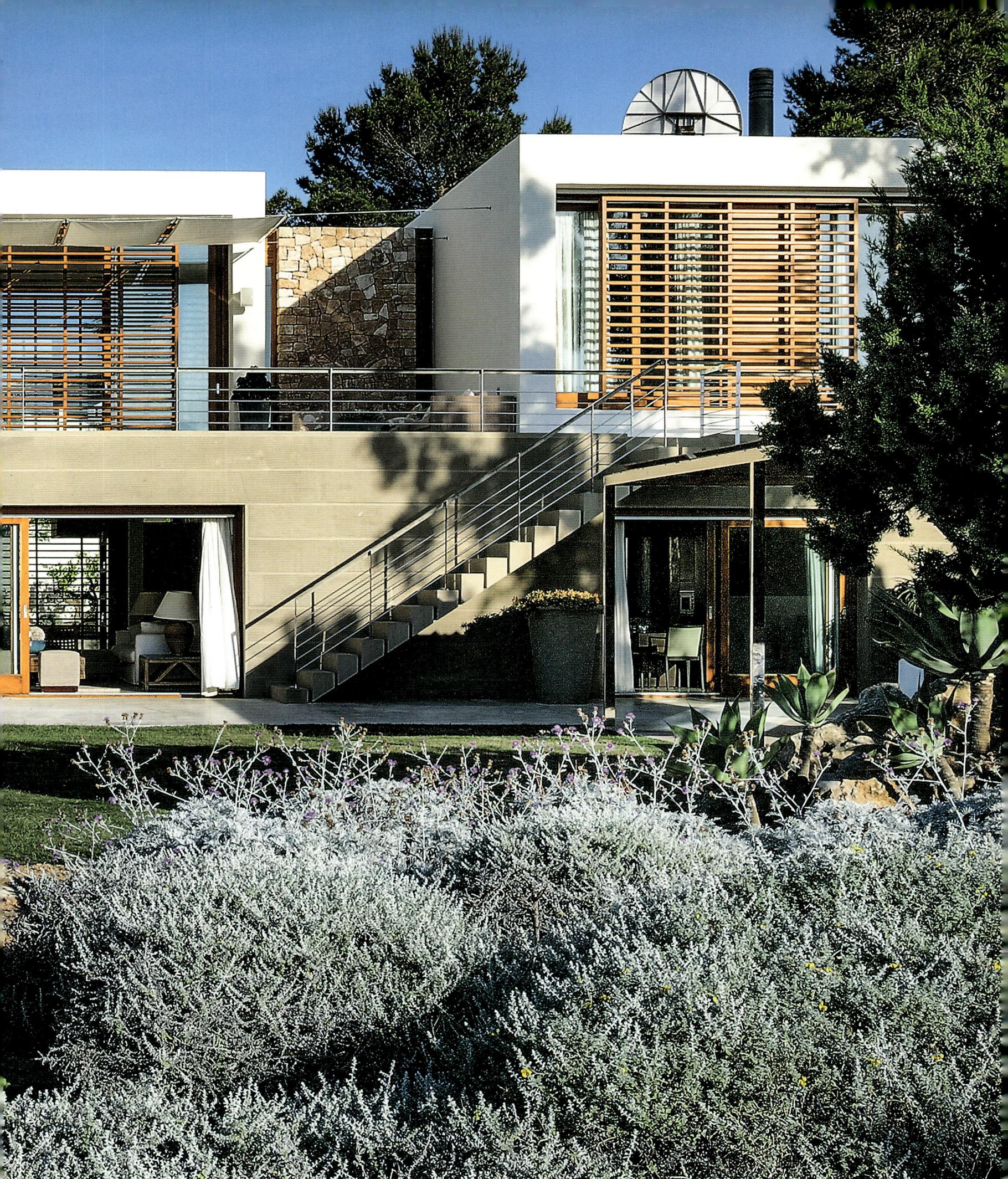

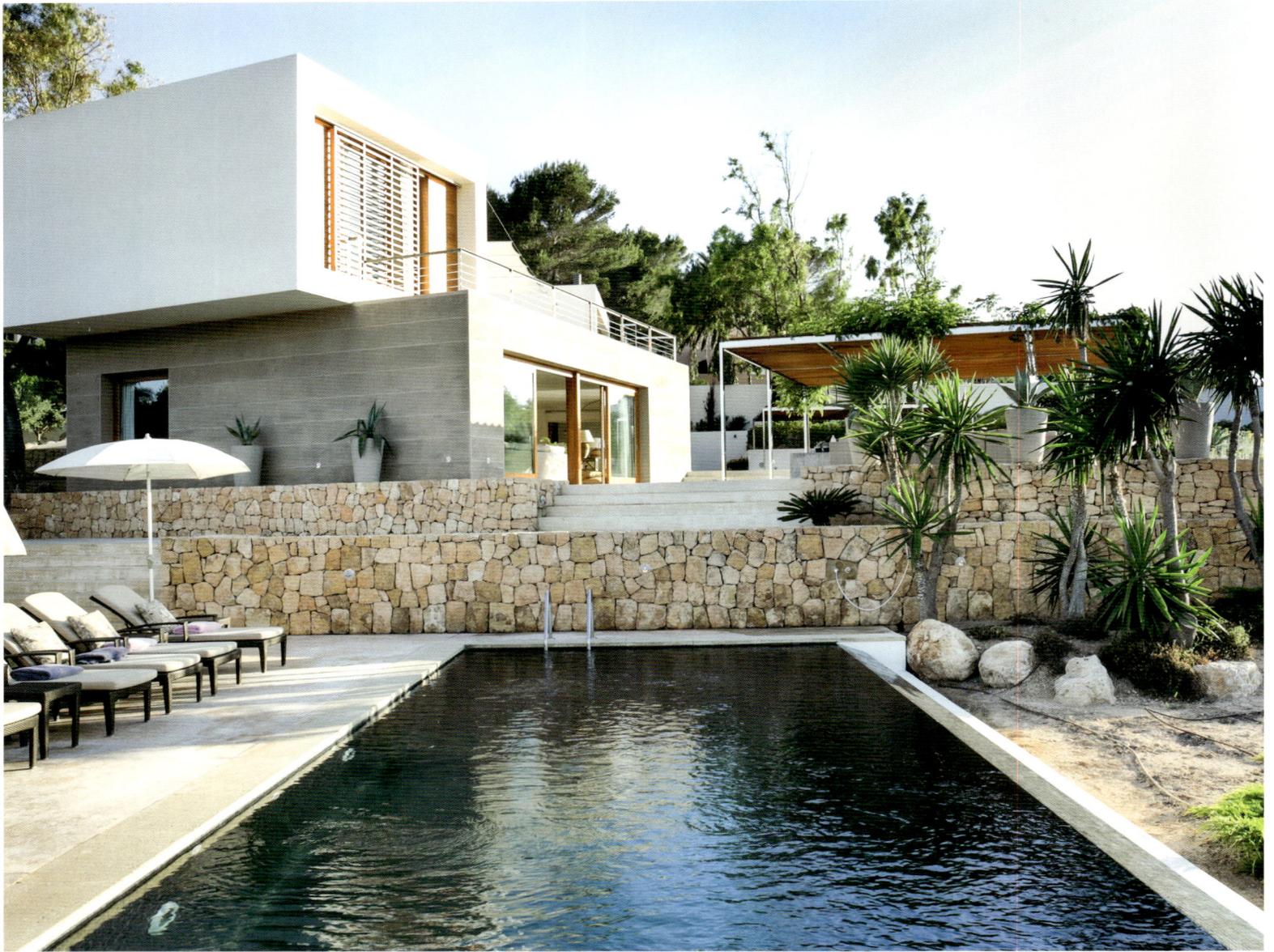

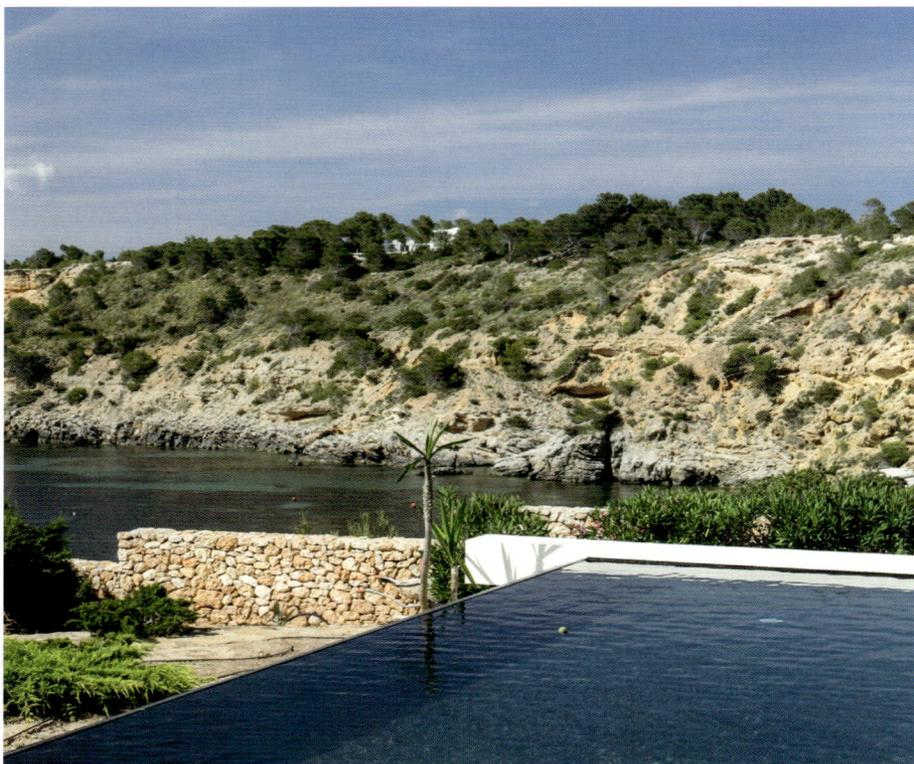

*Embedded infinity pool with a view of the bay. Panama Java beach chairs from Dedon. Double sunbed for relaxing in luxurious comfort.*

*Eingebetteter Infinity Pool mit Blick auf die Bucht. Sonnenbetten Panama Java von Dedon. Doppelsunbed zum Entspannen de luxe.*

*Piscina de desborde con vistas sobre la bahía. Tumbonas Panama Java de Dedon. Un lecho doble de lujo para relajarse al sol.*

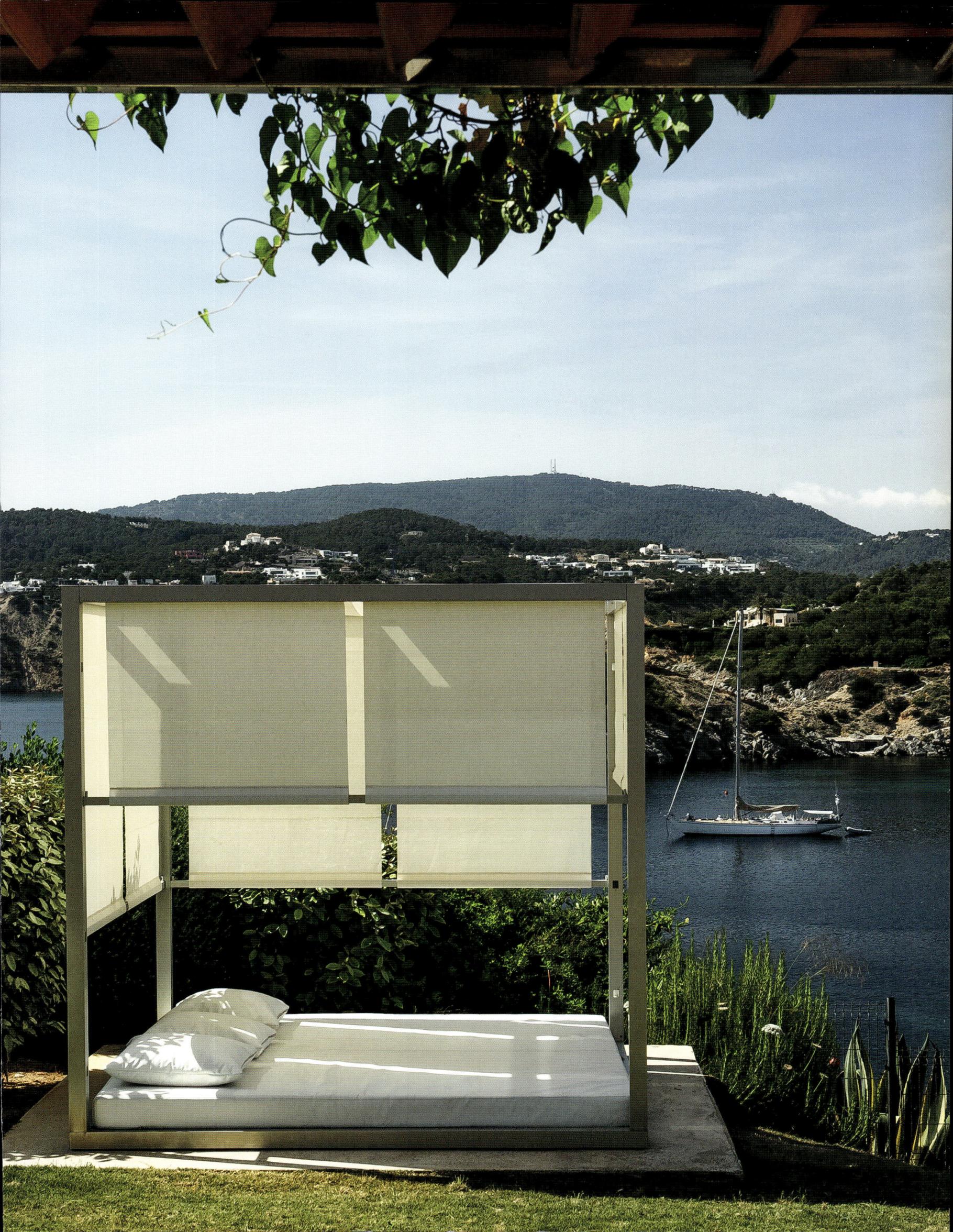

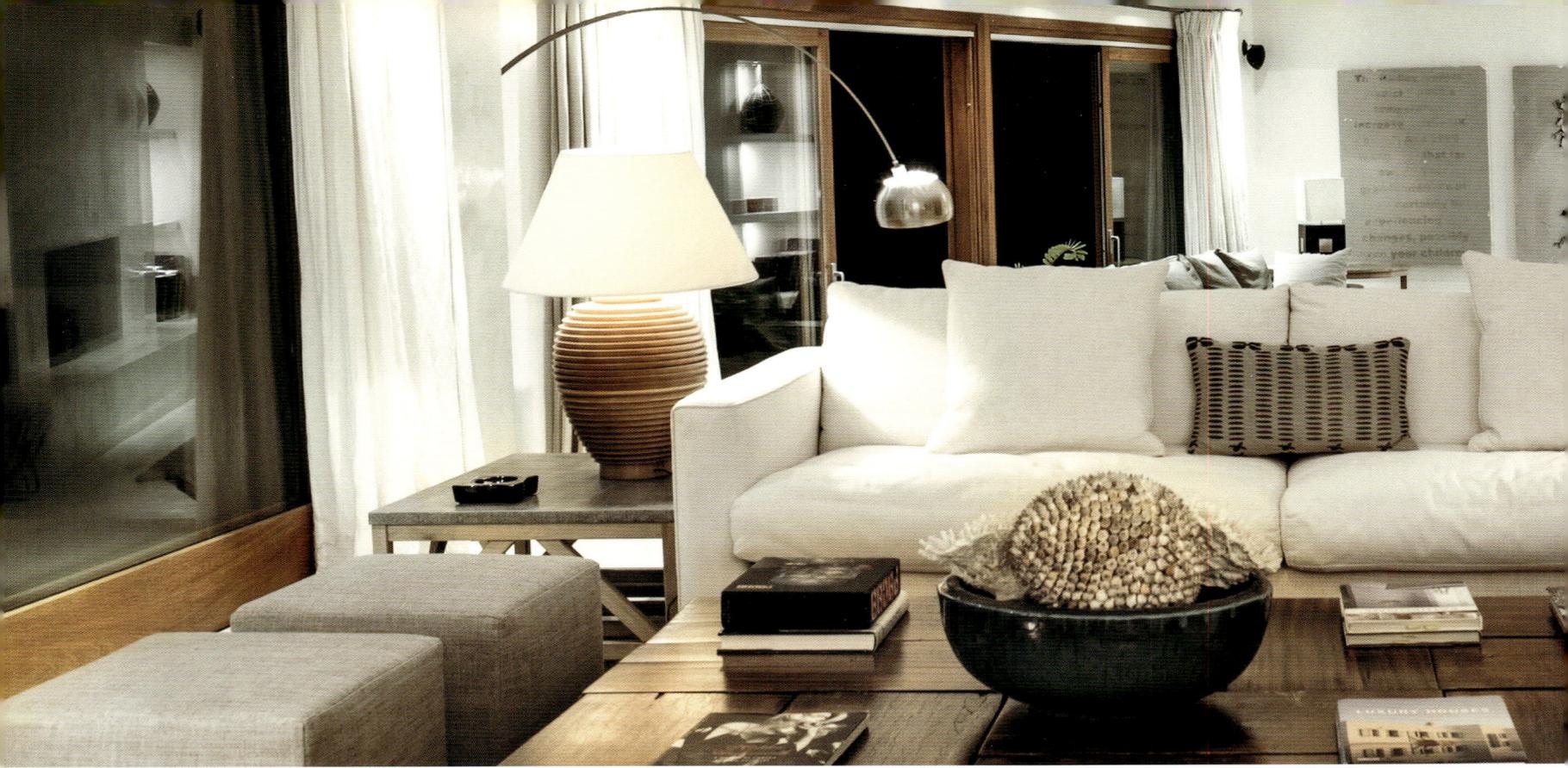
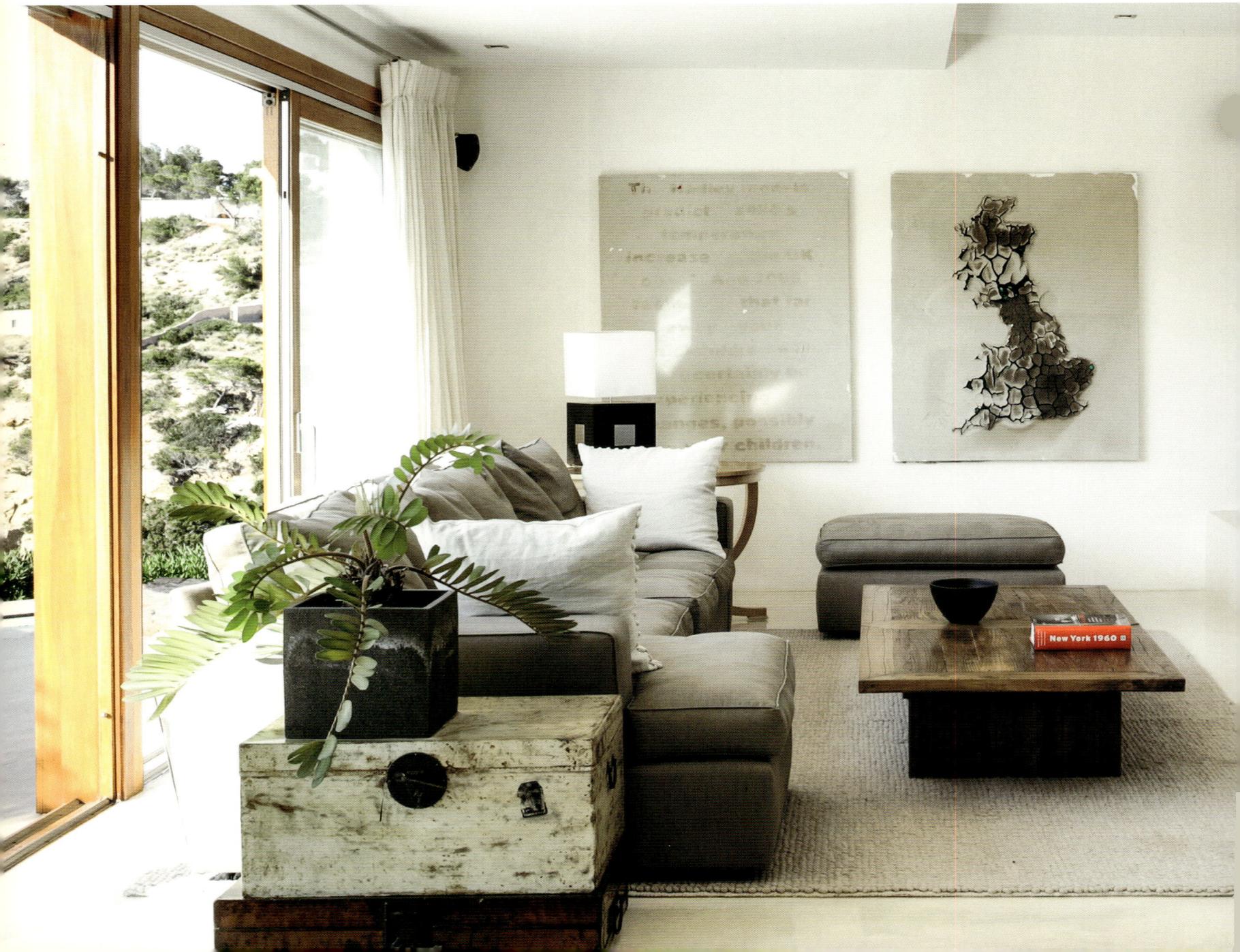

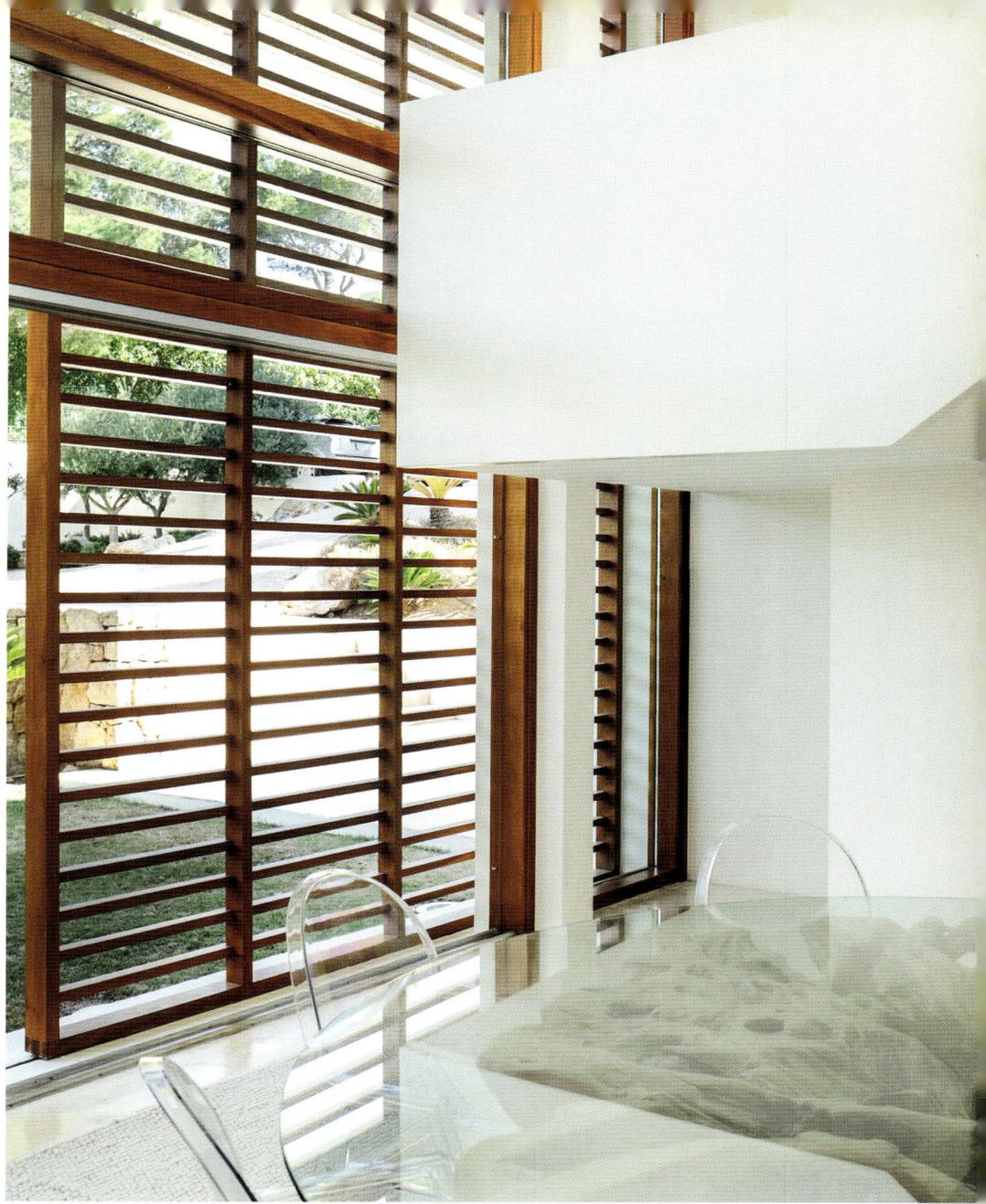

*Natural materials and colors fill the living areas with a warm atmosphere. Bookshelves are built into the wall on either side of the fireplace.*

*Warme Atmosphäre in den Wohnbereichen durch Naturmaterialien und -farben. Um den Kamin eine gemauerte Regalwand.*

*Los materiales y colores naturales crean una atmósfera acogedora en las áreas comunes. En torno a la chimenea, estanterías de obra que cubren toda la pared.*

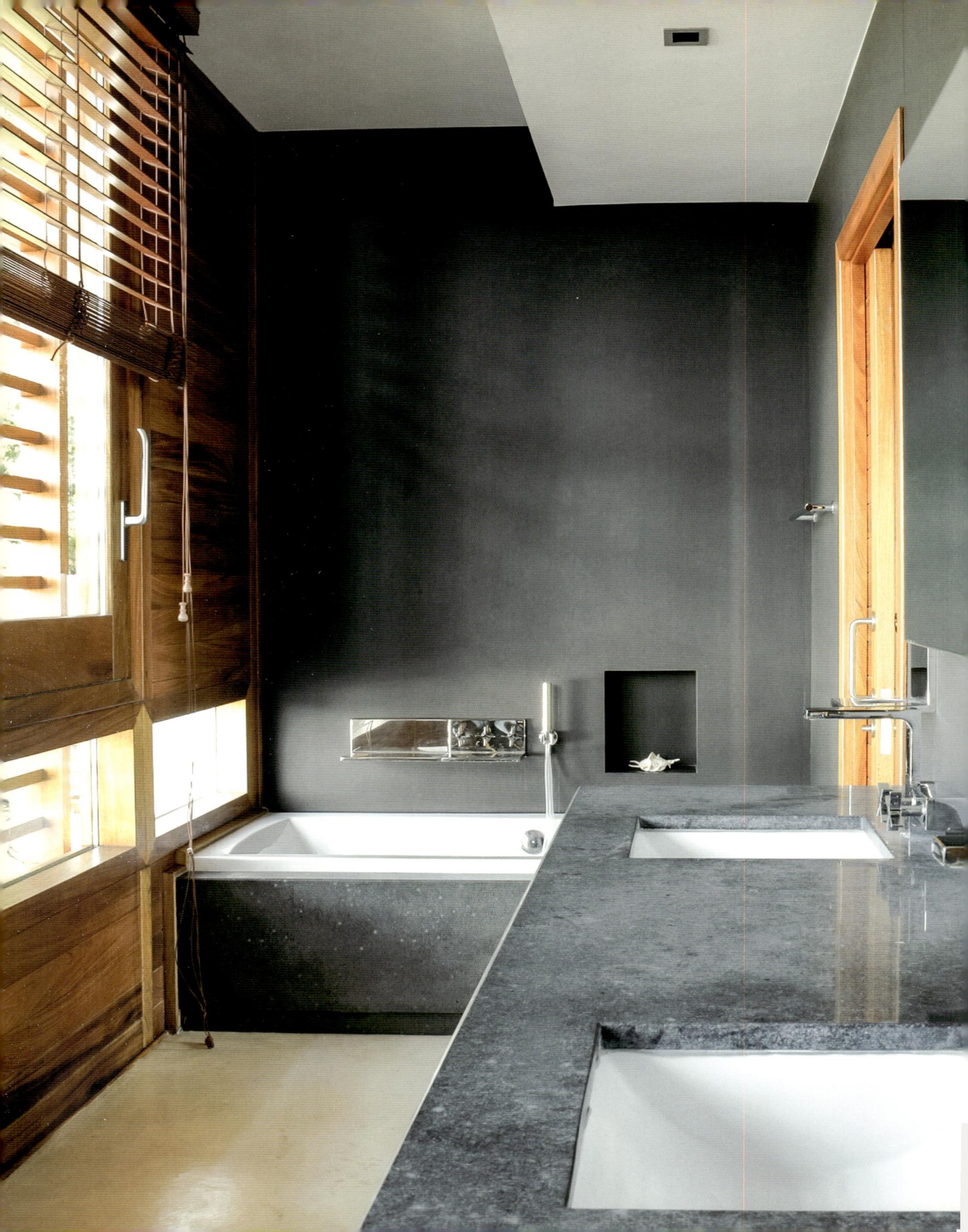

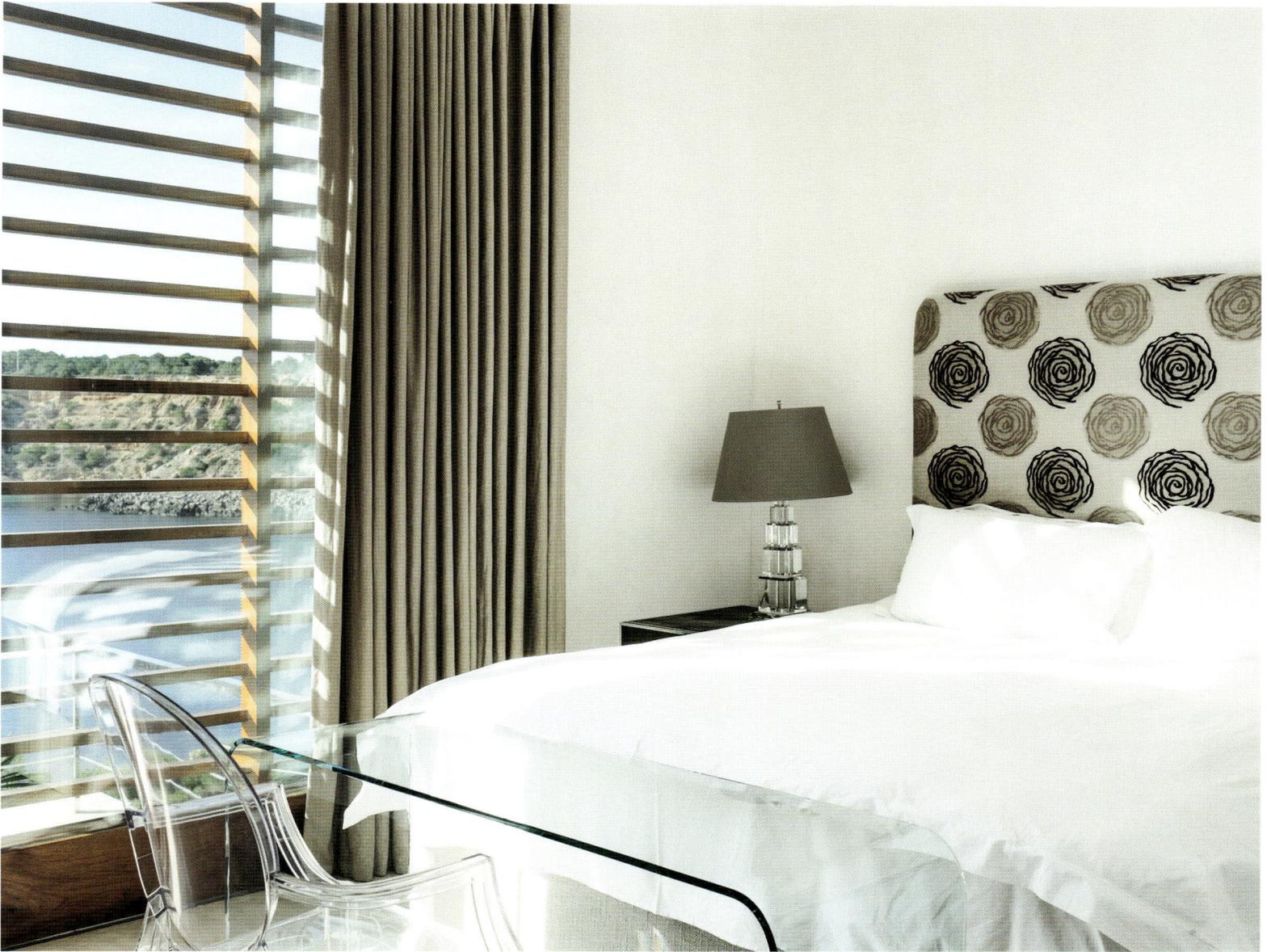

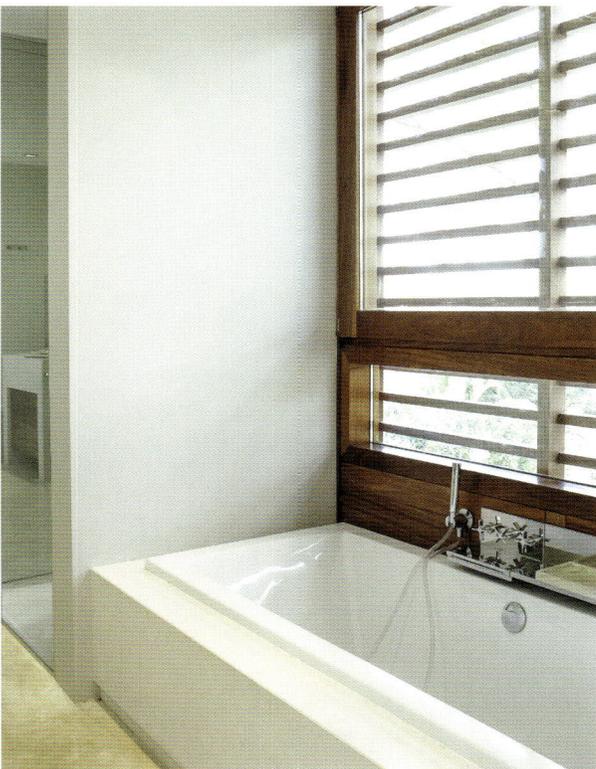

Minimalist bathroom decorated in anthracite and natural stone. Light filtering through the wooden blinds made of iroko wood lends warmth to all the rooms.

Minimalistisches Bad in Anthrazit und Naturstein. Warmes gefiltertes Licht in allen Räumen durch die Holzjalousien aus Irokoholz.

Baño minimalista en antracita y piedra no tratada. Las celosías de madera de iroko filtran la cálida luz que penetra en las habitaciones.

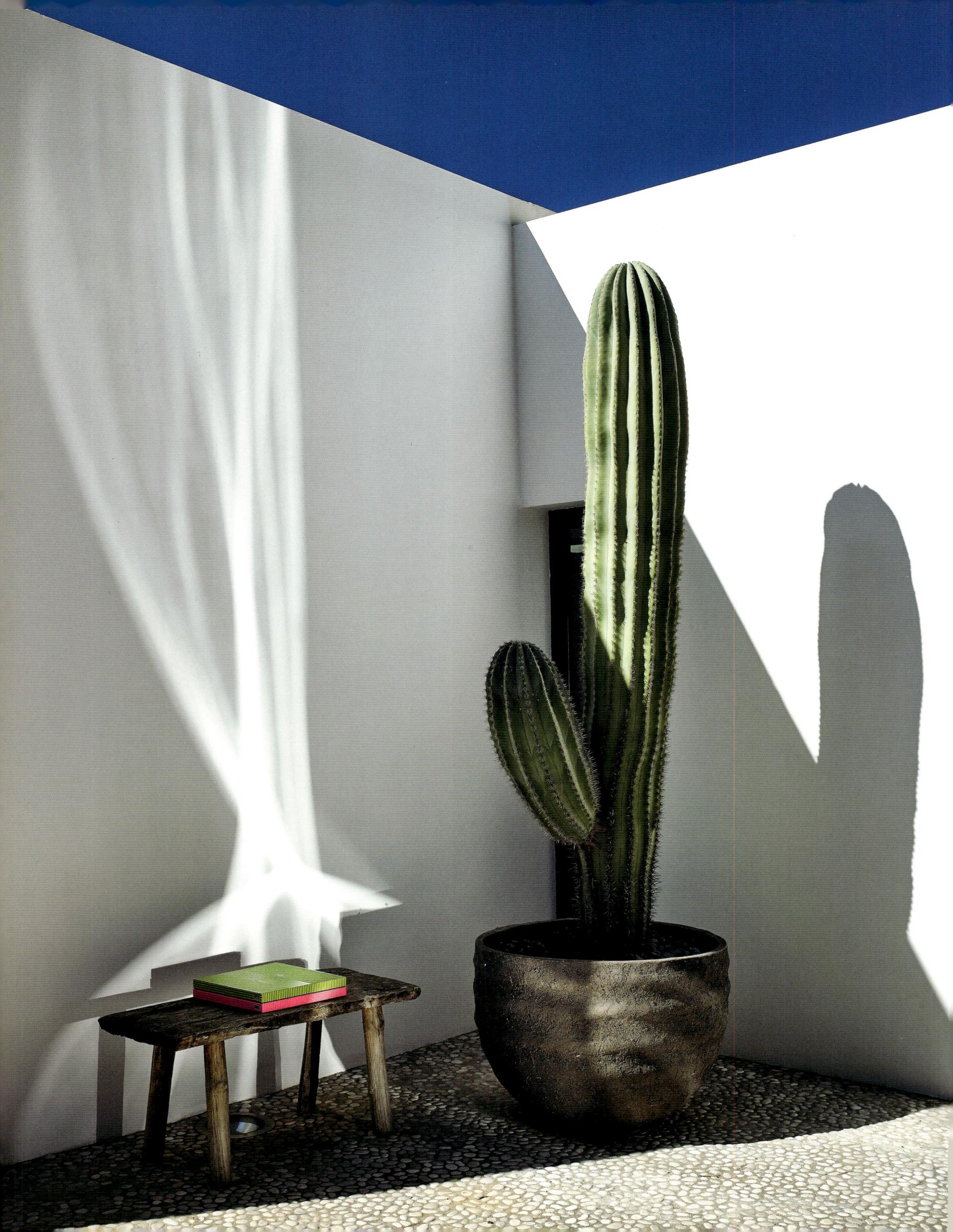

# Casa Amantiga

THE CUBIST-INSPIRED ARCHITECTURE of this home, developed by architect Jaime Serra Verdaguer, radiates an atmosphere dominated by a mix of nature chic, ethnic purism, and art. Tailored to the very specific tastes of its owner, an international epicurean, the house stands in stark contrast to the surrounding nature. A bank of sliding glass doors open all the way onto covered terraces that double the living space. A specially designed system of LED lights transforms the outdoor areas into a magical space filled with an ever changing glow of dancing colors. The owner-designed pool is made of black Italian slate, whose color changes from emerald green to anthracite to dark blue in the sunlight. Most of the furniture is custom-made by Morgen Interiors from limed oak and combined with classic design elements.

EINE MISCHUNG AUS Natur-Chic, Ethno-Purismus und Kunst bestimmt die Atmosphäre in dieser kubistisch anmutenden Architektur von Jaime Serra Verdaguer. Zugeschnitten auf die sehr klaren Vorstellungen seines Besitzers, eines internationalen Lebenskünstlers, bildet das Haus einen Kontrast zur umliegenden Natur. Durch die überdachten Terrassen lässt sich die Fläche des Wohnbereichs mithilfe komplett zu öffnender Glasschiebefronten verdoppeln. Ein speziell konzipiertes LED-Lichtsystem verwandelt die Außenanlagen im Glanz immer neuer Farbspiele. Der vom Besitzer entworfene Pool ist aus schwarzem italienischem Schiefer, dessen Farbe im Sonnenlicht von Smaragdgrün über Anthrazit bis zu Dunkelblau changiert. Die Möbel wurden größtenteils von Morgen Interiors aus gekalkter Eiche speziell angefertigt und mit Designklassikern kombiniert.

UNA COMBINACIÓN DE chic natur, purismo étnico y arte domina el ambiente de esta creación arquitectónica de resabios cubistas de arquitecto Jaime Serra Verdaguer. Desarrollada a partir de instrucciones muy claras de su propietario, bon vivant internacional, la casa ofrece un marcado contraste con la naturaleza circundante. Las terrazas cubiertas permiten duplicar la superficie del salón gracias a unos ventanales que pueden abrirse por completo. Un sistema de iluminación LED concebido especialmente para la residencia somete las instalaciones exteriores a una mutación cromática constante. La piscina, diseñada por el propietario, es de pizarra italiana negra, a la que la luz del sol dota alternativamente de tintes esmeralda, antracita y azul marino. La mayoría de muebles son obra de Morgen Interiors y fueron fabricados específicamente en roble encalado para la casa. Entre ellos se intercalan algunos clásicos del diseño.

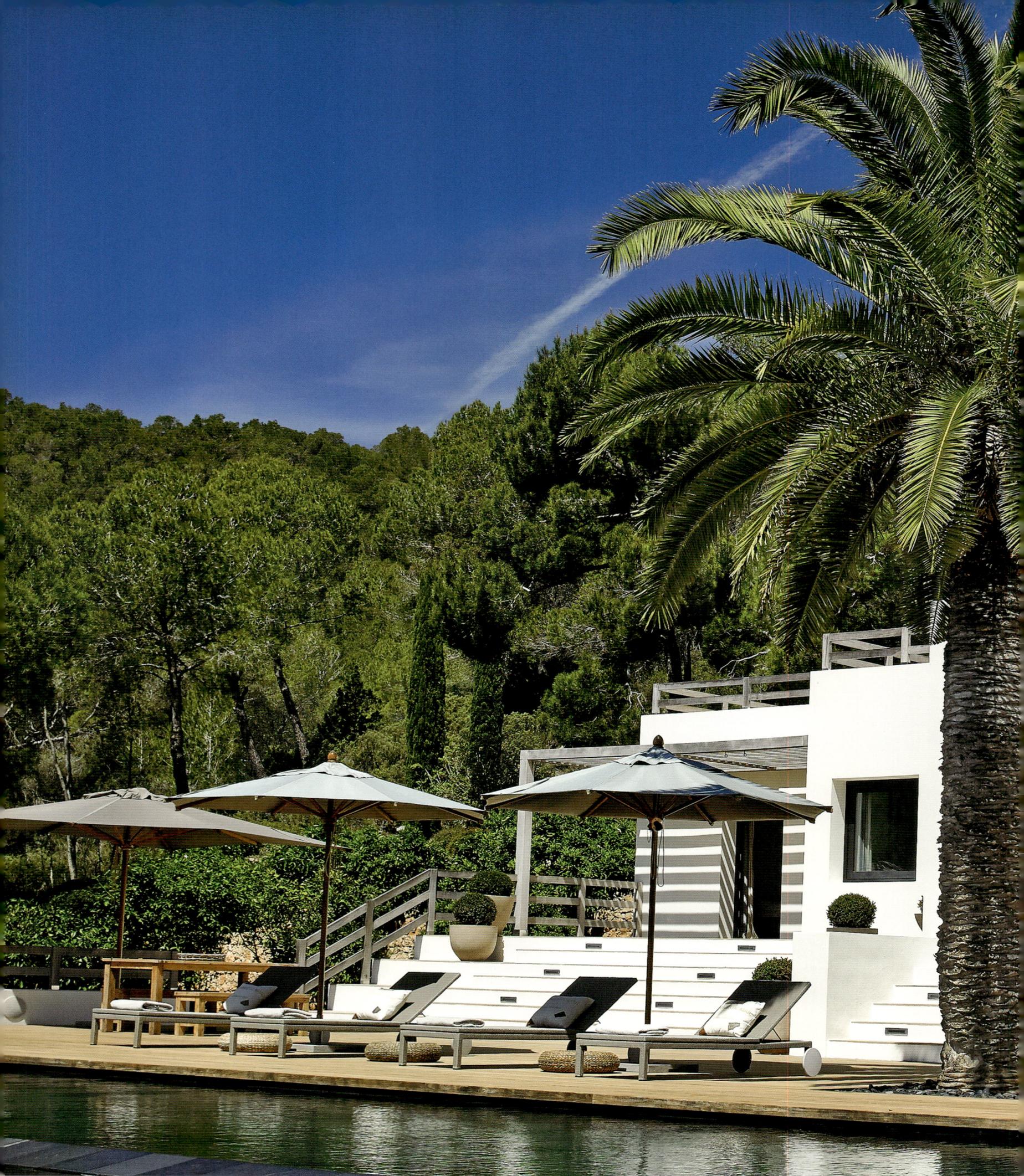

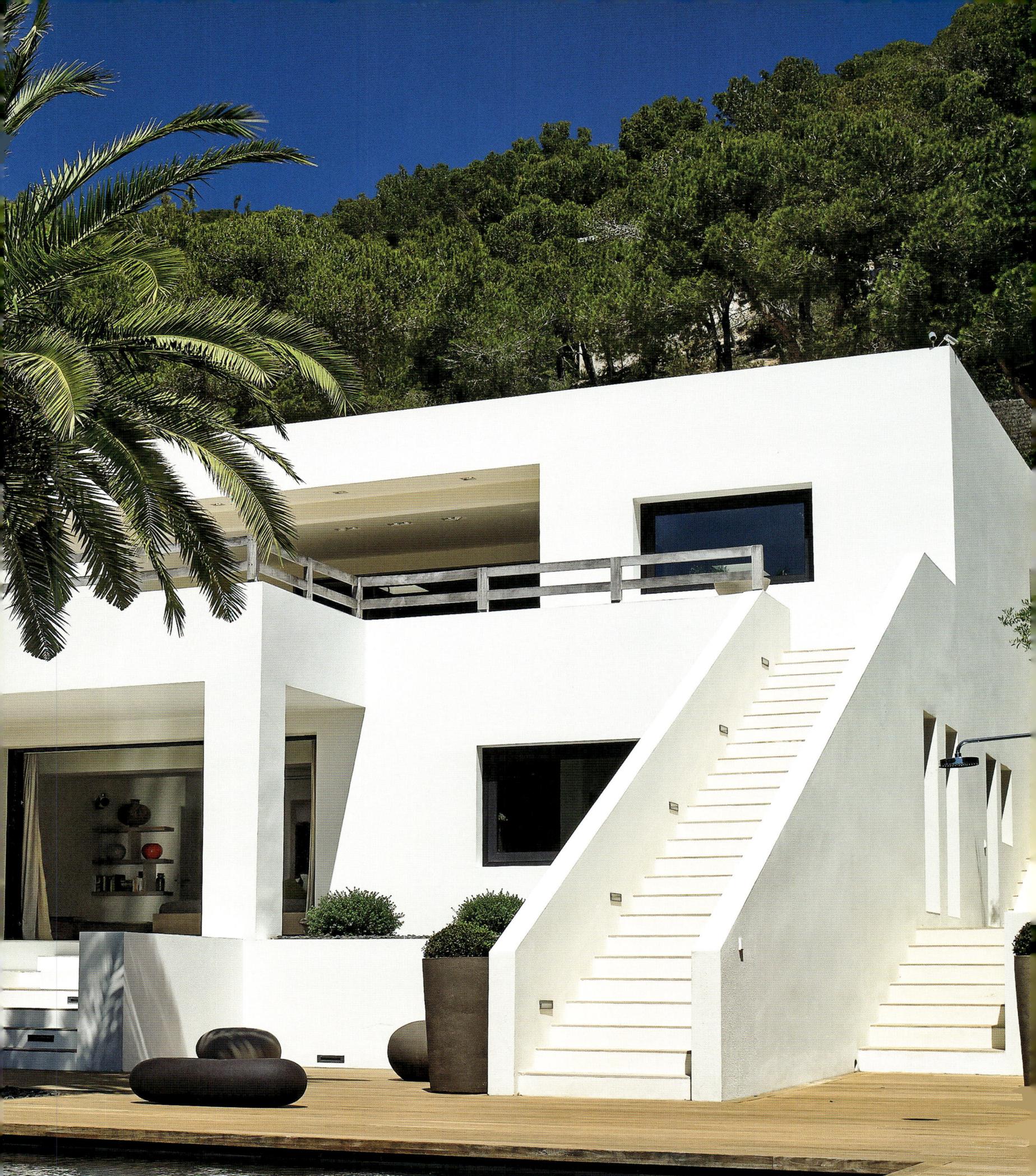

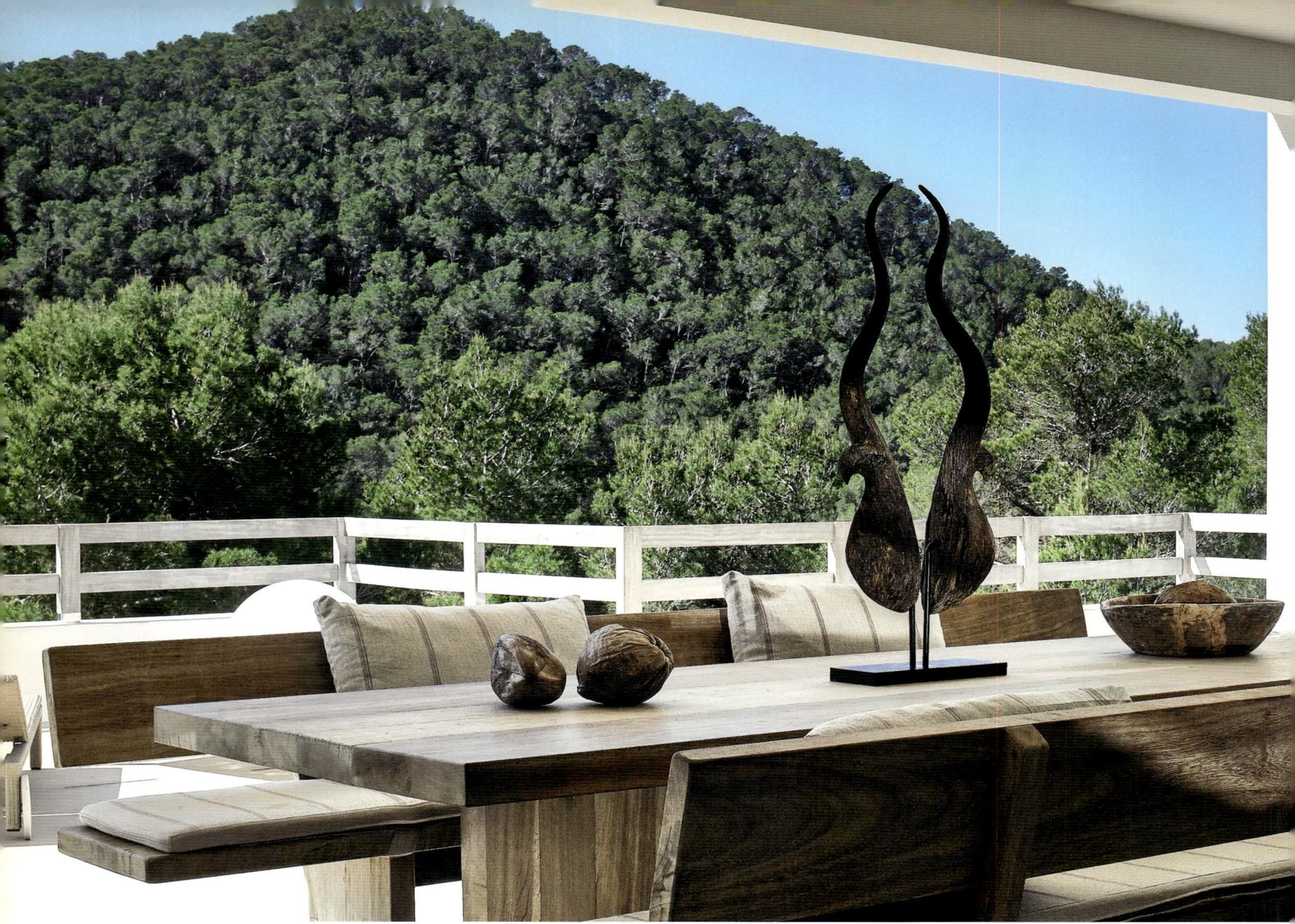

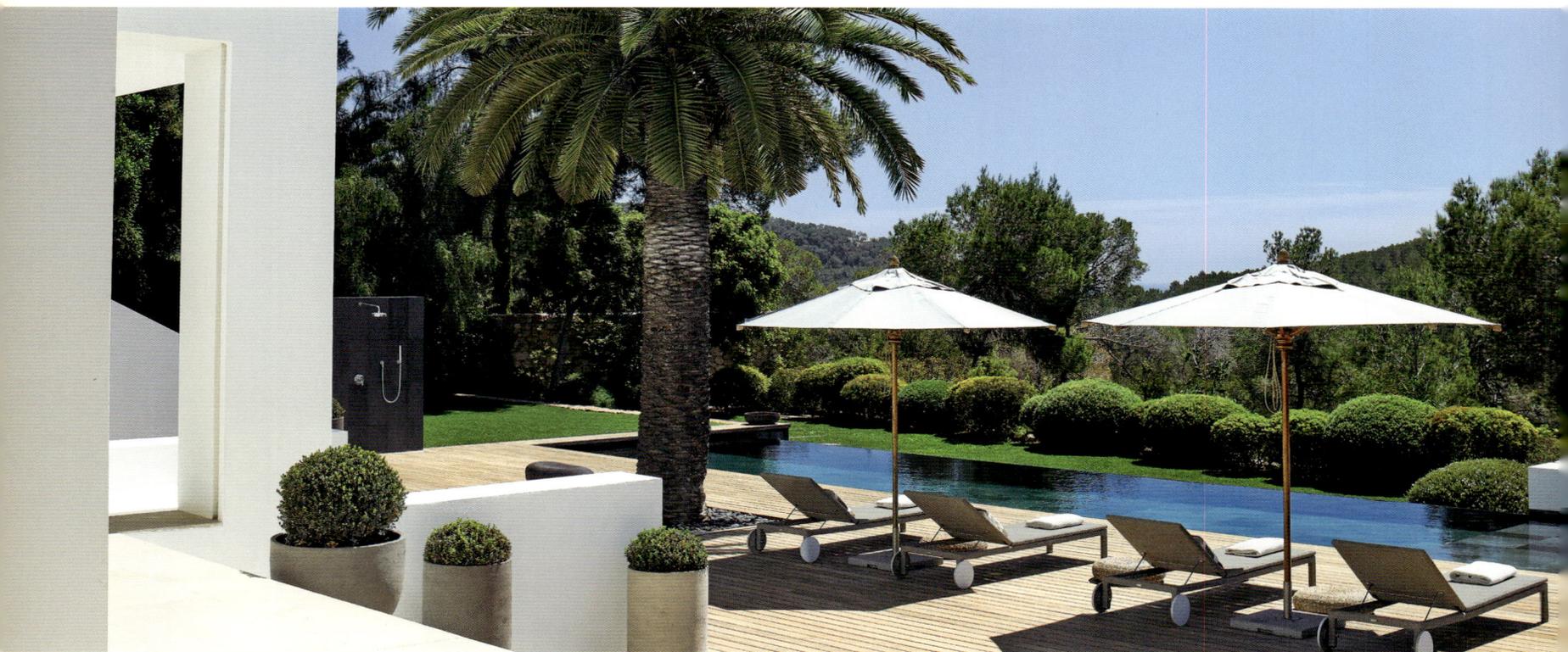

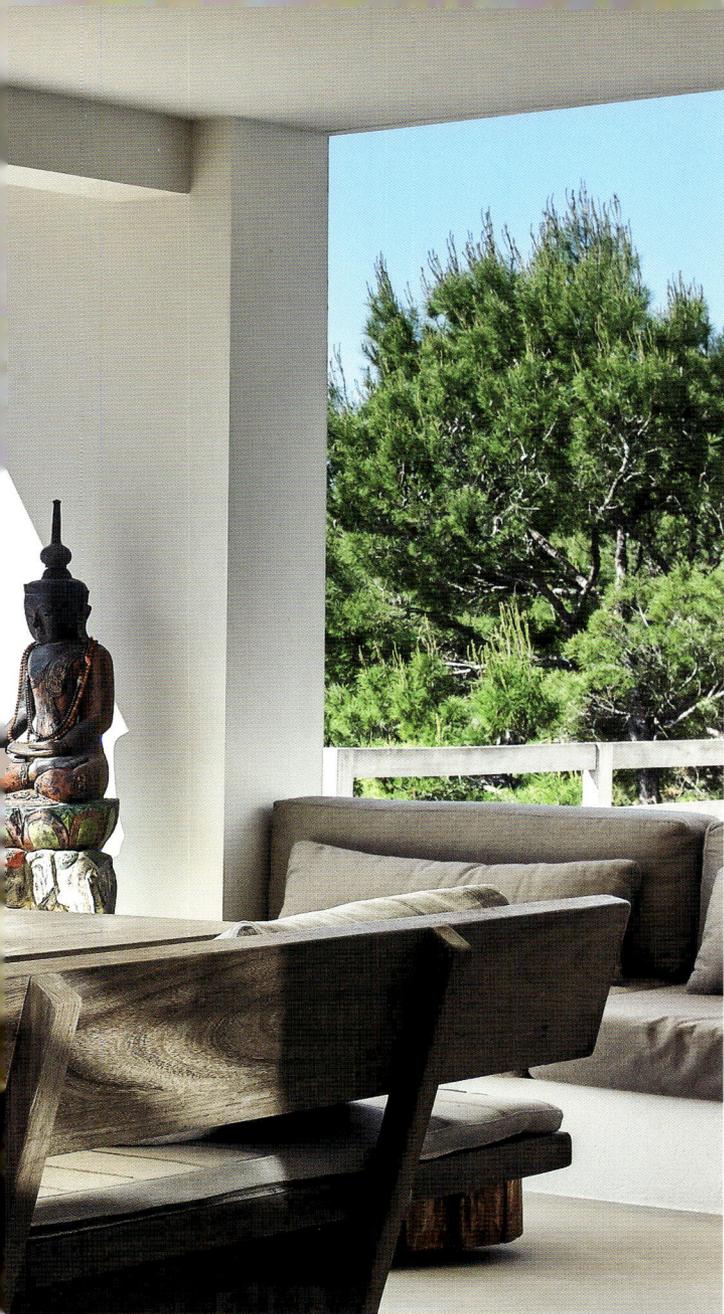

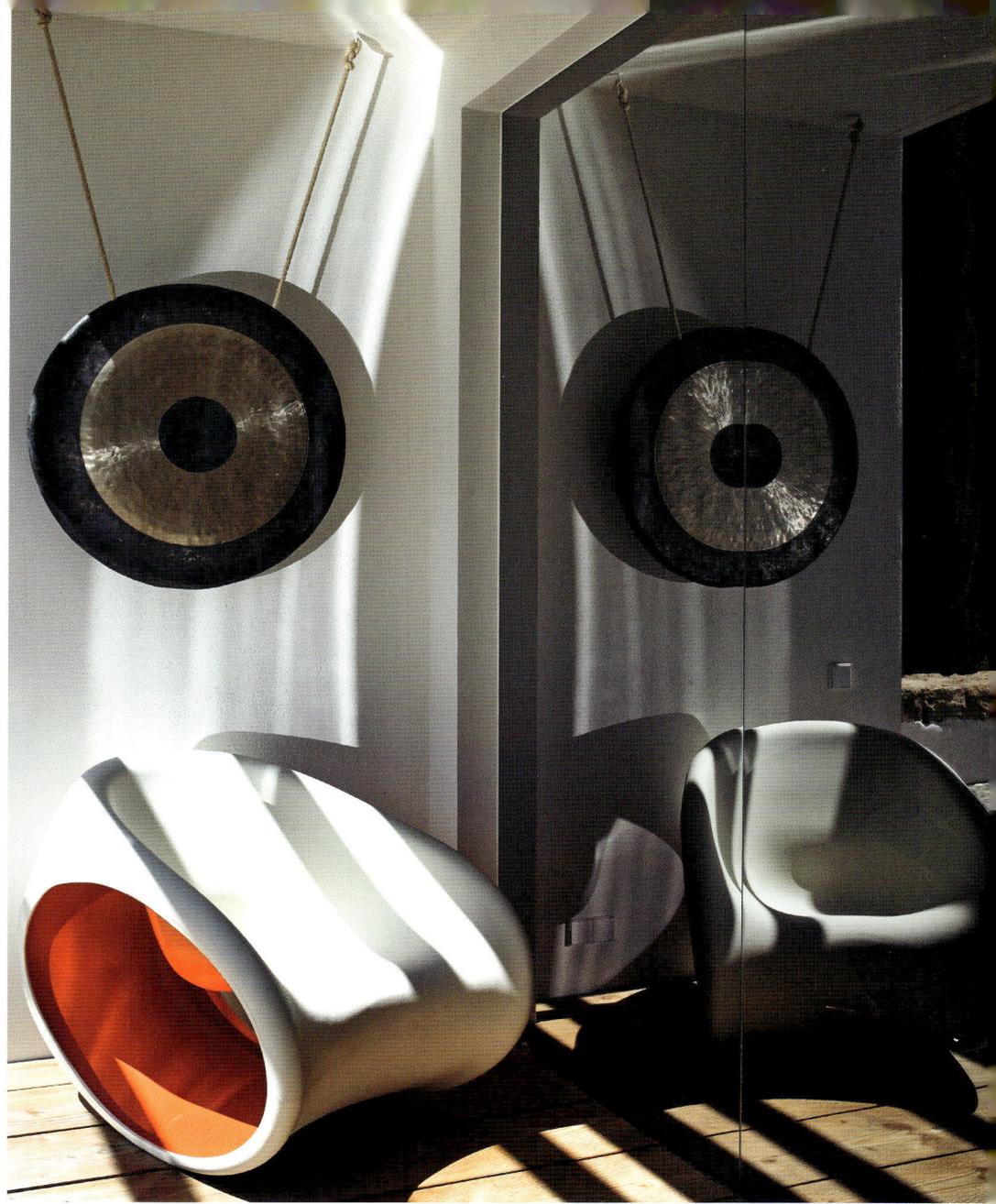

Patio furniture made of limed oak, Ron Arad chair and ethnic mementos from all over the world are surrounded by a pine forest and deep tranquility. Hassocks by Paola Lenti and Tribu sunbeds.

Außenmöbel aus gekalkter Eiche, Stuhl von Ron Arad und ethnische Fundstücke aus aller Welt umgeben von Pinienwald und absoluter Ruhe. Pouf-Sitzkissen von Paola Lenti und Tribu Sunbeds.

Muebles de exterior en roble encalado, silla de Ron Arad y diversos elementos étnicos procedentes de todo el mundo, rodeados de pinares y una calma absoluta. Puf de Paola Lenti y tumbonas de Tribu.

Functional, open kitchen in minimalist style with a
hand-crafted stainless steel island in the middle.
Butterfly lamp by Ingo Maurer.

*Minimalistische und funktionelle, offene Küche mit
handgefertigter Edelstahlinsel im Zentrum.
Schmetterlingslampe von Ingo Maurer.*

*Cocina abierta y minimalista, con isla de acero
inoxidable acabada a mano en el centro. Lámpara
mariposa de Ingo Maurer.*

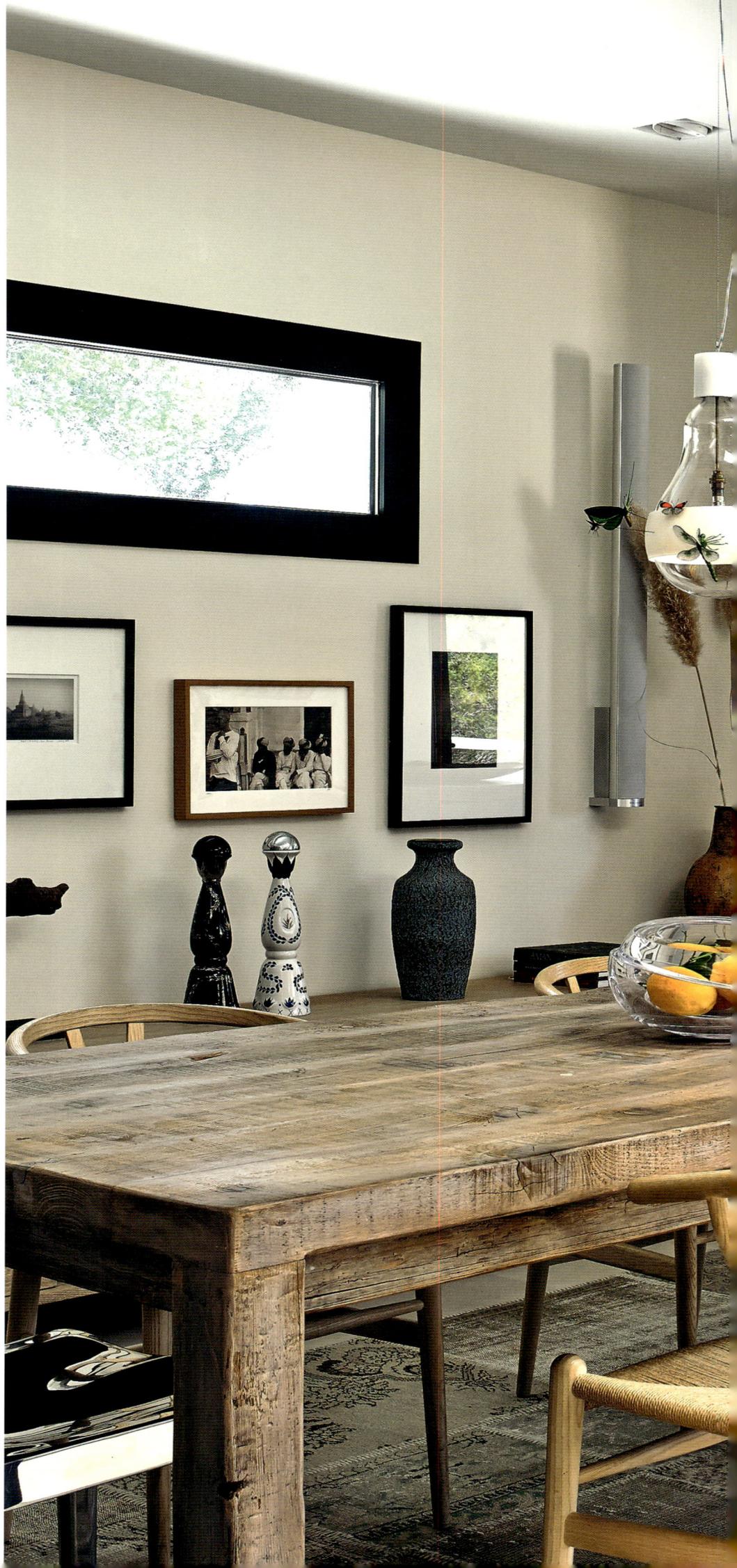

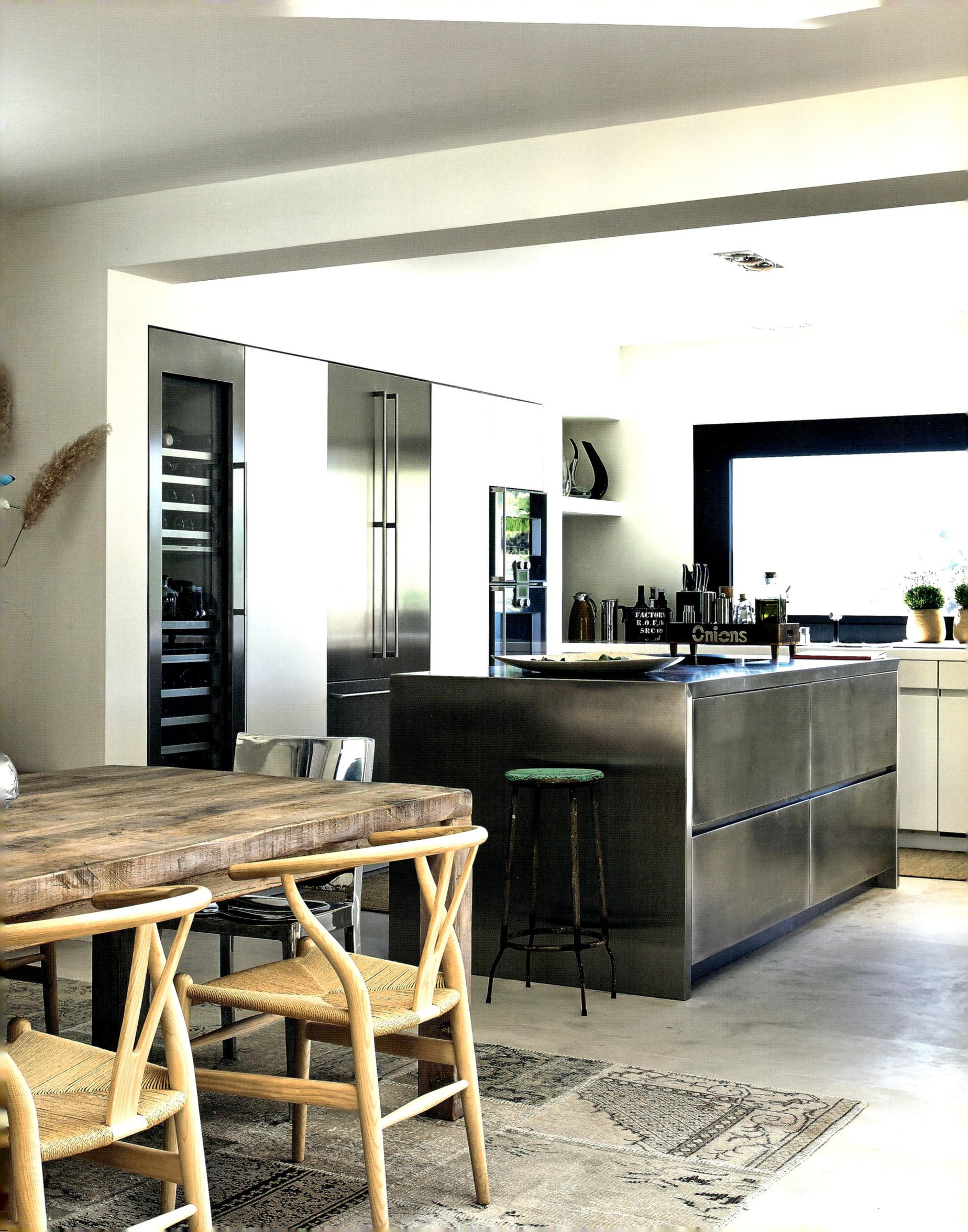

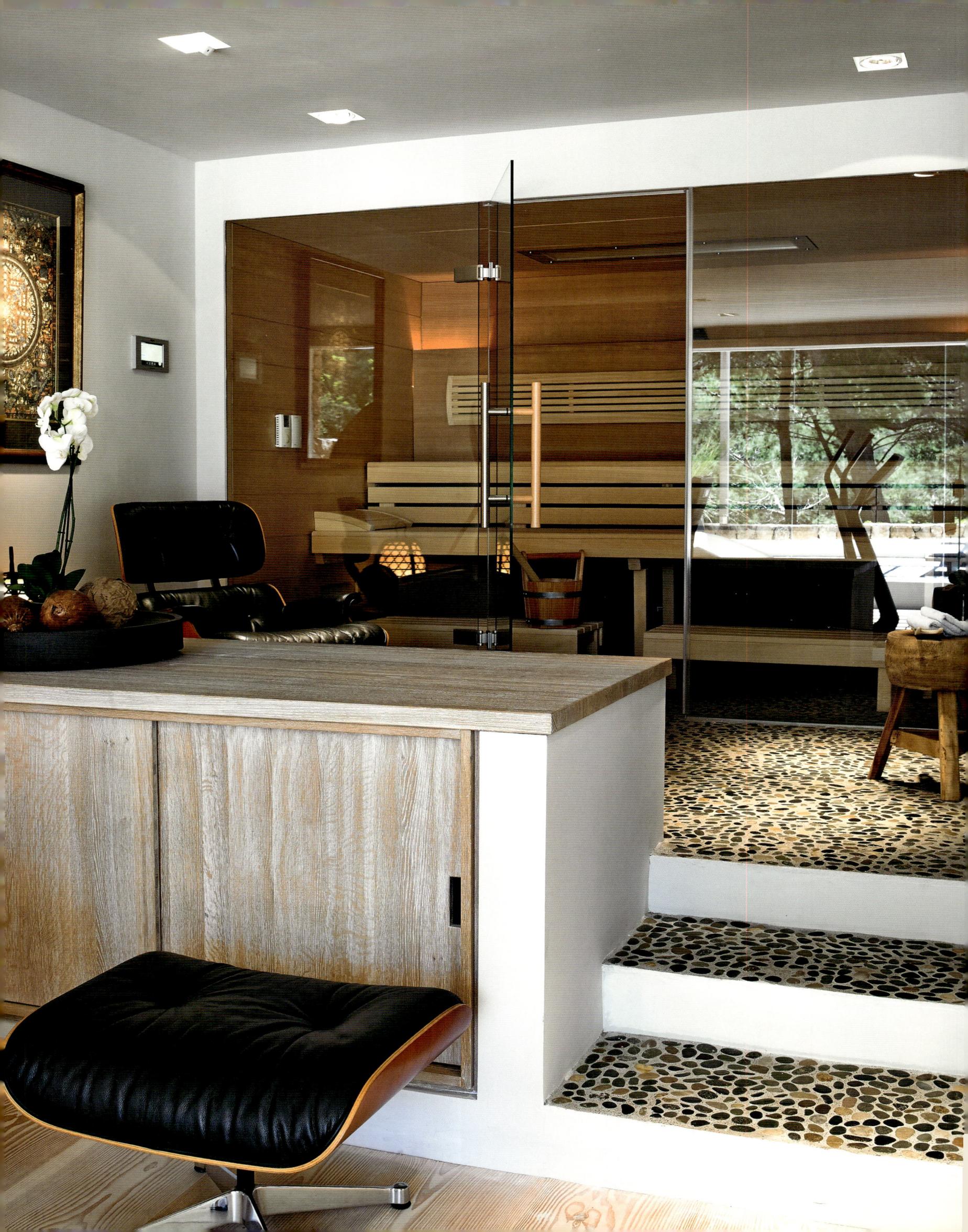

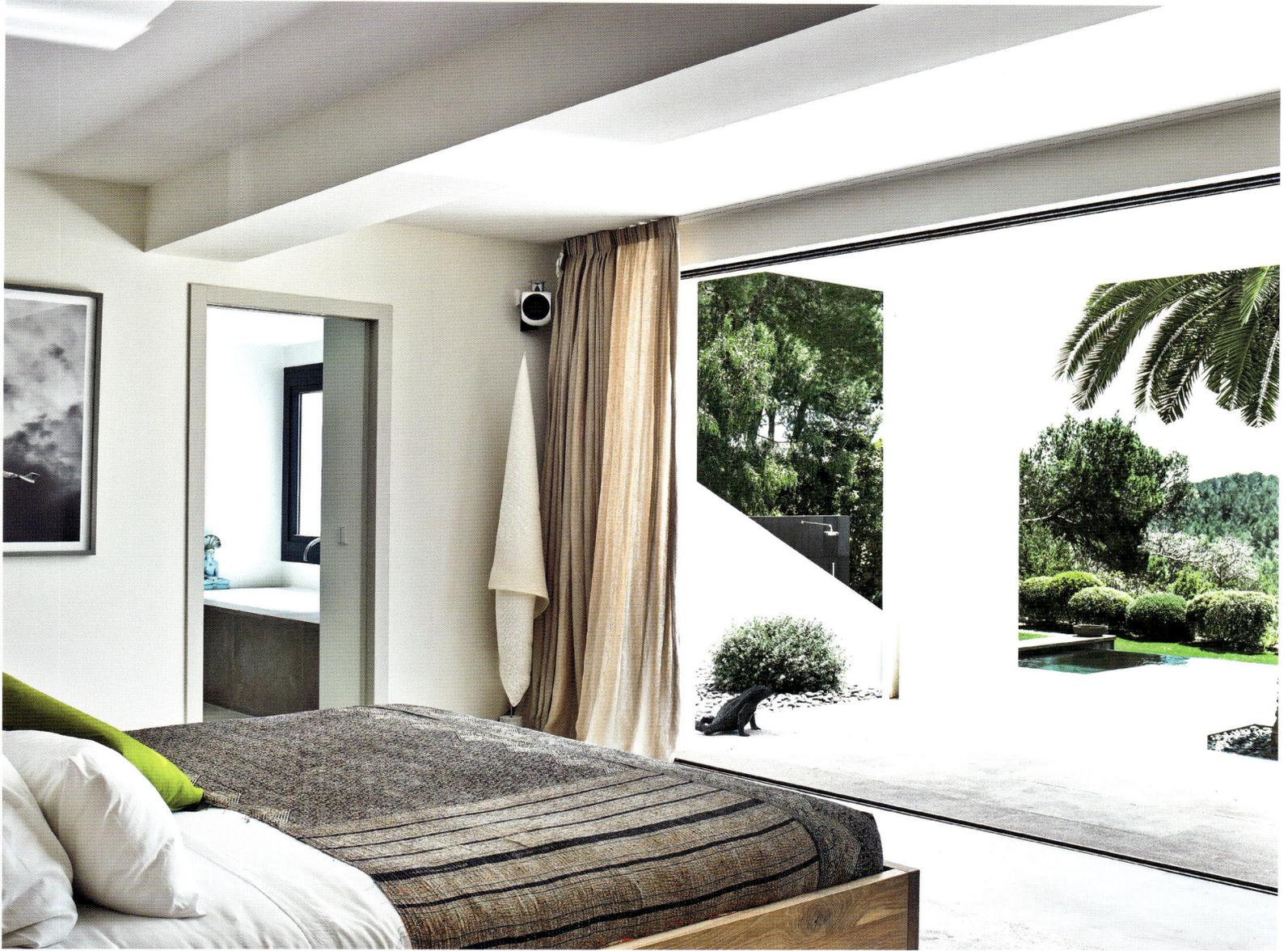

*Sauna and large gym area next door. The sliding glass doors in the master bedroom open all the way. The lamp in the stairwell is by Ingo Maurer*

*Sauna mit anschließendem großem Fitnessbereich. Die Glasschiebetüren im Masterbedroom lassen sich komplett öffnen. Lampe im Treppenaufgang von Ingo Maurer.*

*Sauna con zona de fitness contigua. Las puertas correderas de vidrio que dan al dormitorio principal pueden abrirse por completo. La lámpara en la escalera es de Ingo Maurer.*

# Can Cactus Azul

THIS EXTRAVAGANT HOME high in the Benimussa hills offers views of the west coast and Conillera Islands. The Norwegian owner rebuilt the house from the ground up, complete with new interior design. She chose materials native to the island for both the furnishings and the structure. Warm natural hues give the home cohesion, from the hand-hewn natural stones to the sand-colored cement walls. Furniture and treasures brought back from many travels fill the rooms. Extensive gardens with lush vegetation and a Mediterranean layout are hidden from view. They offer the owners and their guests an absolutely private space for watching spectacular sunsets and the sparkling evening lights of the vibrant San Antonio Bay.

AUF DEM OBEREN Berg von Benimussa liegt dieses extravagante Anwesen mit Blick auf die Westküste und die Conillera Inseln. Das Haus wurde von der norwegischen Eigentümerin komplett neu gebaut und designt. Bei der Einrichtung und den Baustoffen wurden typische Materialien der Insel verwendet. Die warmen Naturfarben ziehen sich von den handgeschnittenen Natursteinen über die sandfarbenen Zementwände. In den Räumen finden sich Möbel und Fundstücke von unzähligen Reisen. Der üppige und weitläufige Gartenbereich im mediterranen Stil ist uneinsehbar und gewährt Besitzern und Gästen äußerste Privatheit mit einem spektakulären Blick auf den Sonnenuntergang und die funkelnde Abendbeleuchtung der pulsierenden Bucht von San Antonio bei Nacht.

EN LO ALTO DE LA montaña de Benimussa se alza una extravagante residencia con vistas sobre la costa oeste y la isla de Conillera. La propietaria, de nacionalidad noruega, ha reformado por completo la casa y la ha dotado de un nuevo diseño, para el que se ha recurrido a los materiales de construcción típicos de la isla. Los cálidos colores naturales se extienden desde las piedras naturales talladas a mano hasta las paredes de hormigón de color arenoso. En las habitaciones, muebles y *bibelots* coleccionados a lo largo de innumerables viajes. El espléndido y extenso jardín de estilo mediterráneo, oculto a la vista, garantiza a propietarios y visitantes privacidad absoluta, así como una vista espectacular del atardecer y la iluminación nocturna de la animadísima bahía de Sant Antoni.

Entrance to the villa and a 72-foot heated salt-water pool with waterfall and a view of San Antonio Bay far below.

Der Eingangsbereich der Villa und der 22 Meter lange, beheizte Salzwasserpool mit Wasserfall und Weitblick auf die darunter liegende Bucht von San Antonio.

La zona de acceso de la villa, y la piscina climatizada de agua salada con cascada y vistas de la bahía de Sant Antoni.

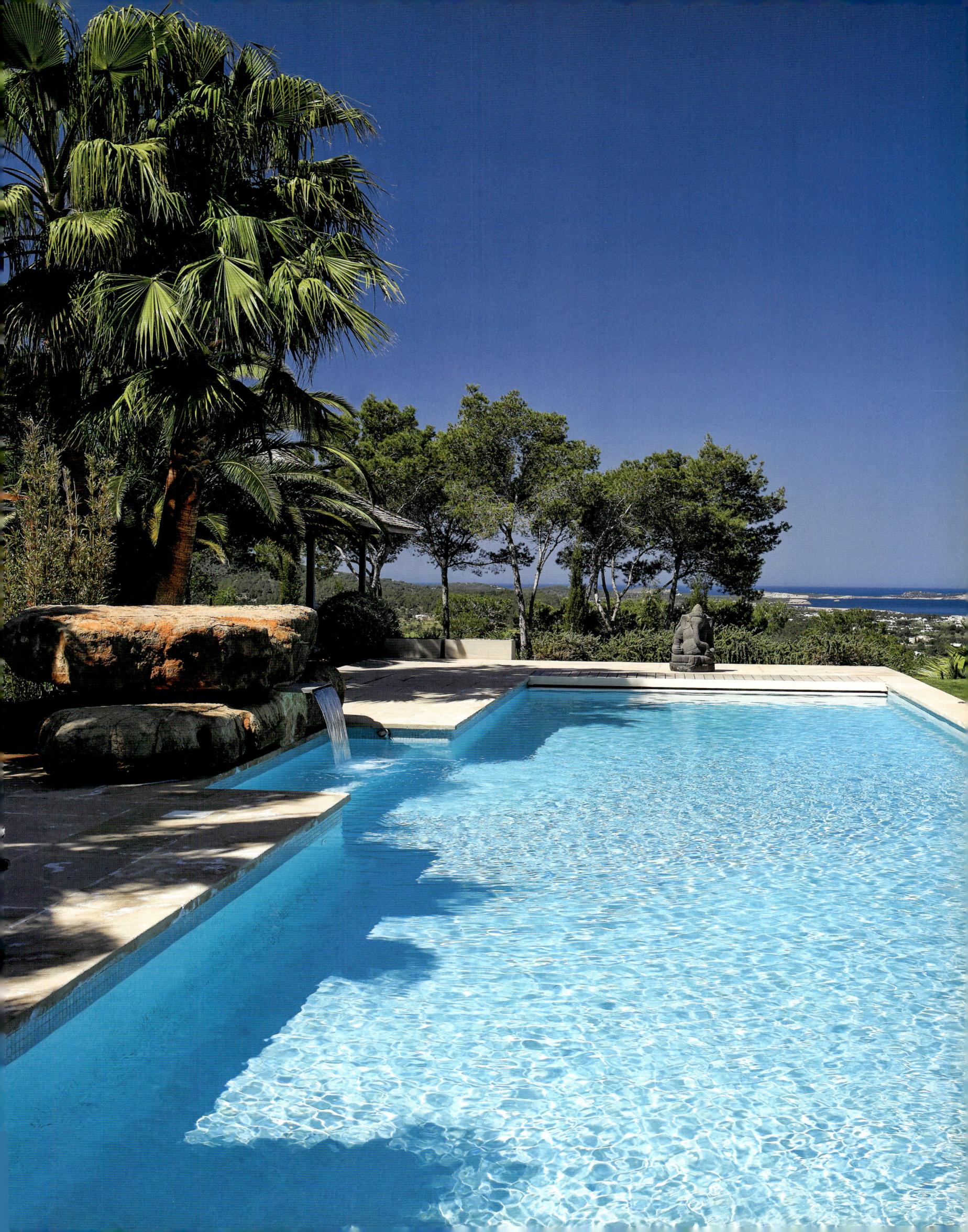

An eclectic mix of country style and ethnic treasures collected from all over the world contrasts with a modern professional kitchen and an open fireplace.

*Eklektische Zusammenstellung von Landhausstil und ethnischen Fundstücken aus allen Ländern neben der modernen Profiküche und dem offenen Kamin.*

*Ecléctica combinación de estilo señorial y piezas étnicas procedentes de todo el mundo junto a una moderna cocina profesional y un hogar abierto.*

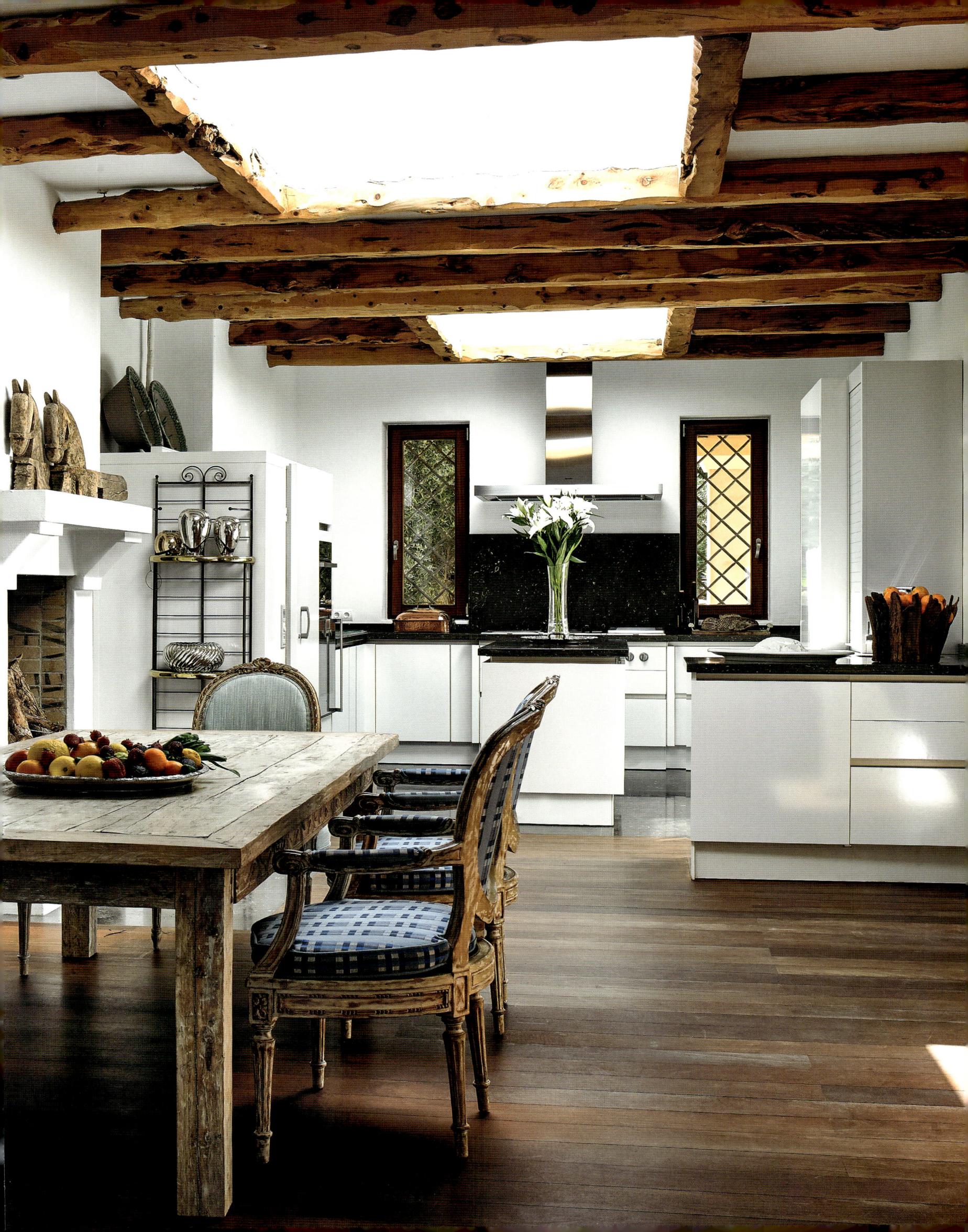

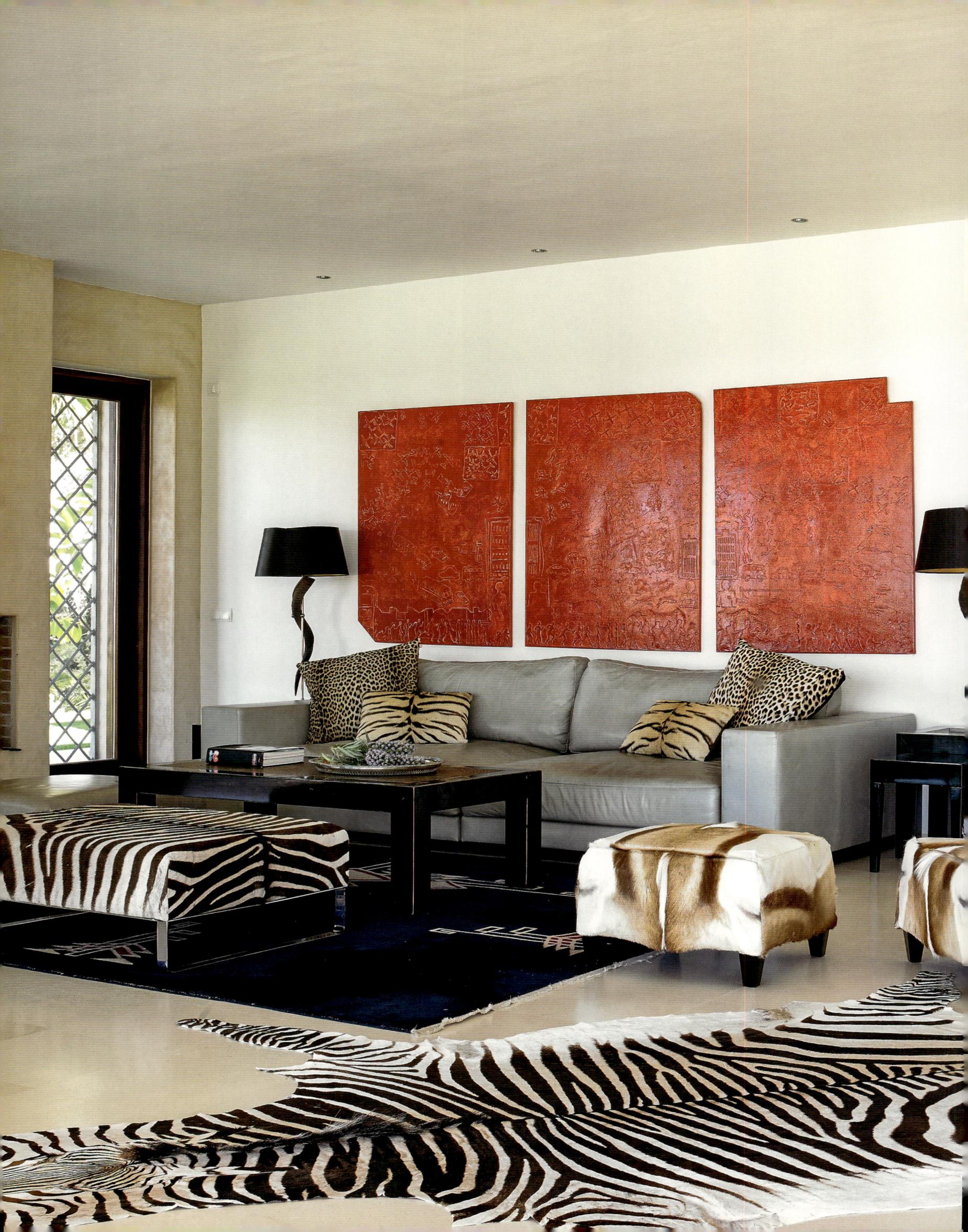

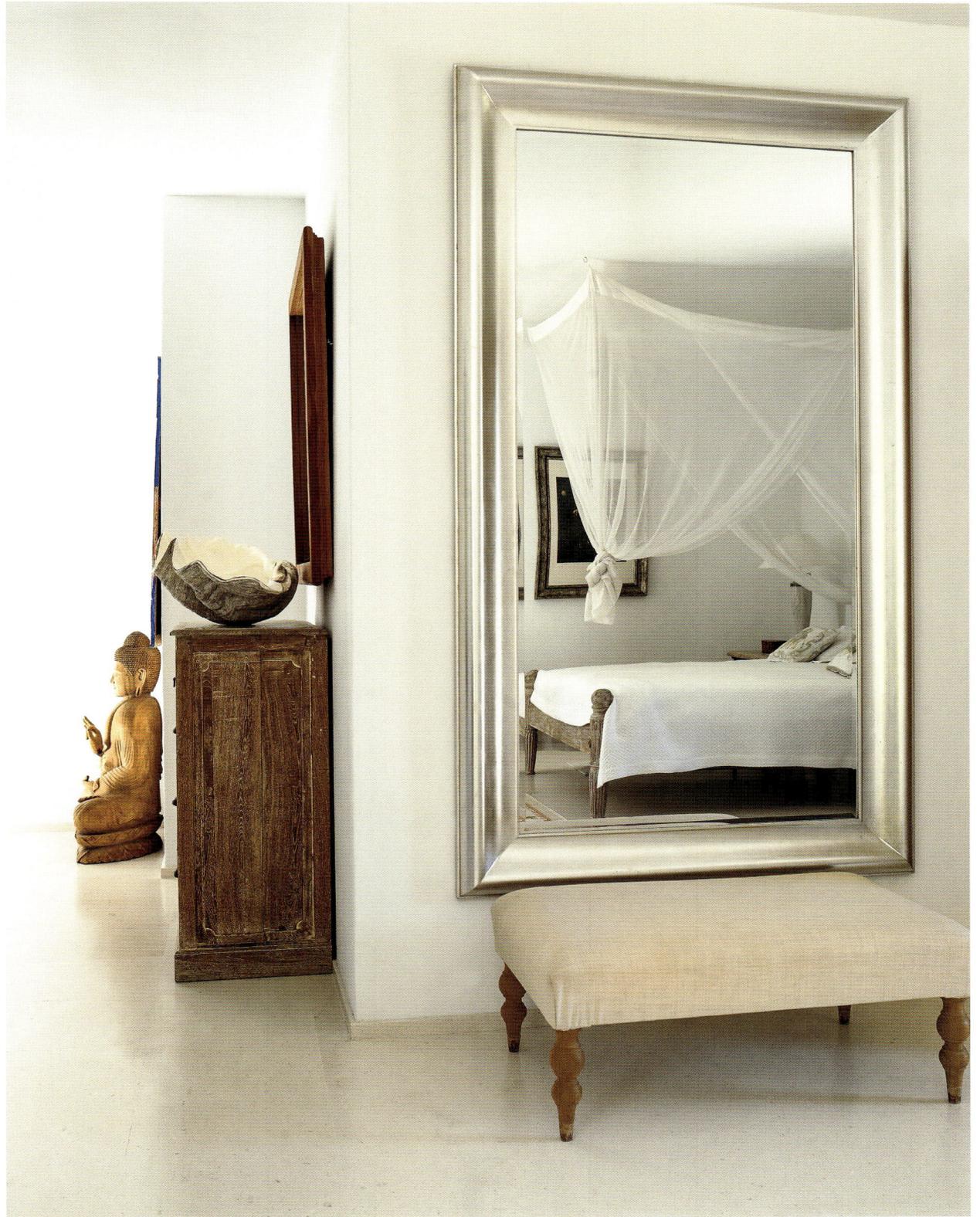

Contemporary art by prominent Brazilian and German artists sets accents in the living area and bedrooms. African pelts and kudu lamps harmonize with modern lines.

*Zeitgenössische Kunst renommierter brasilianischer und deutscher Künstler setzen Akzente im Wohnbereich und den Schlafzimmern. Afrikanische Felle und Kudulampen harmonieren mit moderner Linienführung.*

*Piezas de arte contemporáneo de reconocidos artistas brasileños y alemanes dan un toque personalizado al salón y los dormitorios. Las pieles africanas y las lámparas de cuernos de kudu armonizan con un conjunto de líneas modernas.*

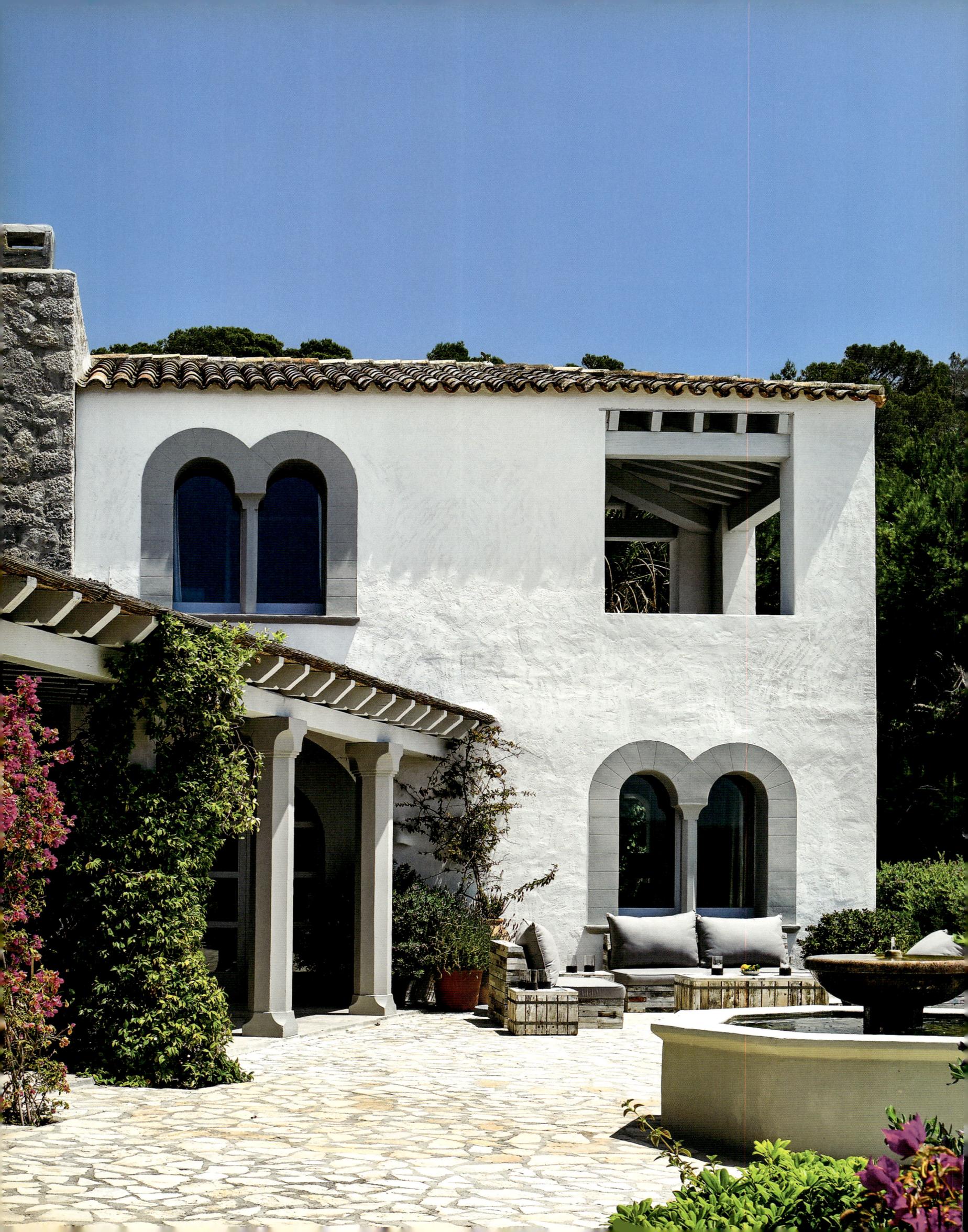

# Can Lagarto

CLASSIC IBIZAN STYLE combines with Moorish elements to create the unique architecture and design of this country home owned by a former Formula One driver. Designed by architect R. J. Blakstad, it stands on a hill overlooking Ibiza Town with views of the historic city center, the sea and Formentera. The interior features A-shaped wooden ceilings, reminiscent of a loft, that lend the home a casual, laid-back atmosphere and provide a unique and harmonious contrast with the building's striking gray stone. Marble floors, antiques and a country-chic ambience lend the interior its charm. The open-plan living room merges with the kitchen/dining area, which is separated by columns and lighting elements. The light-filled interior spaces open onto a patio straight from the "Arabian Nights."

KLASSISCHER IBIZENKO-STIL MIT maurischen Elementen bestimmen Bauweise und Gestaltung im Landhaus eines ehemaligen Formel-1-Fahrers. Entworfen vom Architekten R. J. Blakstad liegt es auf einem Hügel oberhalb von Ibiza-Stadt mit Blick auf die historische Altstadt, das Meer und auf Formentera. Die an ein Loft erinnernden, A-förmigen Deckenbalken im Inneren erzeugen eine informell-lässige Atmosphäre. Im Zusammenspiel mit dem lebendigen grauen Stein des Gebäudes entsteht so ein einmaliger und harmonischer Kontrast. Die Böden sind aus Marmor, Antiquitäten und Country-Chic geben dem Interieur seinen Charme. Offen gestaltet geht der Wohnraum über in den durch Säulen und Beleuchtungselemente abgetrennten Ess- und Küchenbereich. Die lichtdurchfluteten Innenräume führen auf einen Patio wie aus „1000 und einer Nacht".

EL ESTILO IBICENCO clásico, matizado con algunos elementos norteafricanos, marcan la pauta y las líneas de la residencia en la isla del antiguo piloto de Fórmula 1. Diseñada por el arquitecto R. J. Blakstad, la casa se alza sobre una loma por encima de la ciudad de Ibiza, asomada al casco antiguo, el mar y la lejana Formentera. Los techos de madera en A, de alguna manera reminiscentes de los de un loft, generan un ambiente desenfadado e informal en los interiores. En combinación con el vivo gris de la piedra del edificio se genera así un armónico contraste de características únicas. Los suelos de mármol, las antigüedades y el country chic no hacen sino reforzar el atractivo del conjunto. El espacioso salón se abre a una zona de cocina-comedor delimitada por varias columnas y elementos de iluminación. Los luminosos espacios interiores conducen a un patio propio de "Las mil y una noches".

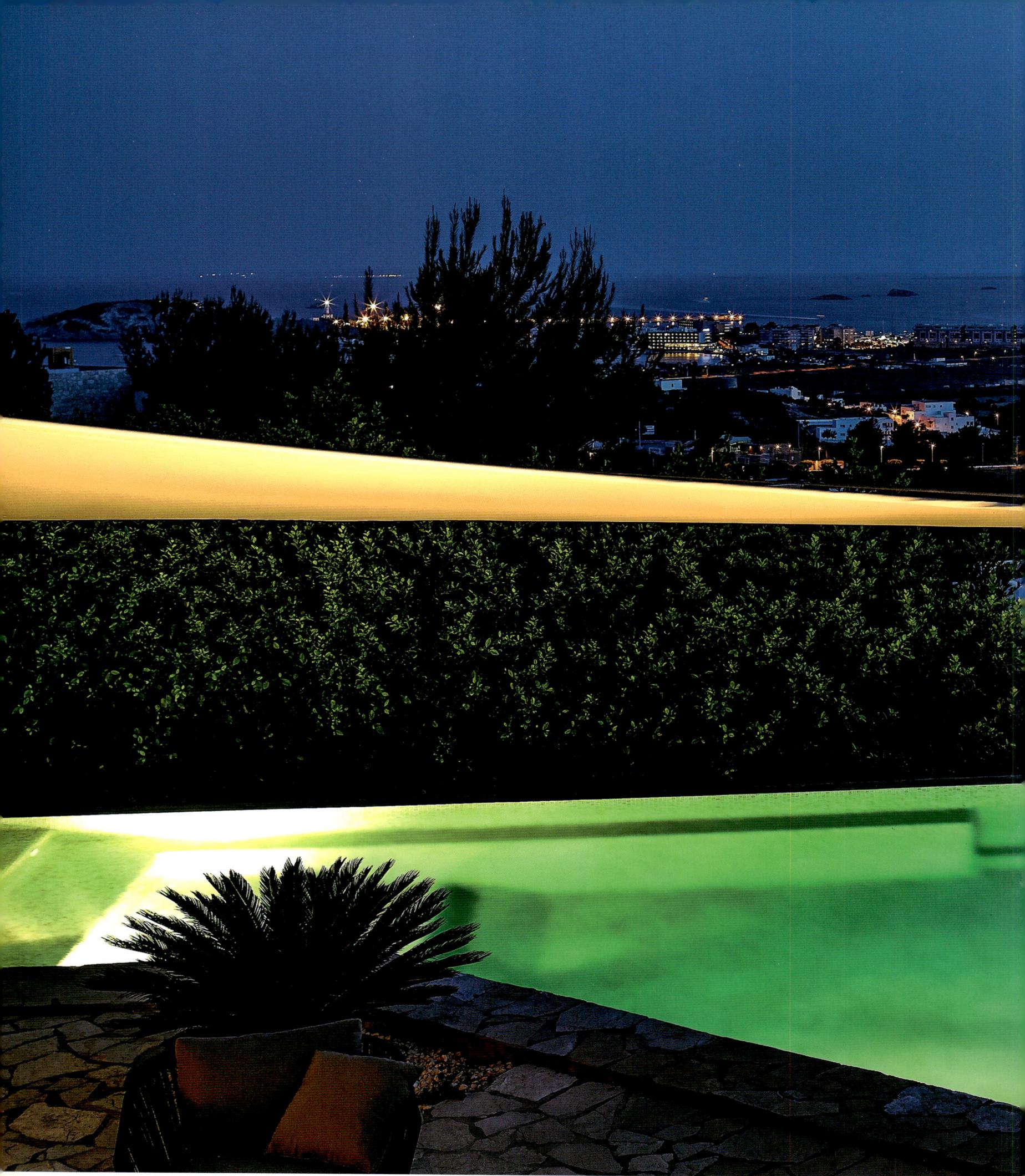

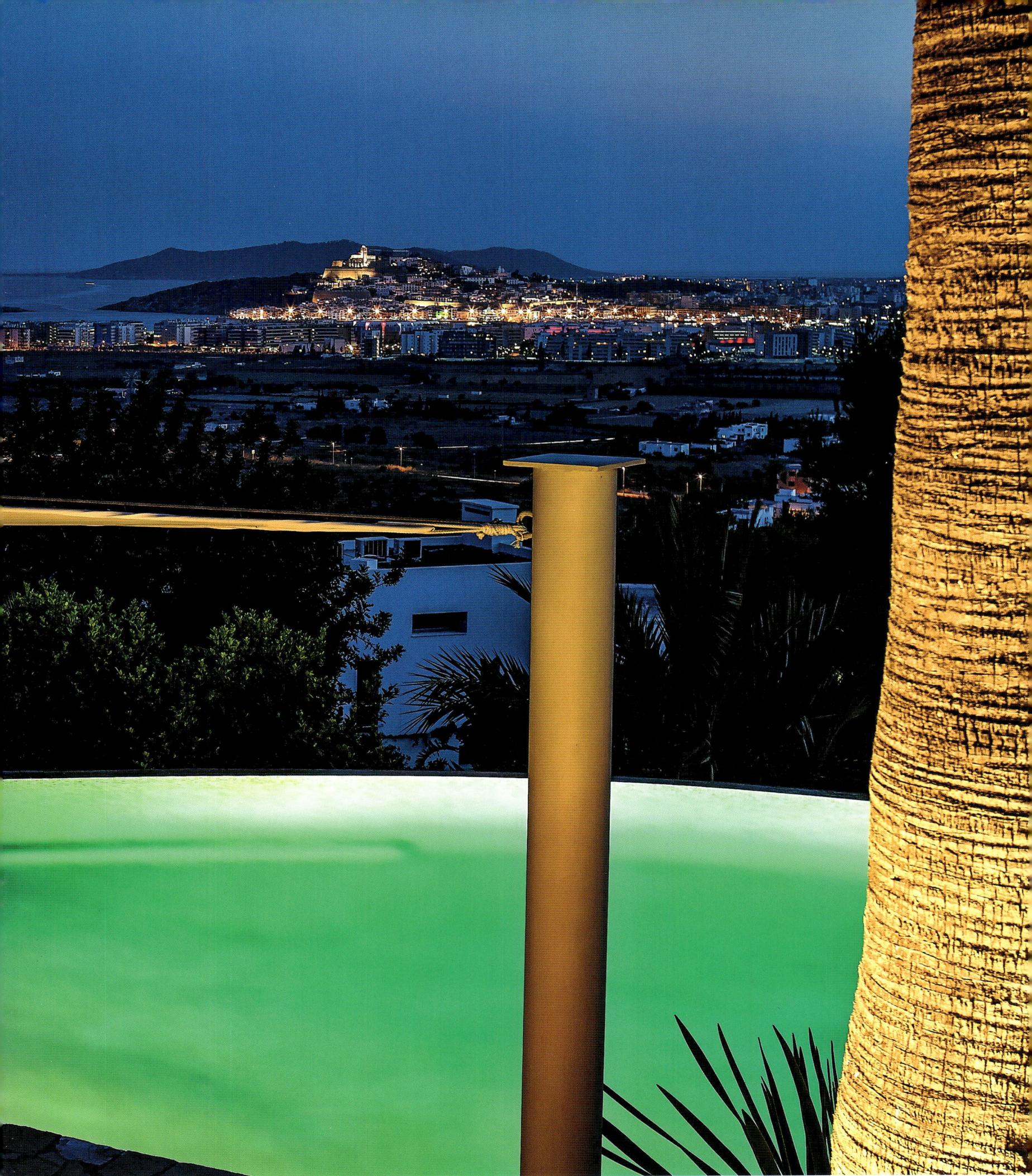

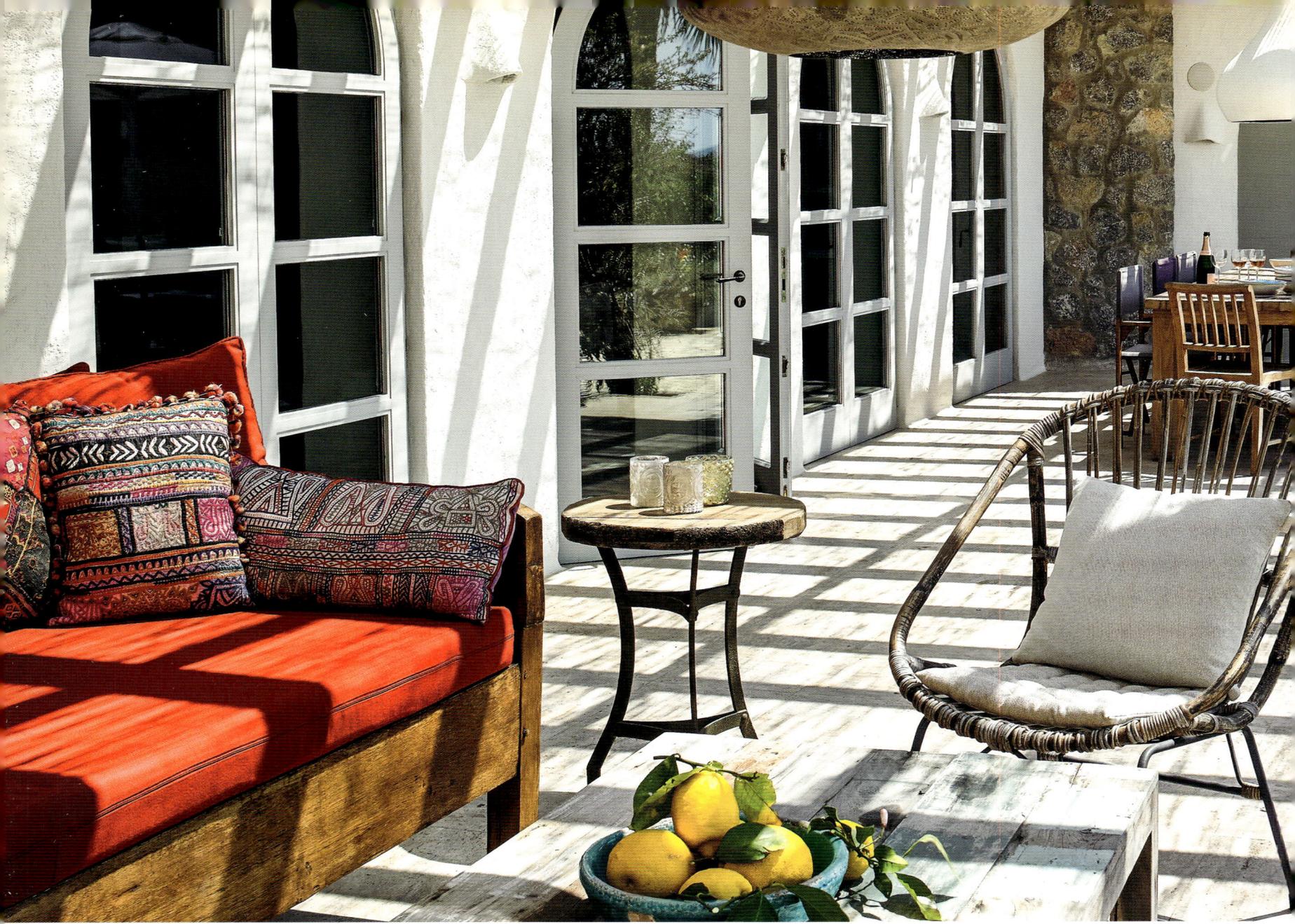
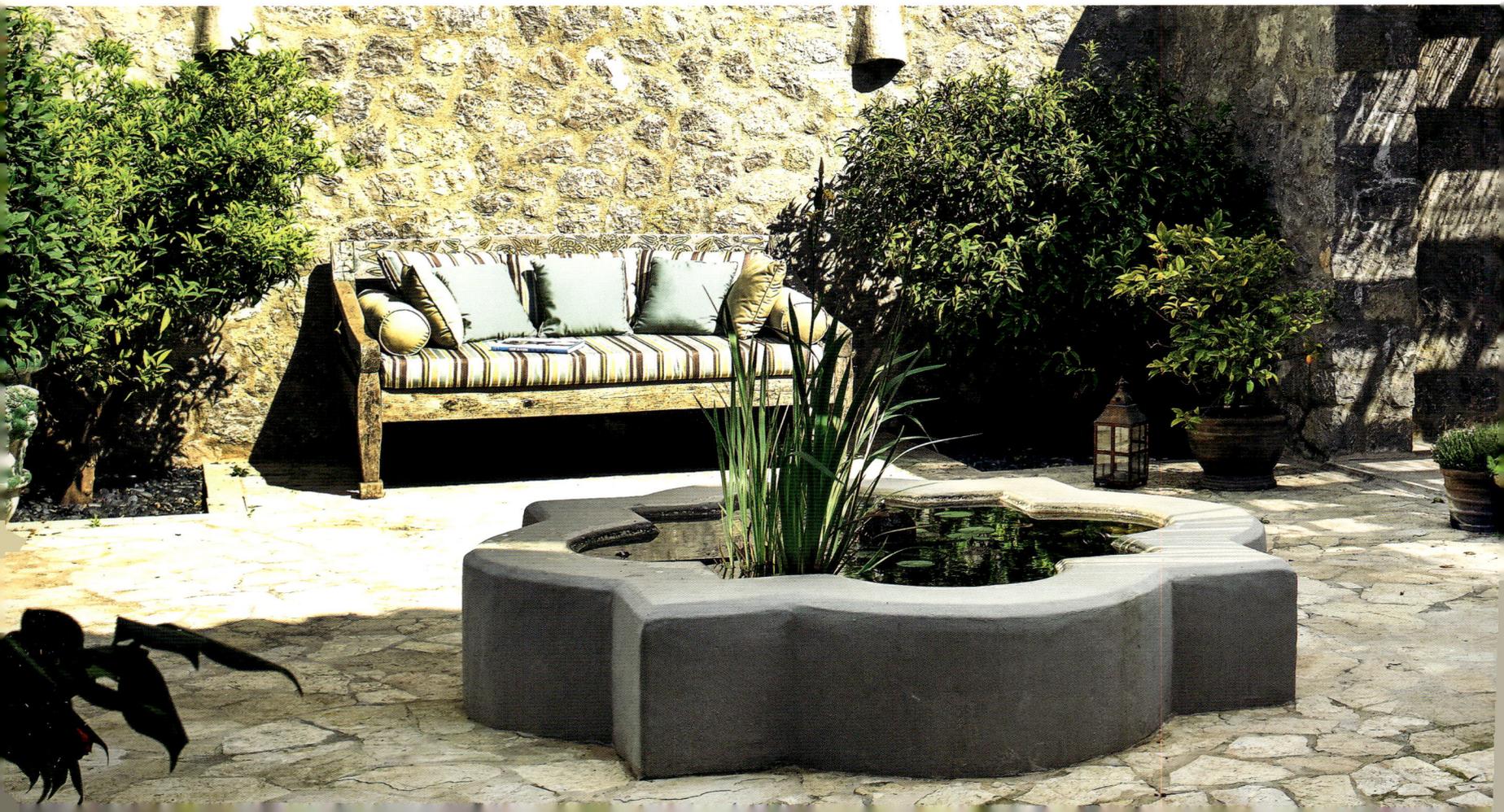

Outdoor terraces with typical Ibizan décor and ethnic-style accessories. The patio bears witness to Moorish traditions.

*Außenterrassen mit typisch ibizenkischer Dekoration und Accessoires im Ethno-Look. Der Patio als Zeuge maurischer Tradition.*

*Terrazas exteriores con decoración típicamente ibicenca y accesorios de aire étnico. El patio hace un guiño a la tradición morisca.*

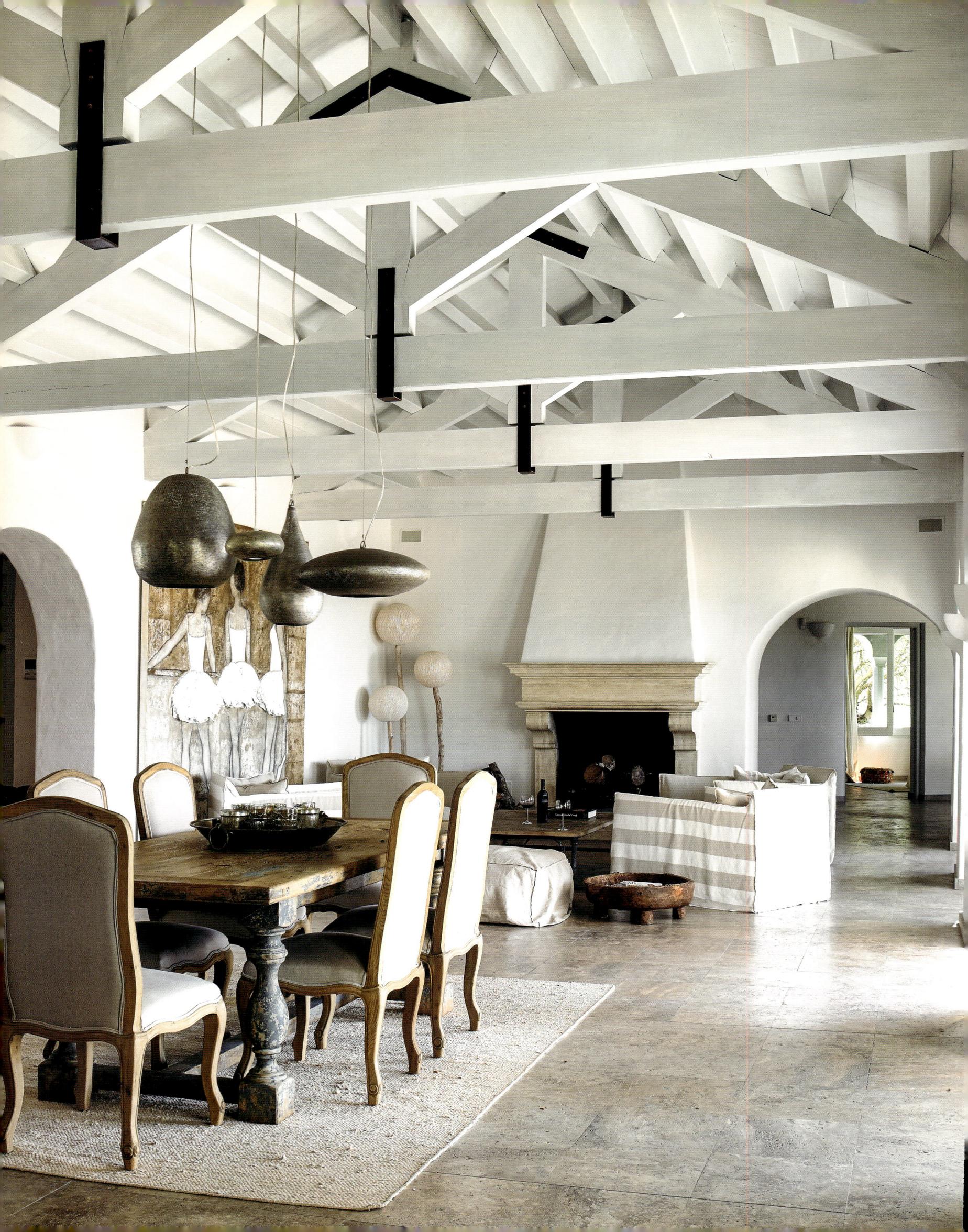

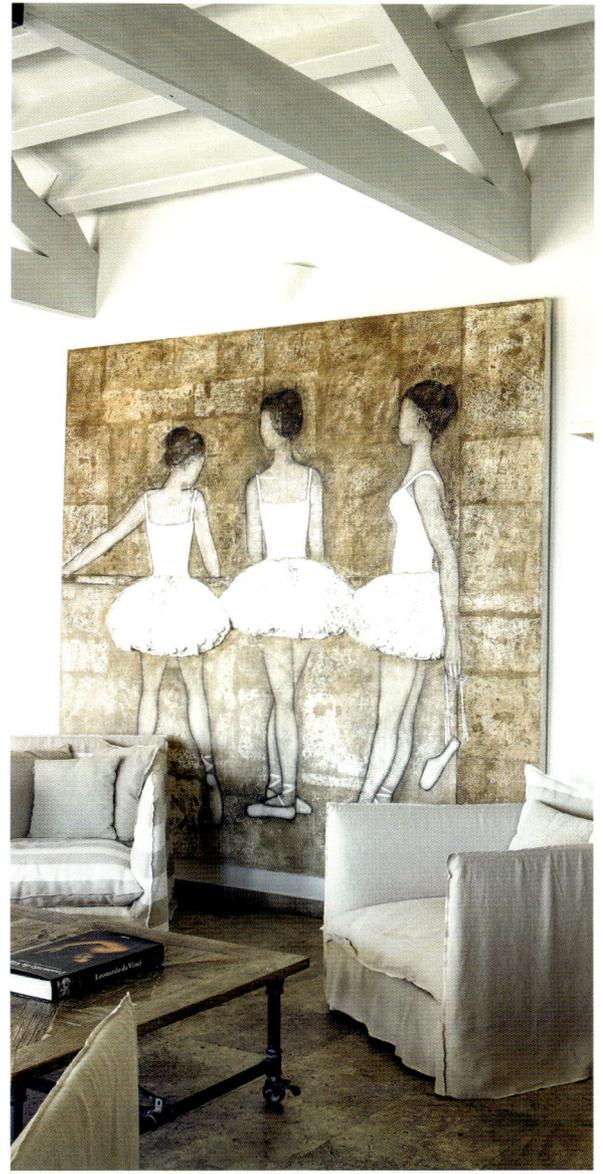

An antique French dining table beneath an impressively high ceiling with massive beams. A country-style fireplace with fauteuils from Gervasoni and marble floors throughout the house. The artworks were painted by Renate Clary.

Antiker französischer Esstisch unter einer massiven, beeindruckend hohen Balkenkonstruktion. Landhauskamin mit Fauteuils von Gervasoni und Marmorböden in allen Räumen. Die Gemälde sind Arbeiten der Malerin Renate Clary.

Antigua mesa de comedor francesa bajo un imponente entramado de vigas. Frente al hogar, sillones de Gervasoni et suelos de mármol en todas las habitaciones. Los cuadros hay obras de Renate Clary.

# Biographies

## Anke Rice

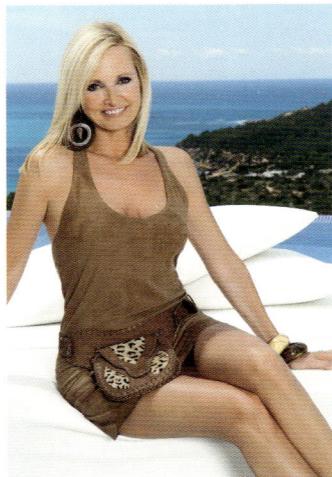

ANKE RICE LIVES a truly cosmopolitan life. Born in Germany and raised in New York, she now lives on Ibiza and also divides her time between Munich, London and Barcelona. After studying law and interning at a bank—both of which she did "to please Daddy"—she decorated her first apartment in London as "keeping busy therapy," an endeavor that brought her immediate success. However, this free spirit acquired her confident sense of style in Paris, where she studied art history and French literature at the Sorbonne. The "therapeutic project," along with her family, has become her biggest passion. Today, the international, self-taught designer manages projects on Ibiza as well as in London and Kitzbühel, Austria. She also designs furniture for her own projects. She landed on Ibiza in 1977 when a violent storm struck her uncle's sailboat—and it was love at first sight.

ANKE RICE IST eine wahrhafte Kosmopolitin: Geboren in Deutschland und in New York aufgewachsen, lebt sie heute auf Ibiza, in München, London und Barcelona. Nach einer Juraausbildung und einer Banklehre – welches sie nur studierte, um „Daddys Willen" zu entsprechen – richtete sie in London als „keeping busy therapy" ihr erstes Apartment ein, welches ihr sofortigen Erfolg bescherte. Ihren stilsicheren Geschmack erwarb sich der „free spirit" allerdings in Paris, wo sie an der Sorbonne Kunstgeschichte und französische Literatur studierte. Aus der „therapeutischen Maßnahme" wurde dann, neben ihrer Familie, ihre größte Leidenschaft. Die internationale, autodidaktische Designerin betreut heute Projekte auf Ibiza sowie in Kitzbühel und London und entwirft Möbel für ihre eigenen Projekte. Auf Ibiza landete sie 1977 bei einem schweren Sturm auf dem Segelboot ihres Onkels – es war Liebe auf den ersten Blick.

ANKE RICE ES una auténtica cosmopolita: nacida en Alemania y criada en Nueva York, en la actualidad reside en Ibiza, Múnich, Londres y Barcelona. Cursó estudios de Derecho y se inició en el negocio de la banca para complacer a su padre; en Londres diseñó su primer apartamento "como terapia ocupacional" y obtuvo con él sus primeros éxitos. Mujer de espíritu libérrimo, afinó su gusto y estilo en París, donde estudió historia del arte y literatura francesa en la Sorbona. Con el tiempo, y excepción hecha de su familia, aquella "medida terapéutica" acabó convirtiéndose en su mayor pasión. La diseñadora autodidacta de renombre internacional coordina hoy proyectos en Ibiza, Kitzbühel y Londres y diseña muebles para sus proyectos. A Ibiza llegó un tormentoso día de 1977 a burdo del velero de un tío suyo: fue amor a primera vista.

## Clarisse Grumbach-Palme

A NATIVE OF VIENNA, photographer Clarisse Grumbach-Palme traveled extensively before discovering Ibiza and making it her second home. Her love of the Mediterranean and the laid-back southern lifestyle developed over nearly a decade of living in London, the United States and on Mykonos. She later traveled throughout Asia and Southeast Asia, after which she studied photography in California and launched a career as a photographer specializing in the rock and jazz scenes. Her work has ranged from reports on Frank Zappa, Miles Davis, and other music legends to celebrity profiles for publications such as *Tempo* and *Vanity Fair*. After opening her own photo studio in Vienna with her partner at the time, she moved on to film, where she worked as an art director and set designer on Majorca and elsewhere. Most recently, she ended up on Ibiza, where she's involved in various interior design projects.

IN WIEN AUFGEWACHSEN, hat die Fotografin Clarisse Grumbach-Palme nach ausführlichen Reisen Ibiza für sich entdeckt und es zu ihrem zweiten Zuhause gemacht. In fast zehn Jahren zwischen London, den USA und Mykonos wuchs ihre Liebe zum Mittelmeer und der südlichen Gelassenheit. Nach weiteren ausgiebigen Reisen durch Asien und Südostasien schloss sie in Kalifornien ihre Fotografieausbildung ab und begann eine Laufbahn als Rock- und Jazzfotografin. Nach Reportagen über Frank Zappa, Miles Davis und andere Musiklegenden, Celebrityporträts, u. a. für *Tempo* & *Vanity Fair* gründete sie zusammen mit ihrem damaligen Partner ein eigenes Fotostudio in Wien. Später wechselte sie zum Film, wo sie für Ausstattung und Setdesign zuständig war, unter anderem auch auf Mallorca. Von dort aus gelangte sie mit diversen Einrichtungsprojekten nach Ibiza.

TRAS CRIARSE EN Viena, la fotógrafa Clarisse Grumbach-Palme descubrió Ibiza para sí en uno de sus extensos viajes y decidió convertir la isla en su segundo hogar. Su amor por el Mediterráneo y el pausado estilo de vida meridional se cimentó durante casi diez años vividos entre Londres, EEUU y Míkonos. Tras varios viajes por Asia y el sudeste asiático completó en California sus estudios de fotografía e inició una carrera como fotógrafa de rock y jazz. Creo portadas de discos para Frank Zappa, Miles Davis y otras leyendas, y sus retratos de famosos aparecieron publicados en *Tempo* y *Vanity Fair*. Posteriormente abrió un estudio fotográfico en Viena junto con la que por entonces era su pareja, y de ahí saltó al cine, donde ha diseñado escenarios y atrezzo para rodajes en Mallorca. Posteriormente, diversos proyectos de interiorismo la han llevado hasta Ibiza.

# Credits

## Tiny von Wedel

TINY VON WEDEL is a freelance writer and interior designer. In addition to book projects, she also writes articles, interviews, columns and essays. She runs *Copper House Living*, a company that creates interiors for customers in the Balearic Islands, London, and Hamburg. After growing up in Hamburg and South Africa, the German native has also lived and worked in Los Angeles, Marbella, Marrakesh, London, and other cities around the world. She spent many years working as an advertising consultant and also did stints as a model, film producer, yoga teacher and copywriter. Since 2001, she has been commuting between Mallorca and Hamburg. Her first novel, *Für immer bis zum nächsten Mal,* was published in 2012.

TINY VON WEDEL ist freie Autorin und Inneneinrichterin. Neben ihren Buchprojekten schreibt sie Artikel sowie Interviews, Kolumnen und Essays. Mit ihrer Firma *Copper House Living* realisiert sie für ihre Kunden Interieurs auf den Balearen, in London und Hamburg. Die gebürtige Hanseatin ist in Hamburg und Südafrika aufgewachsen und hat u. a. in Los Angeles, Marbella, Marrakesch und London gelebt und gearbeitet. Sie war lange Jahre Kundenberaterin in der Werbung, hat als Model, Filmproducerin, Yogalehrerin und Texterin gearbeitet. Seit 2001 pendelt sie zwischen Mallorca und Hamburg. Ihr erster Roman *Für immer bis zum nächsten Mal* ist 2012 erschienen.

TINY VON WEDEL es escritora e interiorista. Además de a sus proyectos literarios, dedica su tiempo a escribir artículos, columnas y ensayos. Su empresa *Copper House Living* lleva a cabo proyectos de interiorismo para sus clientes en las Baleares, Londres y Hamburgo. Sus primeros años transcurrieron a caballo entre Sudáfrica y Hamburgo, y la vida y el trabajo la han llevado a residir y trabajar en Los Ángeles, Marbella, Marrakech y Londres, entre otros lugares. Asesora durante muchos años en una agencia publicitaria, ha sido también modelo, productora cinematográfica, profesora de yoga y ahora escritora. Desde 2001 reparte su tiempo entre Mallorca y Hamburgo. Su primera novela *Für immer bis zum nächsten Mal* fue publicada en 2012.

# Imprint

© 2014 teNeues Media GmbH & Co. KG, Kempen

Edited by Anke Rice and Clarisse Grumbach-Palme
Texts by Tiny von Wedel

Translations by Romina Russo Lais and Heidi Holzer
(English), Romina Russo Lais and Pablo Ellacuria
Alvarez (Spanish)
Editorial coordination by Inga Wortmann
Production by Alwine Krebber
Design by Jens Grundei
Color separation by Medien Team-Vreden

Published by teNeues Publishing Group

teNeues Media GmbH & Co. KG
Am Selder 37, 47906 Kempen, Germany
Phone: 0049-2152-916-0
Fax: 0049-2152-916-111
e-mail: books@teneues.com

Press department: Andrea Rehn
Phone: 0049-2152-916-202
e-mail: arehn@teneues.com

teNeues Digital Media GmbH
Kohlfurter Straße 41–43, 10999 Berlin, Germany
Phone: 0049-30-7007765-0

teNeues Publishing Company
7 West 18th Street, New York, NY 10011, USA
Phone: 001-212-627-9090
Fax: 001-212-627-9511

teNeues Publishing UK Ltd.
12 Ferndene Road, London SE24 0AQ, UK
Phone: 0044-20-3542-8997

teNeues France S.A.R.L.
39, rue des Billets, 18250 Henrichemont, France
Phone: 0033-2-4826-9348
Fax: 0033-1-7072-3482

www.teneues.com

Bibliographic information published by the Deutsche
Nationalbibliothek. The Deutsche Nationalbibliothek
lists this publication in the Deutsche Nationalbib-
liografie; detailed bibliographic data are available in
the Internet at http://dnb.d-nb.de.

ISBN 978-3-8327-9805-5
Library of Congress Control Number  2013957670

Printed in the Czech Republic

**teNeues Publishing Group**
Kempen
Berlin
London
Munich
New York
Paris

teNeues

FSC
www.fsc.org

MIX
Papier aus verantwor-
tungsvollen Quellen
FSC® C005833